THE ART OF THE *Macchia* AND THE *Risorgimento*

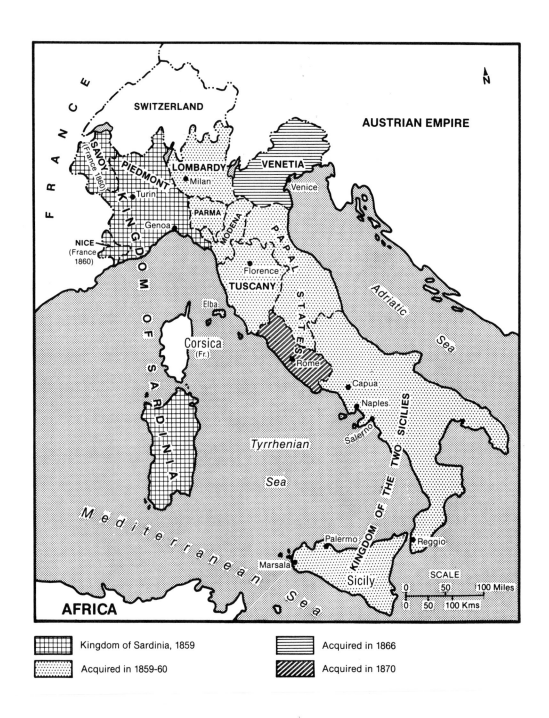

Kingdom of Sardinia, 1859

Acquired in 1866

Acquired in 1859–60

Acquired in 1870

The Unification of Italy, 1859–70

THE ART OF THE *Macchia* AND THE *Risorgimento*

REPRESENTING CULTURE AND NATIONALISM IN NINETEENTH-CENTURY ITALY

Albert Boime

THE UNIVERSITY OF CHICAGO PRESS / CHICAGO AND LONDON

Albert Boime is professor of art history at the University of California, Los Angeles.

The University of Chicago Press, Chicago 60637
The University of Chicago Press, Ltd., London
© 1993 by The University of Chicago
All rights reserved. Published 1993
Printed in the United States of America
02 01 00 99 98 97 96 95 94 93 5 4 3 2 1

ISBN (cloth): 0-226-06330-5

Library of Congress Cataloging-in-Publication Data

Boime, Albert.
 The art of the Macchia and the Risorgimento : representing culture and nationalism in nineteenth-century Italy / Albert Boime.
 p. cm.
 Includes index.
 ISBN 0-226-06330-5
 1. Macchiaioli. 2. Painting, Modern—19th century—Italy. 3. Art and society—Italy. I. Title
 ND617.5.M3B65 1993
 759.5′51′09034—dc20 92-17169
 CIP

Photo credits—4.6: © Arch. Phot. Paris/S.P.A.D.E.M.; 3.1–3.3, 3.16: Soprintendenza per i B.A.S. di Napoli; 3.21: Bequest of Collis P. Huntington (25.110.66); 4.2: Gift of Mrs. J. W. Simpsom, 42.22; 4.1, 4.5, 4.10, 4.12, 4.13, 4.33, 6.14: © Photo R.M.N.; 5.8: Purchase in memory of Ralph Cross Johnson; 7.26, 7.23: Galleria d'arte moderna di Palazzo Pitti; 7.34: Alinari/Art Resource N.Y.; 7.44: Instituto Centrale per il Catalogo e la Documentazione

This book is printed on acid-free paper.

FOR CLARA BLOCK
Who Taught Us All "La Bandiera Rossa"

Contents

	List of Illustrations	ix
	Acknowledgments	xix
	Introduction	1
ONE	(Re)constructing Italian Nationalism	19
TWO	Strategies of Representation	41
THREE	Macchiaiolismo versus Accademismo	75
FOUR	The Macchia and the Risorgimento	115
FIVE	The First Italian National Exposition of 1861	165
SIX	Patronage and Reception of the Macchiaioli	201
SEVEN	Religious and Social Themes	235
EIGHT	Requiem for the Caffè Michelangiolo	297
	Notes	307
	Index	329

Color plates follow page 74

Illustrations

Map, The Unification of Italy, 1859–70 *Frontispiece*

1.1 *Attack on the Pickets of the Garibaldi Guard on the East Branch of the Potomac,* illustration in the *Illustrated London News,* vol. 39, July 20, 1861, p. 47 28

1.2 Thomas Nast, *Garibaldi,* wood engraving, 1882. Reproduced in *Harper's Weekly,* June 17, 1882, p. 381 30

1.3 Vincent van Gogh, *Portrait of Père Tanguy,* 1887–88. Musée Rodin, Paris 30

1.4 Thomas Nast, Two illustrations of Garibaldi's Sicilian campaign for the *Illustrated London News,* vol. 37, October 20, 1860, p. 378 31

1.5 Thomas Nast, *The Uprising of Italy,* wood engraving, 1866. Reproduced in *Harper's Weekly,* July 14, 1866, p. 436 31

1.6 Giuseppe Bertini, *The Meeting of Vittorio Emanuele II and Napoleon III at Milan,* 1859. Museo del Risorgimento, Milan 36

1.7 *Entrance of Emperor Napoleon and the King of Sardinia into the City of Milan,* 1859. Reproduced in *L'Illustration,* vol. 33, June 18, 1859, p. 433 36

1.8 Domenico Induno, *Bulletin of July 14, 1859, Announcing the Peace of Villafranca,* 1861. Galleria d'arte moderna, Milan 37

2.1 Giuseppe Bezzuoli, *Entrance of Charles VIII into Florence,*
 1829. Galleria d'arte moderna, Pallazzo Pitti, Florence 45

2.2 Giuseppe Bezzuoli, *The First City of Tuscany Paying
 Homage to the Grand Duke,* engraving, 1814. Reproduced
 in *Descrizione dell'apparato fatto in Firenze . . . ,* Florence,
 1814 47

2.3 Massimo D'Azeglio, *Challenge of Barletta,* 1831. Private
 Collection, Milan 51

2.4 Massimo D'Azeglio, *Challenge of Barletta,* study, ca. 1831.
 Galleria d'arte moderna, Turin 51

2.5 Massimo D'Azeglio, *Waterfall,* ca. 1830s. Galleria civica
 d'arte moderna, Turin 52

2.6 Massimo D'Azeglio, *View of the Town of Apeglio (Canton
 moderna,Ticino) on Lake Maggiore,* ca. 1840s. Galleria
 civica d'arte moderna, Turin 52

2.7 Francesco Hayez, *Sicilian Vespers,* 1846. Galleria d'arte
 moderna, Rome 56

2.8 Andrea Gastaldi, *Pietro Micca on the Verge of Igniting the
 Powder Keg Consecrates His Last Thoughts to God and
 Country,* 1858. Galleria d'arte moderna, Turin 59

2.9 Francesco Hayez, *The Kiss,* 1859. Pinacoteca di
 Brera, Milan 60

2.10 Gerolamo Induno, *Garibaldi Legionnaire in the Defense of
 Rome,* 1851. Museo del Risorgimento, Milan 60

2.11 "The Volunteer and his Beloved," popular love song,
 ca. 1860 61

2.12 Gerolamo Induno, *Sad Presentiment,* 1862. Pinacoteca di
 Brera, Milan 61

2.13 Gerolamo Induno, *Sad Presentiment,* detail 61

2.14 Francesco Saverio Altamura, *The First Italian Flag
 Carried into Florence,* 1859. Museo nazionale del
 Risorgimento, Turin 62

2.15 Giovanni Fattori, *The Defenders of Florentine Liberty
 Converse while Confronting the Executioner's Block,*
 ca. 1856. Private Collection, Florence 64

2.16 Paul Delaroche, *Cromwell and Charles I,* 1831. Musée des
 Beaux-Arts, Nîmes 64

2.17 Giovanni Fattori, *Mary Stuart on the Battlefield at
 Crookstone,* 1861. Galleria d'arte moderna, Palazzo
 Pitti, Florence 66

2.18 Cristiano Banti, *Galileo Galilei before the Inquisition,* 1857.
 Private Collection, Milan 66

2.19 Vincenzo Cabianca, *Florentine Storytellers,* 1860. Galleria
 d'arte moderna, Palazzo Pitti, Florence 67

2.20 Odoardo Borrani, *The Corpse of Jacopo de' Pazzi,* 1864.
 Galleria d'arte moderna, Palazzo Pitti, Florence 69

3.1 Giacinto Gigante, *Sorrento Coastline,* 1842. Museo di San
 Martino, Naples 79

3.2 Vincenzo Abbati, *The Funerary Mounument of Paolo Savelli
 in the Church of Santa Maria Gloriosa dei Frari in Venice,*
 ca. 1855. Private Collection 81

3.3 Giuseppe Abbati, *the Chapel of San Tommaso d'Aquino in
 the Church of San Domenico Maggiore, Naples,* 1859. Private
 Collection, Naples. 81

3.4 Giovanni Signorini, *The Riderless Horse Race,* 1844.
 Accademia di belle arti, Florence 81

3.5 Karoly Markò, *Florentine View (Landscape with Figures),*
 1863. Civica Galleria d'arte moderna, Genoa 83

3.6 Giovanni Signorini, *Panorama of Florence from Monte alle
 Croci.* Museo di Firenze com'era, Florence 83

3.7 Telemaco Signorini, *Veduta di Vinci,* etching, 1872.
 Reproduced as frontispiece to Uzielli's *Ricerche intorno a
 Leonardo da Vinci,* 1872 84

3.8 Telemaco Signorini, *The Mercato Vecchio at Florence,* 1882.
 Private Collection, Montecatini 85

3.9 Telemaco Signorini, *Piazza at Settignano,* ca. 1889. Private
 Collection, Milan 85

3.10 Telemaco Signorini, *Leith,* 1881. Galleria d'arte moderna,
 Palazzo Pitti, Florence 86

3.11 Telemaco Signorini, *Leith,* detail 86

3.12 Luigi Mussini, *Sacred Music,* 1841. Galleria d'arte
 moderna, Palazzo Pitti, Florence 92

3.13 Stefano Ussi, *Inquisition Scene,* ca. 1846. Galleria d'arte
 moderna, Palazzo Pitti, Florence 93

3.14 Vincenzo Cabianca, *Peasant Woman at Montemurlo,* 1862.
 Galleria nazionale d'arte moderna, Rome 95

3.15 Raffaello Sernesi, *Roofs in the Sunlight,* ca. 1860–61.
 Galleria nazionale d'arte moderna, Rome 95

3.16 Giuseppe Palizzi, *The Charcoal Burners,* 1857. Museo e
 Gallerie nazionali di Capodimonte, Naples 106

3.17 Giovanni Fattori, *The Brush Gatherers: The Environs of
 Livorno near Antignano,* 1865. Private Collection, Milan 107

3.18 Francesco Gioli, *The Women Wood Gatherers,* 1887. Private
 Collection, Los Angeles 109

3.19 Nicola Cannicci, *The Sowing of Grain in Tuscany,* 1882. Galleria nazionale d'arte moderna, Rome — 111

3.20 Egisto Ferroni, *Return from the Woods,* 1881. Galleria d'arte moderna, Palazzo Pitti, Florence — 111

3.21 Jules Breton, *Pulse Gatherers,* 1868. The Metropolitan Museum of Art, New York. Bequest of Collis P. Huntington, 1925 — 112

3.22 Eastman Johnson, *The Cranberry Harvest, Island of Nantucket,* ca. 1875–80. Collection of the Timken Museum of Art, San Diego. The Putnam Foundation — 112

4.1 Alexandre-Gabriel Decamps, *Towing Horses,* 1842. Musée du Louvre, Paris — 119

4.2 Alexandre-Gabriel Decamps, *Rustic Courtyard,* 1849. The High Museum of Art, Atlanta — 119

4.3 Vito D'Ancona, *Portico,* ca. 1861. Galleria d'arte moderna, Palazzo Pitti, Florence — 120

4.4 Giuseppe Abbati, *View from Diego Martelli's Wine Cellar,* ca. 1865–66. Private Collection, Florence — 120

4.5 Alexandre-Gabriel Decamps, *The Defeat of the Cimbrians,* 1833. Musée du Louvre, Paris — 121

4.6 Alexandre-Gabriel Decamps, *Study for the Defeat of the Cimbrians,* ca. 1832. Musée des Beaux-Arts, Saint-Lô — 121

4.7 Constant Troyon, *Study of Sheep,* ca. 1850s. Mesdag Museum, The Hague — 122

4.8 Filippo Palizzi, *A Donkey,* ca. 1866. Galleria nazionale d'arte moderna, Rome — 123

4.9 Filippo Palizzi, *Friends,* 1866. Galleria nazionale d'arte moderna, Rome — 123

4.10 Constant Troyon, *Oxen Going to Work; Morning Effect,* 1855. Musée du Louvre, Paris — 123

4.11 Serafino De Tivoli, *A Pasture,* ca. 1856–59. Galleria d'arte moderna, Palazzo Pitti, Florence — 124

4.12 Constant Troyon, *Cows at the Watering Place,* ca. 1850s. Musée du Louvre, Paris — 125

4.13 Rosa Bonheur, *Haymaking in Auvergne,* 1855. Musée national du Château de Fontainebleau, Fontainebleau — 125

4.14 *The Arrival of Prince Napoleon at Florence, May 31, 1859.* Reproduced in *L'Illustration,* vol. 33, 1859, p. 408 — 128

4.15 Giovanni Fattori, *French Soldiers of '59,* 1859. Private Collection, Viargeggio — 128

4.16 Giovanni Fattori, *The Look-Out,* ca. 1872. Private Collection, Rome — 130

4.17 *General Blanchard Distributing Medals Awarded to the Third Regiment of Grenadiers of the Imperial Guard.* Reproduced in *L'Illustration,* vol. 34, July 2, 1859, p. 4 · 130

4.18 Giovanni Fattori, *Bivouac of the Bersaglieri,* 1860. Private Collection, Montecatini · 132

4.19 Giovanni Fattori, *The Encampment,* ca. 1860. Private Collection, Rome · 132

4.20 *Bivouac of Piedmontese Troops on the Heights of San Martino, after the Battle of Solferino.* Reproduced in *L'Illustration,* vol. 34, July 9, 1859, p. 37 · 132

4.21 *Bivouac of the Third Corps at Solferino.* Reproduced in *L'Illustration,* vol. 34, 1859, July 9, 1859, p. 29 · 133

4.22 *View of Gavazzano, on the Road to Tortone.* Reproduced in *L'Illustration,* vol. 33, May 28, 1859, p. 352 · 133

4.23 *Brolio, The Ancestral Seat of the Ricasoli Family.* Reproduced in the *Illustrated London News,* vol. 39, August 3, 1861, p. 119 · 135

4.24 Chianti Classico Bottle Label, 1986 · 135

4.25 Raffaello Sernesi, *Portrait of Bettino Ricasoli,* ca. 1859. Museo del Risorgimento, Milan · 135

4.26 Francesco Saverio Altamura, *Marius Conqueror of the Cimbri,* 1864. Museo di Capodimonte, Naples · 145

4.27 Giovanni Fattori, *After the Battle of Magenta,* 1860–62. Galleria d'arte moderna, Palazzo Pitti, Florence · 146

4.28 Giovanni Costa, *The Mouth of the Arno,* oil on wood, 1859. Private Collection, Florence · 149

4.29 Giovanni Fattori, *The Arno at the Cascine,* ca. 1863. Private Collection, Venice · 149

4.30 Giovanni Fattori, *Study for the Battle of Magenta,* ca. 1859–1860. Galleria nazionale d'arte moderna, Rome · 152

4.31 Giovanni Fattori, *Bersagliere,* drawing ca. 1860. Museo Civico, Livorno · 152

4.32 Photograph of Piedmontese Soldier, ca. 1850s · 152

4.33 Ernest Meissonier, *Napoleon III at Solferino,* 1864. Musée du Louvre, Paris · 153

4.34 Adolphe Yvon, *Battle of Solferino,* 1861. Musée national du Château de Versailles, Versailles · 154

4.35 Adolphe Yvon, *Battle of Magenta,* 1863. Musée national du Château de Versailles, Versailles · 154

4.36 *The War—Attack on the Church of Magenta.* Reproduced in the *Illustrated London News,* vol. 35, July 2, 1859, p. 1 · 155

4.37 *Auxiliary Transport of the Wounded.* Reproduced in *L'Illustration,* vol. 33, 1859, p. 377 156

4.38 *Passage from Adda to Cassano.* Reproduced in *L'Illustration,* vol. 33, 1859, p. 449 156

4.39 Giovanni Fattori, *Garibaldi at Palermo,* ca. 1860. Private Collection, Montecatini 158

4.40 *Garibaldi and His Army Arriving at Marsala,* lithograph, 1860 158

4.41 Giovanni Fattori, *Garibaldi at Palermo,* detail 159

4.42 Victor Adam, *Rue St. Antoine,* lithograph, 1830 160

4.43 Giovanni Fattori, *Garibaldi at Aspromonte,* ca. 1862 161

5.1 *View of the site of the First Italian National Exposition,* 1861 167

5.2 *The Façade of the Main Building of the National Exposition,* 1861 167

5.3 Giuseppe Moricci, *The Volunteer's Letter to His Family from the Field,* 1861. Galleria d'arte moderna, Palazzo Pitti, Florence 168

5.4 Giovanni Mochi, *King Vittorio Emanuele's Reception of the Tuscan Delegation Presenting Him with Tuscany's Decree of Annexation,* 1862. Galleria d'arte moderna, Palazzo Pitti, Florence 168

5.5 Cosimo Conti, *The Execution of the Cignoli Family by Order of the Austrian General Urban,* 1861. Galleria d'arte moderna, Palazzo Pitti, Florence 169

5.6 Antonio Fontanesi, *Countryside with Herds an Hour after the Rain,* 1861. Galleria d'arte moderna, Palazzo Pitti, Florence 169

5.7 Opening of the Italian Exposition at Florence by Victor Emmanuel. Reproduced in the *Illustrated London News,* 1861. 170

5.8 Hiram Powers, *America,* plaster, ca. 1848–50. National Museum of American Art, Smithsonian Institution, Washington, D.C. 174

5.9 Pietro Magni, *Girl Reading,* marble, ca. 1861. Galleria d'arte moderna, Milan 177

5.10 Stefano Ussi, *Expulsion of the Duke of Athens,* 1861 (dated 1860). Galleria d'arte moderna, Palazzo Pitti, Florence 184

5.11 Odoardo Borrani, *The 26th of April 1859,* 1861. Private Collection, Florence 184

5.12 Beppe Veraci, *Stefano Ussi and Alessandro Lanfredini,* pencil and watercolor drawing. Private Collection, Florence 186

5.13 Odoardo Borrani, *Tuscan Artillery at a City Gate,* 1859.
 Private Collection, Florence 186

5.14 Enrico Fanfani, *The 27th of April 1859,* 1860. Galleria
 d'arte moderna, Palazzo Pitti, Florence 191

5.15 Enrico Fanfani, *The 27th of April 1859,* detail 191

5.16 *Panorama of Milan.* Stereoscope view by G. Brogi, 1 Via
 Tornabuoni, Florence, ca. 1880s 196

5.17 Giuseppe Abbati, *The Tower of the Palazzo del Podestà,* oil
 on wood, 1865. Giacomo and Ida Jucker Collection,
 Milan 196

5.18 *Roman Forum.* Stereoscope view by Keystone View
 Company, Meadville, Pennsylvania, ca. 1900 197

5.19 *Ancient Cloister of St. Paul's, Rome.* Unknown Italian
 photographer, ca. 1870s 197

5.20 *The Large Camera Obscura,* seventeenth century 197

5.21 Telemaco Signorini, *Children in the Sunlight,*
 ca. 1860–62. Galleria d'arte moderna, Palazzo Pitti,
 Florence 198

5.22 *Palazzo della Signorina, Florence.* Stereoscope view
 distributed by A. Mendes, Bordeaux, ca. 1860s 198

5.23 Odoardo Borrani, *The 26th of April 1859,* detail 199

6.1 *De Tivoli's Patent Omnibus.* Reproduced in the *Illustrated
 London News,* vol. 38, 1860, June 9, 1860, p. 562 202

6.2 Vito D'Ancona, *View of Volognano,* 1878. Private
 Collection, Florence 204

6.3 Giovanni Fattori, *The Assault at the Madonna della
 Scoperta,* ca. 1866. Museo Civico, Livorno 205

6.4 *Concerted Attack on the Village of Montebello.* Reproduced in
 L'Illustration, vol. 33, 1859, June 4, 1859, p. 376 207

6.5 Giovanni Fattori, *Peasant Woman in the Woods,* ca. 1861.
 Private Collection, Montecatini 209

6.6 Giovanni Fattori, *Peasant Woman in the Field,* ca. 1867.
 Private Collection, Montecatini 212

6.7 Silvestro Lega, *Landscape with Peasants,* ca. 1871. Private
 Collection, Montecatini 213

6.8 Giovanni Fattori, *The Water-Carriers of Livorno,* 1865.
 Formerly Alvaro Angiolini Collection, Livorno 216

6.9 Vincenzo Cabianca, *Canal in the Tuscan Maremma,* 1862.
 Private Collection, Lecco 220

6.10 Giovanni Fattori, *Pasture in the Maremma,* 1863–64.
 Private Collection, Florence 220

6.11 Giovanni Fattori, *The Cowboys,* 1893. Museo Civico, Livorno 221

6.12 Giovanni Fattori, *The Branding of Colts in the Maremma,* 1887. Private Collection, Montecatini 221

6.13 John Constable, *Landscape: Ploughing Scene in Suffolk (A Summerland),* ca. 1824. Yale Center for British Art, Paul Mellon Collection, New Haven 222

6.14 Jean-François Millet, *The Gleaners,* 1857. Musée du Louvre, Paris 222

6.15 Odoardo Borrani, *Vegetable Garden at Castiglioncello,* ca. 1864. Private Collection, Montecatini 223

6.16 Odoardo Borrani, *House and Seacoast at Castiglioncello,* ca. 1864. Private Collection, Montecatini 223

6.17 Odoardo Borrani, *Red Cart at Castiglioncello,* ca. 1867. Private Collection, Florence 224

6.18 Giuseppe Abbati, *Cart and Oxen in the Tuscan Maremma,* ca. 1867. Private Collection, Florence 224

6.19 Giovanni Fattori, *Cart and Oxen,* ca. 1867–1870. alleria d'arte moderna, Palazzo Pitti, Florence 224

6.20 Telemaco Signorini, *Anchiano,* etching, ca. 1872. Reproduced in Uzielli, Ricerche intorno a Leonardo Da Vinci, 1872, p. 33 229

6.21 Giovanni Fattori, *Battle at Volturno,* ca. 1891. Galleria d'arte moderna, Palazzo Pitti, Florence 230

6.22 *The Revolution in Naples.—Before Capua, Sept. 19.* Reproduced in the *Illustrated London News,* vol. 37, 1860, October 6, 1860, p. 319 231

6.23 *The Battle on the Volturno.—The Final Repulse of the Neapolitans.* Reproduced in the *Illustrated London News,* vol. 37, 1860, October 20, 1860, p. 375 231

7.1 Telemaco Signorini, *The Venice Ghetto,* ca. 1860. Private Collection, Milan 238

7.2 Telemaco Signorini, *The Tuscan Artillerymen at Montechiaro Saluted by the French Wounded at Solferino,* 1859–60. Private Collection, Valdagno 240

7.3 Telemaco Signorini, *The Cemetery of Solferino,* ca. 1860. Private Collection, Rome 240

7.4 *Recovery of Weapons Abandoned by the Austrians in the Cemetery of Solferino.* Reproduced in *L'Illustration,* vol. 34, 1859, p. 33 240

7.5 Telemaco Signorini, *The Florence Ghetto,* 1882. Galleria nazionale d'arte moderna, Rome 243

7.6 Vincenzo Cabianca, *Morning (The Nuns)*, 1862 replica.
 Private Collection, Milan 245

7.7 Gentile Da Fabriano, *Flight into Egypt*, 1423. Gallerie
 Uffizi, Florence 247

7.8 Sandro Botticelli, *Annunciation*. Gallerie Uffizi, Florence 247

7.9 Lorenzo Lotto, *Predella of the Dead Christ*, Parish Church
 in Asolo, Vicenza 247

7.10 Giuseppe Abbati, *Cloister*, ca. 1861–62. Galleria d'arte
 moderna, Palazzo Pitti, Florence 248

7.11 Giuseppe Abbati, *The Cloister of Santa Croce*, ca. 1862.
 Giacomo and Ida Jucker Collection, Milan 251

7.12 *Ancient Cloister of St. Paul's Rome*. Stereoscope view by
 Underwood and Underwood, New York, 1897 251

7.13 Silvestro Lega, *The Female Painter*, 1869. Private
 Collection, Montecatini 256

7.14 Silvestro Lega, *Dedication to Work*, 1885. Formerly Private
 Collection, Livorno 256

7.15 Giovanni Fattori, *Cousin Argia*, 1861. Galleria d'arte
 moderna, Pallazzo Pitti, Florence 260

7.16 Giovanni Fattori, *Portrait of the Artist's First Wife*, 1865.
 Galleria nazionale d'arte moderna, Rome 260

7.17 Giovanni Fattori, *The Palmiere Pavilion*, 1866. Galleria
 d'arte moderna, Palazzo Pitti, Florence 260

7.18 Cristiano Banti, *Gathering of Peasant Women*, 1861.
 Galleria d'arte moderna, Palazzo Pitti, Florence 261

7.19 Odoardo Borrani, *The Seamstresses of the Red Shirts*, 1863.
 Private Collection, Montecatini 265

7.20 Silvestro Lega, *Portrait of Garibaldi*, ca. 1850. Museo
 Civico, Modigliana 272

7.21 Silvestro Lega, *Don Giovanni Verità*, 1885. Museo Civico,
 Modigliana 272

7.22 Silvestro Lega, *Giuseppe Mazzini on His Deathbed*, 1873.
 Museum of Art, Rhode Island School of Design,
 Helen M. Danforth Fund, Providence 272

7.23 Silvestro Lega, *Giuseppe Mazzini on His Deathbed*, detail 273

7.24 Silvestro Lega, *The Bersaglieri's Ambush—Episode from the
 War of 1859*, 1861. Private Collection, Milan 275

7.25 Silvestro Lega, *Bersaglieri Leading Prisoners*, 1861. Galleria
 d'arte moderna, Palazzo Pitti, Florence 275

7.26 Silvestro Lega, *Pestilence*, 1858. Lunette for the Oratorio
 della Madonna del Cantone, Modigliana 276

7.27 Silvestro Lega, *Famine,* 1858. Lunette for the Oratorio
 della Madonna del Cantone, Modigliana 276

7.28 Silvestro Lega, *Earthquake,* 1858. Lunette for the Oratorio
 della Madonna del Cantone, Modigliana 276

7.29 Silvestro Lega, *War,* 1858. Lunette for the Oratorio della
 Madonna del Cantone, Modigliana 276

7.30 Silvestro Lega, *Charity,* 1864. Private Collection, Pistoia 278

7.31 Luigi Mussini, *Almsgiving according to Evangelical Charity
 and according to Worldly Ostentation,* 1844. Accademia di
 belle arti, Florence 280

7.32 Silvestro Lega, *Singing the Stornello,* 1867. Galleria d'arte
 moderna, Palazzo Pitti, Florence 282

7.33 Piero della Francesca, *The Discovery and the Verification of
 the True Cross,* ca. 1452–57, fresco. San Francesco,
 Arezzo 282

7.34 Silvestro Lega, *The Trellis,* 1868. Galleria Brera, Milan 285

7.35 Silvestro Lega, *The Visit,* 1868. Galleria nazionale d'arte
 moderna, Rome 287

7.36 Silvestro Lega, *The Betrothed,* 1869. Museo della Scienza e
 Tecnologia, Milan 287

7.37 Silvestro Lega, *The Betrothed,* 1869. Private Collection,
 Florence 287

7.38 Silvestro Lega, *Little Girls Playing as Adults,* 1872. Private
 Collection, Milan 288

7.39 Silvestro Lega, *The Grandmother's Lesson,* ca. 1881. Città
 della Peschiera del Garda 288

7.40 Silvestro Lega, *The Mother,* ca. 1864. Private Collection,
 Montecatini 289

7.41 Odoardo Borrani, *The Illiterate,* 1869. Private Collection,
 Montecatini 291

7.42 Telemaco Signorini, *The Mental Ward at San Bonifazio
 in Florence,* ca. 1865–70. Galleria d'arte moderna,
 Ca'Pesaro, Venice 292

7.43 Silvio Giulio Rotta, *Clinic,* 1895. Galleria nazionale d'arte
 moderna, Rome 294

7.44 Telemaco Signorini, *The Morning Toilet,* 1898. Private
 Collection, Milan 294

8.1 Adriano Cecioni, *The Caffè Michelangiolo,* watercolor on
 paper. ca. 1860s. Private Collection, Montecatini 298

8.2 Giuseppe Pellizza Da Volpedo, *The Fourth Estate,*
 1898–1901. Civica galleria d'arte moderna, Milan 304

Acknowledgments

The conceptual framework for this book developed during the years 1979–80 in the congenial atmosphere of the American Academy at Rome, whose award of the Rome Prize Fellowship reoriented my research from France to Italy. A graduate seminar I taught on Italian painting and the Risorgimento in the fall of 1983 helped me consolidate my ideas, and the stimulating freshness of the material demonstrated in the process that there was a whole world out there waiting to be explored. The exhibition of the Macchiaioli at UCLA organized under Edith Tonelli in 1986 presented me with a splendid opportunity to put down on paper my intensive investigation of Italian art institutions, although in the limited catalogue format I could only touch the tip of the proverbial iceberg.

Archival work and museum study took me through most of Italy, and I received help from so many museum curators, academy administrators, scholars, and librarians that to thank each one of them individually would be impossible. However, no one can undertake serious research of the Macchiaioli without consulting the documentation of the Archivio dei Macchiaioli and the vast expertise of its director Dario Durbé and his associate Lela Titonel. I wish first to express my deep gratitude to them for their decisive contribution to my work on nineteenth-century Italian painting.

I also take this opportunity to thank several other people and institutions that have made it possible for me to complete this work. The support of Alberto Bonniver, consul-general of Italy, and Gerlando Butti, director of the Italian Cultural Institute, Los Angeles, has been indispensable in the project's final stages. At UCLA, my colleagues Giovanni Cecchetti and Althea Reynolds generously tolerated what must have been irritating phone calls, at all times of the day, to calmly advise me on numerous points of translation, literary references, and historical sources. Alessandro Falassi, Pier Maria Pasinetti, and Robert Wohl also generously shared their knowledge of sources and issues. The UCLA art library staff under the direction of Joyce Ludmer did everything possible to obtain the resources I required to bring my project to a satisfactory conclusion. At the UCLA Wight Art Gallery, Ramona Barreto and Cindi Dale generously made available to me archival photographs. The encouragement of my colleagues in the Department of Art History, in particular Carlo Pedretti and John Tagg, made the experience of both the exhibition and the book a memorable one. The research of graduate students Julia Aamodt, Sanda Agalidi, Ellen Kaplan, Pamela Kort, Connie Moffatt, Roberta Panzanelli, Shalom Sabar, James Smalls, and Lilian Staple, all contributed to enrich my thinking on Ottocento pictorial practice and issues. Thanks are also due to Nathan Shapira and Giulio Panza for their help in translating some difficult passages from the Italian. I also want to take the opportunity to thank Suzanne Branciforte, who was somehow omitted in the catalogue of 1986, for her precious research in Florence.

In Italy I owe a special debt of gratitude to my friends Marisa Dalai Emiliani, Anna Finocchi, Mimita Lamberti, Sandro Pinto, Rosanna Maggio Serra, Ettore Spalletti, and Rosalba Tardito who opened many doors and fulfilled many requests. In France Pierre Rosenberg complied generously and promptly to my requests, reminding me of our first meeting over twenty-five years ago when he steered me, a newly arrived graduate student, through the maze of the Louvre reserves. A special debt of thanks is also owing to Krzysztof Pomian for helping me locate key references on San Bonafazio; his support of this work has been a constant source of inspiration. Denis Mack Smith's encouragement kept me going during the arduous process of converting my previous work into a book-length manuscript.

The staff of the University of Chicago Press has been enormously helpful; I feel fortunate to have had as manuscript editor Claudia Rex, whose sensitive and scrupulous reading supplied constructive guidance and greatly improved the text's legibility.

I am especially grateful to my friend Hrayr Karagueuzian, who

not only offered invaluable suggestions, but also did the superb translation of Nalbandian's poem, now the official Armenian national anthem. Above all, I value his unfailing support during the completion of the present project. Other brave souls who ventured with me into unfamiliar territory and shared the discoveries are Myra Boime, Oretta Bongarzoni, Barbara Cinelli, Francesca Di Cesare, Vera Durbé, Loren Hebel, Cynthia Jaffee McCabe, David Patterson, Cynthia V. Sainty, and Puran Singh.

Finally, I recall the generosity of the security guard at the Museo Nazionale del Risorgimento Italiano in Turin, Benito De Paoli, who generously allowed Mimita Lamberti and me into the museum for a quick run through, even though it had officially closed for the day. I take this both as a special act of kindness and as a typical example of the warm and unhesitating support of my many friends in Italy who made this project possible.

Introduction

The history of nineteenth-century Italian art—indeed of any art—can be thought of as a kind of dialogue between nature (here taken in its broadest sense to include all living creatures) and society, mediated through verbal and visual language systems. In this dialogue artistically gifted people made a series of choices within the limits imposed by nature and social constraint. The result of these decisions, the production of the art object and its explication/interpretation, yields a glimpse into the way Italian society viewed itself in its own cultural habitat. The Macchiaioli, who emerge from the political and cultural background known as the Risorgimento, reveal in their work a rich succession of layers of this social topography, portraying the ways Italians in a particular time and place tried to shape and occupy a national space. This study retraces some of the main contours of the space mapped out by the Macchiaioli painters.

The Macchiaioli were for the most part democratic intellectuals and activists who formed a group in Florence in the late 1850s and attained their collective apogee in the following decade, a period coinciding with the establishment of a unified constitutional kingdom in Italy. As is so often the case in the development of modern group formations in the metropolitan centers of Europe, the members met regularly in a public drinking house, a meeting ground for local as well as for international artists, bohemians, and conspirators (attributes sometimes combined in the

same person). Their ostensible purpose for uniting was to protest the dogmatic training of the Florentine Academy, but behind this lay their antagonism to the same foreign influences (whether enlightened or not) that dominated not only Tuscan political life but almost all the provincial territories of the peninsula.

My study explores the social and political foundations of Macchiaioli activity and the shared ideology that bound individuals from different regions and social classes into a coherent group. It grows out of my long essay of 1986, written for the first major show of this group organized in North America, and the latest of a series of similar comprehensive exhibitions held outside of Italy— in Paris, Munich, Manchester, and Edinburgh.[1] Faculty, staff members, and graduate students at the University of California, Los Angeles, greeted the suggestion for such a project with immediate enthusiasm, wondering why it had not been done previously in the United States, a country with a major population of Italian descent and whose history and progress is inevitably bound up with Italian discovery and ingenuity. Furthermore, Italy was and is an international center of art as well as religious pilgrimage where Americans went and still go in droves to produce art (witness the American Academy in Rome), absorb culture, or just see the sights.

Annie-Paule Quinsac addressed this question in the introduction to her seminal catalogue, *Ottocento Painting,* published in 1972,[2] and suggested that this singular neglect stemmed from an entrenched French bias that tolerated few rivals. With the possible exception of English art, no other non-native school of the nineteenth-century has been so systematically explored in North American art history. The French connection results from a number of factors, not the least of which is the world art market with its apotheosis of a certain lineage of modern art. The formation of the language of modern art criticism was based on the aesthetic ideology of the avant garde that was set up over and against academic classicism with an evolutionary sequence of categories such as romanticism, realism, impressionism, post-impressionism, symbolism, and Cubism. All of these categories were naturally exemplified in the work of French artists, and still constitute for art historians the core of their critical analysis and the gauge for evaluating all other artistic contributions.

These stylistic classifications became reified as a set of absolutes and projected on to the pattern of aesthetic developments in other countries. Despite efforts to seek alternatives, terms like "American Realists" or "American Impressionists" have become commonplace, and show to what extent scholars have assimilated the French terminology as the canonical measure of international cul-

tural production. European critics have often referred to the Macchiaioli coyly as "Italian Impressionists," although their work antedated the French school by almost a decade. Some critics even measure the success or failure of the Macchiaioli against the achievements of Impressionism, which itself had a life span not much longer than the Italian movement and its offshoots, and was rudely displaced by post-impressionism. The most important American scholar of the Macchiaioli, Norma Broude, whose pioneering dissertation of 1967 was the first thorough study of the group in English, concluded at that time that the Macchiaioli were (in my paraphrase) "failed Impressionists" who wasted a golden opportunity and fell short of their potential.[3]

Broude contended that macchia sketches were comparable to academic studies for more finished canvases, and as such belonged to a much older and more traditional system. The Macchiaioli, in her opinion, could not accept "the immediacy of sensation and response as the primary value of the work of art," and thus failed to achieve "a totally new and revolutionary aesthetic approach." Here the French bias manifested itself, elevating plein airism, or outdoor painting, into the sine qua non of nineteenth-century art production and into canonical law for twentieth-century art history.

Yet the existence of so many examples of Macchiaioli commitment to "immediate sensation" independent of preliminary studies contradicts this assertion, and indicates that the Macchiaioli and Impressionists share similar assumptions rooted in the more general historical developments relating to the spread of positivism within the expanding capitalist system. By the third quarter of the nineteenth century, bourgeois society could vaunt its solid scientific achievements. Scientific progress was in fact the model for progress generally, expressed most eloquently in the system of positive philosophy developed by Auguste Comte. The positive, or scientific, method centered on the experimental sciences and provided a historical rationale for evolutionary advance. The era of positivism represented the highest and culminating phase in a series of stages through which society had to pass on the way to utopia. Progress in art, like progress in the sciences, followed this trajectory in seeking new ways of picturing an increasingly precise equivalent of facts, ideas, topography, fashions, and spectacles. Thus the notion of "immediate sensation" was shared across the spectrum of nationalities, allowing for the registering of individual psychology in its encounter with external reality, i.e., modern life.

The "unfinished" character of the result was inseparable from the emphasis on the transitory effects of light and color that guar-

anteed both the empirical validity and personal sincerity of the depicted sensation. Although this holds true for the macchia as well as the impression, in the case of the Impressionists, who evolved gradually out of the French academic tradition, it may be claimed that their manifestations of varying degrees of incompleteness derived from local circumstances. A long tradition of sketch practice, including outdoor sketching, informed the technical procedures of the Impressionists. Finally, outdoor painting did not then, and does not now, constitute an absolute for making magisterial creations, and cannot be used as a pretext to fault the Macchiaioli, whose work responded to their particular cultural space and its construction of their reality.

This is essentially the argument of Nancy Troyer, another American scholar of the Macchiaioli, whose recent dissertation explores the impact of photography and Japanese prints on the Italian painters.[4] She sees both their *plein air* studies and studio-finished pictures as part of an "Italian contribution to the nineteenth-century study of light and air and atmosphere." This did not preclude the use of a photograph now and then, since with it the painter could study natural effects at leisure and with fewer distractions. (In addition, the *veduta* tradition—the rendering of a famous or unusual sight akin to the souvenir function of modern postcards and snapshots—was appropriated by photographers, which encouraged landscapists to seek their way through vivid color and light effects.) Troyer hoped to extricate the Macchiaioli from the narrow regional confines of Tuscany and project them into the larger global context, but she nevertheless did so on the basis of criteria, as she stated, "established for French, English, and American painters of approximately the same period."

Although deferring to the hallowed French categories, Troyer pointed to another reason for the traditional neglect of Italian art. Prior to unification, Italy's art production was based on a collection of regional traditions centered on academies. Milan, Turin, Venice, Rome, Florence, and Naples each formed their own school around their respective academy, often dominated by a foreign ruler who used the institution to propagandize in support of his regime. The regionalization of nineteenth-century Italian art did not allow for the kind of press that French art could command in the Paris Salon, a central clearinghouse for the expression of French national culture. The consequent provinciality of Italian regional styles resist the French stylistic categories, and, in an age glorifying the avant garde, were doomed to suffer neglect. Part of this had to do with the fact that most of what was produced was historical-narrative art, comprising painting and sculpture that seemingly held fast to anachronism. Yet as we will see, much of

what passed for *retardataire* was part of a strategy to evade censorship, expressing the national will to unification by indirect reference to past glory.

The present scholarly interest in the Macchiaioli developed from a willingness to view nineteenth-century art production as part of a synchronistic historical framework. The trend in modern scholarship is to avoid the canonical elitism of the humanities embodied in the "Great Books" concept of Robert Maynard Hutchins, and to attempt to understand both the individual and the product in the interdisciplinarian context of social, political, and cultural institutions. Semiotic research has revealed the extent to which linguistic communication—spoken, written, and visual (the reading of images as texts)—relies even in its earliest manifestations on a matrix of social norms. It has expanded the potential of art history to achieve a more balanced view of the avant garde and stimulated a reexamination of a variety of non-avant-garde categories such as academic art, regionalist painting, feminist, and ethnic modes of cultural representations. This development parallels a general shift from exclusive devotion to biographical studies of avant-garde heroes and/or formalistic and stylistic descriptions of their work to a more critical social history of art. The approach used here shares thematic and stylistic qualities with contemporary art practice which has revived in large measure figurative and narrative forms in a post-avant-garde context.

Renewed interest in the Risorgimento—enormously stimulated by the publication, translation, and exegetical studies of Antonio Gramsci's *Prison Notebooks,* which first appeared in the years 1947–51—further contributed to the enthusiastic reception of the Macchiaioli exhibition.[5] The deep strain of sympathy in North America for the progress of nineteenth-century Italy embodied in the activism of a Margaret Fuller, in the articles and cartoons of *Harper's Weekly,* and in the writings of William Roscoe Thayer, has been reawakened by Gramsci's writings on the Risorgimento, which have proven to be a fundamental source of inspiration and discussion for Marxists and non-Marxists alike. Imprisoned under Mussolini's regime, Gramsci tried to trace the reasons for the weakness of Italian bourgeois democracy and to uncover the foundations upon which the Fascist state had been built. This undertaking engaged him in an examination of the Risorgimento that led to his demonstration of the political function of culture, ideology, and social institutions, all of which Marxist thinkers had previously relegated to the almost theoretically irrelevant "superstructure." The capacity of the governing classes to wield power through these institutions he called "hegemonic." Gramsci's work

has become one of the principal bases for renewed historical de-
bate and discussion of the Risorgimento among social scientists
both here and abroad.

Closely related to scholarly investigations and shifts is the dy-
namic evolution of the art market. Scholarly developments in art
history parallel the twists and turns of the market and the emer-
gence of collectors (both old and new) who take the risk of pur-
chasing in a new area. The rapidly rising prices of the works of
academicians, regional, and so-called minor masters indicate the
potential value of relatively new areas of nineteenth-century art
such as the work of the Macchiaioli. Certainly the prices of Mac-
chiaioli paintings have risen dramatically in Italy over the past
half-century, and a recent Italian study devotes itself entirely to
the market for these works. It would be naive to imagine that
collectors and dealers and art historians contribute to exhibitions,
both in public and private spaces, without the pressure of the
market mechanism which demands validation and provenance. A
large-scale show such as that sponsored by UCLA and the Mac-
chiaioli Archives, Rome, is only possible by virtue of the impact
of this market mechanism.

OVERVIEW OF PREVIOUS MACCHIAIOLI SCHOLARSHIP

Macchiaioli scholarship in Italy has had a fascinating history in
itself, documented in part by Roberto Longhi's memorable intro-
duction to the Italian translation of John Rewald's *History of Im-
pressionism* (1949).[6] Dedicated to the memory of the critic who
aligned himself with the Macchiaioli, Diego Martelli ("the only
serious critic of our Ottocento"), it traces the Italian critical recep-
tion of avant-garde French painting and parallel taste for the Mac-
chiaioli from 1860 to the time of publication. Longhi's position
derived from the general post–World War II reaction to Fascism.
During the Mussolini era, the Macchiaioli gradually became iden-
tified with the ultranational and chauvinistic propaganda that
downgraded French contributions to Italian culture. Some Italian
critics and art historians not only put the Macchiaioli on a par
with the Impressionists, but declared their superiority in terms of
their earlier emergence. Longhi wanted to redress what he felt
was an ideological imbalance by putting things into chronological
focus, akin to the model of Rewald. As a result, he tended to go
too far in the other direction, keeping a scoreboard of wins and
losses in which the Impressionists came out on top. Only Mar-
telli, who was the first Italian critic to appreciate the Impression-
ists, received his unqualified praise. Otherwise, Longhi castigated

Italian writers who would make Italian painters like De Nittis a precursor of Impressionism, when in fact it was the other way around.

Italian critics began confounding Impressionists and Macchiaioli in the mid-1920s, beginning with Lionello Venturi's *Gusto dei Primitivi* (Taste of the Primitives), which argued for "the spontaneous character of the primitivism of the Macchiaioli and the Impressionists."[7] In 1928 Enrico Somarè really took off with this notion in his *Storia dei pittori italiani dell'Ottocento,* whose patriotic rhetoric tended to confront French and Italian painters indiscriminately.[8] By the end of the decade, Ugo Ojetti (important for his collection of Macchiaioli letters and original documents) could claim that sketches of the Macchiaioli were as admired and sought after at home as the rude sketches by Cézanne outside of Italy.[9]

This process of the confounding the two on the abstract plane of avant gardism continued through the 1930s. In 1933 Venturi, in an article written for the French journal *Gazette des Beaux-Arts,* ventured to identify the Macchiaioli as a revolutionary group bent on establishing an independent style consonant with the movement of the Risorgimento.[10] They set out on a quest to win artistic liberty, to emancipate themselves from the baggage of the academies and to commit themselves exclusively to the depiction of actual experience. According to Venturi, their attitude paralleled that of the French Impressionists. Longhi had little patience with the generality of these assertions, asking astutely which "Risorgimento" Venturi had in mind—the version of the moderate liberal Ricasoli or that of his more radical contemporary Cattaneo. He perceived Venturi as just another nationalist historian, a somewhat unfair reading in that Venturi—soon to write major works on the Impressionists—was seeking only to legitimate the Macchiaioli alongside the French painters and move against the grain of uncritical chauvinistic criticism in Italy.

Longhi's irritation at the chauvinistic attitude to the Macchiaioli during the Fascist era is understandable, especially given his reconstruction-period perspective, but he no doubt reinforced the negative or indifferent Anglo-American art criticism, which took its cue from the French categories. The new post–World War II criticism in America looked to the New York School as the direct heir of the Paris School, which continued to hold up the Impressionists as forerunners of the avant garde. This apotheosis of the French served to reduce other analogous movements, like the Macchiaioli, to subordinate, fringe groups.

It was left to the Italians to continue to pursue the studies of Macchiaioli in the post–World War II period, but with a new sobriety qualified by the scholarly sagacity and warning of Lon-

ghi. Longhi had pointed out the pitfalls of exaggerated criticism, and the new scholars attempted to study the Macchiaioli in a more modest, contextual way. The younger generation was led by the indefatigable researches of Dr. Dario Durbé, whose work provides the basis of research for every modern scholar of the Macchiaioli.[11] Durbé has attempted to interpret the Macchiaioli within the strict framework of the Italian, and more specifically, the Tuscan tradition. This explains his emphasis on the cultural heritage of the Macchiaioli and their relationship to their local traditions which more globally minded critics, like Troyer, reproved. In this way, however, Durbé and his generation eliminated the chauvinism of the past and laid the foundations for a social-historical approach to the Macchiaioli. They reject comparisons or value judgments of individual works, styles, or movements, but attempt to depict the relationship between history and art in an effort to clarify culture and meaning in both.

Starting with his brilliant essay on Fattori in the context of the Livornese struggle for independence in 1848–49, Durbé has pioneered in laying out the social and cultural context of the Macchiaioli.[12] When he began his investigations, old-guard scholars such as Longhi and Giuliano Briganti preferred Durbé's work on the French Daumier, Delacroix, and Ingres over that on the Macchiaioli, who were once again considered in the academic sphere to be inferior to the French. But his interests were sustained by Lamberto Vitali and Giorgio Castelfranco, and even Longhi himself encouraged Durbé's early tentative work on the Macchiaioli, and welcomed his historical approach, which drew upon a progressive political position reflected in the seminal Fattori essay.

Durbé's own maternal grandfather—a theater critic and playwright—was intimate with several artists in Fattori's circle who visited the house in Livorno where Durbé was raised. As a child, Durbé spent many hours in the studios of Renato Natali and Gino Romiti, who recalled Fattori as the beloved master. Finally, Fattori's landscapes were immediately recognizable to Durbé since he roamed the environment in which the painter worked. After the war, when the Liberation rekindled his love of the melodrama of the Risorgimento, Durbé discovered the means to link the Macchiaioli to his new awareness and patriotic feelings. Amid the pressures of everyday life in the gloomy postwar years, a desire to regenerate the ideals of the Risorgimento stimulated him to unite his Macchiaioli studies with intensive historical investigation into the nineteenth-century past. He helped organize the first major postwar show on Fattori in 1953, and ever since he has contributed to the publicizing and promoting of the Macchiaioli. In addition to his numerous scholarly texts and catalogue essays, Durbé has founded at Rome the precious Archivio dei Macchiaioli.

Against the advice of his closest colleagues, Durbé cautiously launched the Macchiaioli into the wider community, but their success in Paris and Munich erased all doubts as to the reception of the "provincial" painters. This made him confident in his new historical approach, which neither exalted the Italians in exaggerated fashion, nor discussed them with a sense of an inferiority complex. The great public success of these two shows set the stage for the rethinking of the Macchiaioli movement in a synchronic framework.

The large retrospective exhibition of Macchiaioli painting in Florence during the summer of 1976, brought almost intact from Munich where it had been shown the previous winter, emphasized the local character of the artists and their subjects. Although the title of the Munich exhibition was *Toskanischen Impressionen* (Tuscan Impressions), the 1976 exhibitions made significant progress in relating the Macchiaioli to Tuscan culture and history. These shows were in turn followed in 1982 by the outstanding catalogue commemorating the centenary of Garibaldi's death, *Garibaldi. Arte e Storia,* which amplified more fully the historical situation and revealed the profound connections between the Macchiaioli and the Risorgimento.[13]

THE MACCHIAIOLI AND THE IMPRESSIONISTS

Despite the advances of scholarship in distinguishing the vast differences between the Italian Macchiaioli and the French Impressionists, the two groups are still confused with one another, to the detriment of an understanding of their respective historical roles. The use of the term "Italian Impressionists" in the Manchester and Edinburgh exhibitions demonstrates the persistent use of the French category to describe the Macchiaioli, and misconstrues their relationship. While the two groups shared certain ideas, relating mainly to outdoor sketching practices, each sprang from distinct cultural and social formations.

First of all, the Macchiaioli preceded the Impressionists by more than a decade.[14] Their careers unfolded during the highpoint of the drive for national unity. The Impressionists organized in the early 1870s following the Franco-Prussian War and the Paris Commune. Unlike the Macchiaioli, who participated in the insurrections and wars of the Risorgimento, the Impressionists and their circle generally felt little sympathy for either the national (under the imperial aegis of Napoleon III) or the civil conflict. Bazille was the only one to volunteer, while Renoir was conscripted, Sisley sought refuge with his family in Louveciennes, and Cézanne went into hiding in the south of France. Monet and

even Pissarro—the post politically active of the group—awaited
the outcome of events in London. Only Manet and Degas, who
served in the National Guard, made any pretense at participating
in the defense of Paris for the provisional Republican government
during the Prussian siege. The unhesitating participation of the
Macchiaioli in the national struggle steeped their seminal work in
the alembic of direct political engagement, and gave it an urgency
rare in nineteenth-century art.

Second, the Macchiaioli emerged from the social conditions of
a primarily agrarian economy, while the Impressionists came
out of a largely bourgeois, urban society. Like French intellectuals
generally, the Impressionists developed their aesthetics within
their specific political and social tradition. While we find city
views and rural views in both movements, Impressionist painting
much more frequently addresses the progress of industrializa-
tion—far more advanced in France than in Italy—and bourgeois
social relations. The most characteristic theme of the French
group is that of vacation spectacle: the Sunday outing, the week-
end excursion, the summer voyage to a popular tourist resort.
They celebrate with sensuous color and technique the leisure-class
activities of their colleagues and social set. They were in many
ways typical bourgeois with middle-class aspirations, and in life-
style and attitude adhered to the traditional ideal of the artist.

The eleven painters whose work constitutes the core of the Mac-
chiaioli activity were all born between 1824 and 1838, and were
on the average several years older than the Impressionists. Cris-
tiano Banti (1824–1904), Vito D'Ancona (1825–1884), Gio-
vanni Fattori (1825–1908), Silvestro Lega (1826–1895), Serafino
De Tivoli (1826–1892), and Vincenzo Cabianca (1827–1902)
form the older group; Giuseppe Abbati (1836–1868), Odoardo
Borrani (1833–1905), Adriano Cecioni (1836–1886), Raffaello
Sernesi (1838–1866) and Telemaco Signorini (1835–1901) the
younger. Their diverse social backgrounds were roughly as fol-
lows. Nobility and upper middle class: Lega, Banti, and D'An-
cona; middle class: Abbati, Cecioni, Signorini, and De Tivoli;
lower middle class: Borrani and Fattori; artisan and working
class: Sernesi and Cabianca. The fathers of Signorini, Abbati,
and Borrani were professional painters who clearly encouraged
their sons' initial efforts in this direction. This is a significant sta-
tistic, indicating a degree of parental support absent from the ca-
reers of most of the Impressionists and nineteenth century artists
generally.

As indicated, each of the Macchiaioli participated directly in the
key events of the Risorgimento. Fattori did not join any of the
military expeditions (although he painted battle scenes more con-

sistently than any of the others), but he served as a courier for the Leftist coalition in Livorno during the revolutionary years 1848–49. All of them were close to the radical working-class movement led by the master baker Giuseppe Dolfi in Florence. The painters' meeting place was the Caffè Michelangiolo on the popular thoroughfare of Via Larga (now Via Cavour), which began as a headquarters for the development of Dolfi's political intrigues and later served as a kind of "think tank" in which aesthetic problems arising from their progressive political positions were discussed. They perceived themselves as part of the larger process of Italian liberation and human enrichment to which they wished to contribute their art.

The objectives of the Risorgimento, essentially achieved between 1859 and 1870, were to expel foreign rulers, unify the peninsula, and give it a secular, constitutional government. The full implication of these goals meant revolution, and ran on a collision course with the moderate liberal politics of the leaders of the movement, many of whom were hesitant to challenge the papacy or to admit the revolutionary nature of their cause. (Indeed, it is probable that the term "risorgimento" was a euphemism deliberately promoted to avoid the connotations of "revolution.") Other participants in the national struggle—primarily bourgeois and petty-bourgeois radicals—wanted to carry the Risorgimento further, to incorporate the masses in a scheme for the full democratization of Italian society. While they made the necessary compromises for strategic purposes to bring about national unity under a constitutional monarch, they also continued to advocate social change by reformist means in such crucial areas as land distribution, public education, suffrage, and women's rights. The Macchiaioli and their defenders belonged to this militant group, and although their efforts ultimately culminated in disappointment they forged an energetic alliance around the central idea of a democratic Italian revolution. I believe that the three main principles of Risorgimento democracy, as defined by Clara Lovett—"secularism, political equality, and the concern for social justice"[15]—are metonymically embodied in Macchiaioli painting. The writings of their key spokesperson and apologist, Telemaco Signorini, supported by a host of eyewitness testimony, confirm their origins in radical Tuscan politics.

This active engagement with the contemporary political and social issues did not allow for the lavish use of the leisure theme that is so central to the work of the Impressionists. Neither in their color nor in their settings do the Macchiaioli display the holiday atmosphere of their French peers; while they may visit resort areas near La Spezia, Lerici, and Livorno, they generally

focus on the working-class activities of the native population rather than on the vacationers. In this sense, they were much closer to the philosophical position of the French Realists than that of the Impressionists, and in fact they share Courbet's attachment to the radical writings of Pierre-Joseph Proudhon. While the painters occasionally depict their protagonists idly sitting, staring into space or chatting, most often the figures—even in domestic situations—engage in useful work or in some sort of collective activity. Impressionist interiors reveal little comparable to those Macchiaioli canvases which show women absorbed in sewing red shirts or tricolor flags in the service of the Risorgimento. In short, Macchiaioli painters rarely took time off for a "day in the country" without justifying such an excursion within their scenario of Risorgimento ideals.

Despite their predominantly middle-class backgrounds, the Macchiaioli chose a name that identified them with marginal social elements. The very term *macchiaioli* sets the group apart from all avant-garde art movements of the modern period. While other terms such as *impressionist* and *fauvist* were likewise coined in a derogatory context, both referred to a psychological or a mental disposition more or less attuned to the conventional bohemian idea of the artist. That the Macchiaioli identified with the sketch phase of the pictorial process, both in jest and in political solidarity with the middle and lower classes, constituted an unprecedented aesthetic position. They were self-professed "outlaw sketchers"— a term the Impressionists, bent on achieving social legitimation, could never have accepted for themselves.

For the Macchiaioli, the macchia-sketch ideal did not necessarily imply the preliminary study or preparatory activity prior to the execution of a definitive, or "finished" work. It meant instead the preservation in final paintings of the qualities associated with the sketch: the light effect, the color, the verve, and in some cases even the movement of the brush corresponding to the first impression of a scene in nature or an idea in the imagination. Thus the traditional hierarchical relationship of sketch to finished work—and perforce the conventional emphasis on certain types of subject matter for polished perfection—was inverted. The Macchiaioli based their art on the humble world of figures, attitudes, profiles, compositional movements, color combinations and touches, or "patches," which they preserved in their sketchbooks and, partly, in their memories.

Borrowing from their experience, the philosopher of art Benedetto Croce (1866–1952), in an essay entitled "A Theory of the 'Macchia,'" reached the conclusion that every successful work has an original pictorial nucleus called the macchia, from which it

develops and which confers on it artistic life and unity. This embryonic cell consists of an accord of lights and darks, lines and colors that recreate the effect glimpsed in nature or in an imaginative insight, initially embodied in the form of a sketch or rough draft. In the artist's hand this embryonic cell is then capable of growing and expanding into a more detailed and coherent picture, but one that possesses all the intrinsic power of the initial impression. If it is lost in the process between sketch and picture, no amount of polish and detail will succeed in compensating for it, while the unadorned macchia, even though relatively unformed and unclarified, can stir the emotions of the spectator.[16]

Croce based this early essay on his reading of the art critic Vittorio Imbriani (1840–1886), whose own insights were inspired by the Neapolitan animal painter, Filippo Palizzi (1818–1899), an artist well known to the Macchiaioli. Imbriani observed in Palizzi's studio a crude sketch consisting of a piece of cardboard only a few centimeters large on which there were only four or five brushstrokes. Despite the seemingly incoherent character of this sketch, Imbriani felt it was livelier than all the finished compositions in the room. Croce then extended this concept to poetry:

> Every poet knows that inspiration comes to him precisely as a *macchia,* as a motif, a rhythm, a psychic motion, or whatever you call it, in which nothing is determinate and all is determinate: in which there is already that meter and no other, those words and no others, that arrangement and no other, that extension and those proportions and no others. And every poet knows that his work consists in working out that *macchia,* that motif, that rhythm, to obtain at the end—in a shape that is fully developed and may be recited aloud, and transcribed in writing—the self same impression that he had received, as a flash, in his first inspiration. The value of the poem, as of the painting, lies in the *macchia.*[17]

Simplifying Imbriani's insight, Croce here elaborates on the idea of the macchia in the context of creative inspiration; this development parallels the theoretical extension of the concept of the sketch and its attributes into a self-conscious scheme of originality, what the art historian Richard Shiff has called "a code of visual communication."[18]

But Croce's antipositivist formulation is the result of the critical modern and art-historical elevation of nineteenth-century art developments into autonomous movements, independent of practical urges and of the constraint of political and other extra-

aesthetic interests. The Macchiaioli identified with the macchia specifically because it allowed them to translate their immediate perceptions onto canvas, and to express themselves as Italians answering to their specific time and place. The test of their "sincerity"—the mark of the old masters they admired—was precisely this capacity to preserve their individual and national identity in the spontaneous qualities of the macchia-sketch. Their macchia procedures developed primarily in the context of Tuscan history, society, and geography, a context in which they recorded the cultural landscape of the Risorgimento era.

THE FAILED REVOLUTION AND ITS FAILED ARTISTIC HEIRS

As this study foregrounds the Risorgimento and its dynamic aesthetic counterpart, the Macchiaioli, some further discussion of their critics' arguments is required. The Italian Marxist Antonio Gramsci put forth the view of the Risorgimento as a "rivoluzione passiva," a passive and unfulfilled revolution that came to be known more unproblematically as the "rivoluzione mancata,"[19] while Norma Broude, the first American scholar to pay serious attention to the Macchiaioli, implied in her original study of 1967 that they were "impressionisti mancati," failed impressionists. Both used as their standard of success a French model; in Gramsci's case it was French Jacobinism, and in Broude's, French Impressionism. While their perspectives and levels of analysis are worlds apart, their revisionist positions help clarify the wellsprings of the present approach.

For Gramsci the Risorgimento was essentially an agrarian-populist revolution that had a brief chance and then petered out.[20] His studies convinced him that an Italian "Jacobin" democratic-agrarian revolution could have and should have been pushed through, but that moderate liberalism and Cavourian statecraft succeeded in absorbing the Garibaldian democratic-populist movement into conservative-liberal politics. Indeed, Cavourian manipulations had not only appropriated Garibaldi's popular revolution, but had perverted it through duplicity and fraud into a component of dynastic conservative liberalism.

Gramsci's analysis of the Risorgimento comprises three themes: the concept of the Risorgimento as a "passive revolution," in the sense that the Italian bourgeoisie came to terms with the traditional forces on the peninsula instead of waging an all-out attack on them, an attack which would then have had the active cooperation of the popular classes; the importance of the leadership

struggle, which saw the liberal monarchists outflank their republican and democratic opponents; and the great division between town and countryside, a problem deeply rooted in Italian history, and one which the republicans never met head on. While Gramsci readily admitted the positive nature of the unification of the state, he lamented the failure of the Italian bourgeois revolution, especially when compared with its French and English predecessors.

Gramsci tried to illustrate the major themes in his analysis with reference primarily to the south and to the critical years 1859–60. He ignored, however, that the fundamental objective of the leaders of the Risorgimento—especially after the disillusionments of 1848–49—was the military struggle for independence and unity. While the liberal monarchists under Cavour profited most from this position, even Mazzini and Garibaldi agreed to throw away their differences in the interest of a single policy with which to confront Europe and to hammer away at it until it became established fact. In post-1848 Europe this made the most sense to many republicans who defected to the monarchist side: in a predominantly antirepublican world, and with an Imperial France, there seemed little chance for the survival of a republican Italy. But expulsion of the foreigners and territorial unity did not usher in substantive social change, and led to the disaffiliation of the popular classes. Except for pockets of left-wing alliances in the northern industrial cities of Milan and Turin, the democratic-republican segment of the bourgeois nationalist movement collapsed and could be reconstituted only in the aftermath of World War II.

Gramsci first acted as a catalyst upon the historical conscience of the younger Italian intellectuals, while at the same time fascinating and provoking contrasting reactions from the more traditional-minded intellectual and professional classes. Gramsci in fact has produced a cleavage between those who subscribe to his revisionist wave and material interpretation of the Risorgimento, and the claim of Benedetto Croce that the inspiration of the modern Italian state lay in the spirit and ethos of liberalism. Croce's "idealist" interpretation ("History . . . is the history of liberty") asserts the immanence of a spiritual force that manifests itself in the ideals of individuals and elites, with the Risorgimento exemplifying this vision in nineteenth-century Italian history. One of the heroes of Croce's *Storia d'Europa nel secolo decimonono* (History of Europe in the Nineteenth Century) is Cavour, who in most revisionist writing was viewed as a calamity for the Italian nation. The liberal vision of Croce was seen as a rationalization of the modern world of the same authoritarian, elite combination of southern landowners, northern industrial magnates, and the in-

fluential professional and intellectual classes who deflected the Risorgimento from its authentic revolutionary course.

The Crocean vision of the Risorgimento is seen in his comparison of the movement with a great work of art:

> If it were possible in political history to speak of masterpieces as we do in dealing with works of art, the process of Italy's independence, liberty, and unity would deserve to be called the masterpiece of the liberal-national movements of the nineteenth-century: so admirably does it exhibit the combination of its various elements, respect for what is old and profound innovation, the wise prudence of the statesmen and the impetus of the revolutionaries and the volunteers, ardor and moderation; so flexible and coherent is the logical thread by which it developed and reached its goal. It was called the Risorgimento, just as men had spoken of a rebirth of Greece, recalling the glorious history that the same soil had witnessed; but it was in reality a birth, a *sorgimento,* and for the first time in the ages there was born an Italian state with all and with only its own people, and molded by an ideal.[21]

Croce's viewpoint became the official, liberal version of the Risorgimento, the heroic result and triumph of moderate liberalism. In this sense, Croce even went beyond the opinions of the actual Risorgimento leaders who became dissatisfied with the outcome, especially Garibaldi, who symbolized for Croce all that was noble and poetic about Italian unification.

Ironically, Gramsci's materialist interpretation of history owed much to Croce's historical observations, a debt that he readily admitted. Much of his work is devoted to a rigorous critique of Crocean philosophy in relation to Marxism. Nevertheless, Gramsci's conclusion about the Risorgimento's leadership puts forward a contrary position:

> They said that they were aiming at the creation of a modern state in Italy, and they in fact produced a bastard. They aimed at stimulating the formation of an extensive and energetic ruling class, and they did not succeed; at integrating the people into the framework of the new state, and they did not succeed. The paltry political life from 1870 to 1900, the fundamental and endemic rebelliousness of the Italian popular classes, the narrow and stunted existence of a skeptical and cowardly ruling stratum, these are all the consequences of that failure.[22]

Yet despite the irreconcilable differences between Gramsci and Croce, their common concern was the need to make a new Italy, to carry out a revolution in culture that would be the basis and substance of a revolution in every aspect of Italian life. Their emphasis on culture as a determining force equal in importance to economic and political facts has had an invigorating impact on the whole of the social sciences, including the social history of art. Though they disagreed on the benefits of its outcome, as well as the extent of its disappointments, they reveal that the Risorgimento itself was not only an event but also a culture, an outlook of theory and practice which had shaped both lives and minds for several generations.

Just as Gramsci criticizes the Risorgimento governing elite for not emulating the French Jacobins and pushing to the limit all the possibilities for progress that were objectively present in the Italian situation, so Norma Broude faulted the Macchiaioli for not emulating the French Impressionists and realizing the full potential inherent in plein airism. The inability of the Macchiaioli "to accept the immediacy of sensation and responses as the primary value of the work of art itself," unequivocally distinguished them "from the Impressionists, identifying the Italian group with an older tradition, while the Impressionists, on the other hand, are responsible for introducing into painting a totally new and revolutionary aesthetic approach." She concluded that the Macchiaioli's work still related to the older academic tradition of the preparatory sketch, while the Impressionists developed "a totally new and original response to the complexities of visual experience."

Here, unlike Gramsci, Broude argued from an anachronistic position in projecting the standards of contemporary notions of the avant garde onto the past. Her judgment of the Macchiaioli was based on the modernist art criticism of the 1960s that perceived the development of art in terms of a linear movement proceeding from Impressionism and culminating in the New York School, the last word in modernism at the time she wrote her dissertation. But even from this perspective it is clear that impressionism was only a short-lived and overinflated movement, soon to be displaced by neo-impressionism and symbolism and styles owing even more to the older academic stylistic and conceptual tradition than impressionism itself.

I have cited Broude's case to demonstrate both how our ideas of history (including my own) are conditioned by the inevitable "presentism" and desire operative in scholarly thinking at a given time and how this affects the limits of art-historical discourse. Broude has since modified her previous stance on the status of the Italians in her 1987 publication on the Macchiaioli and in her

World Impressionism of 1990.[23] These more recent publications open themselves to exploring visual production in a wider framework, suggesting that different cultures exposed to similar stimuli and sharing certain common assumptions may result in parallel outcomes. Yet even in these works Broude continues to privilege impressionism "as the most vital artistic expression of the day," and, despite her disclaimers, her latest thoughts on the subject take the French movement as their titular point of departure and standard by which all other "impressionisms" are to be judged. Her essay on the Italians in *World Impressionism* is entitled "Italian Painting During the Impressionist Era," and two-thirds of her general introduction is devoted to the French influence, self-admittedly, the "major part" of what the book is about. Thus, if in her later studies of the Macchiaioli Broude appears willing to allow the Italians to freefloat in a postmodernist ether, they are still forced to carry the ballast of the outworn categories.

In the end, history is neither a beauty contest nor a carnival, although it often partakes of both. We may draw lessons from it for future conduct or seek alternative possibilities to developments for future guidelines, but it is useless for measuring the success or failure of a turn of events. We cannot elevate into an absolute a particular historical outcome and use it to interpret other outcomes. Naturally, the urge to make comparisons for the sake of interpretation is irresistible, but it has to be held in check. The historian simply spins wheels in reducing either a national movement like the Risorgimento or an aesthetic movement like the Macchiaioli to the level of unrealized potential based on the achievements of previous or even parallel social and cultural movements. I try to avoid this pitfall by reconstructing the ways in which the actual contemporaries and direct participants determined the nineteenth-century Italian cultural landscape. Naturally, my own interpretation is hardly disinterested, and its built-in bias, recognized or unrecognized, should alert readers that there is no such thing as an "art history for art history's sake."[24] Those scholars still insisting that art discourse is beyond or above politics are themselves defending a particular political position. Just ask Jesse Helms or Hilton Kramer.

ONE

(Re)constructing Italian Nationalism

Risorgimento—referring to the dynamic current of nationalism in nineteenth-century Italy leading to unification—is a term woefully unfamiliar to most Americans.[1] Between the Renaissance and Fascism we draw an enormous historical blank, a blank which in fact coincides with the national resurgence and renewal of Italy's place in the European industrial and economic mainstream. One aim of this study is to help fill that blank with evidence that we have been missing out on one of the most dramatic epochs in modern European history. Fascism represented a perversion of the nationalism generated by the Risorgimento, and exploited its symbols and rhetoric, as well as its failures, in its bid for power. Hence the need for American audiences to grasp the elusive phenomenon, if only to understand some of the incredible myth-making that unfolded during the interval.

Although the idea of the Risorgimento comes as close as any periodic signifier to the amorphous concept of the zeitgeist—that grand chunk of chronology that is reduced by sleight of hand and mind to finite proportions—its use as a strategic rallying cry for the construction of a new Italian state in the nineteenth century helps to embed it in the material circumstances. Like nationalisms generally, its complexities resist reductive and essentialist ploys; but whatever the aims of the diverse participants—frightened conservatives, enraged peasants, scheming liberals, revolutionary or sentimental republicans, professional anarchists, discontented

men and women in all camps—they somehow combined, most often inadvertently, to create a united Italy. It is the process of making and shaping this state out of a land mass that Metternich had once referred to disparagingly as a "geographical expression" that is implied here in the use of the term Risorgimento.

Since its ideals and political expression constituted the opportunity for the emergence of the Macchiaioli, I want to start by plotting some of the Risorgimento's critical historical markers. The very idea of resurgence is a homegrown reference to that time warp mentioned above between the Renaissance and post-1789 Italy. Despite Italy's remarkable role in the forging of Western civilization, beginning from around the end of the sixteenth century the country failed to keep pace economically with the other major continental powers: France, England, and the Netherlands.[2] Overseas trade via the new routes to the Americas and Asia favored Europe's Atlantic seaports at the expense of Italy, with the center of commercial activity shifting to North Sea areas. Italy's economy, and then Italy generally, dropped from the main western European development and fell into a cultural and economic backwater. Then, to intensify the actual as well as psychological sense of decline, the country fell prey to foreign invaders and became a European battleground of warring factions. These conflicts drained off much of indigenous Italy's productive energy and social vitality, preventing it from engaging in constructive domestic enterprises.

By the end of the eighteenth century, Italy was in the grips of foreign states who regulated its social life and extracted its resources like modern colonial powers. Austria ruled over Lombardy (centered in Milan), the Veneto (Venetia, centered on Venice), and over Tuscany, with grand dukes from the House of Habsburg-Lorraine. The Spanish Bourbons ruled over Naples and Sicily, and the pope—who might as well have been a foreign power—ruled over the Papal States in Umbria and the Marches. Only the Kingdom of Sardinia-Piedmont, with its capital in Turin and governed by the House of Savoy, managed to retain its Italian identity, and it would figure prominently in the subsequent history of the Risorgimento.

The events of the French Revolution and the Napoleonic empire were of immense importance in triggering popular participation in the Risorgimento and momentarily interrupting the Italian process of decline. French armies overran the country, except for the islands, and either annexed their conquests outright or established some sort of satellite regime in them with French-inspired constitutions and reforming laws. Eventually, the new political groupings and annexations were transformed into the

Kingdom of Italy (1805) with Napoleon as king, and his stepson Eugène de Beauharnais, as viceroy.

The liberal segment of the Italian population greeted the newcomers as liberators, welcoming the defeat of their traditional enemy, Austria, and the abolition of the remnants of the seigneurial or feudal system, and the freeing of internal commerce. The Inquisition was abolished, the gates of the ghettos were taken down, and Jews were granted full civil rights. While to Napoleon Italy was a reservoir for manpower and a useful financial support, his efficient administrative apparatus had the result of breaking down old boundaries and establishing a uniform system of law in the Code Napoléon. Out of this emerged the first sense of national consciousness; people began to think of and write about themselves as Italians rather than Piedmontese or Tuscans. Napoleon's treatment of the Church made it clear that the possession of temporal power was not a necessary condition for the performance of the Church's spiritual function. Under Napoleon's pressing financial needs, privileges and exemptions were eliminated, whether of nobility or ecclesiastics, and all had to contribute. He opened a career to talent and he trained the youth of the country to fight in defense of their liberties.

But as the French indulged in excesses under pressure from their enemies, demanded even higher levies in troops and money, looted the national art treasures, or failed to make the Continental system help more than it hurt, a negative reaction to the French followed. Napoleon and his surrogates in the north and south now became regarded as tyrants and invaders themselves, and a secret society based on Freemasonry—the Carbonari (charcoal burners, ready to ignite into action)—organized to undermine their reign and ultimately expel the French.[3] Napoleon thus provided a negative impetus for the growth of Italian nationalism, which dictated that Italy should recover on its own its past greatness, through a resurgence of Italian energy, national unification, and economic power.

After the fall of Napoleon, the first generation of nationalists stood by in disbelief as the Congress of Vienna carved up Italy again into territories for colonization. It did not take long for liberals to realize that Napoleon had been a more positive force for Italian unification than Metternich. The Carbonari now aimed their sights at the Restoration governments. Italian writers devoted themselves to the praise of the nation, looking to the past for their models of inspiration, as in the case of the romantic novelists Francesco Guerrazzi, Massimo d'Azeglio, and Alessandro Manzoni, whose *I promessi sposi* (1827)—an epic saga of corrupt nobility, avid priests, and heroic artisans—was the most widely

read Italian novel of the nineteenth century. Giacomo Leopardi, the most famous of Italian poets in the nineteenth century, sang the glories of the fallen Italian nation. Silvio Pellico, a chief contributor to *Il Conciliatore*—a patriotic journal in Milan—used the antiforeign theme in his *Le mie prigioni* (My Imprisonment, 1832), basically an account of his experience in the Spielberg jail where the Austrians confined their Italian political prisoners.

Indeed, in the next half-century leading to unification, nationalism became the predominant theme in Italian letters. Historians like Carlo Troya (1784–1858) began a collection of documents in Italian history, the *Archivio storico italiano,* and gathered about him a major intellectual circle in Florence; and Vincenzo Gioberti wrote one of the primers of the young Macchiaioli, *Il Primato* or, more fully, *On the Moral and Civil Primacy of the Italians,* published in Brussels in 1843. Gioberti proposed that the various states of Italy, in order to achieve independence from foreign interference, federate under the pope as president. His followers were called Neo-Guelphs, after the pro-papal faction that struggled against the Ghibellines in medieval Italy. The following year, Cesare Balbo (1789–1853) sounded a clarion call in his *Delle speranze d'Italia* (On the Hopes of Italy) which accepted Gioberti's thesis that a federal state should be the goal of any drive for Italian unity. But as a loyal subject of Carlo Alberto, king of Sardinia-Piedmont, he envisaged that monarch, rather than the pope, as the leader of any future confederation. Despite the diverging views of the various reformers, they were bound together by their common devotion to a unified, economically viable Italy. Gioberti dedicated his book to Pellico, and Balbo dedicated his to Gioberti—these last two attesting to the powerful presence of an intellectually and socially progressive elite in the independent state of Sardinia-Piedmont. (Indeed, nearly every major Italian radical in the modern era has emerged from this state, including Mazzini and Garibaldi, and more recently Gramsci, Togliatti, and Berlinguer.) Liberals elsewhere in Italy took their lead from this state, and, as in the case of the Tuscan Macchiaioli, marched under its banner and tested their work before its public.

Gioberti had also been inspired by Giuseppe Mazzini, a native of Genoa, which at the time of Mazzini's maturation also formed part of the state of Piedmont. Destined to become the most active radical of the Risorgimento, the charismatic Mazzini had begun his career as a member of a Carbonaro society and later formed his own network known as La Giovine Italia (Young Italy).[4] The aims of Giovine Italia were to indoctrinate a new generation of Italians in the concept of a united and independent Italy with its

capital at Rome and a republican form of government. Young Italians were charged to consider Italy's mission in the world, a united and free state with social justice for all that could take its place as part of a broad federation of new Europe. In the process of struggling for independence, Young Italians would regenerate themselves by their self-sacrifice.

Committed to the necessity of popular insurrection, Mazzini expended much of his energy editing subversive newspapers, smuggling them across Italian borders, and fomenting uprisings in key regions in Italy. As a result, he was forced to live in exile most of his life, settling more or less permanently in London. Here he attracted many prominent followers including Thomas Carlyle and Algernon Charles Swinburne. Mazzini was feared by moderates and conservatives alike, who nevertheless needed him to ignite a spark that they could then exploit to implement their own more cautious plans and bring their opponents to heel. Mazzini made a brief appearance in Italy during the Italian insurrections of 1848, and enjoyed his finest hour when, in March 1849, he was elected a member of the triumvirate of the new Roman Republic following the flight of the pope. When Rome was attacked by the French, Mazzini organized a heroic resistance in which Garibaldi played a major role. After Rome fell in June, Mazzini escaped to London once again.

Mazzini's passionate zeal and single-minded devotion to the cause of Italian independence captured the imagination of liberal men and women everywhere. Margaret Fuller Ossoli, an American woman married to a Roman nobleman, idolized Mazzini, and supported the short-lived Roman Republic which he shepherded during a stormy five months, while William Cullen Bryant's last public appearance was made to deliver an address on the Italian patriot, stressing for Americans that the sole passion of this "countryman of Columbus" was "Italian unity and liberty."[5]

Almost every major leader during the epoch of the Risorgimento passed through a Mazzinian stage which they then had to break from in order to "come of age." Gioberti, a priest, admired the evangelical features of Mazzini's program, but left the movement because of its emphasis on insurrection. Nevertheless, after the bitter disappointments of the 1848 revolts, Gioberti moved closer to a democratic solution. His *Del Rinnovamento civile d'Italia* (On the Civic Renewal of Italy, 1851) switched from a papal to a Piedmontese orientation, advocating the establishment of an Italian constitutional monarchy under the aegis of the House of Savoy. The failures of 1848 and Pope Pius IX's abandonment of his moderate position made this solution acceptable to most lib-

erals and republicans, and even the Mazzinian Garibaldi threw his efforts behind this concept. All progressive forces—including Mazzini himself—agreed to forge a united front to expel the foreigners and create the unified state.

GIUSEPPE GARIBALDI

The most colorful figure of the Risorgimento was Giuseppe Garibaldi, whose charismatic personality and stupendous military achievements stamped the popular imagination with the heroic side of the nationalist movement.[6] He would become one of the most compelling myths of post-unification Italy, embodying two opposing ideals that could attract both Right and Left—that of father of his country and that of symbol of permanent opposition. His was the only effigy which at the height of the Cold War appeared on a postage stamp in both the USA and the former U.S.S.R., commemorating the centenary of his triumphant march through Sicily in 1860. The United States honored the hero to whom Lincoln offered the rank of major-general in the Union army during the Civil War, and the Soviet Union acclaimed him for his support of the Paris Commune and Marx's First International. His international popularity even in his own time is shown by the enthusiasm he aroused in Great Britain during his Sicilian campaign and his visit to London in 1864. As the reporter of the *Times* wrote just prior to Garibaldi's arrival:

> In a few days one of the most remarkable men in Europe will set foot on these shores. For years the name of GARIBALDI has been familiar to all who are interested by narratives of heroic daring, strange adventure, and generous devotion to the cause of freedom.[7]

Garibaldi was born in Nice, at that time belonging to the House of Savoy. He began his career as a merchant-captain, sailing the eastern Mediterranean in small trading vessels. It is certain that it was as a coastal trader and entrepreneur that he first encountered the obstacles to trading and shipping set up by the foreign-dominated provinces in Italy. All his life he identified with the entrepreneurial class and promoted business ventures, and it is likely that the unfolding of his liberal doctrine took place in this context. The risings of 1830–31 stirred his patriotic commitment to an almost professional level; he was initiated into Young Italy in the autumn of 1833, and early the next year participated in an abortive uprising in the Piedmontese navy.

Now an exile, Garibaldi crossed to South America, forming part of the large wave of Italian immigration to the Americas in the 1820s and 1830s. For a while he captained a coastal trader for his own company at Rio de Janeiro, where he joined the Young Italy group there as well as a Freemason lodge. Freemasonry had inspired the more radical Carbonari movement, and Catholic spokesmen, either in good or bad faith, always confused them. Masonry recruited its members from the educated classes, and had been instrumental in the diffusion of egalitarian political ideals and of new scientific theories. Both the papacy and autocratic sovereigns were always suspicious of a secret organization in which freethinkers, Protestants, and Jews met and exchanged ideas in an unorthodox way, and this caused more revolutionaries and radicals to join the Freemasons. Although a large number of militant Risorgimento democrats belonged to masonic lodges, freemasonry was not itself a revolutionary group, but functioned as a type of "front organization" where Carbonari members and Young Italians could meet with people sympathetic to their aims. Major leaders of the Risorgimento such as Mazzini, Giuseppe Dolfi, Francesco Crispi, and Garibaldi belonged to the freemason organization.

During the next thirteen years, from 1835 to 1848, Garibaldi engaged in almost continuous fighting, at first in the service of the Rio Grande province of Brazil in its attempt to establish an independent republic, and later in Uruguay against its attempted conquest by the dictator Juan Manuel de Rosas of Argentina. He formed an Italian legion in Montevideo that became the prototype of his volunteer forces in Italy. The men of the Legion were the first to wear the famous "red shirt" which later in Italy became the popular symbol of the *garibaldini*. The uniform went through several stages of evolution, but it originated in the most prosaic fashion. Wishing to dress the legionaires as cheaply as possible, the Montevidean authorities found a stock of red overalls worn by the butchers in the slaughter houses at Ensenada to camouflage the stains of the blood of the cattle and converted it into poncho-like robes. These loose-hanging outfits were modeled on the garment worn by the Uruguayan gauchos; they hung over the trousers, had no buttons, and mere holes for the head and arms. The final refinement of this outfit—inspired by the uniform of New York firemen observed by Garibaldi during his exile in the United States in 1850–51—came a few years later, when brass buttons were added and it became a genuine "shirt."[8]

The remarkable European revolutions of 1848 gave Garibaldi the opportunity to fight on the hills and plains of his native land. In April of that year, he sailed with sixty of his Legion, and ar-

rived in June to find Piedmont at war with Austria. The king, however, who knew him only as a Mazzinian republican and a condemned mutineer and deserter, refused his services. Instead Garibaldi enlisted with the provisional government in Milan, but before he saw action, Piedmont was defeated and withdrew from the war. To Carlo Alberto's embarrassment, Garibaldi practically challenged Austria single-handedly with a brief campaign in the Alpine foothills, until forced to escape to Switzerland with the remaining half of his sixty. He ultimately wound up in Rome, which had been declared a republic in February 1849, and was soon beset on all sides by superior armies competing for various reasons of politics or ideology to crush it and restore the pope. Garibaldi defended the infant republic against the French invaders, repulsing them on April 30, but during the next two months the superior numbers and equipment of the French finally overwhelmed the *garibaldini*, and the French marched into Rome. Garibaldi had escaped the night before, on July 2, with some 4,000 volunteers. With him went his Brazilian wife, Anita, who had arrived from Nice a week earlier to be with him during the crisis. Chased by 65,000 French, Austrian, Neapolitan, and Spanish troops, Garibaldi's small force moved stealthily after dark by mountain tracks and made its way to the tiny hill-republic of San Marino, which had managed to preserve its independence by maintaining strict neutrality. Garibaldi left the remnant of his troops in this territory, and then escaped with the help of the Young-Italy network. His flight was facilitated by the parish priest of Modigliana, Don Giovanni Verità, who hid Garibaldi and his officer Leggiero in his house and acted as their guide. Tragically, Anita, wracked with illness, perished during their arduous trek through the marshes near Ravenna.

Now a proscript and an exile, Garibaldi—like so many other European refugees in the period 1848–60—made his way to the United States, docking at Staten Island on July 30, 1850.[9] The Italian tricolor flew with the stars and stripes over the quarantine buildings in honor of the Italian refugee. He lived with his friend Antonio Meucci in the village of Clifton, Staten Island, part of Richmond Borough. Meucci was a remarkable person in his own right—the inventor of an electromagnetic telephone long before Alexander Graham Bell, but whose poor finances and immigrant status prevented him from securing a proper patent.[10] Meucci and Garibaldi opened a candle factory, which became famous and remained in operation for nearly fifty years. Garibaldi was not skillful at dipping the wick in the tallow, but he carried barrels of tallow from the Vanderbilt landing wharf to the boiling vat at the factory. He took a keen interest in the welfare of the Italian com-

munity of New York, and allowed his name to be used for charitable appeals. He also joined the local volunteer fire brigade and a Masonic organization on Staten Island to which Meucci belonged, the Tomkinsville Lodge, No. 401, where he took degrees. He frequented a popular saloon on Fulton Street, near Broadway, owned by Lorenzo Ventura, a favorite rendezvous for actors of the adjacent Park Theater and journalists and authors of Printing House Square. Here Garibaldi met John Anderson, a rich tobacconist who identified himself with the Italian cause and who may have subsidized some of his later military expeditions. Anderson did business in Havana, and even tried to interest Garibaldi in the idea of a revolution for Cuban independence. Apparently, Garibaldi began the process of naturalization, but never completed it. Yet all his life he regarded himself as a citizen of the United States.

He moved on in 1851, this time to Central and South America where he engaged in merchant shipping, and from Latin America he commanded an ocean-going vessel for two years on long Pacific voyages, before returning to New York in autumn of 1853. He took off again for Europe in January 1854, and, calling at Newcastle on his last voyage to collect coal, he was touched by a reception on the part of Tyneside colliers who presented him with a sword of honor—a sign of the growing sympathy in Great Britain for himself and the cause he represented. The Piedmontese government allowed him to return in 1854, and the following year he purchased half of the island of Caprera off the north coast of Sardinia, where he planned to devote himself to agriculture and commercial shipping. But he was only biding his time until the years 1859–60, when he conducted his brilliant campaigns with his *Cacciatori delle Alpi,* the Sharpshooters of the Alps, in the Alpine foothills, and his *Mille* (the Thousand) in Sicily, enlarging the state of Sardinia-Piedmont to more than double its size and paving the way for the proclamation of a new kingdom of Italy early in 1861.

Garibaldi had received active and valuable support from Americans during his campaign in Sicily and Naples; American-outfitted vessels—some with names like *Washington, Franklin,* and *Oregon*—transported his troops and carried arms and provisions to supply them after the landing at Marsala.[11] His admiration for the United States predisposed him to monitor its internal affairs. During the summer of 1861 at Caprera he followed with great interest the news of the American Civil War. Escaped African-American slaves fought with him in Montevideo, and he felt strong sympathy for the antislavery cause in the United States, standing firm on the side of the North in the Civil War. The American Government actually invited Garibaldi to take

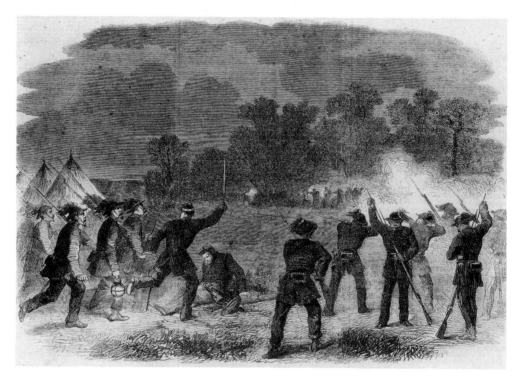

1.1 *Attack on the Pickets of the Garibaldi Guard,* the *Illustrated London News,*
July 20, 1861

a high command in the armies of the North.[12] Secretary Seward
sent the American minister in Brussels to Caprera to persuade
Garibaldi to accept a commission as major-general, but Garibaldi
stipulated two conditions for acceptance: he wanted an appoint-
ment as commander-in-chief and the power to abolish slavery.
The negotiations fell through, much to the disappointment of the
American public. The symbolic character of his name is already
seen in the fact that a Garibaldi Guard was organized in the
Northern army, and hundreds of Immigrants who answered Lin-
coln's call for volunteers, marched in review at the Independence
Day parade in Washington dressed in the red shirts of Garibaldi's
troops (fig. 1.1). While Lincoln and Garibaldi could not make a
deal in 1861, both would have taken satisfaction in seeing their
names used to designate Italian and American volunteer brigades
who fought side by side in the Spanish Civil War seventy-seven
years later.

Garibaldi's magnetic personality, his ideals, and improbable
achievements electrified his contemporaries. Writers dedicated
their books to him, and there is such a large body of art and lit-
erature devoted to his person and exploits that a block-buster ex-

hibition was organized around him in 1982 for the centenary of his death. But artists not only painted him and writers not only novelized him, they fought for him as well, including most of the painters who would later be associated with the Macchiaioli. His extraordinary appeal is exemplified in the statement by a young Italian who had gone to Rome to study art and who went down to a piazza one day, merely hoping to catch a glimpse of Garibaldi:

> I had no idea of enlisting. I was a young artist; I only went out of curiosity—but oh! I shall never forget that day when I saw him on his beautiful white horse in the marketplace, with his noble aspect, his calm, kind face, his high smooth forehead, his light hair and beard—everyone said the same. He reminded us of nothing so much as of our Saviour's head in the galleries. I could not resist him. I left my studio. I went after him; thousands did likewise. He only had to show himself. We all worshipped him; we could not help it.[13]

And this was no fickle emotion; eleven years later the same artist joined the Sicilian expedition to wage an even more daring enterprise.

Garibaldi's appeal went beyond Italian borders, drawing to him Dutch, English, and American artists as well. Van Gogh, too young to have fought with Garibaldi, nevertheless viewed him as a model of heroic and effective action.[14] One of the clippings found among his personal possessions is a full-page graphic tribute to Garibaldi on the occasion of his death in 1882 by the American cartoonist Thomas Nast (fig. 1.2). Van Gogh drew upon this page as a source of inspiration for his portrait of the ex-Communard, Père Tanguy, giving the participant in the popular struggles in France the same modest traits and gesture of folded hands used by Nast for his hero (fig. 1.3). Nast deeply admired Garibaldi and had not only depicted him several times for newspapers like *Harper's Weekly* but he also joined the second Sicilian expedition of reinforcements led by Giacomo Medici in June 1860.[15] At Palermo, Nast secured a red shirt, and it was he who reported Garibaldi's claim that the "red shirt" had been inspired by the dress of the New York City firemen. Nast marched with the *garibaldini,* serving as reportorial illustrator for several newspapers including the *London Illustrated News* (fig. 1.4). It was certainly the most memorable experience of Nast's life, and something of his exalted ideal of Garibaldi is captured in another illustration Nast did for *Harper's Weekly* in 1866 (fig. 1.5). He depicts Garibaldi and Vittorio Emanuele II perched on a rocky out-

1.2 Nast, *Garibaldi,* 1882

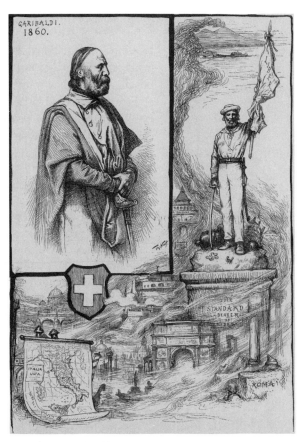

1.3 Van Gogh, *Portrait of Père Tanguy,* 1887–88

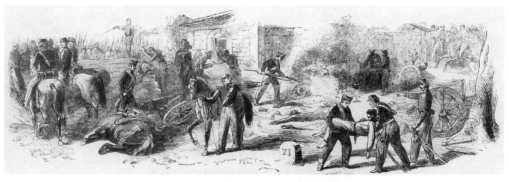

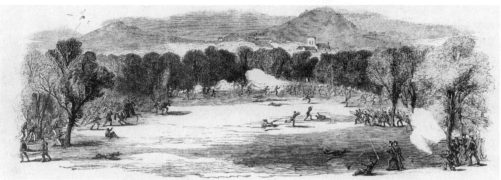

1.4 Nast, Illustrations of Garibaldi's Sicilian campaign, the *Illustrated London News,* October 20, 1860

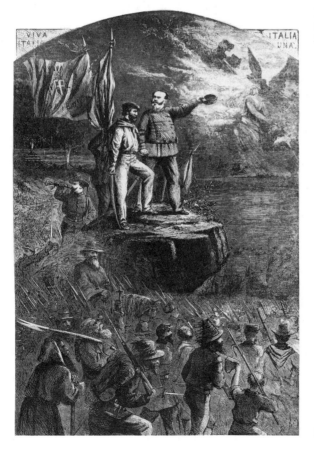

1.5 Nast, *The Uprising of Italy,* 1866

crop—the pinnacle of Italy's drive to unification. Above them waves a tricolor flag bearing the monogram of the king and the name of Garibaldi.

THE ECONOMICS OF THE RISORGIMENTO

Nast's idolatry of Garibaldi parallels Croce's notion of the Risorgimento as an abstract ideal of freedom struggling to express itself. This helps explain the popular depiction of Garibaldi in the arts. Garibaldi's iconic status represents the "romantic" side of the Risorgimento that glosses over the less glamourous but no less effective role of the moderate landowners and the entrepreneurs in its realization. Inspired by English free-trade theorists like Richard Cobden and Nassau Senior, and by French economists like Jean Baptiste Say and Frédéric Bastiat, they advocated political unification to get a larger market for the encouragement of larger and more economical industrial establishments, and for a greater division of labor. They wanted more freedom in economic enterprise, greater savings and investments, a better system of transportation, and the introduction of the most efficient techniques of agricultural and industrial production.

Italy's economists and philosophers rationalized the Risorgimento ideals in terms of a liberal-nationalist-technological theory of economic growth. Among these were Carlo Cattaneo (1801–1869), who preached the doctrine of economic expansion in the hope that economic ties would lead to a federation of all Italian states and ultimately to a United States of Europe. His ideas provided an economic foundation for thinkers like Mazzini and Garibaldi, who were nationalists looking ahead to international organizations and commerce. These ideas were advanced by the elite agrarian and economic societies such as the Accademia dei Georgofili in Florence and the Associazione Agraria Subalpina, founded by Cavour at Turin in 1844. They were given currency by the leading scientific institutes and congresses who expressed the need for the creation of a unified Italian state, and whose scientific and industrial studies cut across regional frontiers and brought diverse communities together.

The negative aspect of regionalism revealed itself within the realm of cultural organization: Italian art depended upon regional academies and private societies called the *Promotrici* (literally, the "promoting societies") which sponsored exhibitions and organized lotteries for their members. The peculiarly regional stamp and perfunctory distribution was less effective in publicizing Italian painters than the Paris Salon, a national forum for French art.

The French also organized major world's fairs in 1855, 1867, and 1878 which (unlike the London Great Exhibition of 1851) devoted a major section to the display of art objects and brought together under one vast roof the various domestic and foreign schools. Ironically, Italians who visited the Paris Universal Exposition of 1855 could get a clearer glimpse of what their own regional schools were doing than they could at home. While there were some exchanges among the Promotrici prior to unification, this process was stepped up afterwards and aided in the centralization of the art world. Following the model of the French, the newly proclaimed Kingdom of Italy decreed a National Exposition in 1861 that brought together the art and industry of the various provinces of the state. Contacts were established between artists of like-minded styles who were exposed to the examples of the different regions. This was especially true of the landscape and genre trends; the Torinese school headed by Antonio Fontanesi, the Tuscan by the Hungarian-born Karoly Markò, and the Neapolitan school of Posillipo could now be viewed altogether under the same roof. The young Macchiaioli painters were strikingly modern in their zeal to exhibit, and seized every opportunity to show their work in the Promotrici of Turin and Genoa as well as of Florence, and figured prominently in the National Exposition of 1861 that celebrated Italian political, geographic, economic and cultural unification.

The preparation of Italy for the wars of unification had been orchestrated in large part by Count Camillo Benso di Cavour (1810–1861).[16] The second son of an old noble Piedmontese family, he could not make his way entirely on the basis of family advantages. He ran the family estate at Leri, about twenty-five miles northeast of Turin, and, by the introduction of new kinds of chemical fertilizer and farm machinery, and the creative financing and marketing of his agricultural products, he made farming a profitable commercial enterprise. He invested in a variety of concerns such as silk, steamship, and railway industries, and in 1844 helped found the aforementioned Associazione Agraria for the promotion of agriculture in the Po Valley. Cavour evolved into a classical example of one type of Risorgimento leader, a gentleman-farmer who believed in economic and scientific progress, and representative government with limited suffrage. Nationalism he understood mainly as an avenue to industrial modernization.

In December 1847 he and Balbo brought out a newspaper under a name which later seemed immensely prophetic, *Il Risorgimento*. Compared to Mazzini's program, however, its political policies were mild: the independence of all Italian states; some reduction in their number, presumably by Piedmont absorbing

some of the smaller ones in the Po valley; a league of Italian rulers; and a program of orderly reform. But despite its moderation the newspaper was independent of the government, and in the conservative atmosphere of Piedmont it provided a breath of fresh air. Cavour pursued his liberal goals with tactical brilliance, and in 1848 was one of the first Piedmont editors to advocate a constitution.

Five years later he became prime minister under Vittorio Emanuele II, the son of Carlo Alberto. Cavour worked to develop Piedmont's economy, building railways, encouraging agriculture (especially rice culture) and industry; he believed in free trade both at home and abroad, and under his ministry Piedmont's foreign commerce more than doubled. As prime minister, he backed and came to dominate the Società Nazionale Italiana (Italian National Society), a moderate organization that was not only the first of real national scope but also the first that represented a common meeting ground for all factions working for unification under the House of Savoy. It in essence called for a united front, and drew away many militant republicans from the policies of Mazzini. Garibaldi—whose politics eventually moved him to the left of this group—signed the founding petition, and later was elected president of the organization. The Società Nazionale played a major role in the war effort, propagandizing for Italian unity under Piedmont's king and secretly enrolling volunteers throughout the states of Italy to fight for the national cause.

Cavour's first step in the realization of a war against Austria was to get the support of England and France for his cause and restore confidence in Piedmontese arms. To this end he joined these powers in the Crimean War against Russia (1854–55) with a contingent of 15,000 crack troops, an act that won allies to his long-term purpose. He was invited to the peace conference at Paris in 1856, giving Piedmont world-class status, and he made such a masterful presentation of Italian complaints against Austria that he won a major segment of public opinion to his purpose and persuaded the Concert of Europe to recognize the validity of his claims.

Cavour's plans to defeat Austria depended on Napoleon III, the emperor of France, whose Italian connections, nationalist leanings, and desire for military prestige Cavour assiduously exploited. When, after several years it looked as though matters would rest there, events played into Cavour's hands. On January 14, 1858, an Italian nationalist, Orsini, threw a bomb at the imperial couple as they were about to leave their carriage for the Opera.[17] Several persons were killed and injured, but Napoleon III and the Empress Eugénie escaped unscathed. The emperor, however, came

away from this event with a vastly different perspective on the Italian problem.

At last, in July 1858, Cavour and Napoleon III met secretly at Plombières, a spa in eastern France, to plot war against Austria. They agreed that Piedmont would acquire all of northern Italy including Lombardy, the Veneto, and the Romagna, and that the grand duchy of Tuscany would be enlarged into a central Italian kingdom. These two large states and possibly the Kingdom of the Two Sicilies (in the event Ferdinando II abdicated) would then form a confederation under the pope. France would receive Nice and Savoy, and Napoleon III's cousin, Prince Napoleon, would marry Vittorio Emanuele's reluctant fifteen-year-old daughter, Clothilde. For Napoleon III the arrangement provided several avenues for increased Bonapartist influence, while preventing the formation of a unified Italian state that would threaten France.

As tensions mounted, and Cavour hunted for a pretext for war against Austria, Russia and England pressed for peace, and France wavered. Cavour was so upset by this turn of events that he came close to taking his own life. Austria, however, horrified to see young Lombards and Venetians escape conscription by streaming to Piedmont as volunteers, played right into Cavour's game plan. It issued an ultimatum to Piedmont so strong that Cavour needed only to reply with cautious dignity to have his war. On April 29, 1859, Austria invaded Piedmont, and France went to their aid according to the agreement formulated at Plombières.

The conflict was relatively brief. In early June the Austrians were seriously defeated in Lombardy, at Magenta, but the Battle of Solferino, three weeks later, was as indecisive as it was murderous. Giuseppe Bertini's painted sketch of *L'incontro di Vittorio Emanuele II e Napoleone III a Milano* (The Meeting of Vittorio Emanuele II and Napoleon III at Milan) celebrates the triumphal entry of the allies into Milan on June 8, 1859, and the momentary euphoria following their victory at Magenta four days earlier (fig. 1.6). The Italian tricolor at the right heralds the liberation of Lombardy by the coalition forces, but the emerging political differences between the French and Italian crowns may reveal itself in the way the artists of the two nations give their respective rulers the greater prominence (see fig. 1.7). As the Austrians retreated to the fortresses controlling the Lombard plain, Napoleon hesitated to face what he knew would be stiff opposition. Rather than confront increased discontent at home (the Italian war was not popular in France), further losses, a long siege, the danger that Prussia might come to Austria's aid, and the possibility that a unified Italy might result from the war, he unilaterally agreed to a truce. The emperors of France and Austria met in the village

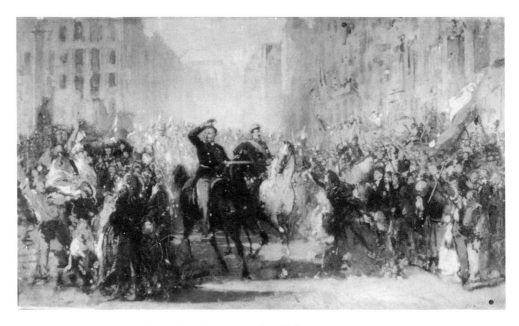

1.6 Bertini, *Vittorio Emanuele II and Napoleon III at Milan*, 1859

1.7 Napoleon III and the King of Sardinia Entering Milan, *L'Illustration*, 1859

1.8 Domenico Induno, *Bulletin Announcing the Peace of Villafranca*, 1861

of Villafranca on July 8 and signed an armistice to last until
August 16. Three days later they negotiated the preliminaries
of a peace treaty, which included ceding Lombardy but not the
Veneto to Piedmont, and maintaining the other Italian states
as before.

No Italian soldier or statesman of any rank or position was
present at this conference; Napoleon III had gone ahead without
consulting his main ally. Vittorio Emanuele accepted the terms of
the armistice over the violent opposition of Cavour, who in furi-
ous protest handed in his resignation. But the news of Villafranca
stunned Italians of every state north of Rome. Embittered shop-
keepers replaced the images of Napoleon III in their windows
with portraits of Orsini. The full impact of this event is captured
with all its agonizing implications in a work by Domenico In-
duno, a Milanese artist, who depicted the reaction of an assembly
of diverse social types in Milan to news of the treaty (fig. 1.8).
One veteran to the left raises his hands in despair, an older man
stares off into empty space at the right. Everywhere individuals
shrug their shoulders in disbelief, collapse in depression, or ap-
pear on the verge of tears. Induno deliberately set the scene in
Milan, represented by the Gothic Duomo on the horizon, thereby
emphasizing the unselfish devotion of the Milanese to the na-

tional concept despite their own liberation. Induno himself, to-gether with his brother Girolamo, had participated in the Milan insurrection of March 1848, and in the aftermath took refuge in Florence. He eventually became quite close to the Macchiaioli, exerting a notable influence on Vincenzo Cabianca's early work. Induno's specific topographical site for the context of his scene anticipates the Macchiaioli's Tuscan backdrops as an expression of Italian nationalism.

Meanwhile, prior to Villafranca, mild revolutions accompanied the march of Piedmontese troops throughout northern and cen-tral Italy. When local patriots gathered in the streets and squares, the dukes of Modena, Parma, and Tuscany simply fled. In these areas and in part of the Papal States (the Romagna), supporters of Cavour—usually members of the Società Nazionale—assumed dictatorial powers in provisional governments that adopted Pied-montese laws and currency and called for elections to representa-tive assemblies. Thus the terms of the Villafranca truce could not be carried out. These governments cautiously went their way, carefully maintaining order and propagandizing in favor of annex-ation. After several months they arranged plebiscites on the ques-tion of annexation: the results were overwhelmingly in favor, and Napoleon III could hardly reject them. Vittorio Emanuele now officially accepted the request to rule from the Alps to Rimini, on the Adriatic. For its part, France received the province of Savoy and the city of Nice, Garibaldi's birthplace. The hero of the Ri-sorgimento never forgave either Cavour or Napoleon III for this stain on his national memory.

The extension of the Piedmontese states was a triumph of mod-erate liberals with which more democratic nationalists were not wholly satisfied, and nascent revolts in Sicily gave them a chance to lead a different sort of Risorgimento. Mazzini and his followers actively formulated plans and called on the intrepid Garibaldi to lead their scheme for an armed expedition to the Kingdom of the Two Sicilies. They hoped that such a force, uniting with local insurrectionists, would overthrow the Bourbon regime. Cavour dared neither to openly support nor oppose the undertaking, but other moderates, like Massimo D'Azeglio, then governor of Mi-lan, successfully blocked a shipment of guns from Milan to the expeditionary force. Garibaldi set sail for Sicily one night early in May 1860 with little over a thousand men, mainly middle-class youths from Lombardy, the Veneto, and the Romagna.

No event in the nineteenth century so captured the popular imagination everywhere as that bold undertaking. The expedition was like some ancient epic reborn in the modern age: untrained men (and a few women) wearing the red shirts fought against

overwhelming odds and were enthusiastically supported in the countryside. In two weeks Garibaldi occupied Palermo, and within two months he overran almost all of Sicily. On August 20 he crossed the Straits to the mainland, on September 7 he entered Naples, and on October 1 he defeated the Neapolitan troops at the battle of Volturno. All this happened with such lightning speed that the Concert of Europe had no time to collect its wits before the action was completed, and even Cavour momentarily lost the initiative to the radicals in the cause of unification.

But Cavour skillfully recaptured control. He sent Piedmontese troops into the papal territories of Umbria and the Marches, where they were then to push on and preempt Garibaldi's proposed march on Rome. This way Cavour appeared as savior of the Risorgimento for both foreign foes and domestic partisans. The Piedmontese armies easily defeated the papal troops, and by the second half of September were in a position to confront Garibaldi. The heavy losses sustained at Volturno, moreover, and the plebiscite for annexation of the southern provinces weakened the republican position. Garibaldi surrendered his title of "il Duce" and withdrew to his island retreat on Caprera. When in March 1861 the Kingdom of Italy was proclaimed, Cavour could momentarily rest secure in the knowledge that his moderate liberalism had triumphed.

He died too soon after to witness the uncertainties, contradictions, and delays of the young state in attempting to win a place in the economic and political competition between the European powers. The conflicts of the distant past and the serious problems that remained unresolved, continued to be a burden, and on more than one occasion it seemed that the young edifice would topple, that unity would disintegrate in the face of the indifference of large segments of the population and the hostility of the major foreign powers.

Gramsci claimed that the most radical faction of the Risorgimento, the *Partito d'Azione* (Action party), "was steeped in the traditional rhetoric of Italian literature." [18] The intellectuals that the party comprised—and this includes the Macchiaioli—confused the cultural unity experienced by a minority of Italians with the political and territorial unity embracing the great popular masses, and were doomed to disillusionment. But unification gave Italy an identity at long last, and the Macchiaioli their reason for being. Their struggle to forge a cultural complement to Risorgimento dynamics had been encouraged by the example of their literary and artistic predecessors, whose "traditional rhetoric" notwithstanding, helped pave the way for the Macchiaioli's own distinctive contribution.

TWO

Strategies of Representation

There is a close connection between the historical novel, history painting, and the patriotic nationalism of the Macchiaioli prior to unification—a paradigmatic instance of social and visual practices subsumed to the laws of language.[1] Under the domination of Austria or the Bourbons, it was impossible for creative minds to espouse directly militant action or to condemn openly the foreign oppressors. Writers and painters had to manifest their patriotic sentiments indirectly, by means of covert discourse and allusion. This was done most successfully in the field of the patriotic historical novel. It owed its inspiration and technique largely to Sir Walter Scott (read obsessively by almost all Italian reformers), but the Italians used it to arouse national pride and resentment against foreign domination. The medium of the historical novel allowed them to bring to life past periods of national greatness (the heroic republics of the Middle Ages and the colossal achievements of the Renaissance), and though making their readers aware of the contrast between Italy's past greatness and later decline they evaded government censorship by avoiding direct reference to the present. Nevertheless, these novels were taken seriously by foreign governments trying to interpret Italian thought, and their national message stirred the generation that fought under Garibaldi.[2]

The historical novel first made its appearance around the time of Napoleon's capitulation.[3] Although novels with historical themes

could be found in previous epochs, the historical novelist's self-conscious invocation of what moderns call "presentism" stamped it with its unique character. In addition to the psychology of the protagonists, the manners, speech, and judgments were entirely those of the writer's own day. The missing component in the older historical tales before Sir Walter Scott was precisely this carefully plotted intersection of contemporary life with the past.

The impetus to this development may be found in the historical conditions of the time in which the historical novel emerged. From the period of the French Revolution to the fall of Napoleon every European nation experienced more upheavals than they had experienced in centuries. These upheavals occurred in rapid succession, well within the realm of the average person's lifetime, making their historical character far more accessible to human comprehension than would have been possible in the slow, gradual changes taking place prior to 1789. This made it possible for populations to understand the extent to which their own existence was historically conditioned, and to grasp history as something unfolding in "real" time and vitally affecting their lives.

At the same time, the dissemination of the revolutionary idea by the Napoleonic armies engendered the notion that the national idea belonged to all classes and was inseparable from historical development. The awakening of a national sensibility based on the French model and with it a feeling for national history were experienced together. The Napoleonic wars especially evoked a wave of nationalism and enthusiasm for national liberation. While these mass movements contained a blend of progressive and reactionary ingredients, they vividly conveyed a sense of history to a wide community. The appeal to national independence and national character were inevitably linked to a revival of interest in national history, to memories of past greatness, even to moments of national dishonor, whether this resulted in a progressive or a reactionary ideology.

ANTICLASSICISM AND THE HISTORICAL DANCE

The literature and art that evolved out of this mind-set had to become free of the constraints of classical form and content. To reach the broad audience reawakened to a sense of history, the writer or artist had to enter into the experiences and feelings that were inaccessible to the rigid, abstract principles of classical doctrine. In the case of Alessandro Manzoni (1785–1873), the first of the Italian historical novelists, we have an example of this attack on classicism as a prior stage in the working out of his historical conception.[4] He argued that classicism was an empty imitation of

the past, characterized by the Aristotelian unities of time and space which required that events take place within a twenty-four-hour time frame. He attacked these on the grounds that they forced authors to denature the passions and eliminate the subtleties of character development. He required the psychology and growth of flesh-and-blood creatures, and this meant allowing the characters to unfold in historical time.[5]

This anticlassical position coincided with the conservative rejection of a style associated with French, and specifically, Napoleonic culture, expressed in England and France with a glorification of the events of the (late) Middle Ages. But it also corresponded to the reawakened national energies unleashed by the Napoleonic presence, and provided a counterweight to the reactionary programs of restoration governments. What we call Romanticism in this period refers to the fusion of this new nationalist sensibility with ideas of individual liberty in the artistic realm. This implied a new economic relation between producer of culture and audience, reflecting the new market relations established by middle-class enterprise. It is no coincidence that Manzoni was born in Milan, the most important industrial and commercial center in the peninsula. As Manzoni reached adulthood, it attained the zenith of its glory as the capital of the greater part of Italy when Napoleon took the title of king of Italy. Manzoni's appeal to a mass audience in the Tuscan vernacular rested on his own liberation from feudal-aristocratic patronage classical taste. Manzoni's use of vernacular Italian represented a major breakthrough in the linguistic codes of the period that either served a transnational elite or local and regional notables with their myriad of tribal-like dialects. In this sense, Manzoni's work provided a textual model for the Macchiaioli, whose display of the macchia patch was meant to be an equivalent pictorial Tuscan vernacular.[6]

For Manzoni, Italy itself had fallen into cultural stagnation, exploited by foreign occupants and obligated to follow their particular cultural line for financial and social success. He thus sought a literary form that would answer specifically to Italian aspirations and touch nationalist feelings. While politically and religiously moderate, always balancing his social and political ledger with the abuses and virtues of left and right, he opposes above all the exploitative tyranny of foreign occupation.

Manzoni's *I promessi sposi* (The Betrothed, 1827), set in seventeenth-century Lombardy, focuses on the evils of Spanish domination. The vicious nobleman, Don Rodrigo, with the collaboration of the village priest, Don Abbondio, succeeds in forcing the separation of the young peasant lovers, an artisan named Renzo Tramaglino and Lucia Mondella. Rodrigo has decided that he wants Lucia for himself, and the atmosphere of general op-

pression and fear is established early on by his ruthless machina-
tions. The divergent paths of Renzo and Lucia growing out of
their individual struggles to survive take them to various locations
in Italy and reflect the entire geographical and social fabric. Bread
riots, plague, and military invasion provide the sociological back-
drop for their harrowing adventures.

Manzoni's novel is genuinely historical in the sense that we have
defined this category, one that roused the present and made his
contemporaries feel as if it were their own prehistory. It treated
the collective condition of the Italian people resulting from Italy's
fragmentation, and the internecine regional conflicts which in-
vited foreign intervention. Thus, while Manzoni's leitmotif cen-
ters on the love, enforced separation, and reunion of a young
peasant man and woman, the magnitude of his projection trans-
forms it into a general tragedy of the Italian people locked into a
state of national degradation and fragmentation. While characters
are set in a specific geographical and chronological framework,
their story expands in historical time to represent metaphorically
the condition of the Italian people tossed about by feudalistic
remnants in the present.

Historical understanding also changes the protagonists of the
novel, leaving the way open for them to alter their state. For ex-
ample, when Cardinal Federigo Borromeo confronts Don Ab-
bondio with the impact of his actions on the lives of the two
peasant lovers, the parish priest suddenly sees himself in a new
light:

> Don Abbondio said nothing; . . . The speech he had
> just heard was full of unexpected conclusions and
> novel applications, but they all followed from a doc-
> trine which had long been rooted in his mind and
> which he had never gainsaid. The suffering of oth-
> ers—from which his attention had long been dis-
> tracted by the fear of having to suffer himself—now
> appeared to him in a new light. . . . He felt a certain
> dissatisfaction with himself, a compassion for others,
> a mixed sensation of tenderness and embarrassment.[7]

Similarly, other characters rise to their highest pitch of character
in the midst of profound human suffering, a conservative idea of
change to be sure, but one rooted in awareness of the possibilities
of historical development.

The same year that Manzoni published his novel, the historical
painter Giuseppe Bezzuoli (1784–1855)—with an opposite po-
litical agenda—was commissioned by the Grand Duke Leopoldo
II of Tuscany to paint the *Entrance of Charles VIII into Florence*
(fig. 2.1).[8] Bezzuoli dominated the Academy of Florence when

2.1 Bezzuoli, *Entrance of Charles VIII into Florence*, 1829

the Macchiaioli were students, and incarnated in his authoritarianism the views of the Habsburg-Lorraine regime they steadfastly opposed. Nevertheless, his use of history painting to make contemporary commentary affected such exuberant disciples as Fattori, D'Ancona, and Antonio Puccinelli. First exhibited in 1829, the *Entrance of Charles VIII* embodied the conservative standpoint of the patron. It depicts a triumphal interlude between the ambitious French king's march to Naples to claim his disputed crown through his descent from the house of Anjou, and his use of this position as a stepping-stone to Constantinople and ultimate coronation as emperor of the east.

Charles VIII's vague claim to the Neapolitan crown required an invasion of Italy, and by buying off rival states and taking advantage of a hopelessly divided and militarily weak Italy he made his way down the peninsula virtually unopposed. He and his troops arrived at the main gate of Florence on November 17, 1494. It is the moment of entrance that Bezzuoli depicts, manifesting his own ideological convictions most strikingly in the mixed reception of Charles VIII by the citizens of Florence. The French king gets grudging respect or indifference from some and enthusiasm from others, but the primary mood of the spectators is one of apathy. This sense inheres in the lack of unity in the crowd, in the cliques and factions that express their individual group sensibility.

Prominent Florentine heroes such as Machiavelli and Savonarola are depicted in the foreground groups and exemplify the mixed reception. Machiavelli was twenty-five years old when Charles VIII invaded Florence and opened up an era of wars between France, Spain, and the Austrian Habsburgs for the possession of the Italian peninsula. By the time he died in 1527 all of western and central Europe had been sucked into this conflict, which gave rise to a complicated network of alliances revolving around the struggle between the Habsburg rulers of Austria and the French and Spanish kings. Florence had become a pawn in the rivalry between the pope, Emperor Maximilian I of the Holy Roman Empire, and the French king, and was reduced to a nominal and humiliating independence. The decline of Florentine power profoundly demoralized the Florentines, long proud of its republican tradition. Thus Machiavelli, an admirer of French military discipline and strategy, may have derived his first lessons on the need for a powerful Florentine militia and the practice of power unqualified by the usual ethical norms from the example of Charles VIII.

For Savonarola, the entrance into Florence of the French king also contained pregnant possibilities for his future, allowing him some breathing space prior to his martyrdom in 1498. The clerical reformer had preached against the abuses of the ruling Medici family, and welcomed the invasion of Charles VIII as a means of eliminating the government corruption. Indeed, two years earlier he had predicted his coming and easy victory. Lorenzo's son Piero was driven into exile and Medici rule overthrown. The friar had already begun negotiations with the French king prior to his arrival in Florence, and this relationship allowed him to mediate among the various factions in the aftermath of the invasion and prevent large-scale violence. His action as mediator in pacifying most of the population permitted the king to proceed on his march to Naples after only four days and guarantee a policy of alliance with the rejuvenated city-state.

Savonarola now introduced democratic government along the lines of the old republic, and his own authority increased enormously. His independent position and friendship with Charles VIII threatened other Italian and foreign powers opposed to French hegemony. They established the "Holy League" or League of Venice, which included the duke of Milan, the Holy Roman emperor, the pope, and the Venetian doge. They wanted Florence to join them, but Savonarola and his followers refused to participate, hoping to maintain close political ties with the French king. The League, with the connivance of the pope, now conspired against him, and he was condemned to a martyr's death.

The implications of these events for the future of Florence would not have been lost on Grand Duke Leopoldo II. An admirer of Machiavelli, he commissioned the work to coincide with the three-hundredth anniversary of the death of the political thinker. Leopoldo himself had succeeded to rulership of Tuscany only three years before, and was still highly conscious of his role as the dynastic heir of the house of Habsburg-Lorraine. He more than likely identified himself with Machiavelli's "Principe." The painting he commissioned from Bezzuoli testified to his ideal blend of authority and benevolent despotism. While Bezzuoli's representation of the half-hearted response to Charles metaphorically pointed to divisions within contemporary Florentine society, this lack of enthusiasm is countered and overshadowed by the majestic appearance of Charles VIII entering on horseback. He dominates the entire right-hand portion of the picture, rising loftily above the fray. Thus Bezzuoli's work crystallizes significant developments in Florence's history from the perspective of the grand duke: the suppression of anarchic tendencies and the restoration of authority and token gestures of liberalism.

This was not the only time that Bezzuoli used his skills to polish the grand-ducal image, nor was he always so indirect in his visual flattery. Following the collapse of the Napoleonic empire and the restoration of Leopoldo II's father in 1814, Bezzuoli participated in a festive reception for the returning prince organized by the newly constituted Accademia di belle arti right outside its doors in the Piazza San Marco. Bezzuoli provided the design for one of the painted bas-reliefs *(pitture a bassorilievo)* ornamenting the colossal sculpture of the enthroned Ferdinando, repeating this image of the grand duke surrounded by various allegorical personifications of Tuscan towns paying homage to him with their peculiar cultural and commercial contributions, while Florence, "the first city in Tuscany," hands him the keys to the metropolis (fig. 2.2).[9]

Joseph Bezzuoli pinxit

ETRVRIAE VRBES PRINCIPI INDVLGENTISSIMO TRIBVTA PERSOLVERE GESTIENTES

2.2 Bezzuoli, *The First City of Tuscany Paying Homage to the Grand Duke*, 1814

Although Bezzuoli's picture differs from Manzoni's text in expressing a mainly conservative ideology, its example provided a vehicle that a younger generation could exploit to represent a more progressive viewpoint. Not surprisingly, it was exhibited again at the Italian National Exposition of 1861 with a host of liberal offspring celebrating the Risorgimento and national liberation.[10] Now it stood for an outmoded perspective and as an aesthetic frame of reference for the ancien régime. By the same token, its presence also signified by reverse allusion the transference of power from a foreign oppressor to an indigenous Italian state which had also learned a lesson or two from Machiavelli's textbook.

Manzoni's exact contemporary, Giovanni Battista Niccolini (1782–1861), did for drama what Manzoni did for the novel.[11] Niccolini, who lived most of his life in Florence and spoke out early in favor of the principle of unification under the House of Savoy, became an activist writer of the Risorgimento. His best known plays were *Giovanni da Procida* (1830) and *Arnaldo da Brescia* (1843). These plays, dealing with popular insurrection in Sicily and Rome, made effective propaganda. When *Arnaldo da Brescia* was finally allowed to be performed on a Florentine stage shortly after the revolt in 1859, it aroused the audiences to wild enthusiasm. Prolonged applause followed Arnaldo's speeches, which defied the pope and called for a united Italy loosened from the yoke of foreign despotism. The Macchiaiolo Telemaco Signorini, who fell under the sway of Niccolini's tragedies in his youth, seized the opportunity of the performance of *Arnaldo* in Florence to distribute patriotic literature published by Giuseppe ("Beppe") Dolfi.[12]

Another leading novelist of the early Ottocento was Francesco Domenico Guerrazzi (1804–1873), a lawyer and political leader from Livorno active in the Tuscan movement for independence both in 1848 and 1859. His large-scale historical works manifest the style of his idol Scott: *The Siege of Florence* (1836), based on the chronicles of Benedetto Varchi and Francesco Guicciardini and second in popularity in its time only to *I promessi sposi,* served the purpose of awakening and reviving the idea of independence in Tuscany through the dramatic recitation of one of its most heroic moments in the Renaissance.

The capitulation of the young republic on August 12, 1530, after a nine-month siege, brought about the restoration of the Medici. The Medician Pope Clement VII and the Holy Roman Emperor Charles V joined forces to attack the state of Florence, which held out against enormous odds. The brave partisan Francesco Ferrucci, governor of Empoli, distinguished himself during

the siege, as did Michelangelo, who took part as a military engineer, organizing the fortification of the walls against the anticipated attacks. When the imperial troops finally entered Florence in triumph they handed it over to the pope. The making of this unholy partnership of the pope and the scion of the Habsburg dynasty (coupled ironically by Guerrazzi as "Il Papa e l'Imperatore") for the purpose of suppressing the infant republic (established 1527) had its parallel in Guerrazzi's own time in the papal alliance with Grand Duke Leopoldo II of Tuscany. A militant democrat and anticlerical, Guerrazzi led a revolutionary faction in his native Livorno in 1848–49 and again in 1859 against the grand-ducal government. He was arrested and imprisoned in 1849 when Leopoldo was returned under the protection of the Austrians. The conscious parallel in his mind between 1530 and the present is seen in the conclusion of the 1855 edition of the book where he closes with the ringing declaration of modern Italians: "We wish to be free from foreign oppression." [13]

Historical novels and plays were consistently interspersed with such asides and allusions to the present. In Guerrazzi's *Beatrice Cenci*, for example, after describing the sight of a glorious sunrise, the author laments:

> The only glory, since our degradation has taken away
> from us even that which it seemed impossible to lose—
> the feeling of our own abasement. Oh God! how great
> must be our sins and thy anger, since neither tears, nor
> blood, nor anything is able to fertilize a flower of vir-
> tue upon this soil! [14]

And the malevolent Count Cenci would extinguish this one glory for everyone around him—hence he is Italy's enemy. The eponymous heroine of the novel is the symbol of resurging Italy, but she fails to goad her brother Giacomo to insurrection because his long-term oppression has weakened his will to resist. Allusions to Louis-Napoleon and the betrayal of Rome by Republican France in 1849 are interspersed with devastating critiques of the Church, and even to Guerrazzi's own incarceration in prison for his role in the revolutions of 1848–49 where he wrote the novel. He noted that if the great heroes who lay buried beneath the crypts in Santa Croce were now alive they "would be laboring in prison" for the truths they proclaimed.

Guerrazzi's novel broaches both the feminist and Jewish issues, exalting the courage of Beatrice against her depraved father, which would make the Virgin Mary "proud to be a woman," and showing the generosity of Jacob, the Jewish pawnbroker, who

takes in the shunned wife and children of Giacomo with the re-
mark that "all miserable people are brothers." While the creatures
of God are divided from each other by social injustice they are at
least "united in sorrow." Thus the oppression of women and Jews
is taken for the spiritual condition of Italy as a whole and their
energies are enlisted in the emancipation of the entire society.[15]

Perhaps the individual that most dramatically attested to the
union in art and literature of the historical tendency was Manzoni's
son-in-law, Massimo D'Azeglio (1798–1866), both historical
novelist and historical painter, as well as political activist. He
produced two popular novels, *Ettore Fieramosca* (1833) and *Nic-
colò de' Lapi* (1841), under the influence of *I promessi sposi*. Of
these, the first treats of a famous episode in 1503, the so-called
Challenge of Barletta, when a team of Italians—defending Italian
national honor against the slur that Italians cannot fight—defeat
a team of Frenchmen in a knightly joust. *Niccolò de' Lapi* is a story
of Florence during the siege of 1530, and reconstructs the val-
iant efforts of the loyal Florentines against the pope and the
French king.

D'Azeglio based his novel *Ettore Fieramosca* on his painting of
1831, *The Challenge of Barletta*, whose scene of knightly joust
provided the central core of the book (figs. 2.3, 2.4). In typical
fashion, D'Azeglio set diminutive figures in medieval costume
in an Italianate landscape. Although medievalism could also be
treated conservatively as in the case of the Nazarene-influenced
Purists, D'Azeglio divests it of its religious framework and secu-
larizes it. Identification of landscape with a specific Italian site was
of critical importance in historical novels, as in *I promessi sposi*
where Manzoni describes "a true Lombard sky." Moved to action
by the Italian regional revolts of 1830–31, D'Azeglio sought a
theme appropriate to the political heroism of the moment.

He found it in Italian history of the year 1503, in the tourna-
ment at Barletta between Italian and French knights. He decided
to portray the moment when the fighting was in progress, with
the judges and spectators intently watching the fray. The subject
permitted a view of the landscape between Andria and Corato,
just south of Barletta on the Adriatic coast. In the background
is the rocky promontory of Monte Gargano, north of Barletta.
D'Azeglio's landscape studies demonstrate that he always went to
great lengths to get his geography right, although he recon-
structed the details in his final compositions according to the en-
vironment he presumed to have existed at the time of the incident
(figs. 2.5, 2.6).

That creative expression and political agitation intermingled for
D'Azeglio is revealed in his confession of dissatisfaction with the

2.3 D'Azeglio, *Challenge of Barletta*, 1831

2.4 D'Azeglio, *Challenge of Barletta*, study, ca. 1831

2.5 D'Azeglio, *Waterfall*, ca. 1830s

2.6 D'Azeglio, *View of the Town of Apeglio*, ca. 1840s

painting. He concluded before he completed the work that if he really wanted "to stir up the Italians" it would be more effective to narrate the story. At this point he began earnestly undertaking historical research into the period and studying with the help of maps the topographical features of the locality which he described so faithfully in his writing. Thus the geographical features of the landscape became synedoches for Italy as a coherent national ideal.

Throughout the novel the challenge to Italian courage is not a challenge to a regional group, but to the Italian nation as a whole. The organizer of the tournament recalls the ancient Romans, who ruled at a time when "those who now come from the other side of the Alps to drink the blood of the Italians . . . then trembled at the very mention of the Roman name." All the Italian provinces are represented in that tournament on the Italian side. At one point, Fieramosca is enraged when learning that an Italian mercenary will fight for the French, and draws his sword against him: the two are constrained by the intercession of the French knight Bayard, who kisses Fieramosca's brow and says: "Blessed be the woman who bore thee." D'Azeglio's footnote to this passage in the 1859 English edition reads: "Oh! how many such youths are now mowed down for the love of their country on the bloody fields of Lombardy!"

D'Azeglio's political intentions are clear from his dedication and preface to the 1859 American translation of the novel. Here he explicitly refers to the Italian nationalist drive in progress that very year, and at a time "when a struggle for national independence is going on in Europe, I offer this work to the friends of Italy in America." His comments also betray his moderate viewpoint: he dedicated the work to "those true Americans who think justly of Italian virtue, who, alive to Italian misfortunes, do not expect Italian social regeneration from blood, stiletto, or conspiracy, but from order, law, mutual respect, and from the revival of Italian wisdom, and of Italian valor."[16]

Yet it is clear that he found his primary inspiration in the past rather than in the events of the present. As he wrote himself about his painting and novel: "I can never express in words the intimate pleasure and the deep happiness I experienced in painting and describing those characters and living the life of the chivalry of those days, in complete forgetfulness of the present." Moreover, D'Azeglio's retreat into the past was motivated by his reaction to Giovine Italia, which he despised. His view was that it was necessary to concern oneself with the national character, and to forge the Italian nationality through education rather than through violent revolution. His plan was to influence people through a patriotically inspired literature, and *Fieramosca* was the first step he

took in that direction.[17] That he succeeded in this intention is seen in the testimony of one of Garibaldi's Thousand, who paused in the heat of battle to compare the proud bearing of one of his officers to "the thirteen champions who jousted at Barletta."[18]

In his second novel, *Niccolò de' Lapi*, written several years later, D'Azeglio attempted to recreate the historical moment with even greater precision, and to enter the everyday life of old Florence. Dedicating the work to another patriotic novelist, Tommaso Grossi, D'Azeglio claimed that now he wanted to achieve more than just another swashbuckling tale. He hoped to convey the heroism of the burgher class of Renaissance Florence, and he made his protagonist a silk manufacturer pitted against a corrupt nobility. This called for research on the site, going right into the heart of old Florence:

> I traversed the courtyards, the stairways, penetrated everywhere, striving to figure to myself the customs, the countenances, the forms of speech, the habits of these by-gone inhabitants, as, on seeing an old rusty helmet, and raising the visor, fancy sometimes attempts to paint the noble and daring visage, which once beamed from beneath.

He scoured the countryside, interviewing the peasant and shepherds of the hills of Pistoia, who spoke the pure Tuscan language:

> I bless the hours, that I passed thus, seated at those humble firesides, lending ear to the rude, but really lofty narrations of these simple men, who know so much of those remote and glorious ages, and so little of the present, as if by an intuitive sense of what is of real value.[19]

D'Azeglio claims that during these exchanges, he actually became oblivious to the present and was transported to earlier times: "I saw before me, living and real, these men so well-known to me through the historian, the dramatist, and the novelist."

Massimo D'Azeglio personalizes the monuments of Florence, investing them with a demonic energy that makes them palpable and awesome. When Liza breaks with her family and her country, all the patriotic associations pour in on her. As she leaves Florence, she casts one final look "at the tower of the Palazzo Vecchio, which she was accustomed to consider the personification, so to say, of the popular cause, and of Florentine liberty, [and] it seemed to her like an avenging phantom, that was watching her flight, only to overtake and punish her with some new and

tremendous calamity." D'Azeglio's call to patriotism in the con-
temporary period is underlined in the declamation of Niccolò:
"Union! Concord! for God's sake! divided cities are always the
prey of the enemy; Florence knows it, and Italy knows it"—
a curious thing to put into the mouth of a sixteenth-century
Florentine.

PICTURING ITALY IN HISTORICAL TIME AND SPACE

While anachronisms abound in the historical novels, their attempt
to specify history in terms of actual site and everyday life set the
political and aesthetic precedent for the work of the Macchiaioli.
One historical painter who mediated this transition was Francesco
Hayez (1791–1882), a Venetian who settled in Milan.[20] His
library was rich in examples of the historical novelists, most
of whom he knew personally. He knew intimately Manzoni,
D'Azeglio, Tommaso Grossi, and painted their portraits as well as
borrowed themes from their writings. His political position was
identical to that of moderates D'Azeglio and Cavour, a militant
nationalist, a liberal on domestic issues like the role of the Church,
and a conservative on social questions.

 One of his most engaging pictures is *I Vespri Siciliani* (Sicilian
Vespers) a work he did in several versions beginning in 1821–22
(fig. 2.7).[21] The theme is drawn from the history of Sicily near the
end of the thirteenth century, when the country was ruled by
Charles d'Anjou of France. The Angevin ruler exacted a harsh toll
from the Sicilians, who were also subject to the random violence
of their French colonizers. They endured a grinding oppression
for sixteen years, from 1266 until the spring of 1282. During
Holy Week the island had been calm, and for the festivities on the
Tuesday after Easter people came from all around to attend the
Vesper service. At Palermo there was a festival at the Church of
Santo Spirito. It was here that an incident occurred that sparked
an attack on the French and led to the independence of the island.

 At the hour of Vespers, the citizens began to make their way
towards the church. Suddenly the armed soldiers of the ruling
magistrate appeared on the pretext that they were called there to
maintain order. They began harassing the people, breaking into
their dancing, and abusing the women physically and verbally.
Insults were exchanged, and tension between the two groups
reached a boiling point. At this moment, a young woman ap-
peared with her husband and relations on the way to the church.
One of the French soldiers, Drouet, approached her as if to
examine her for concealed weapons and abruptly seized her bo-

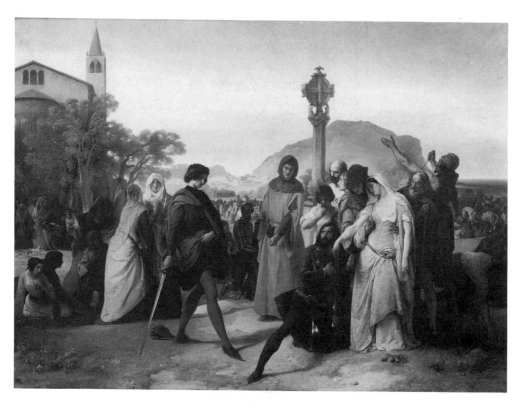

2.7 Hayez, *Sicilian Vespers,* 1846

som. She fainted and fell into her husband's arms who, choked
with rage, shouted: "Death, death to the French!" At the same
moment a youth burst from the crowd which had gathered
around them and struck Drouet with his sword. The crowd now
began to rush with ferocity upon their fully armed opponents,
using rocks, sticks, and knives, but waves and waves of Sicilians
responding to the call for general insurrection finally overwhelmed
the French. At this moment the Church of the Santo Spirito and
all of the churches of Palermo began to ring for Vespers. To the
sound of the bells messengers (prepared in advance for this mo-
ment) ran through the city calling on the entire population to rise
against their oppressors. The ultimate victory of the rebels of the
Sicilian Vespers resulted in the proclamation of the Common-
wealth of Sicily.

　Hayez chose to depict the moment of the incident just after the
Sicilian youth stabbed Drouet and the social unrest begins to
make itself felt. A Sicilian fisherman raises his dagger and shouts
"Death to the French," while a priest shakes his fists in outrage at
the fallen Frenchman. Everywhere the crowd begins to respond
to the incident, uniting spontaneously in common protest against

the political violation of their minds and bodies. Although in fact the revolt had been planned for some time, the myth of the Vespers as the spontaneous uprising of an oppressed people reverberated down through the centuries.

Not surprisingly, the episode took on rich symbolic significance for the period of the Risorgimento.[22] Niccolini's *Giovanni da Procida* (1830) was set against the backdrop of the Sicilian Vespers, and in 1853 Verdi came out with his *I Vespri Siciliani*. As Garibaldi's Thousand made their way to Palermo, they were awakened in the mornings by village bands playing the music of Verdi's opera.[23] Hayez's first two versions of the theme are directly related to the early events of the Risorgimento. The first celebrated the Carbonaro uprisings in Naples and Sicily and Piedmont in 1820–21, and was commissioned by the Marchesa Vittoria Visconti d'Aragona, whose husband had been implicated in the Lombardo-Veneto trials of the Lombard Carbonari who were suspected of having aided the uprising in Piedmont. The second version of 1826–27 was commissioned by the Conte Francesco Todoro Arese Lucini, who had been arrested during the repression in Milan during these years. He commissioned the work shortly after his release from Spielberg prison, indicating the work's significance for sympathizers of the Carbonaro movement.

The last version, the one reproduced here, was commissioned in 1844 by a liberal member of the Neapolitan nobility, Vincenzo Ruffo di Motta e Bagnara, Prince of Sant'Antimo.[24] This new interpretation conforms to Hayez's more careful researches into the history and actual site of the event. In preparation for this work, Hayez took a trip to Naples and Sicily in 1844 and sketched the topographical details at Palermo. The background of the later version displays with geographical accuracy the large rocky mass of Mount Pellegrino, viewed from the southeast. The so-called Rock of Palermo has always been symbolically associated with the site, and its conspicuous presence in the picture established the precise location. As in the case of the historical novelists including D'Azeglio, Hayez's painting progressed in the direction of fidelity to the Italian environment. The incorporation of Italian landmarks that function as synecdoches for Italy parallels the historical novelist's topographical nationalism.

This growing topographical emphasis coincides with Hayez's more developed historical research. The first versions were inspired by Sismondi's *Histoire des républiques italiennes*, with its hazy and colorful account, while the later version grew out of the recently published account by Michele Amari, *La guerra del Vespro Siciliano*, which first appeared in 1842. Hayez made use of the

second edition of this work (published in Paris in 1843) which he had in his library.[25] Amari's work is a highly detailed and precise account of the event and its context based upon painstaking researches into the primary sources. Amari, moreover, was a leader of the Neapolitan liberals who published the work with the intent to encourage Sicilians to rise against the Bourbons in emulation of their ancestors in the thirteenth century. Here authentic history was mobilized in the service of the Risorgimento, rendering obsolete the effectiveness of the historical novel for Italian liberalism. Indeed, the Bourbon government itself could not avoid seeing the analogies between ancient and modern events described by Amari, especially that between Charles d'Anjou and Ferdinando II. As a result the book was prohibited from sale in the Neapolitan area, the censors who had previously permitted its publication were dismissed from office, the publisher was exiled to the island of Ponza, and journals that had reviewed it were suppressed. Amari, both a Freemason and Carbonaro, was summoned to testify before a special hearing, but he escaped to France instead. When the revolution of January 1848 broke out and the citizens of Palermo managed to overthrow the Bourbon government temporarily, Amari returned to Sicily and was elected to the newly constituted parliament, serving as minister of finance under the short-lived constitutional regime. Later, Amari was one of the most energetic supporters of Garibaldi's Sicilian campaign, and Garibaldi appointed him minister of foreign affairs during his provisional dictatorship at Palermo.

Hayez's work paralleled the development of increasing historical and topographical truth, corresponding to the evolution of the Risorgimento from an idealized and romanticized conception to actual historical and political fact. Here Hayez was no singular instance: the work of the Torinese painter Andrea Gastaldi, his younger contemporary, constitutes a similar case study. Gastaldi's *Pietro Micca nel punto di dar fuoco alla mina volge a Dio e alla Patria i suoi ultimi pensieri* (Pietro Micca on the Verge of Igniting the Powder Keg Consecrates His Last Thoughts to God and Country, 1858) addresses the issue of the extreme instance of patriotic self-sacrifice to destroy the foe (fig. 2.8). The account of the proletarian soldier willing to give up his life to prevent the French army from storming the citadel of Turin in 1706 came from the romanticized history *Storia d'Italia continuata da quella del Guicciardini* (Lugano, 1832) by Carlo Botta, but in fact alluded to the idea current in 1858 that a national revolution could succeed only if supported by the Piedmontese army. Garibaldi himself could rally northern Italians to his cause the following year by visiting Micca's house in Sagliano and identifying himself with the eighteenth-century hero.[26]

2.8 Gastaldi, *Pietro Micca,* 1858

While Hayez could never entirely free himself from his medieval and Renaissance packaging, his themes similarly demonstrated a growing topical concern. His famous *Il Bacio* (The Kiss) of 1859, although set in the fourteenth century, could immediately be recognized by Italian patriots as an emblem of the nation's youth leaving their loved ones to participate in the Risorgimento struggle (fig. 2.9). Despite the similarity of the male type to the protagonists of D'Azeglio's and Guerrazzi's novels, his plumed hat and cloak resembled those worn by contemporary volunteers (fig. 2.10). The youth embraces his lover, with one foot perched impatiently on the stone stairway, indicating his readiness for action against the enemies of Italy. Love in the personal sense is subordinated to the love of country. Hayez's encoding was deconstructed in the early 1860s, when Garibaldi again took to the field. The illustration for a popular love song of the period, "The Volunteer and his Lover," shows a *garibaldino* hearing the call of his leader in the midst of a lover's embrace and gesturing

2.9 Hayez, *The Kiss*, 1859

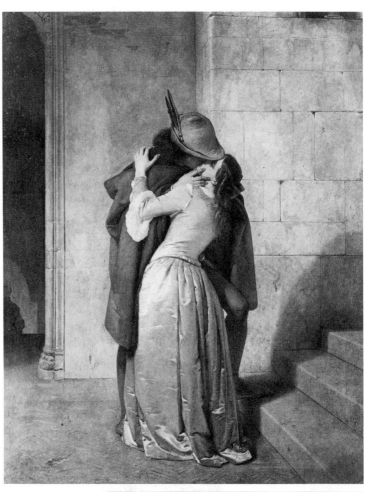

2.10 Gerolamo Induno, *Garibaldi Legionnaire*, 1851

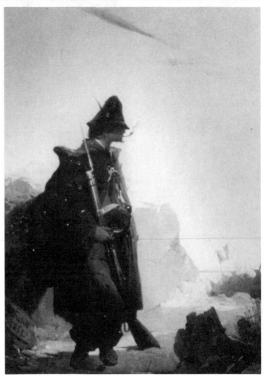

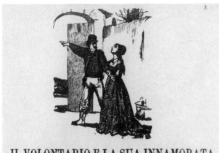

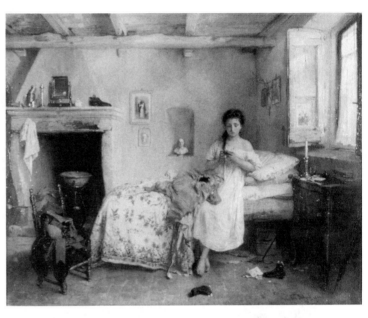

2.11 "The Volunteer and His Beloved," popular love song, ca. 1860

2.12 Gerolamo Induno, *Sad Presentiment*, 1862

2.13 Gerolamo Induno, *Sad Presentiment*, detail

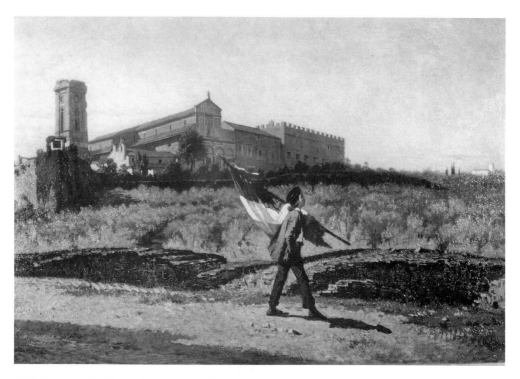

2.14 Altamura, *The First Italian Flag Carried into Florence,* 1859

anxiously towards his obligations beyond the courtyard as he looks back for a final farewell and she reluctantly releases him (fig. 2.11).[27]

Another clue to deciphering the coded message of the work may be found in Gerolamo Induno's *Triste presentimento* (Sad Presentiment) of 1862 (fig. 2.12). A young woman is shown rising in the morning to look at a miniature portrait of her lover who is off fighting with Garibaldi in the south. The Milanese painter, who himself fought under Garibaldi in several campaigns, leaves no doubt about the meaning of the theme since we see a bust of Garibaldi in a wall niche in the center of the picture, and on the window shutter at the right is affixed a lithograph of the period depicting Garibaldi's landing in Marsala, at the western tip of Sicily. Just above and to the left of the niche is a reproduction of *Il Bacio,* demonstrating to what extent Hayez's image touched the sensibilities of Risorgimento youth (fig. 2.13).

It is a similar youth portrayed by Francesco Saverio Altamura, who brings the first Italian tricolor flag into Florence in 1859 (fig. 2.14). Conspicuous in the background is the Tuscan-Romanesque Church of San Miniato al Monte atop the hill to the southeast of Florence. The church is prominent enough to be seen from many different points, and Altamura chose to depict it from

an oblique angle to ensure a full view including its auxiliary buildings. Analogous to Hayez's *I Vespri Siciliani,* the painter has carefully depicted the site to link it to the national-patriotic theme of Tuscan independence. But in reverse of Hayez, he shifted from the medieval past to the modern present, while yet preserving the historical links. It is as if the striding youth, bearing the tricolor flag on his shoulder, stepped right out of medieval Florence into the modern world.

Altamura, a refugee from Naples as a result of his political activities, was profoundly affected by the surrounding Florentine landmarks with their historical associations. He wrote that everywhere he went in Florence he "could not be deaf to the medieval echoes which at every moment and at every street corner murmured to him from the Florentine monuments and chronicles." [28] Altamura painted scenes with medieval and Renaissance settings both before and after 1859, but unlike Hayez he could make the transition to modernity by virtue of the progress of his generation in bringing about fundamental change. It was certain that he was close to the inner circle of Giuseppe Dolfi's radical group which orchestrated the demonstration in Florence on April 27, 1859, when the grand duke fled and left the people in control of their own destiny. It may not be coincidental that the flag-bearer walks past San Miniato: Dolfi had a villa at San Casciano in Val di Pesa, about 18 kilometers southeast of Florence, where plans for the uprising must have been hatched. Anyone walking from there to the city would have had to pass San Miniato, so rich in cultural and historical associations. While he retained the need to maintain connections with the past, he could also assert that modern heroism now stood on the same ground as that of the past. [29]

Almost all of the Macchiaioli began their careers working in the historical tradition, and made a transition similar to Altamura's. Around 1856 Giovanni Fattori did a series of paintings based on Guerrazzi's *Siege of Florence* which had already absorbed the young painter in the early 1840s. Guerrazzi was a hometown hero in Livorno where Fattori was also born, and the painter's passion for the novel was bound up with his youthful exuberance for the Risorgimento ideal. Two of these early pictures of ca. 1856 depict battle scenes from the novel, and anticipate his mature interest in military scenes of the modern world. A third example, *I difensori della libertà fiorentina affrontano conversando il patibolo* (The Defenders of Florentine Liberty Converse while Confronting the Executioner's Block), was dedicated with some irony to Giuseppe Dolfi, the leader of the radical left in Florence (fig. 2.15). [30] Fattori based the composition on a picture by the French artist Paul Delaroche entitled *Cromwell and Charles I* (fig. 2.16). The themes of royal usurpation and victorious struggle against an unjust ruler

2.15 Fattori, *The Defenders of Floren-tine Liberty Confronting the Execution-er's Block*, ca. 1856

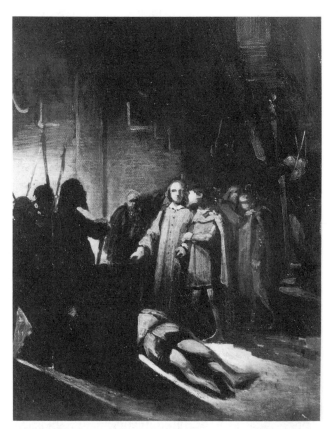

2.16 Delaroche, *Cromwell and Charles I*, 1831

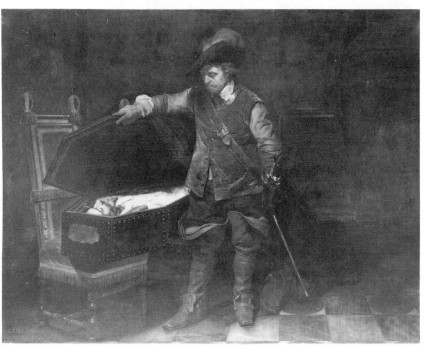

are incarnated in the picture of a pensive Cromwell gazing at the corpse of the former king of England and literally confronting the consequences of his decision to behead him. Delaroche was a favorite history painter of the young Macchiaioli, and in 1856 a solemn honorary funeral service at Santa Croce commemorating his contribution was attended by the group and their friends. His work—including the monumental *Jane Grey*—was available to them in the collection of Anatoli Nikolaevich Demidov (Anatolio Demidoff), a Russian noble whose villa of San Donato housed a major selection of French painters including Delaroche, Delacroix, and Decamps.[31]

Demidov's industrial and agricultural enterprises, as well as his philanthropic and charitable foundations, made him a powerful force in the social and political life of Florence. Awarded the title of principe by the grand duke, Demidov nevertheless behaved more liberally in the social and political realms. Worried about revolution from below, he cloaked himself in the mantle of social responsibility consistent with the paternalistic system of the Italian landowners generally. He devoted his energies to the advancement of science, especially geology, mineralogy, and geography, for which he engaged in extensive travels. He commissioned landscape artists to document his travels not only for illustrations but also to genuinely grasp the topography of a particular region.[32] He opened the doors of his villa to patriots and democrats, and hosted the young Macchiaioli whose activities he promoted.[33] His local clout and taste for modern French painting must have been a source of great encouragement to the youthful renegades and facilitated the positive reception of their work.

Some of Delaroche's influence may also be felt in Fattori's *Maria Stuarda al campo di Crookstone* (Mary Stuart on the Battlefield of Crookstone; fig. 2.17), based on the Scott novel, *The Abbot*. Delaroche (whose *Last Communion of Mary Stuart* was also in the Demidov collection) gained a reputation for his scenes of late medieval English history, and it seems certain that his influence is equally conspicuous in this example—the last work Fattori painted that draws its inspiration from the past. Fattori also drew heavily upon the indigenous romantic history tradition of Bezzuoli and Hayez, borrowing horse and rider from the former's *Entry of Charles VIII into Florence,* and basing his Mary Stuart and subsidiary figures on the latter's costumed epic of 1827, *Maria Stuarda nel momento che sale il patibolo* (Mary Stuart at the Moment of Climbing the Executioner's Block). Fattori began his *Mary Stuart* in the late 1850s and exhibited it in 1861 at the Florentine annual Promotrice. The theme was dear to Italian nationalists who identified with the early Scottish nationalists and

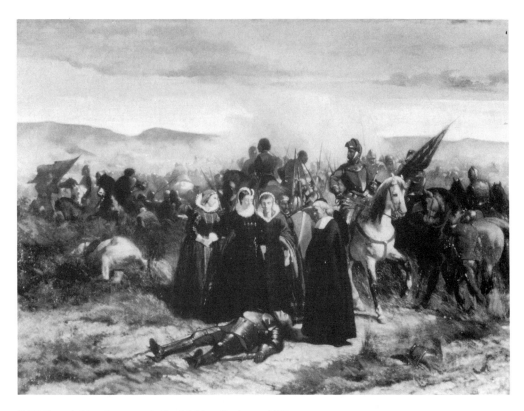

2.17 Fattori, *Mary Stuart on the Battlefield at Crookstone*, 1861

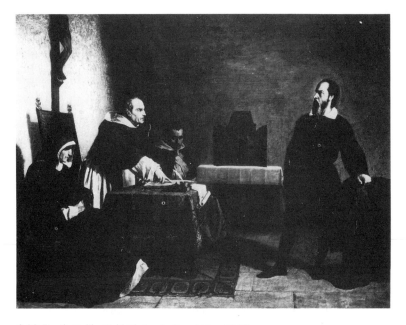

2.18 Banti, *Galileo Galilei before the Inquisition*, 1857

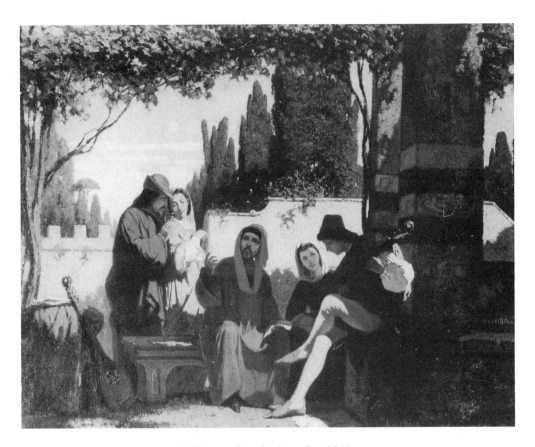

2.19 Cabianca, *Florentine Storytellers,* 1860

their struggle with the English. Mary Stuart, the heroic Queen of Scots who intrigued for the throne of England and eventually isolated herself, especially appealed to this mind-set.

Delaroche, as well as Bezzuoli, also influenced Cristiano Banti, whose *Galileo Galilei davanti al tribunale dell'Inquisizione* (Galileo Galilei before the Inquisition), made his reputation in Florentine academic circles in 1857 (fig. 2.18).[34] Like Machiavelli and Savonarola, Galileo was a native of Tuscany who lived the better part of his life in and around Florence. Buried in Santa Croce, he was a monumental symbol of Florentine literary and scientific achievement. Banti depicts him at his trial in 1633 defiantly confronting several members of the Dominican Order, whose scholarly acumen was invoked by the Inquisition to support their indictment of Galileo's heretical pursuits. Not all of them agreed on this accusation, as seen in the bowed heads of the seated Dominican friars. But the angry standing Dominican points energetically to a passage in Galileo's text as evidence of heresy, while Galileo counters with an equally indignant gesture and reaffirms the Co-

pernican principles of the universe and the fact of the earth's ro-
tation around the sun. On the wall behind the inquisitor hangs a
Crucifix, the head of which has been cropped by the upper picture
plane. In this case, the religious sign points to another martyr
being persecuted for speaking the "truth."

Although a highly fictionalized image of the historical incident,
Banti's work exploits history to glorify scientific and nondogmatic
forms of thought. The Macchiaioli were anticlerical, as were most
of the supporters of the Risorgimento, and the image of Galileo
defying the Inquisition would have encoded this position in
a readily recognizable way. It would also have been common
knowledge that the Inquisition went after Galileo when they did
because they feared his findings would undermine Catholicism in
its struggle with Protestantism. Thus Banti exploited the histori-
cal genre to make a stand for empirical investigation against
dogma, and by extension of all codified academic instruction and
unquestioned political principles.

Banti himself subsequently "recanted" and renounced this his-
trionic painting as a cultural backwater. Yet in their transition not
all of his colleagues abandoned historical themes so abruptly,
though they may have tempered the rhetoric somewhat and in-
dulged in sly digs at the old formulas: Cabianca, for example did
a series of scenes with storytellers and troubadours in Renaissance
costumes cavorting in the gardens of contemporary Florentine
villas, telescoping past and present in a historical continuity that
declared the Macchiaioli and their patrons, who owned the villas,
the equal of their counterparts in the age of Boccaccio (fig. 2.19).
Significantly, Cabianca's work in this genre was criticized for its
"sketchy" character, and his use of bright sunlight suggests that
he had a field day applying his awareness of the broadly brushed
macchia to the standard routine.[35]

Perhaps one of the most surprising of these early Macchiaiolo
history pictures is Borrani's *Il Cadavere di Jacopo de' Pazzi* (The
Corpse of Jacopo de' Pazzi), signed and dated 1864 (fig. 2.20).
The work's eccentric character and late date have kept it from
being discussed systematically in the literature, when in fact it
belongs to the transition phase, despite its retarded completion.
The narrative of Borrani's picture is based on the Pazzi conspiracy
against the Medici on April 26, 1478, and the unexpected sup-
port of the populace in favor of Lorenzo and Giuliano di Me-
dici.[36] The Pazzi, colluding with Pope Sixtus IV, had counted on
the discontent of the Florentines to support their coup against
Lorenzo and Giuliano, but the tables were turned when the
people—outraged by the sacrilegious act in the Cathedral of
Santa Maria del Fiore—went after the conspirators. Jacopo was

2.20 Borrani, *Corpse of Jacopo de' Pazzi*, 1864

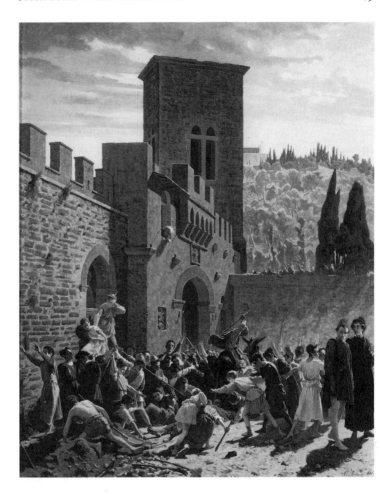

especially harshly treated both before and after his hanging, his corpse being disinterred more than once by roving children who dragged it through the streets of Florence, clubbed it, and threw it into the Arno.

Borrani actually began the painting in 1859, but work on it was interrupted when he volunteered to fight the wars of liberation. He took it up again in the context of Vittorio Emanuele II's double dealing with Garibaldi during the years 1862–63, when the king ordered Piedmontese troops at Aspromonte in Calabria to fire upon the most popular person in Italy, and then, envious of the international status of the convalescing Garibaldi, tried to lure the hero into a situation where he could be permanently eliminated. In 1864 the British ambassador in Turin thought that "nothing would give the king greater pleasure than to know that Garibaldi was knocked on the head."[37] Thus Borrani painted a warning about the culmination of conspiracies that threaten a

popular hero like Lorenzo-Garibaldi. When we recall that the day
and month of the Pazzi conspiracy coincided with the Tuscan
conspiracy of April 26 (carried out the following day), it would
seem that the painter conceived of this picture as a pendant to his
La vigilia della pacifica rivoluzione toscana (26 aprile 1859) (The
Day before the Pacific Tuscan Revolution) of 1861 to point out
the difference between violent and pacific, malignant and benign,
uprisings. Borrani's late picture grew out of an early concept that
he picked up again under urgent circumstances, but rendered the
final result with the new realism—a dazzling sunlit effect, a hardy
touch, and clinical detachment to the point of cruelty. The weird
rowdy youths who are allowed to act unchecked by the mature
figures at the far right exude a frightening rawness. Borrani's cu-
rious admixture of tradition and innovation probably relate to the
disillusionment with royal policy, and fears for the future of the
Risorgimento may have led to a momentary conservative back-
lash. But this was the last gasp of Macchiaioli romantic history
painting, as the members learned to encode all their ideas and
feelings into a structure of modernity.

As the unification of Italy became reality, painters increasingly
drew inspiration from the contemporary world. No longer depen-
dent on the remote past for examples of patriotism, they were free
to analyze their immediate experience. At the same time, their
sense of full-blown heroism would have been tempered by the
bitter disappointments of 1848 and 1859. The stagy, bombastic
and emotional expression of history painting appeared anachro-
nistic and misplaced, and no longer played to a market reality
undergoing drastic change in this period. Instead, the Macchiaioli
turned for content to their immediate surroundings, concentrat-
ing on the countryside, the monuments, the peasant sharecrop-
pers of Tuscany. The application of (the) macchia boldness to
reproduce the light conditions of the world of sensation—gave
their work a scientific and empirical basis consonant with moder-
nity and the advance of liberal ideas associated with the Risorgi-
mento. They no longer felt the pressure to display topographical
features to identify their sites, but attempted to recover them
through their immediate responses to the perceived environment.
By so doing, they discovered that they could transcribe in paint a
historical experience parallel to that of the early Renaissance mas-
ters. They concluded that the key to national expression in all
periods was the preservation of individual sincerity and integrity.

The statesman and philosopher Vincenzo Gioberti, a Neo-
Guelph and Catholic moderate whose *Il Primato* had a major im-
pact on Italian society in the early years of the Risorgimento,
wrote a less well-known aesthetic treatise in 1845, *Del Bello*

(Essay on the Beautiful). In this conservative work he describes his notion of the sublime in landscape, insisting on the artist's imaginative reconstruction of nature in achieving high art. At one point he writes:

> If we were to efface from a perspective of the country everything which we see there in a confused, indistinct, and imperfect manner, or rather all that we do not really see there with our eyes, and which is conceived only by the imagination; if, for instance, we removed those distances in which the sight was lost, those rivers that wander by graceful windings and elbows; those irregular, crossed, and intercepted valleys; those tortuous and sinuous depths and hollow places of mountains; those nooks, those recesses and corners of grottoes, of caves, of groves, of thickets; those gutters and floods of unfathomable depth, that extremity or sharp end of the tops of flowers and plants so inaccessible; those impenetrable forests, those lively and monotonous orchards, those scattered hamlets, those chapels, those hermitages half covered with trees or verdant tufts, and several other things of that kind which carry the imagination of the spectator farther than the reality; we should deprive of their charms the most exquisite aspect of nature, and the painting of landscape.[38]

But this is exactly what the Macchiaioli did in their attempt to overturn convention and to create a landscape appropriate to modern Italy.

The progress of literature paralleled this shift from history to modernity in the visual realization of the Risorgimento. Ippolito Nievo, who served with Garibaldi, wrote just prior to the wars of 1859 an epic novel that attempted to cover almost the whole of modern Italian history up to that time. Entitled *The Confessions of an Octogenarian,* it opens in the last days of the decaying feudal society of the Venetian Republic and was meant to culminate in the present. The characters participate in the main events of the Risorgimento, progressing or succumbing under the pressure of its development.[39] Many of the characters are based on the heroes of the Risorgimento: Lucilio is modeled after Mazzini, and the dashing Ettore Carafa is a barely disguised Garibaldi.

Nievo himself enlisted in the Piedmontese army in May 1859 and later he joined Garibaldi's Sharpshooters. On his departure for the front, he began a volume of verse, left unfinished, his *Loves of the Garibaldini.* These are for the most part simple verses reflect-

ing the soldier's life, but they are pervaded by the metaphors of patriotism.[40] The "I Cacciatori a Cavallo" emphasizes that Garibaldi's unit is made up of middle-class types who have forsaken their ideal lives, the scalpel and the pencil, out of patriotism to the Italian cause. Italian unity is the leitmotif of these hastily jotted verses, often using novel formal and visual devices such as ellipsis dots and question marks to signify the unknown outcome. Nievo, who joined Garibaldi's Thousand and survived to help administrate the aftermath of the expedition, disappeared at sea en route to Naples in March 1861.

Nievo's life and his patriotic writings parallel the work of the Tuscan and Milanese artists. The clarity and casual style of his verses and the form of the *Confessions,* which has a rambling and somewhat diffuse structure, moves his style and form closer to the Macchiaioli than to his romantic predecessors. Other young contemporary writers show similar tendencies, for example, Renato Fucini (1843–1922) and Giovanni Verga (1840–1922), whose work shares some of the traits of the painters. The Tuscan Fucini, who also painted and collected works by the Macchiaioli, was a close friend of Fattori, and his many short stories dealing with the Tuscan countryside and the peasantry catch the irony and sympathetic description of regional life central to the Macchiaioli vision.[41] Verga, although born in Catania, Sicily, comes even closer to the formal character of the Macchiaioli in his work.[42] He lived during the years 1865–67 at Florence, and his popular *Cavalleria rusticana* (Rustic Chivalry), although set in southern Italy, contains many parallels with the Tuscan landscape school. Espousing an approach that later put him in the camp of *verismo* (verism), his peculiar sentence structure and rhythm have some of the qualities of the macchia. Like the Macchiaioli, he was fascinated by topographical exactitude set in a nationalist framework. His earliest works take off from the example of the historical novelists: *Amore e patria* (Love and Nation), set against the backdrop of the American revolution, betrays the influence of the French novelist Alexandre Dumas père and of Massimo D'Azeglio, while his first major work, *I Carbonari della montagna* (The Mountain Carbonari), a historical novel (the original title page bore the qualifying phrase "romanzo storico") published in 1861–62, is steeped in the rhetorical style of Guerrazzi.[43] He began *I Carbonari* in July 1859, at the peak of Risorgimento combat when the Treaty of Villafranca had struck a blow to the "fervent hopes of Italy," and continued through the following year when Garibaldi's "thousand red devils" revivified them.[44] It takes as its central theme the struggles of secret society known as the Carbonari, or charcoal igniters, against the Spanish Bourbons and

Napoleon's brother-in-law, Murat, king of Naples, whose flaws Verga exaggerates to justify the expulsion of another foreigner occupying Italian soil. Verga joined the new National Guard formed after Garibaldi's capture of the island and its incorporation into the state of Piedmont. One of his later short stories, *Libertà,* describes the brutal revolt of the underclasses at Bronte, near Etna, against the agents of feudal landlords. The villagers bitterly resented the loss of the common rights without compensation, and some took advantage of Garibaldi's presence to exact vengeance. But if Verga sympathizes with their reasons for initiating the insurrection, the tragic outcome shows his alignment with the conservatives.

Verga, the son of minor gentry, was never a social radical, but he did analyze the attitudes and life of the Sicilian peasant and villager. Yet it was only in Florence, the center of Tuscan culture and of the language of modern Italian prose, that Verga could disclose for himself the peculiar inflections and rhythms of the Sicilian dialect. He ultimately took up permanent residence in the Tuscan city. But as early as 1863 his novella, *Sulle Lagune* (On the Lagoon), was serialized in the progressive Florentine newspaper, *La Nuova Europa,* a *garibaldino*-Mazzinian publication which had been the first to review his *I Carbonari* in May 1862 and where six months later Signorini published the first major defense of the Macchiaioli. (Set in a Venice still subject to Austrian domination, *Sulle Lagune* opens with a patriotic festival celebrating the news of Garibaldi's entrance into Naples.)

Although much of Verga's syntax derives from the Sicilian dialect, the naturalist content and effect in prose are often equivalent to the plain expression of Macchiaioli painting. There is a steady run-on of thoughts and spare landscape description with little emphasis, a flow of subordinate clauses in chain fashion, like the following in the short story, *La Lupa* (The She-Wolf):

> Pina was the only soul to be seen wandering through the country-side, on the ever-burning stones of the little roads, through the parched stubble of the immense fields, which lost themselves in the sultry haze of the distance, far off, far off, towards misty Etna, where the sky weighed down upon the horizon, in the afternoon heat.

Occasionally, the prose has the matter-of-fact, undramatic characterization typical of Macchiaioli works, its factual and topographical concentration written as a verbal equivalent to the macchia of the countryside. The lack of elaboration of psycho-

logical and descriptive filler corresponds to the elimination of detail and uninflected scenes of the Macchiaioli.

Verga did most of his writing after unification, and his work manifests the attitude of the liberals' dissatisfaction with the slow rate of progress in the solution of the social and economic problems of the peninsula. Once the basic political aims of the Risorgimento were accomplished, the literature and art of that generation no longer had a direct political mission. As this powerful link to contemporary reality disappeared, they lost much of the unity of aim that they shared in the period of the Risorgimento. *Verismo* was turned on society as a kind of sociological analysis of deviant behavior (seen most vividly in the work of Signorini), and in the work of Verga spotlighted the social issues of the south where the continuing illiteracy and economic inequalities pointed to the corruption of the parliamentary system under the new constitutional monarchy. Nevertheless, the arts continued to concentrate on the facts of daily life without embellishment. The age of the historical novel and romantic nationalism had passed.

Giovanni Fattori, *French Soldiers of '59*, 1859.
Private Collection, Viargeggio.

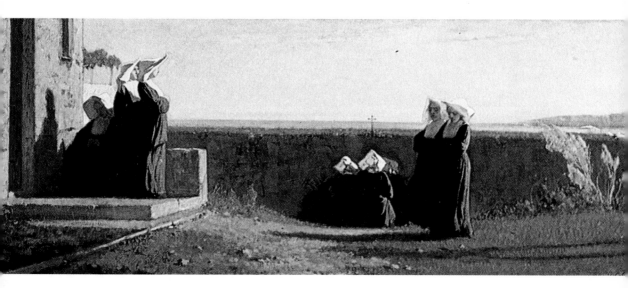

Vincenzo Cabianca, *Morning (The Nuns)*, 1862 replica.
Private Collection, Milan.

Giuseppe Abbati, *Cloister*, ca. 1861–62. Galleria d'arte moderna,
Palazzo Pitti, Florence.

Odoardo Borrani, *Red Cart at Castiglioncello*, ca. 1867.
Private Collection, Florence.

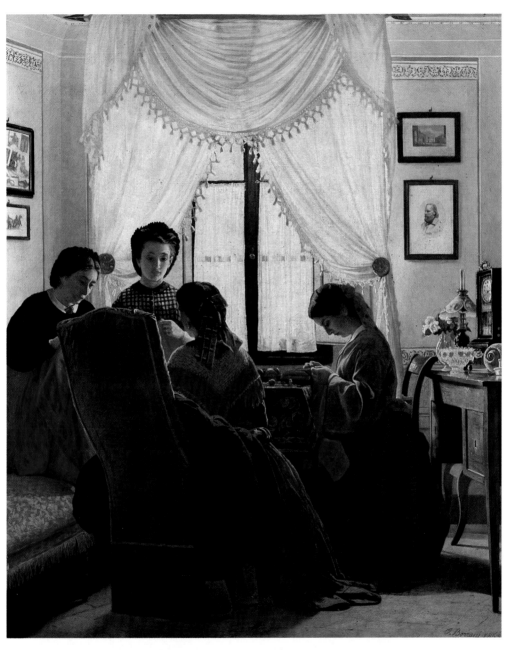

Odoardo Borrani, *The Seamstresses of the Red Shirts*, 1863.
Private Collection, Montecatini.

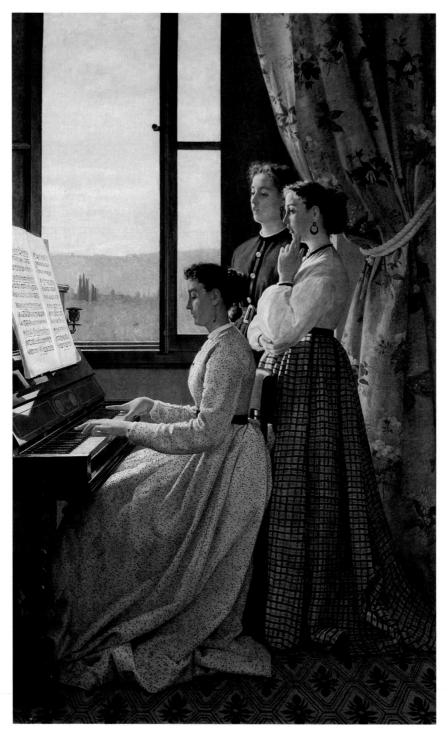

Silvestro Lega, *Singing the Stornello*, 1867. Galleria d'arte moderna, Palazzo Pitti, Florence.

THREE

Macchiaiolismo versus Accademismo

The Macchiaioli (from the various connotations of macchia: spot, sketch, dense underbrush) represented a new cultural formation that took place in Florence just after mid-century and lasted until the late 1860s. The strategy of their dissent took the form of antiacademicism, but in fact was aimed at the foreign, specifically, Austrian, domination of Tuscan institutions.[1] Although Leopoldo II was rather tolerant as despots went, after 1848–49 he had lost his popularity and became increasingly dependent on Austrian reinforcement. The rigid discipline and authoritarian atmosphere of the institution could then be associated with the political order. Imagine a sassy young Macchiaiolo coming upon a portrait of Leopoldo II painted by one of the academy's members bearing the sycophantic title: "Portrait of His Imperial and Royal Highness, the Grand Duke Leopoldo II, our Lord."[2] Under the grand duke, the Florentine Academy was "imperial" and "royal," and one of Vittorio Emanuele II's official rites of purification when ascending the throne of united Italy was to change the denomination and the regulation of the academies.[3]

The organization of the new artistic circle attracted individuals from outlying geographical areas in the Italian peninsula who had fled their indigenous subordinated cultures or were otherwise displaced by the ferment of the revolutionary years 1848–49. Despite the autocratic government of Grand Duke Leopoldo of Lorraine and its dependence on Austrial arms, life was more tol-

erable in Florence than almost anywhere else in Italy; it was an environment these patriotic-minded artists could exploit. They participated in the planning of the huge revolutionary demonstration in Florence on April 27, 1859, which overthrew the regime and opened the way for Tuscany to join a united Italy.

The Macchiaioli spun their political and aesthetical intrigues at the Caffè Michelangiolo in the Via Larga, a wineshop that functioned as the center of Florentine bohemiam life. One of its founding patrons was Giuseppe Dolfi, a baker and pasta maker who was associated himself with the Mazzinians, and played a critical role in the success of the Tuscan revolution. Dolfi and the members of the Macchiaioli and others in their circle conspired together; their part in the events of April 27 is confirmed by the eyewitness account of the American painter Elihu Vedder, who was in Florence at that moment and had become friendly with Banti, Cabianca, and Altamura. This is the way he recalled it:

> There had been much plotting in the Caffè Michelangelo [*sic*]. I had not been taken into the plot, but being a rank republican was considered one of them. So when the final day came, I limped along with the rest to the Fortezza di Basso, and we fraternised with the soldiers. The Italian colours were hoisted and the bands broke out into Garibaldi's hymn and other patriotic airs never heard before in Florence. Where could they have been practising?

Vedder also tells us about the failure of the Grand Duke's strategy, hinting that the painters also had a role in this as well:

> There was a rumour that the Grand Duke had sent sealed orders for the forts to bombard the city, and then an officer had said—rather than do that he would break his sword across his knee; it was terrible. The Grand Duke didn't send to have the orders opened and the sword remained unbroken. On the contrary, the Duke went away with a great quantity of luggage; the crowd assembled to witness his departure remained perfectly silent as his carriages rolled out of the gates; it was most impressive. The town was not bombarded or sacked. A few francesconi changed hands when all the boys of the Caffè Michelangelo came out in their new uniforms, but the money remained in the hands of the tailors. That was all the damage done, at least in Florence.

He concluded his recollections with the memory of the "great night at the Caffè Michelangelo."[4]

It was no accident that the Macchiaioli organized themselves in the Tuscan capital. The city's concentration of cultural and commercial institutions, as well as its dominant role in the history of peninsular civilization, provided the conditions for articulating a new national culture. The study of national history was cultivated in Florence not only by eminent scholars like Giovan Pietro Vieusseux (1779–1863) who founded the *Antologia* and the *Archivio Storico Italiano,* and Gino Capponi who founded the *Giornale Agrario Toscano,* but also by the romantic novelists, such as Guerrazzi and D'Azeglio, who scrupulously examined historical sites and documents for their fictionalized accounts of sixteenth-century Republican Florence. The study of Tuscan history as national history yielded a better knowledge of the Italian past (with lessons for the future) and a clearer sense of the relationship between Italy and Europe. This knowledge, coupled with an examination of present reality, revealed the process of decline Italy underwent after the Renaissance. The general goal of the Tuscan Risorgimento was to raise Italy to the level of the rest of European civilization. The Macchiaioli shared this goal and participated in the revivifying of Italian art and culture, using their Renaissance predecessors and European contemporaries as guides. The group began to lose its cohesiveness only when Florence became the official capital of Italy in 1865—ironically just at the moment when their ideal of Florence as national and international cultural and political center was starting to be realized.

The Macchiaioli expressed their nationalism and internationalism primarily through a modernization of the landscape idiom. They searched the river flats along the Arno, the orchards and farms of the suburbs of Florence, the hill pastures around Pistoia, and the wild Maremma region (with its thick *macchie* of scrub pine and underbrush) for motifs appropriate to their fresh viewpoint. Their topographical specificity and personal response were totally integrated in what may be called the "macchia-scape"—the landscape that retained the sincerity of vision they admired in the Tuscan artists of the Quattrocento but that also conveyed the modernity and nationalism of contemporary Italian life.

THE SHIFT FROM VEDUTA TO MACCHIA

The immediate forerunners of the Macchiaioli were the Vedutisti—the Italian view painters of Venice and Naples. They were

the first to promote topographical realism with reference to a spe-
cific site as an emblem of national or geographical identity. The
Venetian view-painters of the eighteenth-century, for example,
depicted a building, a picturesque corner of a city, a panoramic
townscape, for the sole purpose of preserving the memorable
qualities of Venice for the travelers. The *veduta* in fact was the
original postcard, albeit an expensive version available only to a
privileged tourist for whom it was a badge of culture and wealth.

The term *veduta,* or view, is closely related to the terminology
of perspective, deriving from the same word meaning the line of
sight to a given location, whether of an expanse of countryside, a
city, or an individual building. This prospect was an exclusive
point of view, such as that afforded from the hill of a feudal estate,
accessible only to those who could gain entrance to a court bal-
cony, a window in the Doge's palace, or the terrace of a wealthy
landlord. It also signified the impeccable judgment and taste of
the viewer, who was part of a select group able to seize on the
truly "poetic" *punto di vista,* or picturesque prospect. Thus the
view painters were required to render accurate portrayals of the
most famous or memorable places, tracing the trajectory of this
refined line of sight.

Not coincidentally, English and French aristocratic collectors
constituted the principal clientele of the Italian view painter.
These views often complemented the topographical portraits of
their own estates that English lords commissioned from local
landscapists. The landscape or "real estate" portraits by English
or foreign painters generally terminated with the stately home on
the horizon, akin to the arrangement of the Vedutisti. The young
Englishman taking the Grand Tour to round out his education
thus greatly stimulated the market and the profession of landscape
painting in Italy prior to the Risorgimento.

The English continued to be a major stimulus in the first half
of the nineteenth century, contributing to the rise of a landscape
group in Naples known as the Posillipo school.[5] Long before the
advent of the Barbizon school, Italy had a regional landscape
movement based in the Neapolitan countryside. This group in-
cluded its founder, Antonio Pitloo (1791–1837), and his dis-
ciples Gabriele Smargiassi and Giacinto Gigante, all of whom
made their living depicting scenic views of the Posillipo resort
and its surrounding ports for English and French tourists. They
showed squares with markets in progress, bridges, famous build-
ings, towncapes, and the beautiful hillside sites of Posillipo itself
(fig. 3.1). Another member of the group, Achille Vianelli, also
rendered church interiors within a careful perspective framework.

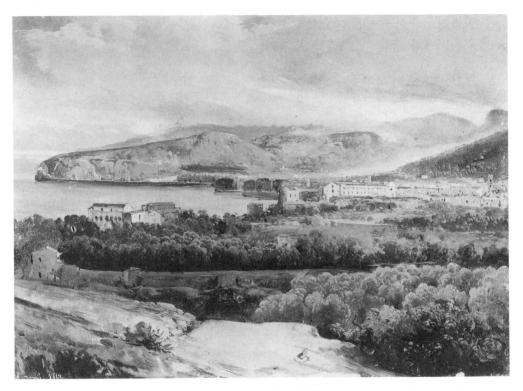

3.1 Gigante, *Sorrento Coastline,* 1842

There is clearly an intimate link between view painting and scenography (including stage design); indeed, the two practices developed in tandem. Scenography, like the *veduta,* was concerned with the representation of space and was dependent upon an accurate perspective scheme. Most view painters could do both types of spatial representation and were encouraged to do so by collectors who wanted *trompe l'œil* church interiors to complement their exterior views. The presence of a major scenographic school at the Royal Theater of San Carlo in Naples testifies to the distinguished place of scenography in that city.

The Neapolitan view tradition entered into the Tuscan center by way of political exiles such as Domenico Morelli (1826–1901), Bernardo Celentano (1835–1863), Francesco Saverio Altamura (1826–1897), and Vincenzo Abbati (1803–1860) (Giuseppe's father), who had studied in the San Carlo school. Vincenzo's fastidiously rendered church and chapel interiors were popular among French (the Duchesse du Berry, daughter of the King of Naples, was his faithful client and helped spread his reputation in France) and English as well as Neapolitan collectors (fig. 3.2).

Giuseppe Abbati's early works unmistakably attest to the influ-
ence of his father and help clarify his new direction under the
impact of the Macchiaioli (figs. 3.3, 7.10, 7.11).

Equal in importance to the Posillipo influence was the contri-
bution of Giovanni Signorini, Telemaco's father, a scenographic
and view painter attached to the grand-ducal court of Tuscany.
The court frequently called upon him to record the spectacles,
celebrations, and even the disasters of the duchy.[6] In a series of
remarkable panoramas executed in the 1840s, he depicted the
chariot races in front of Santa Maria Novella, the carnival festival
in the Piazza Santa Croce, a night scene in the Loggia of the
Mercato Nuovo the evening of the festival of Epiphany, the rider-
less horse races held on the feast day of San Giovanni (the patron
saint of Florence; fig. 3.4), and the Ponte Carraia during an im-
mense display of fireworks. These *vedute,* all done for the court,
give us an insight into the origins of the Macchiaioli style and its
singular departure from tradition.

All are presented from a high vantage point, as if from a bal-
cony, which allows for a stretching out of the horizon for a pan-
oramic look at the crowd and events. Almost invariably, the
spectator is made to feel relegated to the periphery of the main
action, away from the teeming populace, the dust kicked up by
the horses' hooves, and the fallout from the fireworks. Despite
their remarkable topographical accuracy, they reek of the artificial,
the scenographic, the stage set. They document the religious and
official holidays of the Florentine public, those few moments in
which the grand duke deigned to make contact with his subjects.
This contact was rigidly ceremonial, with the grand duke sur-
rounded by an entourage that followed him to every site on his
itinerary. This formality is brilliantly recorded by Giovanni Sig-
norini from the viewpoint of the regime. His *vedute* also hint at
one of the sources of popular discontent with Leopoldo II, for
his contact with Tuscany's people never seemed to get beyond the
level of feast day celebrations.

The Macchiaioli painters' debt to the *veduta* tradition is evident
in the titles of their early exhibits in the Florentine Promotrici,
the annual art exhibitions sponsored by private patronage. The
De Tivoli brothers, Serafino and Felice, used the term in labeling
landscape studies of the early 1850s such as Serafino's *Veduta
dell'Arno dal fondo delle Cascine* (View of the Arno from the End
of the Cascine, 1853).[7] Their master, Hungarian-born Karoly
Markò the elder, another popular court painter who founded a
school for landscapists at the Villa Appeggi in Florence, estab-
lished his reputation for arcadian renditions of the Tuscan topog-

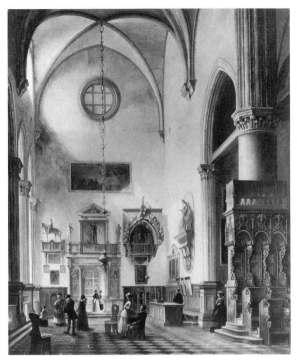

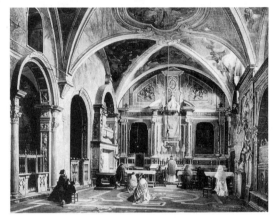

3.2 Vincenzo Abbati, *Mounument of Paolo Savelli*, Church of Santa Maria Gloriosa dei Frari, Venice, ca. 1855

3.3 Giuseppe Abbati, *Chapel of San Tommaso d'Aquino*, Church of San Domenico Maggiore, Venice, 1859

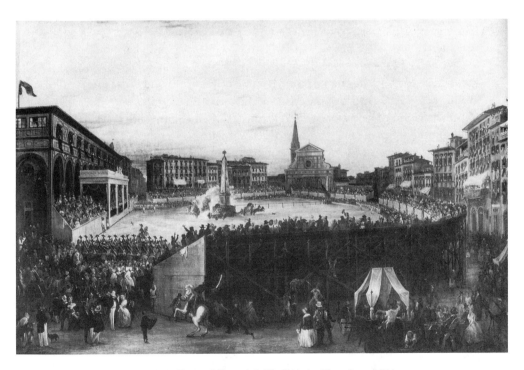

3.4 Giovanni Signorini, *The Riderless Horse Race*, 1844

raphy that he labeled *vedute* (fig. 3.5). As late as 1863, Silvestro Lega used the term to designate one of his studies executed in Piagentina. Another point of contact between the old view painters and the Macchiaioli is their mutual interest in the use of optical devices such as the black mirror, a darkened concave glass for simplifying the tone of the subject, and the more traditional *camera lucida,* a mirror which reflected the scene onto a transparent drawing surface on which the artist placed tracing paper for reproduction. Eventually, these experiments of the Macchiaioli, inherited from *vedutismo* (view painting), would lead them into the rapidly expanding field of photography.

A comparison between the views of the elder Signorini and the *macchie* of his son nevertheless discloses the vast gulf between the two groups of painters. Both fixed on familiar urban sites, but Giovanni Signorini, as indicated, mainly painted special annual events and spectacles. His views are scenic displays tracing the courtly calendar for members of the Tuscan aristrocracy. This group always lies outside the main action, while nevertheless accepting the rituals as if performed for them exclusively. The famous sites and *piazze* are experienced by them in this limited framework, for they cannot and will not participate at any other level.

The elder Signorini's *Panorama di Firenze dal Monte alle Croci* (Panorama of Florence from Monte alle Croci) lays out for the beholder almost every palazzo and villa of note in the city and focuses on the Duomo which is located almost at dead center of the picture (fig. 3.6).[8] The peasant figures on the hilltop, however, seem oblivious to the majestic spectacle and in fact act as foils for a world of splendor and scope beyond their comprehension. Giovanni's panorama is not a public display, but meant to be viewed by those who occupy the buildings below or whose privileged social position permits them to visit them and recognize their historical importance.

The "generation gap" between father and son is most vividly seen in the series of urban and rural village scenes Telemaco executed. Although the younger Signorini reverted to the traditional *veduta* for the more conservative medium of book illustration, as in his work for Gustavo Uzielli's *Richerche intorno a Leonardo da Vinci* (1872; fig. 3.7), his painted landscapes break abruptly with the tradition followed assiduously by the elder. He carries the spectator directly into the noisy, bustling *Mercato Vecchio a Firenze* (fig. 3.8) and the silent, benumbed square of the *Piazza a Settignano* (fig. 3.9). We do not take in these scenes from the perspective of the aristocratic beholder but from that of the shouting street vendors and colliding customers.[9] Instead of organizing the

3.5 Markò, *Florentine View*, 1863

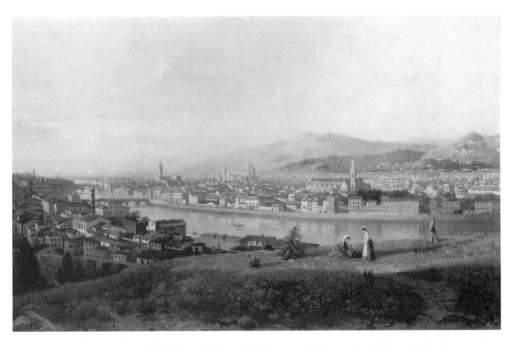

3.6 Giovanni Signorini, *Panorama of Florence from Monte alle Croci*

composition around a dominant monument in all its majesty, Signorini emphasizes the seedy, run-down buildings of old Florence. Indeed, in the *Mercato Vecchio,* we barely see the cupola of the Duomo peeking out above the tiled roof at the left. *Piazza a Settignano* (ca. 1880s) sets us directly into the center of the little village about five kilometers west of Florence, and Signorini carefully identifies the site with an advertisement on the side of a *trattoria.* The view is from below rather than from above the horizon, and the spectator has the sense of cutting across the square toward the *trattoria,* following behind the striding figure. The mood is governed by the unemployed people and/or shoppers leaning against the fountain in the center of the composition or standing in doorways. Signorini clearly delighted in painting the signs on the buildings, not only to establish the locale but also to declare the modernism as well as vulgarity of consumer advertising.

He extended his repertoire—as well as his distance from his father—with *Leith* (fig. 3.10), a landscape done on his journey to Scotland in 1881. Here the scene in the port district at the northern edge of Edinburgh is viewed from below the horizon, and the spectator is made to feel a part of the strolling crowd. We seem to overhear the animated conversation of the group in kilts as we move at a pace set by the young woman pushing the perambulator

3.7 Telemaco Signorini, *Veduta di Vinci,* 1872

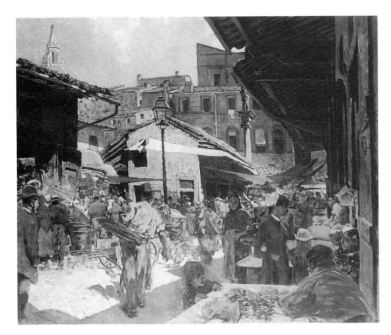

3.8 Telemaco Signorini,
*The Mercato Vecchio at
Florence*, 1882

3.9 Telemaco Signorini, *Piazza at Settignano*, ca. 1889

3.10 Telemaco Signorini,
Leith, 1881

3.11 Telemaco Signorini,
Leith, detail

at the right. The main focus is the huge billboard on the side of the building advertising products from the Kirkgate Provision Store (fig. 3.11).

To move from the work of the father to that of the son is to make a drastic social and ideological shift from an aristocratic to a bourgeois ideal. The Macchiaioli push from the scenic to the participatory, from the privileged to the liberal view, from watching the spectacle to taking part in it. Opposing the exclusivity of the Vedutisti, they declare the sociality of the landscape and the communality of the Risorgimento ideal. Even when they choose an isolated site or image of solitude, they do so for the benefit of the general bourgeois spectator. The site is no longer the most famous or the most memorable, but a slice of Tuscan countryside presented to permit a more personal response, unmediated by guidebook rhetoric. When they do show well-known monuments, they are seen in drastically cropped or unfamiliar guises, from close up or from bizarre angles. They privatize and personalize even the tourist spectacles for a fresh perspective and an unstereotypical insight. Thus the Macchiaioli amplified the geographical significance of the view painters, projecting it into a patriotic-social context. They extended their vision from a specifically Tuscan world to the larger European culture, celebrating public spaces but restoring the monuments to the people, secularizing and divesting them of their ritualistic, theocratic, and aristocratic significations.

Apart from these characteristics, Signorini's *Leith* reveals Macchiaioli irony and self-parody. The visual jolt of the looming billboard, with its bold capitalized ROB ROY, makes a sly allusion to one of their old heroes, Sir Walter Scott. Set in eighteenth-century Scotland in an area between Glasgow and Argyllshire, *Rob Roy* (1819) was one of Scott's most adventure-filled novels. The eponymous hero is a chief of the Highlanders who collects protection money from London merchants. Called affectionately the Robin Hood of Scotland, he occupied a popular position in the Highlands. The carry-over of Scott's romantic tradition to the Risorgimento is seen in the fact that Garibaldi was popularly referred to as the Rob Roy of Italy.

During this same trip to Edinburgh, Signorini also painted the Monument to Sir Walter Scott, located south of Leith near Waverley Bridge. Signorini's trip surely had the character of a pilgrimage to Scott's native land. When we recall that Scott served as prominent role model for the Italian romantic novelists and that both Signorini and Giovanni Fattori drew upon the English writer for their initial subjects, the allusion is not without significance. Indeed, one of Signorini's earliest works, *The Puritans of*

the Castle of Tillietudlem, exhibited in the Esposizione delle Belle
Arti in Florence in 1854 when the artist was only nineteen, was
inspired by Scott's writings.[10] Scott's novels were readily available
in Italian and made a decisive contribution to the imaginative de-
velopment of the young Macchiaioli.

By 1881, in *Leith,* however, Signorini could see his youthful
infatuation with the novelist in a different light. The billboard
title ROB ROY refers to a whiskey label, and its fancy plaid lettering
clashes with the sign above it advertising Rekitts Blue, a laundry
product sold in little bags that gave a "blue-whiteness" to freshly
laundered clothes. Rob Roy has now been divested of its literary,
heroic, and romantic associations and absorbed into the com-
mercial life of a modern, dynamic urban complex. Signorini's
approach here underscores his participation in cultural produc-
tion for a bourgeois mercantile elite rendering the content of
their world with a gusto of light and color then associated with
high art.

As in his paintings of Italian sites, Signorini's *Leith* carefully
marks the locale and its day-to-day life. He painted near the point
where Great Junction and Constitution streets meet, as indicated
by the Kirkgate Provision Store sign on the storefront below the
billboard. The correct spelling of the English words and the pre-
cise details of the billboard strongly indicate that he used a pho-
tographic source rather than that he painted or sketched the
scene on the spot. Signorini's commitment to topographical ac-
curacy, inherited from the Vedutisti tradition, has now been
similarly translated into a saleable modern image for a different
patronage—the triumphant middle classes.

MACCHIAIOLI: MEANING AND CULTURAL ROLE

The designation of the painters as Macchiaioli would have been
impossible prior to the evolution of the Risorgimento. It is in-
separable from a particular epoch in Italian history, and, although
bestowed upon the artists by hostile critics, they came to adopt it
as their own. I maintain that the group label carried a progressive
political signification no less critical to the program than its aes-
thetic and cultural meanings. Their strategic embrace of the term's
politically charged connotations allowed them to gain the ini-
tiative in dealing with their critics and legitimatize their radi-
cal effort.

The Macchiaioli emphasized the need to "surprise" nature on
the wing, to catch it "unawares."[11] Here it implied more than
a simple sketching technique, but a revolutionary method that

overturned all previous and current conventions of painting. On one level, surprising nature stood for a quickened response to the empirical data unmediated by academic formulas and conventions, but, on another, it signified the need to be spontaneous and therefore "Italian." The American painter Elihu Vedder, who grew quite close to a number of the Macchiaioli and their circle, recalled that Giovanni Costa "delighted in stealing upon Nature in her most intimate moods." He tried to take nature by "tradimento," or treachery, Costa's own Italian expression that suggested to Vedder that he "was as great a patriot as he was a painter."[12] Seen in the context of Risorgimento wars and skirmishes, Costa's attitude involves declaring war on nature; he meant to master it visually as Italians were regaining their territory in actuality.

Like the Risorgimento itself, the Macchiaioli idea had both an Italian and a European implication. For all their differences, both Giuseppe Mazzini and Camille de Cavour of Piedmont wanted to bring Italy up to date and to a political, economic, and social level equal with the rest of Europe. Similarly, the Macchiaioli were both nationally and internationally oriented; by asserting Italian individuality they hoped to contribute to a release of energies needed to make Italy a great nation, able to assume a significant role in the affairs of Europe. This becomes evident in the heated journalistic exchange of 1862 between the painter Telemaco Signorini and the critic Giuseppe Rigutini (who signed themselves anonymously as "X" and "Luigi," respectively), in which the term Macchiaioli appeared for the first time in print; Rigutini employed it to deride a review by Signorini of the first group show in which he praised several of the young painters.[13]

A prominent linguist and philologist, Rigutini had a field day punning on the multiple applications of the root word *macchia,* identifying the work of the artists with shapeless stains, blobs, and patches that demonstrated their tortured striving for "the effect *(effetto),*" a key term in the aesthetic lexicon of the nineteenth century. Rigutini, aesthetically and politically conservative, evidently grasped the connection between the Macchiaioli's concentration on the effect and their radical nationalism that he stigmatized as their willful ambition "to reform art."

Under the influence of scientific and industrial discourse, independent painters in England and France began working outdoors in a naturalist style, experimenting with shorthand techniques for capturing ephemeral light conditions. In standard academic parlance the effect comprised the unified relations of planes of light and dark values, or the "harmony" academicians considered central to a successful work of art. One of the first writers to study

systematically the effect was an Italian theorist from Turin, who
as early as the 1820s observed the relationship of the unity of
effect and the sensation of "instantaneity," and the paradoxical
link between the macchie and the object they purport to represent.
For him, generally, harmony of effect was obtained by a subtle
gradation of tonal values building carefully modeled forms and
realized as a perfectly polished or "finished" work of art (*stile
finito*, what Signorini described as an "excessive transparency," or
loss of relief).[14] But he understood very well the exciting visual
sensation created by the relief of the brushstroke *(tocco)* and the
sketchy style *(stile abbozzato);* indeed, it was widely acknowledged
even by academicians that simplication of light and dark and
masses—that is, the elimination of in-between tones—resulted in
sharper relief and greater immediacy of effect.

ACADEMIC PRACTICE

The Macchiaioli all began their training in the regional aca-
demies, and hence would have been inculcated in the tradition
of *capo-lavoro* (masterpiece) creation. The academic discourse
of masterpiece creation linked art production to transcendental
themes from classical and biblical literature, but in actuality these
thematics reinforced existing hierarchies by indirect allusion to a
belief and/or value system that justified the status quo. The 1796
statutes of the Rome Academy, Accademia di San Luca, estab-
lishes in its very first article the institutional aims in two italicized
terms: *conservare* and *propagare,* keeping the faith, and passing
it on.[15]

This is more or less the standard academic line past and present
(currently being played out in the canon debate), although it is
clear that what academies or pedagogical institutions feel that
they are called upon to preserve and transmit at any given time is
conditioned by the sources of power and authority that under-
write them. The head of an Italian academy was originally known
as the "principe," the same word for prince, and an honorary term
bestowed on an aristocratic elite. As far back as the sixteenth cen-
tury, the Florentine Academy consisted of a society of leading
artists under the protectorate of the then Grand Duke Cosimo de'
Medici. When Tuscany later fell under the control of the House
of Habsburg-Lorraine there was an ideological shift, but the
grand-ducal relationship with the academy remained unchanged.

Prior to unity Italian academies differed from other national
academies located in capitals such as Paris and London in their
diverse regional affiliations. There were sixteen primary acad-

emies and more than thirty secondary schools of art, sharing the
standard curriculum but varying it according to the exigencies
of the local political and social order. Italian academies under
Napoleonic hegemony momentarily participated in a common
ideological program in their celebration of the Bonapartist mys-
tique, but after 1815 returned to their regional affiliations. The
aesthetically conservative Puristi (Purists), led by Luigi Mussini
in Florence, were profoundly influenced by the German Naza-
renes who worked in Rome and steeped their work in the Ca-
tholicizing sentiment of pre-Renaissance art. The Puristi were
more politically moderate than the Nazarenes—an extreme right-
wing group who identified neoclassicism with Jacobinism and
Napoleon, and exploited Christian images, themes, and forms as
more appropriate to Restoration ideology of Throne and Altar. A
disciple of Bezzuoli and socially moderate, Mussini catered to the
court like his master by producing pictures such as *La musica sacra*
(Sacred Music) which corresponded to the clockwork practice of
ceremonial and ritualistic gestures of Leopoldo II to persuade
Tuscans of his natural piety and commitment to the Church
that his grandfather had futilely attempted to reform and purify
(fig. 3.12).[16] The Macchiaioli Lega and, for a brief time, Fattori,
studied under Mussini, accepting his principle of looking to in-
digenous Italian sources for inspiration but at the same time
secularizing and modernizing his thematics in tune with the new
national ideal.

The Italian academies, like all academies, socialized and indoc-
trinated neophytes through institutional stress on methodical and
painstaking study of perspective, anatomy, and ornament, and
drawing from plaster casts and the nude body. Resistance to this
curriculum required tapping into certain subsidiary practices con-
ceived of as secondary to, or accessory to, *capo-lavoro* creation, and
giving them unprecedented attention and application. These prac-
tices included sketch exercises emphasizing the chiaroscuro effect
and landscape "unworthy of being represented officially" in the
program of the Florentine Academy.[17]

Sketching when combined with landscape would have struck
them as modern and even helpful in constructing a vision conso-
nant with their perception of the changing social and political
environment. In addition to the hardcore training in drawing the
nude model and plaster casts, academic training in Italy generally
stressed sketching practice, but only in the initial stages on the
way to achieving the definitive masterpiece. Early in the century
the Academy of Turin offered a specialized class in "invention"
and composition for the purpose of "l'effetto del chiaroscuro."
One annual competition required that the painter execute "un

3.12 Mussini, *Sacred Music*, 1841

quadro bozzetto d'invenzione"—a painted sketch from the imagination.[18] Similarly, the Florentine Academy ran competitions for the execution of a "bozzetto a olio d'invenzione" (an oil sketch from the imagination) and an analogous contest for sculptors in which the future Macchiaioli and their circle participated. Lega won the triennial painting competition in 1852 with a *bozzetto* on the biblical theme *Saul, Tormented by an Evil Demon, is Pacified by David Playing His Harp*, and Adriano Cecioni, who both sculpted and painted, gained the prize for a "bozzetto in bassorilievo d'invenzione" in 1857.[19] One typical example of this type of exercise is the compositional study by Stefano Ussi (1822–1901)—a con-

3.13 Ussi, *Inquisition Scene,* ca. 1846

temporary and close friend of several of the Macchiaioli—who won the *bozzetto a olio d'invenzione* contest in 1846 (fig. 3.13).[20] The sharp light and dark contrasts executed in audacious sweeping strokes attest to the spirit of the sketch practice, although it can hardly be called spontaneous since underlying the bold streaks of paint is a carefully plotted-out composition.

Ussi's synthesis of careful form and vivacious execution corresponds to the academic moderation of macchia technique known in the studio parlance as *mezza-macchia,* or "halfway-macchia." Although this practice is never mentioned in the official academic documents, Pietro Selvatico, the well-known professor of aesthetics and perpetual secretary of the Academy in Venice, recommended it as a way of grafting onto a correctly rendered form the broad planes of light and dark observed on the nude model.[21] This suggests that masters encouraged this exercise in the studios, but of course they never would have permitted *tutta-macchia,* the totally unhampered (i.e., "anarchic" by Selvatico's standards) direction in which the Macchiaioli wanted to take the academic

sketching practices. Nevertheless, one painter of the period, pamphleteering the year after Ussi won the sketch competition, criticized the Academy generally for judging artists on the basis of "invenzione ex tempore" (the term *bozzetto ex-tempore* or *bozzetto estemporaneo* is used increasingly after mid-century), and thus encouraging the debasement of high artistic standards. Yet he was no lover of the academies, and advocated the elimination of these institutions to prepare for "un nuovo risorgimento" in art! [22]

The Academicians insisted that the "true" artist was someone who could sustain the original effect of the sketch in the final tableau without sacrificing order, finish, and detail. Yet the growing emphasis on realism and on sincerity of vision predisposed the younger painters seeking their own space and market possibilities increasingly to expose the brush trail on the surface and concentrate on the effect. The fact that this meant accepting a sketch or study as a finished work or leaving a work in a state that resembled a "sketch" or an "incomplete" production led to intense debate as critics on both sides contested the ground for modernity versus tradition. Trained in sketching procedures at the Florence Accademia delle Belle Arti, the Macchiaioli frequently executed preliminary sketches and studies as part of their own routine practice, and many of these are now unwittingly viewed as finished productions (fig. 3.14). But what is important in their work is their consistent preoccupation with effect as the overriding goal of their activities, the foundation of harmony in their landscape and the necessary condition of the expression of their affective response. The macchia was initially that unit of pigment thrust at the canvas and left in an almost pristine state as a building block of the full-blown visualization. The paradigmatic example has always been Sernesi's *Tetti al sole* (Roofs in the Sunlight), where the Macchiaiolo structured his surface directly with paint, forming a mosaic of broad planes of alternating light and dark (fig. 3.15). Later, its proponents perceived the macchia as a dynamic liberating principle to assimilate to more definitive attempts as a means of breaking with slavish tradition and addressing the modern world. It was their way of manifesting *italianità*—the expression of their Italian identity through their personal perceptions of the changing Italian environment and its born-again citizens.

The effect constituted the heart and soul of the landscape, and it is this category of visual practice that most preoccupied the Macchiaioli in their revolutionary phase. The want of this study in the Florentine Academy led away from the institutionalized training to the independent school of Markò and then to their own autonomous group study. The Florentine academy, however, was exceptional with regard to the landscape: Rome, Venice,

3.14 Cabianca, *Peasant Woman at Montemurlo,* 1862

3.15 Sernesi, *Roofs in the Sunlight,* ca. 1860–61

Milan, Parma, Turin, and Bologna all incorporated landscape instruction in their curricula and this also must have isolated the Florentine institution as a backwater.[23] Hence the choice of landscape and its effects as the predominant mode of exploring their Italian identity has to be understood as a form of resistance to the practices of the grand-ducal Florentine Academy.

This identification of the Academy with Leopoldo II's government opened the way for the Macchiaioli to represent their political practice. Relations of power between contending social groups could then be played out in the Promotrici and other independent exhibition outlets. Although the ardent polemic of Signorini and Rigutini centered on aesthetic issues, it was embedded in the politics of the Risorgimento. Signorini wrote for *La Nuova Europa,* an opposition paper with a republican viewpoint and supportive of Garibaldi and Mazzini, while his opponent wrote for *Gazzetta del Popolo,* a moderate conservative and anti-Mazzinian journal supporting the constitutional monarchy of Vittorio Emanuele II.[24] They represented the two wings of the patriotic movement, those in the Action party who preferred a democratic republic, and the conservative monarchists with whom they were forced into an uneasy truce. The republicans had been the first to conceive of a unified Italy, and had seized the initiative in fighting for it at a time when the House of Savoy had either resisted the concept or ridiculed it as a utopian enterprise. This gap closed for a brief period when Garibaldi turned over Naples and Sicily to Vittorio Emanuele, but it opened again when the conservatives and moderates monopolized government in Turin and depreciated the contributions of Garibaldi and Mazzini to national unification.[25] These monarchists could take the high road for a time because the fledgling republican vision of political democracy, lacking a class analysis, could not yet inspire the popular classes as it did the militants of the Action party, mainly petty bourgeois professionals, artists and intellectuals like Signorini, and the founders of *La Nuova Europa.*[26]

The founders of the short-lived *Nuova Europa*—which only ran from April 14, 1861 to October 15, 1863—had originally intended to call the paper *La Democrazia Italiana,* but opted instead for a more universal title. They were anti-Austrian, anti-French (read Second Empire), international, and populist, and their motto was "Liberty, Unity." When they used terms like *New Europe* and *Old Europe* they had a specific agenda in mind. The inhabitants of New Europe were defined as those "athirst" for social justice, political egalitarianism, and freedom of conscience, and destined to overcome Old Europe's feudal and semifeudal structure of privilege.[27] The chief collaborators of the journal in-

cluded such Tuscan militants as Agostino Bertani, who fought in
all of Garibaldi's campaigns, Alberto Mario, the radical journalist
who fought with Garibaldi's Thousand, Giuseppe Manzoni and
Giuseppe Montanelli, who together with Francesco Guerrazzi
had formed the triumvirate of the provisional Tuscan government
in 1849, and the master baker Giuseppe Dolfi, loyal patron and
intimate member of the Macchiaioli circle.[28] The newspaper ar-
dently supported the Florentine workers' society, *La Fratellanza
Artigiana* (Artisans' Brotherhood), headed by Dolfi, Mazzoni,
and Andrea Giannelli, created in February of 1861 under the in-
fluence of Mazzini as a base for antimonarchical opposition in
Tuscany. Bertani's concept of *La Nuova Europa* paralleled their
political action, since he had initially hoped to participate in the
launching of a nationwide consortium of democratic newspapers
with a common financial basis and ideological guidelines. Bertani
and Manzoni were cherished friends of Carlo Martelli, and, after
his premature death, father substitutes for his son Diego, who
became the chief defender and promoter of the Macchiaioli.[29] Not
surprisingly, Diego's newspaper of choice, while it lasted, was *La
Nuova Europa*.[30]

The collaborators of the journal supported realist art that took
the measure of a changing, contemporary world and embodied the
aspirations of the Risorgimento. They were less concerned for the
"cold minutia" presented by the photograph than for the feeling
structure bodied by the light effect and stimulated by the indige-
nous landscape.[31] In another of Signorini's anonymously signed
articles for *La Nuova Europa*, either overlooked or ignored in
modern scholarship, the painter unequivocally espouses realism as
a conscious political choice and national style. Modern art, he
insists there, must reproduce the character of contemporary feel-
ings and customs consonant with the epoch of the Risorgimento,
and not displace or dissimulate these observations by deferring to
the past. Only in the realist mode of "free examination and frank
criticism will we be able to attain to a position of rivalry with
other nations." Artists should thus paint not in order to become
champions of a new sect or school, but "only to demonstrate the
current tendencies of our art wherein resides the hopes of our
Risorgimento."[32]

Thus we now have an explanation of why the *Gazzetta*'s edi-
torials made disparaging remarks about the politics of *La Nuova
Europa*,[33] and why in Luigi Rigutini's article there are disparaging
allusions to Signorini as "un nuovo Europeo" or one of "i nuovi
europei."[34] The idea of a regenerated Italy in a regenerated Eu-
rope was in fact part of the original aim of Mazzini's organization,
Giovine Italia. Signorini expresses this thought in analogous cul-

tural terms when in his review of October 19, 1862 he criticizes
the commercial aims of some of the talented younger generation,
"whereas they could, if they wished, by cooperating with those
who are trying to progress, help modern art to attain the splen-
dors of the past and to compete with what is being produced
at the present time in Belgium, France, and England." Three
paragraphs later he attacks the older generation including Markò,
"whose work points backward rather than to the future."

It is this condemnation of the previous generation that raised
the hackles of Rigutini, who in his response of November 3, 1862
marveled "that the new Europeans of today [had] such a strange
taste in art." He quickly spelled out his moderate position: "If
I criticize the Macchiaioli, it is not because I prefer polished,
smooth painting like miniatures on porcelain; however, the artist
can easily choose a middle way between an oily smoothness and a
rugged crust, between forms without any effect and effects with-
out any form." This was the cultural equivalent of Cavour's *juste
milieu* program for the House of Savoy, which tried to isolate
the right-wing clerical party on the one hand and the followers
of Garibaldi and Mazzini on the other. Rigutini derided the
Macchiaioli's aesthetic experiments just as his political counter-
parts derided the republicans for their "utopian" schemes for
the Italian masses. Indeed, another term for the independents was
effettisti, or "effect-makers," signifying an aesthetically and politi-
cally progressive stance at variance with the preferred style of both
conservatives and moderates.

Signorini's response to Rigutini's attack emphasized the writer's
mistaken assumption about the concept of macchia. Although he
accepted the designation of Macchiaioli as an "apt" title for the
group, he pointed out that the signification of the root term had
undergone an evolution since it was first bandied about in 1855.
Initially, it took an extreme form as a liberating principle, but
gradually the notion became modified as the painters matured,
and took hold as a means to a more realized end. Signorini then
went on to condemn slavish worship of the past and to assert the
need for an ongoing critical and speculative perspective to main-
tain the momentum of the radical Enlightenment and make cul-
ture a vital social force: "What of the Encyclopedists, Diderot and
D'Alembert? We have covered two-thirds of the century they in-
augurated and are still prostrate in adoration, dreaming of the
past in the temples of our glory!" It is retrograde to be fully sat-
isfied with the work of our fathers since we rest on their laurels
and add nothing to the inheritance. Imbued with a Proudhonian
sense of individual liberty, Signorini clarified his connection be-

tween his work as an artist and his support of the left wing of the Risorgimento:

> Let us admire the past but not adore it; since adoration stultifies discussion let us be disposed to acknowledge merit in all times and all places, but let us not reject the inestimable advantages of free examination and criticism, however authoritative the names and works before us may be. If adoration is a good thing in religion, in art it leads to sterile imitation and therefore to decay . . . ; by preventing the free use of reason and imposing silence, it inhibits discussion by depriving thought of the principles and foundations wherein its strength lies.[35]

Thus there are bigger fish to fry in this seemingly exclusively aesthetic tit-for-tat exchange over the virtues or flaws of the Macchiaioli. Indeed, Signorini emphasizes that his praise in defense of the group was "extremely moderate," a fact that Rigutini did "not appear to understand or to want to understand." Signorini wanted to keep hope alive by keeping his and his colleagues' options open through free critique, to demonstrate that the idea of the macchia was still in "transition" as "a powerful aspiration towards the improvement and advancement of art." He then struck at Rigutini's political position: "You undoubtedly fail to perceive this because everything that contains a seed [i.e., the "macchia"] of the future is probably, in your eyes some utopian aberration." Here is the equation of the macchia with the dynamic character of the progressive Risorgimento, in itself perceived as a kind of sketch destined to remain "unfinished" until social justice and liberty of expression are available to every individual in society.

THE MACCHIAIOLI AND PROUDHON

Signorini's principle comes straight out of the writings of the French anarchist Pierre-Joseph Proudhon, whom he frequently quoted and referenced.[36] Proudhon's writings are pervaded by systematic attempts to define liberty consistent with anarchist doctrine. He understands liberty to be progressive in its development, intimately linked with spontaneity and movement. Liberty can never remain static and must forever stay active; it tends to decline when society becomes complacent or delivers itself to submission and indifference.[37] Proudhon's concept of liberty is close to his general idea of revolution, which he sees as an extraordinary

acceleration of movement in the unceasing progress of society. But his ideal of drastic social change took the form of a progressive revolution in ideas and education, and could not be achieved through violence.

Risorgimento democrats were sympathetic to the Proudhonian philosophy, influenced by the egalitarianism of Freemasonry which they shared with him.[38] Like him, they saw the Roman Catholic church as supporting the status quo and thus impeding social progress in their respective countries. Again like him, they advocated political, social, and financial institutions that would protect the rights of the small manufacturers, artisans, shopkeepers, and farmers from the encroachment of monopoly capitalism. Naively, they imagined that the better part of the peasantry and the artisanate would prove to be the bulwark of their support, but this could only occur if there were legal safeguards to control the accumulation as well as the social uses of capital. Without such protection the small producers would lose not only their economic independence but their social status and personal dignity as well.

Proudhon insists on the reorganization of society to achieve the millennium and the rejection of the siren lure of self-sacrifice and humanity to advance the cause of social progress. Through mutualism—the organization of equitable exchange among nearly autonomous economic units—and its political expression in federalism, hierarchy dissolves and a social mechanism based on communal resistance begins. Gustavo Uzielli, the notable geologist and patron of the Macchiaioli, believed that the less government the better, and that minimal restrictions should be imposed on the individual's liberty.[39] Although Uzielli and Martelli had their differences with Proudhon (especially Proudhon's Italian policy, which flew in the face of the Risorgimento by advocating the principle of federalism in place of unity), they were deeply influenced by him. Martelli especially considered himself a follower of Proudhon and projected for the future some type of international or at least European federation of communities, medium-sized groups with local autonomy, joined by a pact of federation as a way to balance authority and liberty.[40]

We know that he and his protégé Signorini owned copies of Proudhon's posthumous work, *On the Principle of Art and Its Social Destination* that they shared with their friends at the Caffè Michelangiolo, a work which demands from artists not only politically sensitive creations but unwavering commitment to "truth and justice in art as well as in politics."[41] Anticlerical to the point of priestly abuse, Proudhon praised his friend Courbet for his controversial picture of the *Return from the Conference* that depicts

drunken clerics and betrays the true character of Catholicism's hierarchical tyranny.[42] Proudhon's rejection of hierarchy in society, his insistence on the establishment of small units of work and groups, are consistent with Signorini's description of the formation of the Macchiaioli as a form of communal resistance.

Although the term *macchiaioli* seems to have first appeared in print only in 1862, it is clear from the writings of Signorini, Martelli, and Cecioni that it was already commonly used in the mid-1850s. Whether the Macchiaioli themselves invented it or not makes little difference: during the key Risorgimento years they came to identify completely with the term and accept it as the designation of their political as well as cultural aspirations. Fattori recalled in a letter to Gustavo Uzielli his first encounter with Felice De Tivoli, brother of Serafino, "both ferocious Macchiaioli" ("ambedue feroci macchiaioli"). Elsewhere he recalled that in his youth he served as a runner for the Action party in Livorno during the revolutionary period 1848–49, and when he subsequently moved to Florence he joined another form of "conspiracy," the new art movement directed against the Academy and classical painting "baptized with the name of Macchiaioli" ("battezzati con il titolo di macchiaioli").[43] Here again it would be delimiting and distorting to confine the original sense of the term to a strictly technical application of paint or to the tonal structure of their pictures.

The debate over the degree of finish (or lack of it) in painting such as that being done by the Macchiaioli was going on all over Europe, with the broader brush technique a slap on the academic canvas, and an underlying rhetoric consistent with liberal ideas of independence and individuality. There can be no doubt that the Macchiaioli responded enthusiastically to the novel techniques of the French painters of the Barbizon school and the English landscapists Constable and Turner, just as the Risorgimento itself was influenced by the French political Revolution and the English Industrial Revolution. But the Macchiaioli, with their own sketch tradition dating from the Renaissance, went even further in identifying specifically with the technique, that is, with the actual process of making a painting. This is an unprecedented attitude, yet one that remains to be discussed in the literature. French independents like the painter Edouard Manet, who still saw themselves as working within the tradition, would never have openly declared their exclusive identification with technique. The idea of Impressionism, although it conjures up a fugitive glimpse of reality, refers to a mental and perceptual response rather than to a material

process. Even the later Fauvism, which seems to make a statement about the way a work is painted, refers to a "primitive" state of mind, an aggressive psychological disposition.

Only the Macchiaioli had the humility and candor to align themselves totally with the idea of the macchia, which in the Renaissance Italian lexicon meant a sketch or sketch technique but which the nineteenth-century painters developed into a method/ideal of reproducing transitory light effects.[44] (Macchia is defined primarily as "spot" or "patch," as in *macchia di sole*, "sunspot," or *macchia d'inchiostro*, "ink spot," and secondarily as "underbrush," or large area covered with dense thickets.) What the French called an *esquisse peinte* or *étude de paysage* (which could be subtitled *effet de soleil*, or "sunlight effect," and *effet de neige*, or "snow effect") the Macchiaioli called the *macchia*. But the French would never have classified themselves as *Esquissateurs* (sketchers), the equivalent of the term *Macchiaioli*. They retained a high-art notion, using such terms as impressionism, neo-impressionism, symbolism, synthetism, and cubism, all of which emphasized the intellectual and conceptual component of creation.

Consistent with their scientific and positivistic outlook, the Macchiaioli chose a label that expressed an empirical attitude. At the same time, their modest group label was based on their identification with the popular classes of Italian society. The suffix *-aiolo* derives from the medieval Latin *ariolus*, which designated the plebeian groups in Florentine society. It was eventually applied to the humblest and often most marginal types of labor. These included ragpickers *(cenciaioli)*, purse snatchers or pickpockets *(borsaioli)*, and even "shit workers" *(merdaioli)*. This designation continued to be applied right through the century, exemplified in the decline of the mezzadria (sharecropper) system and the need to label new subcategories of semiproletarianized mezzadri field hands *(camporaioli)*, vine dressers *(vignaioli)*, and day laborers *(mezzaioli)*. It is altogether consistent with their collective commitment that they depicted scenes of the working classes to which they could attach this suffix: for examples, Signorini's *Le acquaiole della Spezia* (Women Water Carriers of La Spezia, 1860–61), and Banti's *Le trecciaiole* (Women Plait Weavers) and several versions of *Le boscaiuole* (Women Wood Gatherers).[45] Just as the Macchiaioli openly declared their engagement with the making, rather than the conceptualizing, of the art object, so did they readily accept the designation of the underclasses they often depicted in their work. This enthusiasm for painting laborers in a rural ambience is seen in Martelli's description of a lost work by Abbati exhibited at the Promotrice of 1867 which "locates us in the middle of the open countryside, in the full light

of the extended horizons, among robust and characteristic types of working men."[46] Furthermore, during the years 1864 and 1865 the Macchiaioli managed to get the Promotrice installed in the meeting hall of Dolfi's democratic artisans' society, La Fratellanze Artigiana, both to demonstrate solidarity with the skilled artisan and to gain popular support through association with Dolfi's organization.[47] While this plan did not succeed in the short run, it does attest to the radical republican image they wished to project.

Fattori hinted at still another implication for the group of the term *macchia* by repeatedly referring to the movement as a *cospirazione*, or "conspiracy." After joining the Macchiaioli he perceived himself as a *rinnegato*—an "outlaw." Now yet another nuance of the word *macchia*, a corollary of its meaning as underbrush, was its signification for certain types of criminal or clandestine activity such as counterfeiting *(battere moneta alla macchia)*, publishing illegally *(stampare alla macchia)*, hiding out in the woods *(fare alla macchia)*, and living as an outlaw *(vivere alla macchia)*. Macchiaioli could thus refer to anyone who did these things, as well as to a bushman, and "child of the bush," the term for foundlings in Florentine dialect. Here "bush," as in the Australian use of the term, signified "out of civil society," for the children of the bush were the children of no one.[48] Thus the marginal, the disinherited, the outlaw, the primitive could all be grouped under the term "Macchiaioli."

One zone in Tuscany particularly suited to clandestine activity was the Maremma, whole areas of which were covered with thick, impenetrable *macchie*. Here romped the *porco macchiaiolo* or "wild pig" of the type hunted in the marshlands. The boundless plains and dense woods added to the idea of the "lonely Maremma," and it became a place for brigandage and escapees. One of the most fascinating denizens of the Maremma was the famous bandit Domenico Tiburzi, who dominated the southern area. His total control of this zone gave him the title "King of the Macchia," referring to the areas of hill and ravine densely covered with dwarf forest, tangled, thorny, full of pits and precipices, virtually inaccessible, impossible to surround and useless to explore. A contemporary of the Macchiaioli, Tiburzi, who was born in 1826, gained a reputation in the 1850s as a kind of Robin Hood of the Maremma.[49]

The abundant *macchie* in the Maremma made it a hunting-ground for the *carbonari* (charcoal burners). The *carbonari* required scrubwood like gnarled tree trunks and dead leaves for the slow burning process of producing charcoal. The low-lying *macchie* were used in charcoal-making, which was one of the major

industries of some estates in the Maremma such as Diego Martelli's coastal retreat at Castiglioncello on the western periphery of this region. The woods *(boschi)* were placed under the direction of a *capoccia,* who was generally called the *Capo Macchia* (foreman of the macchia) and he had in his charge a team of *carbonari.* The insatiable demand for quick profits from the area led to wholesale destruction of the woods; always high on any agenda for reclamation was the need for re-forestation of the devastated areas.

The close association between *macchia* and *carbonari* within the context of Tuscan life made it inevitable that the label chosen by this group of painters would connote subversive and heroic activity. Although in the late 1850s Carbonaro political action had ceased to exist, the memory of it was still fresh in everyone's mind. As late as 1848, the King of Naples had restored the old Carbonaro constitution of 1820, and in Piedmont Carbonari veterans marched in a parade celebrating the constitution carrying a flag bearing the memorable dates of Carbonaro history, 1821/1831/1833. The term *carbonarismo* now entered the Italian vocabulary as synonymous with insurrectionary activity. It is no coincidence that Giovanni Verga's first published novel, *I Carbonari della montagna,* which appeared in 1861–62, was begun, according to the author himself, "in a day of national struggle," when the Treaty of Villafranca (July 11, 1859) "blasted" the "fervent hopes and prodigious enthusiasm" of the Italian people.[50] Verga's youthful and somewhat outdated (understandable since he was only nineteen when he wrote it) romantic novel transposed the attitudes and ideologies of 1859 into the circumstances of 1810, and made indirect allusion to Napoleon III's sellout by erroneously casting Murat—then King of Naples and the first Napoleon's brother-in-law—as the ruthless villain of the piece. The heroes are the renegade Carbonari who attack Murat's troops from their hideout in the woods, close to real charcoal burners. Corrado, the valiant leader of the Carbonari, had been born a bastard without name and without estate, hence symbolically linked with the underbrush. The novel abounds in references to the *macchie* of the Carbonari's forest refuges invariably, "in the thickest areas of the underbrush" ("nel più folto della macchia").[51] It is altogether unsurprising that the most significant and praiseworthy review of Verga's book appeared in *La Nuova Europa* on May 23, 1862, the same year that Signorini began writing in defense of the Macchiaioli.[52]

Verga's novel also points out that many of the Carbonari eventually lapsed into brigandage or otherwise survived on the margins of society. Ironically, history repeated itself in Verga's own time after Garibaldi won Sicily for the Kingdom of Italy. Unifi-

cation introduced general national service into Sicily for the first time. It proved to be an extremely unpopular measure, and many families tried to evade the drafting of their males. This led to intense hunting and to severe punishment, and the draft dodgers, too frightened to return, hid out in the dense *macchie* of the forest areas, surviving by brigandage.[53]

Verga was obsessed with the theme, and one of his most popular short stories, "L'amante di Gramigna" (Gramigna's Lover), is the story of a peasant woman's infaturation with a bandit who takes cover in the *macchie*. (The name *Gramigna* itself is Italian for crabgrass,[54] and again identifies outlawry with wild nature.) By throwing in with the bandit, Peppa abandons her fiancé and "civilized" status to live on the edge "like a wild animal." Gramigna and Peppa meet symbolically for the first time "in the midst of the underbrush" ("in mezzo alle macchie")[55] and though Peppa returns to society after Gramigna is captured, she is permanently assigned to marginal status.

Fattori's self-perception as a "renegade" taking part in a cultural "conspiracy" with his "co-conspirators" bespoke this mental connection between Macchiaioli and Carbonari. In the 1850's, his hero, Nino Costa (1826–1903) had even painted *La danza dei Carbonari* (The Dance of the Charcoal Burners), displaying a stormy sunset casting a threatening red and orange glow like the smoldering embers of the charcoal process.[56] Giuseppe Palizzi, a painter also well known to the Macchiaioli who had been affiliated with the Neapolitan School of Posillipo and later settled in France, embarked in that same decade on a series of landscapes on the theme of charcoal burning in the Forest of Fontainebleau.[57] French radicals had organized their own branch of the Carbonari to overthrow their Bourbons, and though by the 1850s the original subversive significance of the group was buried in official history, actual charcoal burners still represented a branch of the rural proletariat harboring strong leftist sympathies.[58] Palizzi's 1857 version, *I carbonai* (The Charcoal Burners), depicting a row of mounds used by the charcoal burners to reduce scrubwood to charcoal, suggests a sequence of relay stations stretching towards the horizon and metaphorically igniting the path to progress (fig. 3.16). No radical patriot in either Italy or France could have missed these references in the 1850s, just as no one could have missed the allusion in Fattori's *Le Macchiaiole* (discussed below) a decade later.

Thus the Macchiaioli identified themselves, again with supreme irony, with the secret associations that stimulated the first practical efforts of the Risorgimento. In this connection it is also worth noting that Freemasonry had furnished the organization and sym-

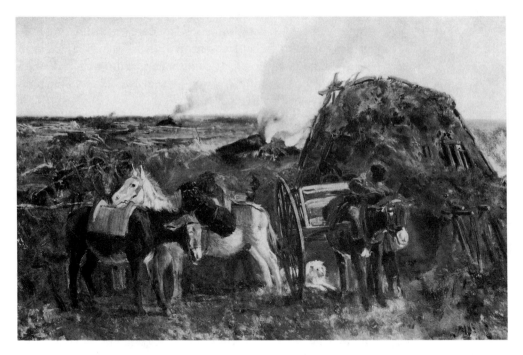

3.16 Palizzi, *The Charcoal Burners,* 1857

bolism of most of the secret societies, including the Carbonari and Giovine Italia. Masonic lodges had been established in all the Italian states during the eighteenth century. As elsewhere, they recruited their members primarily from the educated classes, and they had been instrumental in the diffusion of Enlightenment thought, which put them on a collision course with the Catholic church. By the end of the eighteenth century, masonic lodges in Milan, Tuscany, and Naples had been key centers of reformist agitation within the Old Regime and later of opposition to Napoleonic hegemony. The repressive era of the Restoration put a damper on the masonic mission, but the lodges provided recruits for the new secret societies.

The Carbonari took over the idea of the lodge and the grades of organization from Freemasonry, calling their meeting houses "shops" *(vendite)* for the ostensible sale of charcoal.[59] They also drew their main symbols from the world of the charcoal burners. Initiates made symbolic walks through the woods, representing the progress of humanity towards virtue. An oath was taken with the right hand resting on an axe, the basic tool of the *carbonari,* and other passwords and countersigns based on plants such as nettles and ferns that were found in the underbrush.[60]

The link with secret societies persisted into the mid-century with such distinguished representatives of both wings of the Ri-

sorgimento as Mazzini, D'Azeglio, Ricasoli, Guerrazzi, Garibaldi, Carducci, Mario, Mazzoni, Dolfi, Francesco Crispi, Giovanni di Verità, and Martelli enrolling as Masons.[61] Almost the entire team of *La Nuova Europa* were Masons. The most dedicated adepts and those who achieved the highest ranks in the organization were often to be found on the democratic side: Garibaldi, Mazzoni, Ludovico Frapolli, and Adriano Lemmi all became grand masters. The network of lodges, particularly in the Kingdom of the Two Sicilies, and in duchies like Parma and Tuscany, played a critical role in the democratic movement's anticlerical crusade. Garibaldi became grand master of the Masonic Lodge in Palermo in 1860, giving credence to the suggestion that his extraordinary success in Sicily in this period was facilitated by Freemasons who served in the army of the king of Naples. Martelli's membership reflects his commitment to the ideals of social reform and anticlericalism, which were shared by his friends and guests at his estate, Castiglioncello.[62] In accepting the label "Macchiaioli" with all its subversive shades of meaning, these painters proclaimed their links with the origins and progress of the Risorgimento.

Nowhere is this better demonstrated than in the theme and title of Giovanni Fattori's painting *Le Macchiaiole: Adiacenze Livornesi presso Antignano* (The Brush Gatherers: The Environs of Livorno near Antignano, 1865; fig. 3.17), which showed in the Promotrice of 1866 (then called the Società d'Incoraggiamento). Fattori's title is clearly a play on the root word *macchia* and its double meaning as "spot" and "underbrush," or "scrubwood." Here I must differ with my colleague, Dr. Dario Durbé, who feels that

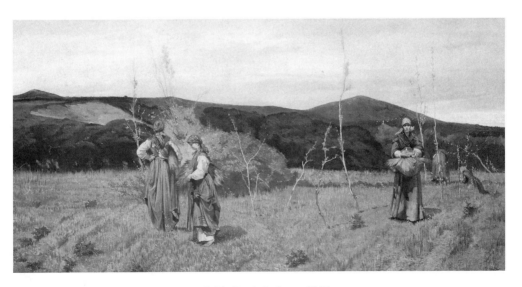

3.17 Fattori, *The Brush Gatherers*, 1865

these meanings were kept quite distinct and that Fattori simply meant to designate the commonplace task allotted to peasant women in the mezzadria system. First of all—as Durbé himself acknowledges—the Macchiaioli were fond of irony and double meanings; Signorini was a notorious punster whose whimsy shows up regularly in his writings and his art. Second, Fattori himself specifically associated the picture with the polemics surrounding the group.

Finally, it should be noted that a long line of Italian critics themselves often mistakenly credited Fattori with originating the name of the group thanks to the notoriety gained through the exhibition of his picture. As one later critic commented in assessing Fattori's role in the movement,

> In this connection, it would not be out of place to clarify a misunderstanding that many people still perpetuate, taking Fattori not only as one of the quintessential representatives of the Florentine Macchiaioli, but also as the founder and baptizer of that artistic group which had taken its name from a picture by him entitled *Macchiaiole,* painted at Antignano and exhibited at Florence in 1867 [*sic*].[65]

This confounding of title and group designation cannot therefore be mere coincidence, but is historically bound up with the aims and thematics of its leading practitioners. In an autobiographical fragment of 1889, Fattori recalled that when it was exhibited, "*Le Macchiaiole* (feminine plural) . . . was awarded a gold medal, [and] was the cause of stormy debates [*di grandi discussioni*] between the *academics* [*classici*] and the *macchiaioli* [masculine plural]," and he italicized only three terms, the title and the two stylistic denominations.[63] Since by 1866 the group's label had become a byword in Florentine art, it would seem that Fattori deliberately painted the work of "three ragged peasant women" collecting scrubwood on a scale usually reserved for history painting (90 × 180 cm).[64] As we have seen, the Macchiaioli frequently identified themselves with the underclasses in this way. Both Signorini and the critic, Diego Martelli (1838–1896), defended Fattori on these grounds against the uproar that followed the bestowal of an award on the picture at that Promotrice.

The theme of the brush gatherers was not only taken up by Cristiano Banti who did several important variations in the 1860s that he entitled *Le Boscaiuole* (The Women Wood Gatherers), but their younger disciple Francesco (Cecco) Gioli—a second-generation Macchiaiolo—projected on a monumental scale the

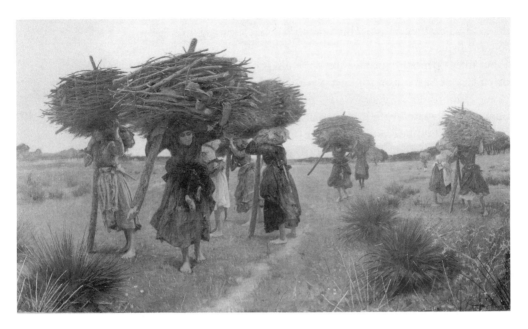

3.18 Gioli, *The Women Wood Gatherers*, 1887

same theme (fig. 3.18).[66] Gioli's large-scale production (6 × 10′) depended on Fattori's precedent, but surpassed it in size and emphasis on the laboring women.[67] Completed in 1887 and first exhibited in Venice that same year, the work presents a panoramic view of the vicinity of San Rossore. San Rossore was a wooded retreat north of Pisa, not far from Castiglioncello, the location of Diego Martelli's country estate. Martelli regularly invited members of the Macchiaioli group to his estate in summer, and Gioli participated in these gatherings in the 1870s.[68] In this way, Gioli received valuable counsel from Martelli and the veterans who surrounded him. It was perhaps during one of these summer retreats that Gioli executed his portrait drawing of the critic. Known as "Cecco" to his inner circle of friends, Gioli carried on a warm and lively correspondence with several of the Macchiaioli artists, including Fattori and Lega who painted his portrait.[69]

Under their influence, Gioli produced a number of pictures of working people whose titles derived from the suffix *-aiolo*, including *Renaioli*, *Renaiole* (sanddiggers or sand porters), *Lanaiuole* (female wool combers), and the *Boscaiuole*. These scenes depict robust men and women moving together in rhythmic order. The *Boscaiuole* shows a group of women of different generations returning from the forest with a heavy pile of wood faggots heaped up on their backs. The weight of these loads is discernible from the bent backs of the laborers, who are forced to rest at regular

intervals. The women carry stout poles to relieve the pressure of the load when they pause, which they also use to lean against for support like a crutch.

Set into a panoramic landscape belonging to an estate used by the dukes of Savoy as a summer retreat, the file of women progresses toward the spectator much too preoccupied with their labors to participate in the contemplation of the landscape. Their heavily weighted bodies confront the spectator and actually disrupt the traditional distance normally provided by the landscapist to allow the viewer to "get into" the picture and avoid having to experience the actual social relations of the countryside. Here there are no idling shepherds or pastoral accessories to encourage the contemplative stance; on the contrary, the work-laden women overpower the landscape field and seize the beholder's attention. The sweep of the stark, barren environment heightens the effect of fatigue: the women appear to recede and advance in perspective across a wide expanse of terrain, suggesting the long distance they have had to traverse and the distance they have yet to cover.

The vertical line of the bodies of the women trying to remain upright with their stout poles and the horizontal crossbar formed by the bundles of brushwood establish silhouettes of a tree-like form. The women's bodies serve as surrogate topographical features in this otherwise monotonous stretch of plain. Thus they are shown to us rooted metaphorically to land, with the seemingly endless procession creating the mechanical operation of a cyclical movement in tune with the ebb and flow of the work process itself. Gioli's privileged class position perhaps intrudes itself here, but he never demeans women's labor by trivializing it, nor does he evade the excruciating pain and struggle of their labor, the wear and tear of toil on their physical beings.

At the same time, Gioli's attempt to heroize hard-working female laborers is unusual for the time, as is readily seen when it is set against sentimentalizing representations of similar themes by his Florentine contemporaries Cannicci and Ferroni as well as by foreign contemporaries like the French Jules Breton and the American Eastman Johnson (figs. 3.19–3.22). Cannicci and Ferroni are the most photographically accurate of this international group but anecdotalize fieldwork for a bourgeois audience, while Breton and Johnson tend to idealize and even trivialize work and those engaged in it. Unlike Gioli, all four are reluctant to portray the effects of rural labor on the minds and bodies of their subjects. Gioli's singular commitment to the faithful depiction of wearisome toil startles the spectator by its rare closeup realism and monumental projection. The fact that Gioli projected a theme devoted to rural labor on such a heroic scale suggests his calculated attempt to reenact the saga surrounding Fattori's *Le Macchiaiole*.

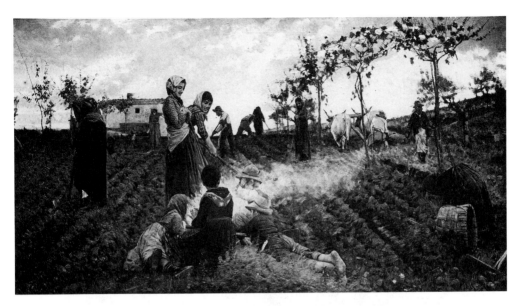

3.19 Cannicci, *The Sowing of Grain in Tuscany,* 1882

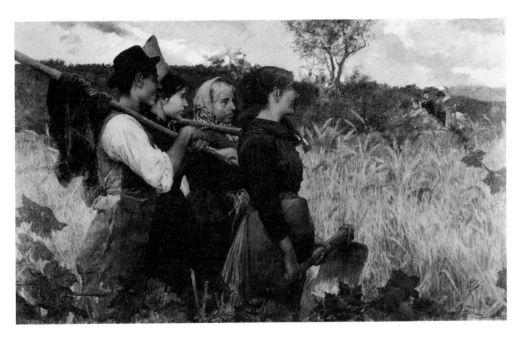

3.20 Ferroni, *Return from the Woods,* 1881

It is this commitment to an extreme close-up and lifesize expression of the effects of labor on working people, and especially women, that singles out this work in the 1880s. Consistent with Macchiaioli detachment, he neither prettifies nor sentimentalizes physical labor. Ironically, it is at the moment when the older generation began to drift from their original commitment to Ri-

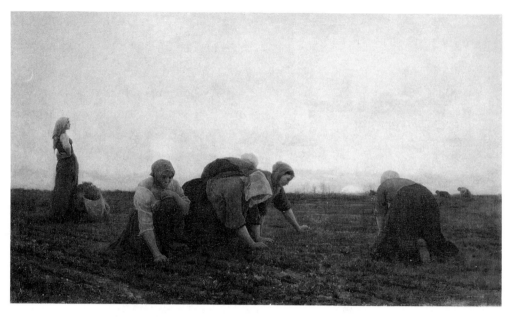

3.21 Breton, *Pulse Gatherers*, 1868

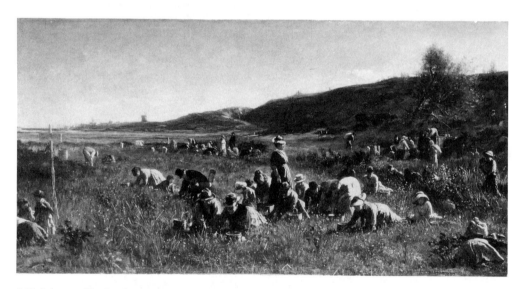

3.22 Johnson, *The Cranberry Harvest*, 1875–80

sorgimento ideals that Gioli produces a picture that reaffirms them. His methodical examination of female labor, his heroic projection of unheroic activity, and his photographic naturalism kept alive the political progressivism of Macchiaioli aesthetics.

This should not seem surprising, given the theoretical and practical foundation of their work. For Risorgimento progressives art production could not be understood apart from social and politi-

cal history. Nor did it constitute a category of social realism in the modern ideological sense: they clearly perceived visual practice as embedded in the matrix of their political norms. Mazzini wrote that for Italians "Art is eminently a social manifestation, an element of collective development inseparable from the play of all the other elements which together form that stock of life whence the Artist, consciously or not, draws his mission."[70]

FOUR

The Macchia and the Risorgimento

The genesis and development of Macchiaioli practice coincides with the critical chain of events of the Italian Risorgimento leading to Italian independence and unity: the participation of the Piedmontese army in the Crimean War which won for Cavour the admiration and support of France and England; the participation of Piedmont in the Peace Conference of 1856; the union of the French and Piedmontese against the Austrians in 1859; the popular uprising in Florence and the expulsion of the grand duke of Tuscany; Garibaldi's madcap adventure in the Kingdom of the Two Sicilies in 1860, and the annexations to the Kingdom of Sardinia-Piedmont of Lombardy, Tuscany, Parma, Modena, the Romagna, and the Two Sicilies (Naples and Sicily). Although historians debate over the time of the origin of the liberal nationalist development, there can be no doubt that it reached its territorial peak between 1859 and 1861—the year the Kingdom of Italy was proclaimed. The Macchiaioli themselves unequivocally attributed the emergence of their innovative collective enterprise to their actual and/or imagined participation in this movement.

Eighteen thousand Piedmontese troops left for the Crimea in April 1855, and in August fought tolerably well against a superior Russian force in the battle of Tchernaya. In this same year the famous Universal Exposition in Paris, France's competitive response to England's Great Exhibition of 1851, attracted international crowds that included the Italian painters Domenico

Morelli, Francesco Saverio Altamura, and Serafino De Tivoli. Telemaco Signorini, a Macchiaiolo and the historian of the group, wrote that De Tivoli was at that time the most innovative thinker of the Caffè Michelangiolo clientele and introduced them to the powerful light effects and paint handling that he had discovered in the works of the French Barbizon and realist painters Decamps, Troyon, and Rosa Bonheur at the Universal Exposition. This introduction entitled him to be called the "papà della macchia."[1] Thus the military and diplomatic breakthrough achieved by Cavour in the Crimea coincided with the aesthetic discoveries of the Macchiaioli.

While in 1855 Piedmont-Sardinia and Tuscany were separate states, their fortunes had already been linked in 1848 when Grand Duke Leopoldo II sent a small force of regulars to help King Carlo Alberto of Piedmont in his abortive effort to defeat the Austrians in Lombardy. In his proclamation of war to the peoples of Lombardo-Veneto, Carlo Alberto used the phrase "*L'Italia farà da sé*" (Italy will make it on its own), a slogan that became the popular expression of Italian hopes in 1848. Throughout Italy liberals urged and even forced their princes to follow Carlo Alberto's lead. Leopoldo II, although a Habsburg, issued a stirring proclamation in which he reminded Tuscans that the cause of Italian independence would be decided on the fields of Lombardy. Even King Ferdinando of Naples, who since January 1848 had been a constitutional king, proclaimed the necessity of participating in the struggle, although the Neapolitan troops never marched beyond Bologna. Not coincidentally, the future Macchiaioli and their friends had responded to the call for action: De Tivoli had enlisted with the Tuscan volunteers who fought in this campaign. Morelli and Altamura had participated in the Naples uprising in May 1848 and eventually were forced to seek asylum in Florence. Hence all three participated in the 1848 insurrections marking the initial phase of the unification struggle.

Their presence in Paris in 1855 had both aesthetic and political motivations. They came to view the work of their friend Vito d'Ancona and that of his teacher Giuseppe Bezzuoli which was shown in the Tuscan display of the Fine Arts section.[2] They also joined part of a larger Tuscan contingent that traveled to Paris to demonstrate support for both the cultural and industrial products of their countrymen. The great Chianti wine producer, Bettino Ricasoli, won a medal for his exhibit, which attracted many Florentine business leaders to Paris, including Cosimo Ridolfi, a pioneer of Tuscan industry and agriculture, and Lorenzo Ginori, the head of the porcelain manufactory in Tuscany.[3] All three were

wealthy landowners who belonged to the prestigious Accademia dei Georgofili, an association whose aim was "the progress, encouragement, and propagation of theoretical and practical knowledge concerning agriculture and any other branch of Economy."[4] Like the painters, they came to Paris not only to see the display of Tuscan industry and agricultural products but also to catch a glimpse of the latest international technical and artistic advances.

The awards ceremony for the 1855 exhibition was opened by the emperor's cousin, Prince Napoleon, who linked the spectacle at home with the stunning victories of the French in Crimea. He claimed that the exposition embodied the emperor's most cherished dreams of progress, setting out before all the nations examples of French perfection in the methods and instruments of labor. Agriculture, especially, which received the emperor's generous solicitude, stood out for its mechanical advances and its potential contribution to the national prosperity. At the same time, these advances promised to emancipate the field-worker, the farmer, and the sharecropper from the "brutal part" of rural labor. These ideas profoundly affected Ricasoli, who shortly afterward experimented with a new mechanical reaper on his recently acquired lands in the Tuscan Maremma.

The aesthetic complement of this spirited promotion of agricultural progress was the rural-scene-painting of the French Barbizon school, which was brilliantly represented in the 1855 exposition. These paintings drew the attention of the Italian artists, especially De Tivoli, with their novel techniques, rustic themes, and fascination with naturalistic light effects. Since 1848 and the peasantry's attainment of the vote there had been increased awareness of agrarian experience among French painters, and even the government of Napoleon III found it expedient to enhance the status of the painters of rural life. De Tivoli's favorites—Alexandre-Gabriel Decamps, Constant Troyon, and Rosa Bonheur—all received the highest awards of distinction in the closing festivities of the universal exposition.

Decamps, who received a Grand Medal of Honor for his fifty-nine works, was already familiar to the Florentines through their contact with Demidov and his collection. His pioneering efforts in the representation of peasant labor was exemplified at the world's fair by the *Chevaux de Halage* (Towing Horses) which had been purchased by the emperor for his private collection (fig. 4.1). In addition to his themes, Decamps's daring experiments with surface textures and eccentric compositions decisively influenced the Macchiaioli: such sample specimens at the exposition as the *Cour de ferme* (Rustic Courtyard) with its areas of

encrusted pigment standing in for rustic textures and its stark exchange between shadow and sunlight contributed to their esteem of dazzling sunlit scenes framed by archways forming vivid contrasts of light and shadow (figs. 4.2–4.4). Signorini would later describe this effect of relief and broad handling of lights as "violent chiaroscuro" of the type that gave birth to the macchia.[5]

Another work Decamps exhibited in 1855, *La Défaite des cimbres* (The Defeat of the Cimbri), would have particularly appealed to the Italians (fig. 4.5). It depicts a crucial victory of the Romans, led by Gaius Marius, over the ancient German tribes the Cimbri and Teutoni, in the valley of Aix-en-Provence in 102 B.C. Previously, the invading tribes had inflicted a series of cataclysmic defeats on the Romans and stood poised to threaten the very gates of Rome itself. Marius reversed the tide of misfortune, and eliminated the threat conclusively the following year with the annihilation of the Cimbri in northern Italy. The stirring appeal of this theme is reflected in the fact that in 1859 Ricasoli, as head of the Provisional Government in Tuscany replacing the ousted Austrians—the modern Cimbri—decreed the subject as one of a series of competitions for patriotic national art. Ironically, it was Altamura, one of the triumvirate of Florentine-based painters making the pilgrimage to the 1855 exposition, who won this particular commission.

The ambiguous political and military aims of Napoleon III ran counter to Italian ambitions, and the preponderance of French over Italian troops made battle outcomes somewhat dubious representations for Italian nationalism. Thus the battle scenes commissioned by the Ricasoli government required innovative pictorial and thematic strategies to make them acceptable to the Florentine public. Here again Decamps may have provided a precedent: eschewing the conventional heroic bombast of military pictures, he emphasized the landscape and downplayed individual action in favor of the collective heroism of the Roman armies. For his picture he studied the topography of the original site of the battle on a plain located near Aix-en-Provence, an effort that would have also reinforced the Macchiaiolo sense of realism (fig. 4.6). In addition, the landscape study gives an indication of his masonry-like *empâtements* and variety of pictorial procedures that he carried over into his final Salon exhibit which he nevertheless considered nothing more than a "large sketch [*esquisse*]."[6]

Troyon's paintings of rural life with their sharp light effects and scumbled and heavily impasted animal bodies would have been familiar to the Macchiaioli and their circle (especially to Morelli and Altamura) through the French artist's exchange with the seminal Neapolitan realists and Risorgimento activists, Filippo

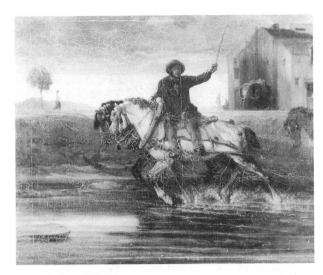

4.1 Decamps, *Towing Horses,* 1842

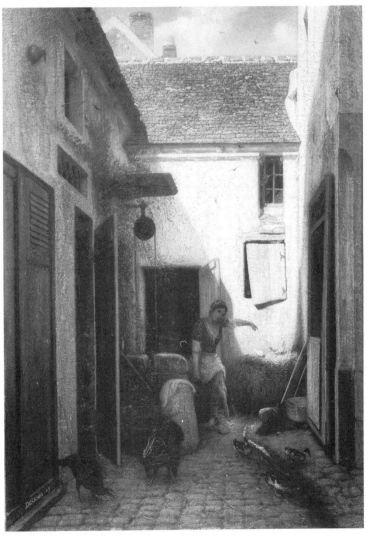

4.2 Decamps,
Rustic Courtyard, 1849

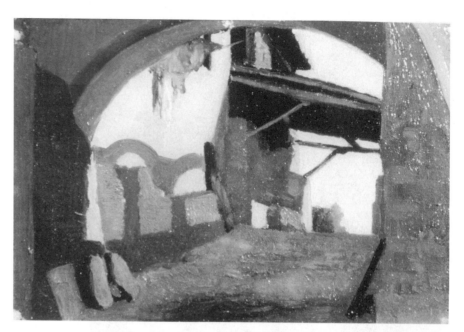

4.3 D'Ancona, *Portico,*
ca. 1861

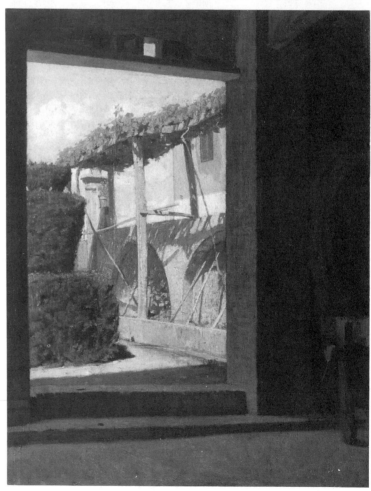

4.4 Giuseppe Abbati, *View
from Diego Martelli's Wine
Cellar,* ca. 1865–66

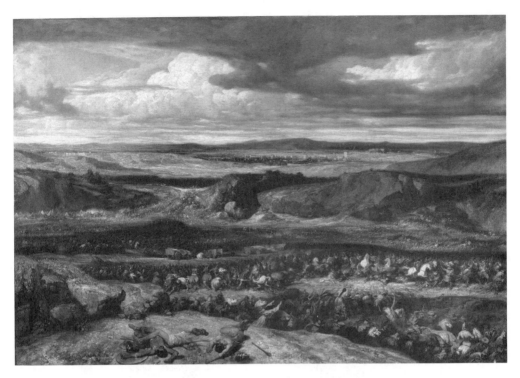

4.5 Decamps, *The Defeat of the Cimbrians,* 1833

4.6 Decamps, *Study for the Defeat of the Cimbrians,* ca. 1832

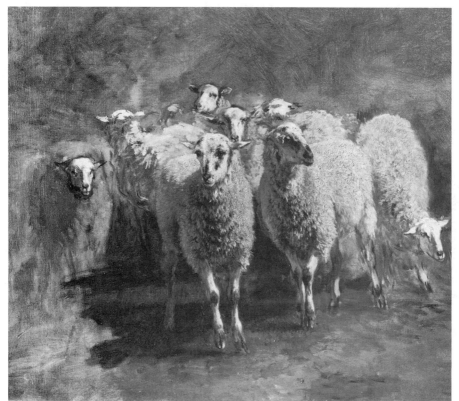

4.7 Troyon,
Study of Sheep,
ca. 1850s

and Giuseppe Palizzi (figs. 4.7–4.9).[7] (Indeed, Giuseppe himself exhibited four works in the French section in 1855 and was well received by local critics.) Troyon's *Les boeufs allant au labour; effet du matin* (Oxen Going to Work; Morning Effect) was one of the sensations of the exhibition and described as a "masterpiece" by one critic (fig. 4.10).[8] Both visually and thematically, it presented the key ingredients sought after by the Italians: vigorous brushwork and an accentuated light effect linking bodies and their field of action, and the celebration of the everyday "heroism" of domesticated country life. De Tivoli's attraction to Troyon is seen in one picture done after his return from Paris, *Una pastura* (A Pasture), that is based directly on one of the French master's favorite motifs, *Vaches à l'abreuvoir* (Cows at the Watering Place), a version of which accompanied *Oxen Going to Work* at the exposition (figs. 4.11, 4.12).[9] De Tivoli substituted Troyon's more veristic bucolic isolation for Markò's conventional arcadianism while yet preserving the Tuscan backdrop.

Rosa Bonheur sent only one work to the world's fair of 1855, but Gautier considered it a "very beautiful thing" and enthusiastically praised its authenticity and science.[10] Her *La fenaison*

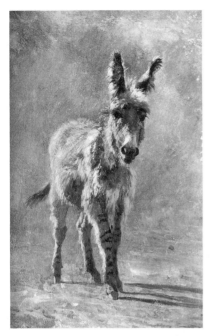

4.8 Palizzi, *A Donkey*, ca. 1866

4.9 Palizzi, *Friends*, 1866

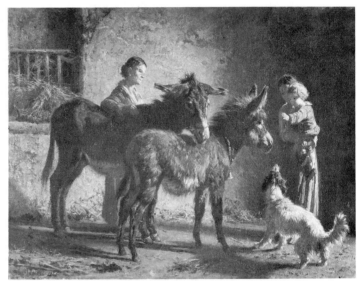

4.10 Troyon, *Oxen Going to Work*, 1855

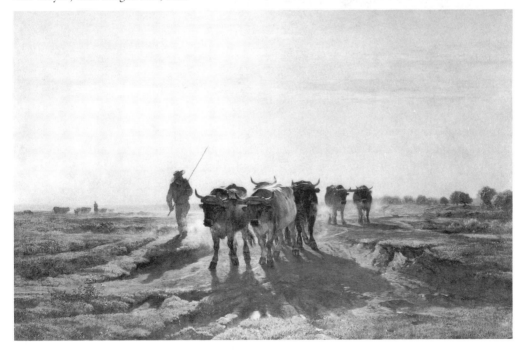

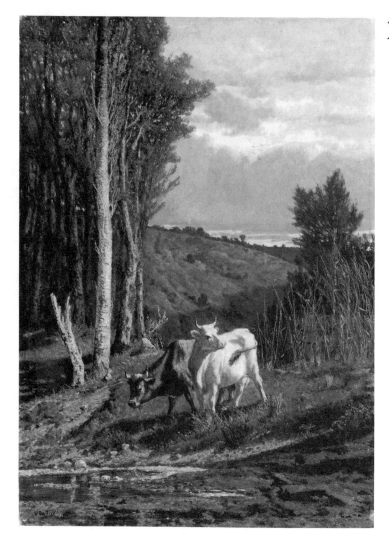

4.11 Serafino De Tivoli, *A Pasture*, ca. 1856–59

(Auvergne) (Haymaking in Auvergne) typically focused on the animals in the foreground, but went beyond Troyon and Breton in carefully depicting the various stages of labor involved in hay-making (fig. 4.13).[11] Bonheur dignifies labor by representing the farm workers as serious and dedicated to their separate tasks of mowing, raking, pitching, and stacking, and projecting this annual harvest event on a monumental scale. Critics did not fail to observe the striking and, for some, disturbing color effect created by the juxtaposition of the brilliant azure sky with the deep green of the new-mown hay and fields, as well as the luminous patches in the white blouses of the haymakers scattered throughout the composition.

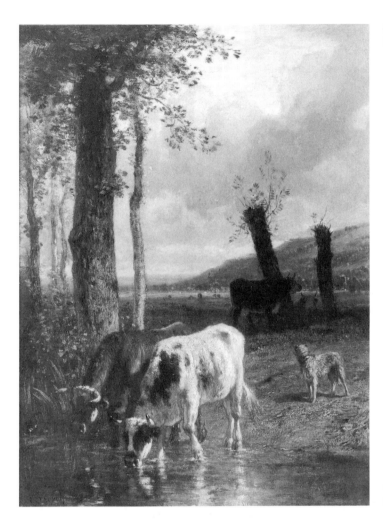

4.12 Troyon, *Cows at the Watering Place,* ca. 1850s

4.13 Bonheur, *Haymaking in Auvergne,* 1855

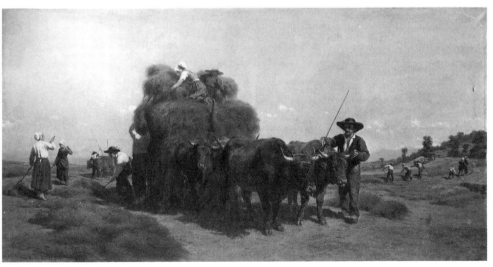

Gautier's review of Bonheur's picture opens with a statement of male condescension towards female artists as a way of respecting Bonheur's singular contribution: "With her, there is no need of gallantry; she does her work seriously and we may treat her as a man. For her painting is not a kind of trivial embroidery [*broderie au petit point*]." The attachment of the Macchiaioli to Bonheur is never qualified by his kind of masculine bravado; their quest for an authentic national voice took the form of an openness to fresh aesthetic efforts that paralleled their progressive political participation in a movement that pushed against the contemporary barriers of gender, class and ethnic prejudice. Bonheur's sex did not hinder their discovery in her work of an important precedent for their own activity. Ironically, the English Pre-Raphaelite critic William Rossetti, whose Neapolitan father had enlisted in the ranks of the Carbonari prior to settling in England, and whose sister Christina was a gifted poet, shared this attitude towards Rosa Bonheur in a review of the 1855 exposition: "That wonderful woman, Rosa Bonheur, contributes to the French Exhibition here; a woman, I imagine, unprecedented in Art for vigor and ability armed at all points. A sketch by her of two calves, is among the most admirable things I know, of a truthfulness, and thence a beauty, quite touching." [12]

The light-infused landscapes of Bonheur, Troyon, and Decamps, with their palpable surface textures, seemed to impart to rural scenery a modern look equivalent to the official ideal of agricultural progress. In addition to the documentary look, these textures defined the rustic locale in specific, and therefore, empirical terms. The concept of a modern style of painting that could parallel modern industrial and agrarian progress was what De Tivoli, Altamura, and Morelli brought back to their artist friends in Florence. The presence of De Tivoli and his colleagues in Paris at that moment, like that of Ricasoli, Ginori, and Ridolfi, was an expression of their need to keep abreast of a changing, contemporary world. The convergence of their aims may be seen in the fact that Ridolfi was soon to collect De Tivoli's work. [13] Just four years later they would pin their political and economic hopes on the military and political alliance between Piedmont and France. It is in this sense that the birth of the macchia is inseparable from the desire to raise Italy to the level of other cultural, economic, and political powers.

The Prince Napoleon who opened the awards ceremony also led the Fifth Army Corps of the French army into Florence in late May 1859, with the avowed purpose of maintaining order in the city and guarding the Florentines from an Austrian takeover. On April 27, the same day that Austria had declared war on Pied-

mont, the grand duke was expelled from Florence. Ricasoli, who became head of the Provisional Government, offered the king of Piedmont the dictatorship of Tuscany for the duration of the war with the understanding that a final political settlement would follow the peace. Pressured by right-wing extremists, Ricasoli requested troops from Piedmont to maintain order in Tuscany. Cavour declined since he felt he could not spare the soldiers, and Ricasoli then turned to the French. On May 17 Napoleon III decided to send Prince Napoleon to Tuscany with the multiple strategy of impeding Piedmont's ambitions in central Italy, staving off the "socialist" movement that he suspected lay behind the Florence uprising, and intimidating the Austrians. Outside these flimsy pretexts, the dispatch of French troops to Tuscany lacked the slightest military justification.[14]

The French troops arrived in Florence on May 28 and made camp on the great meadow of the Cascine, a park in Florence extending parallel to the northern back of the Arno River (fig. 4.14). Called the Pratone, this meadow was the site of a racetrack which the Florentine upper classes attended on Sundays. It was framed on one side by a wooded area and on the other by the outlines of the Apennine hills. The French set up double rows of tents, and the spectacle of these tents, together with the cavalry horses and other military equipment, struck a strange note in the park so often used for promenades and entertainment of various sorts. French engineers even went so far as to erect a showy temple in front of the camp, ornamented with a variety of military trophies and guarded by the colossal busts of Napoleon III and Vittorio Emanuele. Like the town itself, the park was draped through its length and breadth with the tricolored flags of the allied forces.

After the enthusiasm of the initial reception, however, the spectacle of the French troops in the park degenerated into a form of public entertainment. Crowds and carriages began circulating through the rows of tents which now provided a theatrical backdrop for the groups of idle soldiers chopping down park trees, cooking, eating, shaving, and dressing. Refreshments were sold by street vendors, and citizens and soldiers danced together to the tunes of the military band.[15] The invincible military machine began to expose its soft underbelly, opening itself to question and challenge.

It is within this context that we may appreciate Giovanni Fattori's first experiments in the macchia technique. Like his fellow Tuscans, he was drawn to the Cascine to watch the French troops play at soldiering in the park. His seminal studies eliminate the obvious absurdities of the French presence while yet retaining their anomalous condition, examining them with a sobriety and

4.14 *Arrival of Prince Napoleon at Florence, May 31, 1859, L'Illustration*

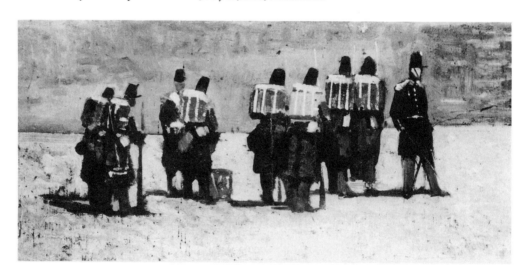

4.15 Fattori, *French Soldiers of '59*, 1859

gravity that set the tone for the Macchiaioli movement. His *Soldati Francesi del '59* (French Soldiers of '59) attests to a new direction in his work, a shift from the academic history pictures of his teacher Bezzuoli to a type of modern history painting based on perceived experience (fig. 4.15). While the series of studies of

soldiers in the Cascine were only tentative, they inaugurated his lifelong fascination with military themes and led to his more monumental Risorgimento battle scenes.

The military picture—that is, scenes depicting contemporary soldiers—permitted young artists trained in the academic tradition legitimately to introduce modern subjects into their work. The spectacular battle was consistent with traditional emphasis on glorious exploits and heroic bombast, but at the same time it required careful study of topography, uniforms, the time of day, and even weather conditions. While no painter of battles could avoid sliding into nationalist propaganda, even the most blatant images of military aggrandizement demanded a high degree of realism. Among military painters of the nineteenth century, however, Fattori was unique not only in divesting his scenes of heroic grandeur but in depicting battles which his side lost.

Of all the Macchiaioli, Fattori was the only one who continued to paint military subjects after unification. Eventually he evolved a stereotyped approach to satisfy a lucrative market stimulated by the moderate liberals who most profited from the Risorgimento. But throughout his career he insisted on fidelity to his perceived view of reality and on the originality of his treatment. In 1873 he wrote his dealer in Trieste, for whom he painted a number of military scenes, that what his work might lack in smoothness and unity of color it more than made up in its attention to actuality and the "exact impression." And he concluded: "Every artist has his monogram, every artist has his way of interpreting reality. . . . If I have acquired a modest reputation in the exhibitions, it has been only on the basis of my originality which neither imitates nor recalls the work of anyone else."[16]

In 1859, he aimed at an accurate depiction of reality and at affirming that his perception had a subjective component that constituted his originality. This went right to the heart of the macchia concept, explaining its heterogeneous manifestations by the Macchiaioli. Fattori developed a characteristic viewpoint of military personnel, often depicting them from the rear on horseback or standing guard, or against neutral backdrops whose bright reflections and contrasting ground emphasize the isolation and tension of military life (fig. 4.16). Military life is neither romanticized nor glorified; Fattori reveals its tedium, its loneliness, its wastefulness, its dreadful anticipation. He derived these insights in part from his exposure to the French contingent on the grounds of the Cascine in late May and early June of 1859.

Thus the *French Troops of '59* is a fundamental study that declares Fattori's new direction and speaks for the outlook of his colleagues. Yet without a consideration of Risorgimento politics it makes little sense. The strangely silhouetted troops staggered

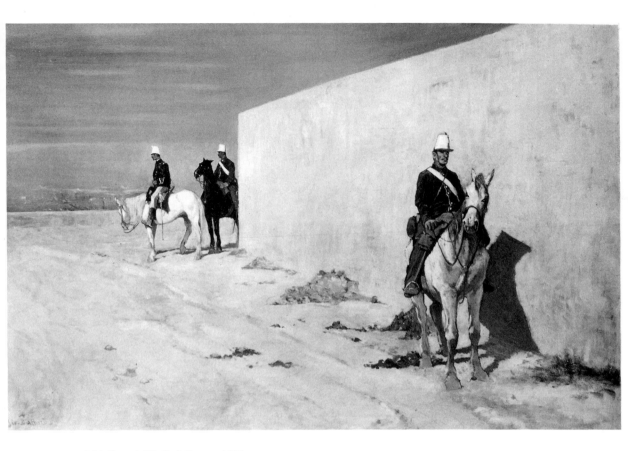

4.16 Fattori, *The Look-Out*, ca. 1872

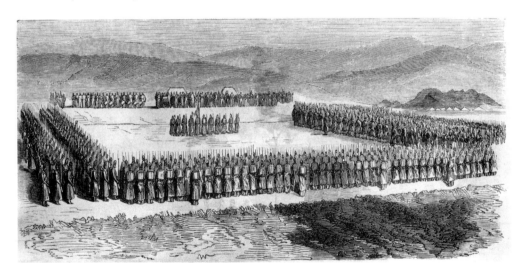

4.17 *General Blanchard Distributing Medals, L'Illustration*, July 2, 1859

in pairs are frozen into immobility by the contrasting back-
ground, somewhat reminiscent of popular newspaper illustrations
of troops in review in a vast open terrain (fig. 4.17). Fattori's
soldiers, however, seem to hover in midair, and despite the cast
shadows they lack fixity of position and project irresolution and
uncertainty. Fattori closely observed the distinction between the
slovenly troops and the more regal bearing of the officer at the
right, but the body of the officer is twisted in expectancy and
seems as confused as the infantrymen. The situation of these
troops is ambiguous and tentative, and Fattori's summary tech-
nique is eminently well suited for the blurred reality of the French
presence in Florence at this time.

But Fattori does not reveal them as the circus oddities they
were for many Florentines. He neither exaggerates nor dramatizes
their circumstances; if anything, his study is understated and dis-
passionate. Like the faceless heads of the soldiers, the picture is
deadpan and uninflected. This restraint seems surprising in view
of the events of the period and the excitement and enthusiasm for
the Risorgimento. Yet it is in exactly this sense that Fattori and
his fellow Macchiaioli address the history of their time—not
in the romantic, swashbuckling manner of such predecessors as
Hayez and Bezzuoli, who looked to the past for the energy that
was lacking in the present—but in the day-to-day unfolding of
events. The lack of emotion and the corollary realism of the mac-
chia are based on a candid appraisal of the visual facts rather than
on a projection of the good things to come. The many disappoint-
ments and disillusionments attending the Risorgimento did not
allow for positive anticipation. This detachment is the foundation
of Macchiaioli empiricism and progressive materialism.[17]

We see this attitude again in Fattori's painted studies of military
life from 1860 such as the *Accampamento di bersaglieri* (Bivouac
of the Bersaglieri) and the *Accampamento* (The Encampment),
both signed and thus not meant to serve as the basis of a more
magisterial theme (figs. 4.18, 4.19). The *bersaglieri* (sharpshoot-
ers, from *bersaglio* or target) with their distinctive plumed hat,
represented an elite cadre in the Piedmontese army akin to the
French Zouaves. They were skilled in quick maneuver and assault
on a single tactical target, especially in mountainous or rugged
countryside. This unit distinguished itself in the Crimean cam-
paign as well as in 1859. In the *Bivouac of the Bersaglieri*, however,
Fattori does not celebrate their already legendary boldness but
instead brings us close up to the drab routine of camp existence.
In *The Encampment* he takes a panoramic view of the camp-
grounds which spread out into the Tuscan countryside, a routine
sight throughout Italy in this period as demonstrated by repor-

4.18 Fattori, *Bivouac of the Bersaglieri*, 1860

4.19 Fattori, *The Encampment*, ca. 1860

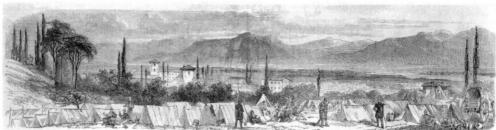

4.20 *Bivouac of Piedmontese Troops . . . after the Battle of Solferino, L'Illustration*, July 9, 1859

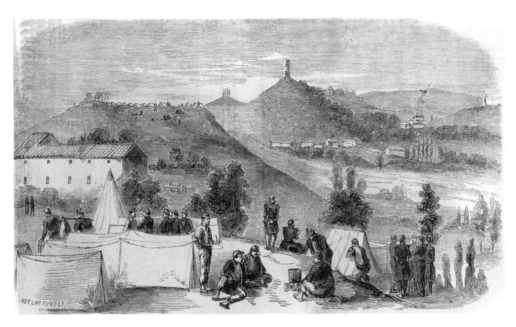

4.21 *Bivouac of the Third Corps at Solferino, L'Illustration,* July 9, 1859

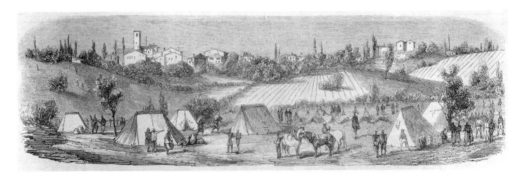

4.22 *View of Gavazzano, on the Road to Tortone, L'Illustration,* May 28, 1859

torial illustration (figs. 4.20–4.22). The uniformity and regimentation of the troops are seen in the neat rows of tents that extend along the horizontal plane like anchored sailboats. Troops are seen loitering in groups or individually, their presence quickly noted in abruptly shifting dabs of paint. When we recall that 1860 was the peak year in the political unification of Italy, unification brought about largely through military action, Fattori's representations of army life seem as breathtakingly detached and low-keyed as the newspaper graphics.

Dario Durbé has called attention to the relationship of *The Bivouac* to Fattori's early Tuscan landscapes of around the same time.[18] The painter's obsessive concern for truthful images of mili-

tary life required precise rendering of the topographical character-
istics of landscape, whether battlefield or campground. In linking
Italian troops to a specific Tuscan site, Fattori made his first con-
tribution to modern Italian realism and the modern patriotic
ideal. He substitutes for the bombast and overblown heroism of
Hayez and Guerrazzi the unadorned, uninflected examination
of reality constructed by the ideological aspirations of Tuscan
progressives.

THE RICASOLI COMPETITIONS

During this same period, Fattori and his colleagues made their
initial entry into official Risorgimento culture. The Provisional
Government under Bettino Ricasoli decreed a series of compe-
titions for fine artists on September 23, 1859. The proposed
themes were directly tied to Florentine history and the recent
events of the Risorgimento. Considering the sad state of the Tus-
can economy after the expulsion of the grand duke, foreign ob-
servers questioned the Provisional Government's willingness to
allocate a relatively large sum of money for the encouragement of
the fine arts, no matter how noble the enterprise. As they were
soon to discover, however, the contests were only a small part of
a huge propaganda campaign. Ricasoli used the press, public
ceremonies, and even cultural events to prepare the public to ac-
cept Tuscan annexation to the Italian union as a fait accompli.
Throughout the remainder of 1859, Ricasoli spoke recklessly of
the union as an accomplished fact, a mad risk backed by his ardent
propaganda campaign.

Bettino Ricasoli (1809–1880) descended from one of the
oldest noble families in Tuscany which since the eleventh cen-
tury had controlled the Chianti hills between Siena and Florence
(fig. 4.23).[19] He carried on the family enterprise effectively by
rigid discipline and the application of advanced techniques in his
agrarian activities. He won awards at the major world's fairs for
his fine Chianti wine which is still produced on the Ricasoli es-
tates, and the labels on the present-day bottles proudly bear his
portrait (fig. 4.24). His determined expression and bearing con-
vey that fixity of resolve that carried him through the complicated
maneuvers of 1859. That the Macchiaioli, despite their more
radical position, were in sympathy with the "Iron Baron's" action
in favor of the painters is seen in Raffaello Sernesi's portrait
from around the time of the announcement of the competitions
(fig. 4.25).

Following the armistice of Villafranca, a complex series of po-
litical and diplomatic machinations were to determine the future of

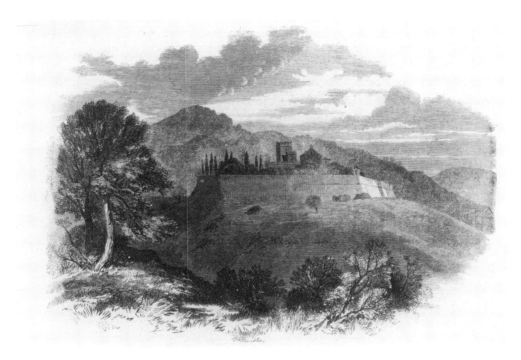

4.23 *Brolio, The Ancestral Seat of the Ricasoli Family,* the *Illustrated London News,* August 3, 1861

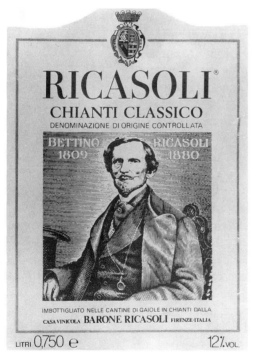

4.24 Chianti Classico Bottle Label, 1986

4.25 Sernesi, *Bettino Ricasoli,* ca. 1859

Modena, Parma, the Romagna, and Tuscany. As hinted earlier, in all these territories a popular revolutionary movement demanded union with Sardinia-Piedmont under Vittorio Emanuele. Both Cavour and the king wanted to annex them, but they hesitated to offend Napoleon III, who had stipulated in the agreement that the Dukes of Modena and Parma and the Grand Duke of Tuscany should be restored. Since Villafranca, however, public opinion in Great Britain grew fervently pro-Italian, and the new Liberal government of Palmerston, Russell, and Gladstone showed itself more sympathetic to Sardinia and the Italian cause than the previous Conservative government. Napoleon III began to waver on his policy; he knew the Villafranca agreement nullified his wish for Savoy and Nice, and now thought to strike a new bargain with Vittorio Emanuele, sanctioning the annexations of the duchies in return for Savoy and Nice.

Meanwhile, Ricasoli, who had gradually reached the conclusion that the welfare of Tuscany and his own political future lay in union with Sardinia-Piedmont, elected to assume power and to work closely with the government at Turin. Ricasoli reached this decision only after slow and painful deliberation. He had not at first wished for the expulsion of the Grand Duke, and even fled Florence the night before the demonstration. The actual work of the "pacific revolution" was carried out by the Left on the night of April 26. But the departure of the Grand Duke and the overwhelming enthusiasm for Piedmont in its struggle with Austria, convinced Ricasoli that his best interests lay with Piedmont. A moderate liberal-to-conservative thinker on political questions, Ricasoli feared revolution from below and invasion from above. He therefore worked to bring central Italy into the Piedmontese state. He had many opponents on both sides of center; some of these wanted a separate kingdom of Tuscany under a prince of the House of Savoy but not outright annexation. Ricasoli tried to convince his peers that fusion was the ideal of the majority, even though autonomists clearly outnumbered the others. But except for a tiny reactionary faction who had privileged positions in the Grand Duke's court, almost all the liberals and radicals united in their opposition to a restoration of the Grand Duke. The whole thrust of Ricasoli's energy in late 1859–60 was to prevent the fallen dynasty of Lorraine from returning again to Florence.

Ricasoli, who actively promoted and advertised his wines and was anxious to increase trade through union with Piedmont, proved to be an expert on the use of propaganda. In order to shore up his political position, he tried to fix in the public mind the idea of annexation as an accomplished fact. Through a series of economic and cultural acts Ricasoli hoped to create a mind-set

that would make the pretenders think twice about returning to Tuscany. He promoted and paid for popular brochures and pamphlets like Stanislao Bianciardi's *Leopoldo II and Tuscany: A Priest's Words to the People* of 1859, which claimed that the rule of Austria meant that the people "should work like donkeys, be beaten like donkeys, have little and nothing good to eat, like donkeys."[20] Its main thesis was that on April 27 the wicked despot and his brood were thrust out of Florence, and now nothing remained left to do but vote for the union of Tuscany with all Italy. Meanwhile, Ricasoli set about creating internal reforms as fast as possible to insure Tuscan independence. On September 17 the *Monitore Toscana*—the government's official paper—announced a whole bundle of unifying decrees affecting passports, the monetary system, customs, the post office, and a variety of economic changes wrought in order to harmonize the administration with the system of Piedmont. For Ricasoli these new laws contained maximum psychological impact. Three days later more decrees issued from the bureau of Minister of Justice Enrico Poggi on extradition, prison sentences, and university decrees so that the state "under the scepter of Vittorio Emanuele might profit without delay from the advantages of national union." By the end of the month the government could proclaim that it exercised power in the name of Vittorio Emanuele, the elected king. The Cross of Savoy now appeared on the tricolor banners and the arms of the House of Savoy were set up in public places. Finally, from then on all public documents were headed "Regnando S.M. Vittorio Emanuele"—The Reigning Vittorio Emanuele. Ricasoli's patriotic festivals, his staging of the National Guard ceremonies in Florence and Livorno, his abundant use of patriotic slogans, signs, symbols, and banners had had their effect. He even pressured the municipality to spend from forty to fifty thousand lire on a patriotic ball to gain Florentine high society to his side. Ricasoli managed to make patriotism as fashionable as the latest clothing styles. The city was plastered with cheap prints of Vittorio Emanuele, and many citizens painted the slogan *Vittorio Emanuele Nostro Re* ("Our King Vittorio Emanuele") on their shutters. Hawkers sold slices of Vittorio Emanuele watermelons, and even pastries displayed crude representations of the king's features.

Singing and musical expression were also enlisted in the service of Ricasoli's propaganda machine. The youthful Giosuè Carducci, the Risorgimento's foremost poet and a close friend of the Macchiaioli, became the poet laureate of the new Tuscan government. His *Alla Croce Bianca di Savoia* (The White Cross of Savoy) was set to music as a battle hymn and stood in high favor with

the bands of the National Guard. Its closing stanza shows an untypical devoutness on the part of this outspoken liberal:

> God save you, O dear flag
> Our love and our joy
> White Cross of Savoy
> God save you and save the king!

Verdi's music was a constant source of inspiration throughout the period, and his name suddenly took on added glamour when it was realized that VERDI was an acrostic for *Vittorio Emanuele Re d'Italia* (Vittorio Emanuele King of Italy). Graffiti slogans of VIVA V.E.R.D.I. were scratched on walls and shouted in the streets of Florence in 1859. The famous Tuscan *stornello* with its special rhyming patterns and rhythms, was adopted to help further crystallize anti-Austrian sentiments; one by the Venetian poet Francesco Dall'Ongaro satirizing "The Last Will and Testament of the Royal and Imperial House of Lorraine," was entitled *Il Babbo* (a term we might translate as "Big Daddy") referring to the paternalism of the Grand Duke:

> Our dad one morning woke and rubbed his eyes,
> And saw the town all tricolors and crosses.
> His knees grew weak with fear, and in surprise
> He ran for all his footmen . . . and his forces.

Enthused crowds would march down the Via Larga, past Caffè Michelangiolo singing the stirring war hymn "Va'Fuori d'Italia" (Get out of Italy), the martial song of Garibaldi's volunteer army of 1859 known as the Sharpshooters of the Alps *(Cacciatori delle Alpi)*.

In addition, Ricasoli laid down the principle that the theater had to "aid the national Risorgimento," and he deployed it as a medium of patriotic education. In February 1860, a month before the plebiscite for annexation, the famous Cocomero Theater changed its name to Teatro Niccolini, in honor of Giovanni Niccolini, the playwright whose long-prohibited tragedy *Arnaldo da Brescia* was performed for the first time in Florence before an overflowing crowd. In the Eighth Scene, Act 2, Arnaldo faces off the Pope in support of the people, and in the final scene, just before his death, Arnaldo foresees a united Italy newly freed from the shackles of foreign despotism. Prolonged and repeated applause followed these speeches, and by the time Arnaldo declaimed that he envisioned streaming from the blood-stained walls of twenty Italian cities "one single banner towering up to

heaven," the entire audience was swept away in pandemonium. The shouts echoed along the Via Larga accompanying the carriage of Niccolini himself who lived down the street from the Caffè Michelangiolo. Significantly, Signorini was present at one of the performances, and he and his companions seized the occasion to distribute patriotic pamphlets written by Beppe Dolfi declaring for annexation.[21]

It cannot be a coincidence that little over a month later the plebiscite was held for the annexation of Tuscany to Piedmont. Voting began on March 11 and the results were announced at midnight on the 15th. Out of approximately 534,000 registered voters on the rolls, 386,445 had declared with union, 14,925 had declared for a separate kingdom. Ricasoli had achieved a major propaganda victory, winning over to his cause the great majority of the voting population against opposition from all sides including even his illustrious colleagues Ridolfi, Capponi, and Lambruschini.

Despite the seeming euphoria of the people, Ricasoli had played a dangerous game, and he knew it. Piedmontese, French, and Austrian diplomacy all had designs on Tuscan independence, with the Austrians using their economic leverage to starve the population. Trade was severely curtailed, and unemployment in Tuscany rose considerably in this period. High taxes and the eternal high cost of bread especially affected peasantry, while the clerical party incited them to reaction. On the domestic side, the extreme left attacked Ricasoli for favoring the landowning and commercial classes and proclaimed the need for a republican government. The extreme right went even further, throwing bombs at Ricasoli's palazzo and at the entrance of the cloister of Santa Croce in an attempt to throw blame on the "reds."

In September 1859 Ricasoli had sent a deputation to Turin to offer Tuscany to Vittorio Emanuele; the Sardinian ministers only blanched at this gesture. Napoleon III, on being consulted, vetoed union as premature. The king was in a quandary; he could not accept the offer without France's consent, and yet, as the self-proclaimed leader of the Italian cause, he could hardly refuse it. In the end he gave the Tuscans an audience, accepted their votes as the true manifestation of the will of the Tuscan people, promised to maintain their cause before the great powers of Europe, but said nothing of union.

No one except Ricasoli could have taken this as anything but rejection. But Ricasoli could not be stopped in his movement toward union. He seized on the verbal vagueness and simply pretended that Vittorio Emanuele had accepted. He announced that Tuscany and Sardinia were now one; he ordered a Te Deum sung

in the Church of the Santissima Annunziata; the city was illumi-
nated as if for a festival, and a huge image of the king was lit
up and surrounded by tricolor banners in front of the Palazzo
Medici-Riccardi on the Via Larga. Ricasoli spoke of the union as
an accomplished fact, a mad risk backed by his ardent propaganda
campaign. By the end of the year, Ricasoli's determination won
the day: Napoleon dropped altogether his opposition to Pied-
mont's expansion into central Italy, and now sought anew for the
acquisition of Nice and Savoy as compensation.

It was in the critical month of September 1859, when Ricasoli
gambled on Turin and Paris to meet his demands, that the fa-
mous art competition was announced. Both the French and the
English recognized its propaganda potential. On September 14
the French consul wrote to his boss Walewski (who at that time
made it a cardinal point in his policy to prevent the incorporation
of Tuscany into Piedmont) that the Tuscan government was des-
perately attempting to win over public opinion to union and to
neutralize the leverage of Vittorio Emanuele and Napoleon III.
He perceived that Ricasoli was acting as if union had already been
achieved, running on ahead as far as possible to make retreat im-
possible. He noted the pomp of Ricasoli's parades and the fanfare
of his review of the National Guard—all geared to consecrate an-
nexation as an accomplished fact. He wrote with irony of the
glowing newspaper reports on the unanimity of the population on
the subject. And in his letter describing the contests he commented
laconically that there was much more "in these liberal dispositions
than the stated intentions which have dictated them."[22]

THE SUBJECTS OF THE COMPETITIONS

The September 23 decree creating the competitions was pub-
lished in the pro-government newspapers.[23] Its opening statement
appealed to the Tuscan people's pride in its artistic tradition:
"Considering that in Tuscany the fine arts were always the noblest
part of its civility, and that a National Government has the obli-
gation to support them in whatever way is worthy of them, [we]
summon them to eternalize great deeds and great men."[24] The
decree called for monumental equestrian statues of "The King,
Vittorio Emanuele" and of Napoleon III to be erected in the Pi-
azza dell'Indipendenza. It specified that these monuments were
not simple decorations but meant to commemorate and perpetu-
ate the memory of the "two champions of Italian independence."
In addition, two monumental statues of the same rulers were pro-

posed for Livorno, and a series of sculptures of leading Tuscan intellectuals and heroes of the Risorgimento from Lucca, Siena, and Pisa. Next, four historical compositions of ancient and modern themes were suggested: Mario the conqueror of the Cimbri, Frederick Barbarossa conquered by the Lombard League, and two recent events of the Assembly of Tuscan Representatives voting the incompatibility of the Austro-Lorraine House, and the Reception of Vittorio Emanuele of the Tuscan delegation who presented him with the decree of annexation of Tuscany to the Throne of Italy.

Another category comprised four military scenes depicting the battles of Curtatone, Palestro, Magenta, and San Martino. Four other works of military episodes were open to candidates who could choose their own theme. Finally, there were six portraits of the great heroes of the Risorgimento—Gioberti, Balbo, Troya, Pellico, Berchet and Giusti—who advanced the national cause through their writings, and medals engraved with scenes of the Tuscan Representatives resolving not to recall nor receive the Austro-Lorraine House, and voting to form part of "a strong throne under the constitutional scepter of the king Vittorio Emmanuele II."[25]

No document could be more telling of the interaction between culture and politics during the Risorgimento. Ricasoli clearly meant the competitions to declare and reinforce the propaganda campaign in favor of unification. Analogous to the French government competitions of 1830 and 1848 that opened official commissions to the broader community of French artists—which Ricasoli surely looked to for his model—he wanted to concretize his platform in the form of visual documents that gave the illusion of reality. Every one of the subjects had been carefully selected to link the glorious Florentine past to the heroic present, and to proclaim union with Piedmont as an established fact. They were meant to persuade the Tuscan peoples that unification was not only inevitable but a present reality, and in this sense they helped prepare the public for the plebiscite that took place the following March.

The French representative perceived the meaning of the competitions when he underlined in his letter to Walewski the subject of the Decree of the Union of Tuscany with the Throne of Italy. But perhaps the major commissions were the pair of monuments to Vittorio Emanuele and Napoleon III; while Ricasoli knew that the French government was hindering annexation plans at the time the contest was announced, he also knew that without the emperor no annexation could take place. He therefore tried to

flatter the French government by this gesture, at the same time giving equal weight to the roles of the emperor and the king in the union of Tuscany with Piedmont.

Even the most cursory examination of the competition themes reveals the programmatic intent of the contest. The competition reflects the creative energy and ingenuity of Ricasoli's government in these trying days and the dynamism provided by the artisanal class led by *capipopolo* (craft union chief) Beppe Dolfi. A simple analysis of the subjects is enough to convince us of this. First, the rulers of the two powers that alone can guarantee Tuscany its independence from Austria; next, two themes from ancient history relating to Italian—one ancient and one medieval—victories over Germano-Austrian forces. As mentioned earlier, Marius was a Roman General and Consul who defeated the Cimbri, an ancient German tribe that constituted a threat to Rome in late second century B.C. This battle took place at Campi Raudii not far from the Piedmontese town of Vercelli. Frederick I, or Frederick Barbarossa, was the great German king of the Holy Roman Empire who, anxious to assert imperial power in Italy, undertook a series of expeditions across the Alps to suppress republican and other independent movements. It was he who overthrew the republican Arnaldo di Bresci in Rome and handed him over to Pope Adrian IV who in return crowned him in 1155. Later, he was opposed by the Lombard towns which formed the Lombard League that finally defeated him at the famous battle of Legnano in 1176. No one could have missed the fact that these two historical themes had direct implications for the recent events in Lombardy, with the idea of unity as the effective antidote to oppression.[26]

The theme of the defeat of Barbarossa can only be appreciated in the context of Italian culture of the Risorgimento. We have already seen to what extent Niccolini's drama of Arnaldo di Bresci fired the enthusiasm of Florentine audiences in February of 1860. In addition, one of Verdi's most important musical contributions to the Risorgimento was the opera, *The Battle of Legnano (La Battaglia di Legnano),* first performed in Rome in 1849. In several of his previous operas Verdi had managed, despite Austrian censorship, to include at least one chorus about "la patria" or one which, by allusion, referred to it, and patriotic Italians of every state had taken these up as national hymns. In a territory where many people were victims of illiteracy, those robust, swinging choruses, with their patriotic sentiments, were an important influence. In Rome, then under the leadership of Mazzini, there was no censorship, and Verdi composed an opera turning entirely and openly on the idea of "la patria." *The Battle of Legnano* celebrated

the defeat of Barbarossa by the cities of the Lombard League. The allusion was perfectly clear, and the premier produced a *furore*. In the finale of its third act the hero, locked in a tower room, hears the sound of trumpets as his friends march off to fight the Holy Roman emperor. The music is stirring, and, in response to the sounds of the distant march, he leaps from the window to join them. At one of the early performances a soldier in the gallery was so carried away by the scene that he leaped from the gallery into the orchestra. No one was injured, but the incident conveys a sense of the effect of the opera on the mind of the public. While Verdi's opera was censored during the reaction and forced to undergo mutation in Austrian-held territories, the *Battle of Legnano* became a rallying point for patriots, and enjoyed a great revival in 1859. Ricasoli's inclusion of this theme in the contests would have evoked immediately the patriotic associations of Verdi's opera.

Ricasoli's two modern themes went straight to the heart of his political position; the first expressed his adamant conviction that the Grand Duke would not be received back under any circumstances, and the second expressed his assumption of Vittorio Emanuele's acceptance of the Tuscan request for annexation to Piedmont. Here in fact was a pictorial realization of what at this moment could in reality only be described as a wishful fantasy. Next, four battle pictures recall the battles of 1848 and 1859: Curtatone, where the Tuscan volunteers fought courageously but hopelessly against Radetzky's troops; Palestro which the Piedmontese troops accomplished largely by themselves; Magenta, one of the main wars of the Risorgimento won primarily by the French; and San Martino, which the Sardinians won on June 24 under the leadership of Vittorio Emanuele. While the king's actual participation in the capture of San Martino was minimal, the propaganda of the time made him into the heroic victor.

The series of either sculptured or painted notables of the Italian states show a distinct pattern of appeal to the progressive classes in Tuscany. Francesco Burlamacchi (1498–1548) of Lucca, was a Renaissance hero who held strong convictions about regional unification in central Italy. As *gonfaloniere* (standard-bearer, or flag-bearer) of Lucca, he took advantage of his honorary position to participate in a plot against Cosimo de'Medici. While Lucca was a republic, the Medici had succeeded in imposing oppressive restrictions throughout Tuscany. The plot was revealed by an informer, and Burlamacchi was imprisoned and later decapitated. Ricasoli called him "the first martyr of Italian unity." Sallustio Bandini (1677–1760) was someone dear to the heart of Ricasoli; he was a priest and progressive farmer of Siena who wrote an

essay on the Tuscan Maremma. He belonged to a physiocratic society—a major economic reform movement centered on France that advocated liberty of trade and industry and a single tax on land. Ricasoli and his colleagues of the Georgofili shared the physiocratic ideal that economic progress depended on freeing agriculture from protectionist restrictions which Austria had imposed on its Italian territories. He believed in free trade, and being in the agriculture business himself threw in with unification with Piedmont as the best way to achieve his economic ideal. Ricasoli's interest in Leonardo Fibonacci—a mathematician in twelfth-century Pisa—also related to his economic interests. In addition to pioneering algebraic studies in Europe, Fibonacci's writings provided a basis of instruction for the merchant classes, explaining reckoning and monetary theory. Hence these statues, to be erected in the various birthplaces of his heroes, adumbrated critical planks of Ricasoli's ideological position.

The painted portraits of Gioberti, Balbo, and Pellico glorify heroes of the Risorgimento, with the first two tied closely to the early constitutional program of Piedmont-Sardinia. The poet Giovanni Berchet (1783–1851) collaborated with Pellico on the biweekly liberal paper, *Il Conciliatore,* and was implicated in the plot to persuade the young Prince Carlo Alberto to lead his Sardinian troops into Lombardy, to drive the Austrians out and to unite Lombardy to the Kingdom of Sardinia under a constitutional monarchy. Carlo Troya (1784–1858) was the great medievalist, a writer on Dante, author of a history of medieval Italy published between 1839 and 1855, and a Neapolitan liberal who resided in exile for many years in Tuscany. The national hero died only the previous year and his memory was in everyone's mind. Another recent popular hero was Giuseppe Giusti (1809–1850), the satirical poet who had served as deputy in the Tuscan Assembly of the short-lived independence in 1848–49. A moderate liberal like Ricasoli, he was close to the Piedmontese circle of the writers Manzoni and Massimo d'Azeglio. Above all, he was an intimate friend of the Florentine leader Gino Capponi, patriotic historian and close ally of Ricasoli. Giusti's satires and lectures inspired the younger generation with the idea that the first duty of citizens was to love their country. He sang of love and prudence as the means of making Italy's "boot" all of one piece and all of one color.

Ricasoli's competition served a multiform purpose: it reinforced his general ideological campaign, allowed him to win over both the gifted talents in Tuscan society and their audience, and through his themes set out a platform of principles that he in fact managed to carry out. It was the most important cultural event of the period, and it is not surprising to find that several of the future

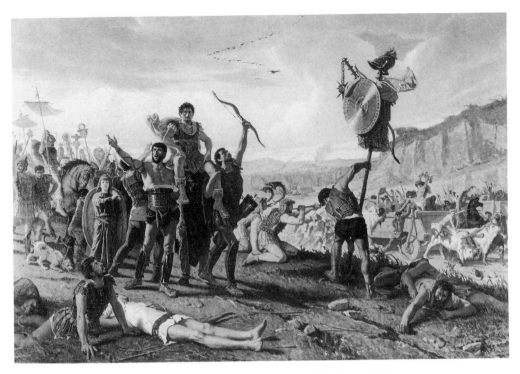

4.26 Altamura, *Marius Conqueror of the Cimbri*, 1864

Macchiaioli and their friends entered and won in the various categories. They had at least one close friend on the jury, Domenico Induno, and they enjoyed the patronage and/or moral support of influential leaders like Dolfi, Demidov, and Ridolfi. Although the moderate liberals dominated the government, they could not have succeeded without the democratic network to which the Macchiaioli adhered. Adriano Cecioni—the lone sculptor in the group and important as their historian—won the prize for his model of the statue of Carlo Alberto. Altamura was commissioned to paint the *Marius Conqueror of the Cimbri* (fig. 4.26), Antonio Puccinelli's composition of the *King Receiving the Tuscan Delegation Presenting the Decree of Annexation* received a first prize, and Silvestro Lega and Odoardo Borrani won awards for their military scenes. But the main prize in the battle category fell to Giovanni Fattori's sketch entry for the *Battle of Magenta*.

COSTA'S INSPIRATION AND FATTORI'S ENTRY

Thus it came about that under the auspices of the Ricasoli competitions Fattori won the opportunity to paint his first major military picture (fig. 4.27). Fattori was delighted to receive this

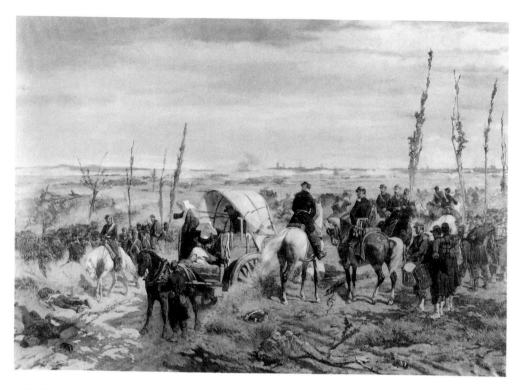

4.27 Fattori, *After the Battle of Magenta*, 1860–62

commission, and until the end of his life he considered it the turn-
ing point of his career. He associated it explicitly with Ricasoli's
cultural program and recollected that it represented the only time
in recent Italian history when art received this type of large-scale
encouragement: "A sublime thought came to the proud baron:
to encourage Tuscan art . . . and with him terminated the epoch
of encouragement."[27]

The decisive moment for Fattori came when Giovanni Costa,
an older painter from Rome not formally identified with the Mac-
chiaioli, persuaded him to participate in the contest. Costa was
the son of a wealthy landowner and wool-manufacturer, and his
family belonged to the liberal segment of the population that
looked to unification for the advancement of trade relations with
the various parts of the peninsula. He joined Mazzini's Giovine
Italia in 1847, and was active in Rome during 1848–49. In 1848
he enlisted in the Roman Legion that was sent to the Venetian
frontier, fought the Austrians in May, and in April of the follow-
ing year defended Rome against the French under Garibaldi. In
1859 Costa enlisted in the crack light calvary regiment of the
Piedmontese army, the *Aosta Cavalleggieri*. Following the disillu-
sionment over the treaty of Villafranca, the depressed Costa made

his way gradually to Florence arriving in the autumn of 1859. He then turned his attention to a study of the Tuscan landscape, painting pictures along the Arno. In a sense, he made a pilgrimage to the cultural and linguistic heartland of Italy analogous to that of the author Manzoni, who claimed to have visited Florence "to rinse his rags in the Arno."[28]

Ricasoli's cultural and bureaucratic reforms, his competition, the Promotrice, and the general political effervescence all drew Costa to Florence. The city in this period hosted foreign notables like the Russian Demidov, the French painter and engraver Marcellin Desboutin, the English Trollopes, and the American artists Elihu Vedder and Hiram Powers, all of whom enthusiastically endorsed the Risorgimento and (with the possible exception of Powers) the aspirations of the Macchiaioli.[29] Artists could also profit from the large influx of tourists seeking Italian culture; as late as the 1880s Signorini advertised himself as a landscape artist in local guidebooks inviting foreign visitors to his studio at 12, Piazza S. Croce.[30] Florence was especially hospitable to exiles and political refugees, a favorite haunt of Italian writers, artists and patriots from outlying regions and Italian provinces. Thus it became a site for what Raymond Williams calls a "paranational" cultural formation,[31] supported by tourism and the wealth derived from the patrons in the service and financial sectors of the Florentine economy who identified their outlook with that of political and artistic dissidents.

The Florentine democratic network typified this cosmopolitan character. It could mobilize the urban artisans and laborers not only in the capital but also in several provincial Tuscan towns, especially Livorno, Pistoia, Prato, and Siena, as well as the students in the university town of Pisa, who came from all over the pensinsula. The Florentine network was at once urban and regional, revealed in the diverse geographical origins of its membership which represented all the important urban centers in Tuscany. This regional diversity is reflected in the backgrounds of the Macchiaioli: De Tivoli and Fattori came from Livorno, Lega from Modigliana, Borrani from Pisa, and Banti from Santa Croce sull'Arno in the province of Pisa. Outside the Tuscan network D'Ancona came from Pesaro, Cabianca from Verona, and Abbati from as far away as Naples.

Costa's choice of Florence was an extension of his participation in the Risorgimento, and underscored his need to rekindle his enthusiasm. Although economically well off, he needed an opportunity to hone his professional skills in a stimulating environment. After the defeats of 1848–49 and the blow of Villafranca he was left with only a small reservoir of hope. His stay in Tus-

cany was to be a period of stock-taking in which he hoped to revivify his possibilities for the future. Like the Macchiaioli, he wanted to find his *italianità* by exploring aspects of the Tuscan countryside liberated from conventional modes of seeing.[32]

Florence became a synecdoche for a regenerated Italy, and the Arno a synecdoche for Florence. Costa began by painting the area around the mouth of the Arno, west of Pisa, where it flows into the Ligurian and Tyrrhenian seas (fig. 4.28). A landscapist searching for motifs near the mouth of the Arno, he was also combing the ground of the geological, agricultural, and historical roots of Tuscany. Costa did a series of pictures in this area with specific topographical designations, which relates his subject matter to that of the Macchiaioli, who all painted in the vicinity of the Arno and used it in their titles. Along with its tributaries, the Arno provided the main source of the fertility for the farmlands around Florence. Its rich historical associations, including its terrifying floods, are etched deeply into Florentine culture. The fascination of the Macchiaioli with the Arno valley demonstrates the key role of geography in linking the landscapists with the Risorgimento.

As soon as Costa settled in Florence, he began to proselytize among the younger painters, urging them to connect their work to the national cause. Costa helped those artists such as Fattori who had not yet broken with the tradition of academicized romanticism. While Fattori was painting his *macchia* studies in the Cascine, he was also working on the *Mary Stuart on the Battlefield at Crookstone*. This painting, which focused on Mary Stuart's presence at the death of George Douglas, was a late example of Italian romanticism and was deeply influenced by the example of Fattori's teacher Bezzuoli. Its civil-war backdrop, its vividly depicted battle scene, and its emphasis on Douglas's heroic dedication to the powerful presence of his queen combined to link it to the present. As Douglas expires he feel the tears of the queen falling on his face and declares that he is proud to "die pitied by Mary Stewart [*sic*]."

Fattori himself later recalled that he was then wavering between the opposing realist and romantic alternatives, and that he intended to make a large picture based on an episode drawn from the history of the Medici. At this point, he was introduced to Costa by Felice De Tivoli. Costa examined Fattori's recently begun Medici work, as well as his macchia experiments in the countryside and the Cascine. Costa told him with great candor that he was wasting his talent on fashionable medieval subjects, and then invited him to his own studio to see his recent landscape studies. Jolted out of his complacency by the sight of Costa's efforts to represent his political aspirations with contemporary landscape

4.28 Costa, *The Mouth of the Arno,* 1859

4.29 Fattori, *The Arno at the Cascine,* ca. 1863

metaphors, Fattori himself began to paint the Arno in a mode reminiscent of his mentor (fig. 4.29).

Shortly afterward, Costa persuaded Fattori to enter the Ricasoli competition. Fattori recalled that they were strolling across the Piazza del Duomo, with the glorious mass of the cathedral, Giotto's bell-tower and the octogonal Baptistery of San Giovanni (where all the prominent citizens of Florence were baptized) sharply defined against the sky, when he turned to Costa and asked, "What would you say if I decided to compete for the Battle of Magenta picture?" "Compete and win!" Costa shot back. Fattori followed his advice and beginning with that moment, as the painter recalled, he "became an artist."[33]

The historical importance of this oft-told anecdote lies in the fact that Costa helped Fattori make the momentous decision by confirming his intuitive sense of the macchia and its implications as a valid cultural expression of Risorgimento activity.[34] The story,

furthermore, is shot through with patriotic references, from the theme of the Medici to the description of the Piazza del Duomo. It cannot be a coincidence that Fattori brought up the competition with the Baptistery directly in full view: as an artist who spent much of his apprenticeship copying the frescoes of the Quattrocento he would surely have recalled the legendary competition of 1401 for the north portal of that edifice which Lorenzo Ghiberti entered and won. In this sense, its historical continuity symbolically linked the Renascimento and the Risorgimento in the evolution of Italian culture. The shift from Medici to Magenta was based on Fattori's need to find his own voice and perpetuate the example of the masters of the past.

Having completed the *Mary Stuart* under the influence of Bezzuoli and the French history painter Paul Delaroche—and by 1861 it was almost an anachronism in Fattori's work—he had shifted to Florentine subjects, as some of the Macchiaioli and his more academically inclined friends were doing. The Ricasoli contest intervened at this moment of creative ferment, permitting Fattori to make a mediated shift to a contemporary mode through the use of an academically acceptable subject.

THE BATTLE OF MAGENTA

Fattori deviated somewhat from the subject proposed in Ricasoli's decree (The Battle of Magenta) to portray *Il campo italiano dopo la battaglia di Magenta* (The Italian Camp after the Battle of Magenta). His decision to paint the *aftermath* of battle rather than one of its peak moments was predicated on the peculiar circumstances of the Italian relation to the encounter. Since the Italians barely participated in this combat, it would have been inappropriate to depict a heroic charge or clash of opposing armies involving their troops. Fattori's approach is consistent with that of his understated macchia depictions of the French soldiers in the Cascine. Fattori sets the scene in a panoramic stretch of the actual battlefield, with the horizon line above the figures in the foreground. Two groups, Italian and French, are separated by a road on which an ambulance has momentarily stopped. The ambulance is run by Sisters of Charity,[35] one of whom treats a wounded Austrian soldier while another signals to an Italian infantryman for help. The mounted French officers and their standing subordinates alike regard the sight of the passing Italians with respect. (They probably represent the remnant of the Ninth Battalion of *bersaglieri* led by Captain Excoffier who fought bravely at Magenta and earned the admiration of the French.)[36] The Ital-

ians march in formation, seemingly unaware that they are being observed with this deference. During the defense of Rome in 1849, the French general Oudinot declared contemptuously that "the Italians do not fight." Ten years later the French learned to see the Piedmontese troops in a different light. Fattori's take on this theme was daring and original, demonstrating the veristic macchia sensibility and passion for fact.

As indicated earlier, the idea of the macchia was not confined to quick painted sketches but related also to finished works in which the light effect constituted a pictorial nucleus which could be preserved in a more definitive work growing out of it. The macchia in this sense becomes the formal leitmotif of the picture, informing its ultimate tonal values and local color. We know that Fattori traveled to the battle site in 1861 to sketch the topographical details, but it is not clear where he derived his information for the painted sketch *Il Campo italiano dopo la battaglia di Magenta* (The Italian camp after the Battle of Magenta) and for the *cartone* (cartoon, a magnified detailed drawing for transfer to the canvas) required by the contest (fig. 4.30).

It is possible that he had access to photographs taken at the site. As Nancy Troyer has shown, the Macchiaioli were deeply affected by photography, a medium whose growth in mid-century Florence had been stimulated by tourism.[37] The Alinari brothers' studio (soon to become the city's leading photographic firm) and several others had set up to photograph monuments, portraits, and landscapes for foreign visitors as a substitute for the old *vedute*. One example of Macchiaioli's dependence on photography is Fattori's pencil sketches of posing *bersaglieri* done in preparation for the *Magenta:* these bear a striking resemblance to the typical military photographs of the period (figs. 4.31, 4.32).

Further evidence of his debt to photography emerges when Fattori's picture is compared with the French painter Ernest Meissonier's *Napoleon III at Solferino*, which was exhibited at the Paris Salon of 1864 (fig. 4.33). Meissonier, who was present at this second major battle of the 1859 war, takes a different viewpoint, but his work displays several details in common with Fattori's *Magenta*. The French troops are situated on the height of Monte Chiaro looking across to the medieval square tower, La Spia, and the battle is in progress in the plain below. Meissonier directs our gaze to the right of the general staff on the hill where we see horse-drawn ammunition wagons waiting in reserve. Fattori, with his deeper and more personal understanding of the signficance of the outcome for the Risorgimento, brings us nearer to the field than Meissonier, who distances his French audience from the Solferino carnage. At the same time such important details as the

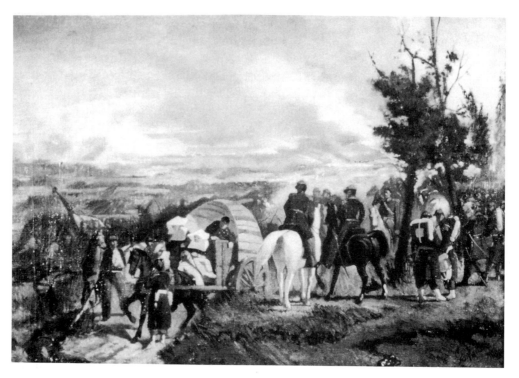

4.30 Fattori, *Study for the Battle of Magenta*, ca. 1859–60

4.31 Fattori, *Bersagliere*, ca. 1860

4.32 Photograph of Piedmontese Soldier, ca. 1850s

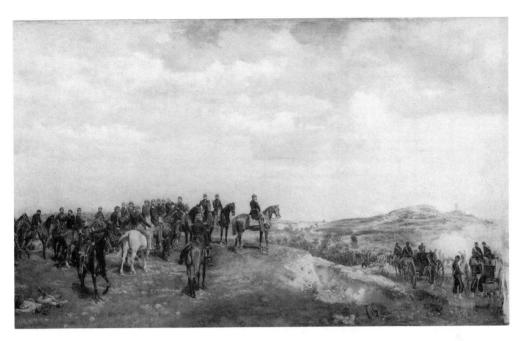

4.33 Meissonier, *Napoleon III at Solferino*, 1864

enemy dead in the extreme left foreground, the disposition of the
mounted officers, and the wagons are similar in the two works.
Since neither artist could have seen the other's work, it is probable
that they relied on a common source such as photographs or
wood engravings reproduced in the illustrated periodicals.[38]

While Fattori's theme and its presentation are unique, they cor-
respond to the substance of a recollection of Solferino written by
another French military painter, Adolphe Yvon, previously com-
missioned by the French government to record the war in Crimea.
Yvon left for Italy shortly after the battle of Magenta and arrived
at Milan on the day of Solferino. He subsequently exhibited
paintings of both battles, a scene of Solferino in the Paris Salon
of 1861 akin to the Meissonier but glimpsed close up in the offi-
cer ranks, and a violent episode from Magenta in 1863 (figs. 4.34,
4.35). The *Battle of Solferino, 24 June 1859* privileges the French
emperor on horseback in the dominant center, commanding the
terrain literally and figuratively as he issues orders for a reserve
force to support the troops in the plain below. Although Yvon's
Magenta, 4 June 1859 also centers on a lone French hero at the
heart of the composition, it is a much bloodier affair, as the
charging Colonel Tixier steps over Austrian and French dead and
wounded in trying to instill courage in the hesitant Zouaves.
Yvon's inflated visual rhetoric is seen when his work is contrasted

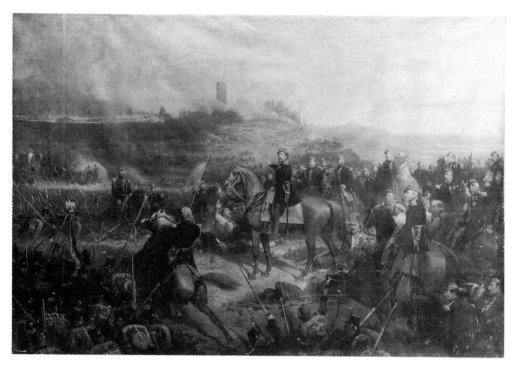

4.34 Yvon, *Battle of Solferino,* 1861

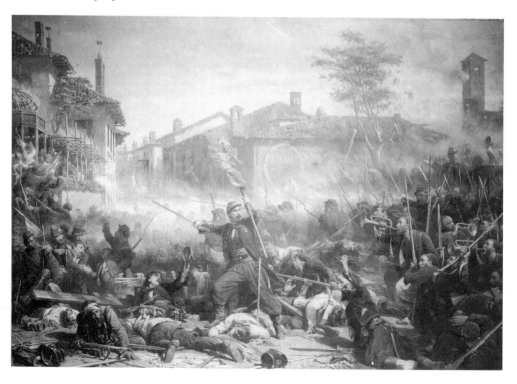

4.35 Yvon, *Battle of Magenta,* 1863

4.36 *Attack on the Church of Magenta,* the *Illustrated London News,* July 2, 1859

4.36 *Attack on the Church of Magenta,* the *Illustrated London News,* July 2, 1859

with a newspaper illustration of the same scene (fig. 4.36). His acknowledgment of such forced centrality and exaggerated heroics in the official commissions is perhaps revealed in his representation and commentary on another work he showed at the 1863 Salon, *Evacuation of the Wounded,* depicting a convoy of Italian ambulances transporting the wounded of Solferino to makeshift hospitals. Describing the lugubrious convoy, he wrote:

> The branches affixed to the wagons provided the wounded with a shelter from the torrid sun and the attacks of flies and grasshoppers. Not a complaint, not a word escaped from these breasts, many of which already seemed to have ceased beating. I could not help saluting, trembling with emotion, these miserable victims united in a community of suffering in their narrow space, without respect for rank, nationality or race. I dashed off on the wing several sketches of these sad corteges.[39]

This sentiment of respect and compassion for all sides and rejection of chauvinism, although articulated from a French perspective, is conveyed in the Fattori painting, which tries to capture something almost indefinable that passes unarticulated between the French and their allies. Yet it is significant that Fattori's mark

4.37 *Auxiliary Transport of the Wounded, L'Illustration*, 1859

4.38 *Passage from Adda to Cassano, L'Illustration*, 1859

of respect for his own countrymen is depicted modestly without
the histrionics or mawkishness usual in nineteenth-century battle
painting. It approximates more closely reportorial illustration of
similar phenomena, but with the advantage of having been struc-
tured with hindsight.

 That both Fattori and Yvon seize on the leitmotif of the am-
bulance is no coincidence since the sight was pervasive during the
wars in Lombardy (figs. 4.37, 4.38). The fact that neither side at
the battles of Magenta and Solferino had made adequate medical
preparations for their casualties aroused public opinion against
the callousness of both the French and Austrians. It was the sight

of thousands of wounded and dying men lying uncared for on the field of Solferino that stirred the Genevan Jean Henri Dunant to publish his observations and urge the formation of some neutral international agency to bring relief to those who fell in battle. His efforts led to the foundation of the International Red Cross.[40]

Fattori's central placement of the ambulance divides the French and the Italians formally but unites them thematically. The white tunic of the wounded victim seen in the front of the ambulance indicates that he is Austrian, and spotlights one of Dunant's most poignant themes. He observed at Solferino that enemy wounded were given inferior care by the victors, a situation requiring a medical team that would treat both sides with equal compassion. Zobi's *Cronaca,* however, reported that local volunteer women's organizations provided health care "for all suffering humanity, not making distinctions between friends or enemies."[41] Here is one source of inspiration for Fattori's original twist on the battle-field theme, attesting to his nationalist yet antiwar sensibility: the French and Italian troops are mediated by the ambulance moving along a diagonal between them, carrying Italian nuns, French and Austrian wounded. Clearly Fattori's view that war is not an opportunity for glory and heroism but an occasion creating a singular community, whose members are bound by common suffering.[42]

FATTORI AND GARIBALDI

A sheet of drawings by Fattori in the collection of the Uffizi displays on one side a study of one of the nuns for the Magenta, and on the verso, studies of Garibaldi's troopers for the painting *Garibaldi a Palermo* (Garibaldi at Palermo, 1860–62; fig. 4.39).[43] The work testifies to Fattori's immersion in the military events of 1859–62. It may be said that these "back-to-back" sketches parallel the back-to-back episodes unfolding in the drama of unification after Magenta. The next major development was Garibaldi's unprecedented campaign in the south and the taking of Palermo against overwhelming odds on May 31, 1860. This incredible feat, like the expedition itself, was an event that caught the imaginations of people around the world. It elevated Garibaldi to the level of a universal folk hero of national liberation movements.

Garibaldi's band of volunteers *I Mille,* the Thousand, inspired numerous popular prints and paintings. Many of these show Garibaldi in heroic attitudes, planting the tricolor at Marsala after disembarking (fig. 4.40) or leading the *garibaldini* in a charge

4.39 Fattori, *Garibaldi at Palermo*, ca. 1860

4.40 *Garibaldi and His Army Arriving at Marsala*, 1860

against superior numbers. Fattori's picture, however, eliminates all taint of romanticism and melodrama. A battle is in progress, as the *garibaldini* attempt to break through the barricade set up by the Neapolitan troops in front of the Porta Nuova next to the Palazzo Reale. Fattori ingeniously suggests the continuity of the action by depicting falling debris in midair, which even casts shadows on the façades of the buildings. It is a marvellously adept bit of painting that imparts a documentary effect to the scene, perhaps inspired again by French illustrators (figs. 4.41, 4.42). Garibaldi himself, accompanied by his officers Nino Bixio and Stefano Türr, is shown observing the scene calmly on horseback, despite the fact that fierce fighting took place on the Via Toledo leading northward to the Porta Nuova, and that Neapolitan warships shelled the area into ruins. One of Garibaldi's Thousand recalled later in connection with another encounter with the enemy, how his leader sat "on a horse, wonderfully cool and collected." While Fattori's painting shows us the poised general, it reveals him neither as an invincible hero nor as Quixote-like adventurer. Thus, even at the peak of Risorgimento glory the painter imposes on his work the character of understatement.

Perhaps even more astonishing, Fattori dared to depict Gari-

4.41 Fattori, *Garibaldi at Palermo,* detail

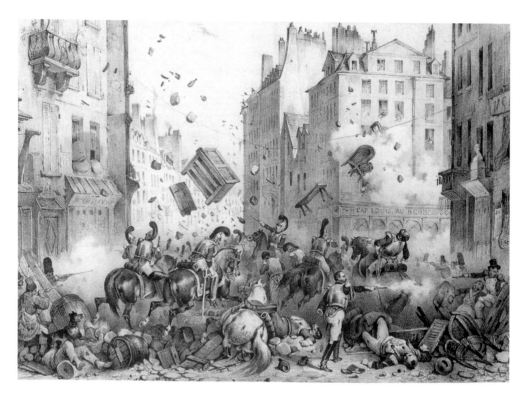

4.42 Adam, *Rue St. Antoine,* 1830

baldi wounded and humiliated at Aspromonte on August 29,
1862, a victim of the evolving political intrigues of Vittorio
Emanuele and Cavour (fig. 4.43). Garibaldi was en route from
Sicily to Rome, with a new group of volunteers when the Pied-
montese government, concerned about the reaction of European
powers, ordered several battalions of *bersaglieri* to stop Garibaldi
and to destroy him if he offered battle. Although Garibaldi had
an advantageous position when the *bersaglieri* were spotted, he
would not consider firing on other Italians, and ordered his
troops simply to hold their positions. As soon as they were within
range, however, the *bersaglieri* opened fire. In the exchange that
followed Garibaldi was hit twice, in the thigh and the left foot.
Some of his men rushed forward, picked him up, carried him back
through the lines, and set him on the ground with his back
against a tree. It was an incident that disgusted most Italians and
damaged the government's cause with many foreigners as well.
Everywhere sympathy was mainly on Garibaldi's side; ultimately
the government refused to prosecute him, but never regained the
respect it had lost in this affair. The episode was another disillu-
sioning moment for the radicals and liberals. And so it seems per-

fectly appropriate for Fattori to depict Garibaldi gazing at the viewer in mingled pain and bewilderment and looking somewhat ridiculous, while several of his men support him and bandage his foot. Here again, Fattori demonstrated his typical and remarkable commitment to restraint and realism.

Fattori always attributed his *macchiaiolo* sensibility to the influence of the Risorgimento as it unfolded in the critical period 1859–61. In his autobiographical statement of 1889, Fattori recalled that 1859 represented "a revolution of redemption for both the country and its art, out of which emerged the Macchiaioli." He defined the focus of their new movement as a fresh inquiry into the nature of reality and its rendering by truthful impressions, and left no doubt that this practice constituted an authentic revolutionary status for himself and his colleagues: "A furious war was waged against me, I was chased out of art like a renegade [*rinnegato*]."[44]

Fattori's understanding of the radical Risorgimento origins of

4.43 Fattori, *Garibaldi at Aspromonte*, ca. 1862

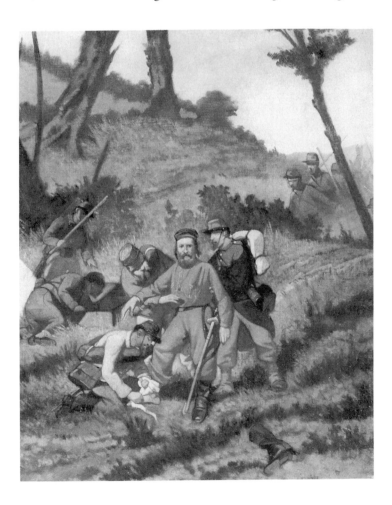

the Macchiaioli is reinforced by Signorini's published comments
in his series on the Caffè Michelangiolo in the *Gazzettino delle
Arti del Disegno* in 1867. Responding to criticism from a Milanese
critic that the group had evolved into a kind of "parish church
of the Arno [*La Chiesuòla dell'Arno*]," Signorini considered the
nature of collective action generally, but had the Macchiaioli spe-
cifically in mind when he reflected that it had originally come
together in "good faith to form an association and socialism." He
did not deny that their diverse personalities and independence of
thought often interfered with collective action, but they did suc-
ceed in negating caste and hierarchy within the group and shared
a set of common beliefs as one would expect from any association.
These broadly shared goals were translated into action when the
French emperor set out to support the Italian Revolution, for "we
then became revolutionaries and soldiers, in order afterwards to
become free citizens of a great nation." At that moment, Caffè
Michelangiolo was deserted since at least two-thirds of the group
enlisted in the volunteer corps [*corpi franchi*] or in the regular
army. Signorini then concluded the article:

> If the artists failed to fulfill all of their great political
> dreams, the experience nevertheless offered them a
> great advantage and a new infusion of vitality that al-
> lowed them to get involved in the active life of the
> countryside, to quit the studio for a time, to see new
> things, to invigorate the body with more force and
> courage, to develop more fully the moral tone of the
> mind and stimulate them to produce with maximum
> power and energy the recent scenes of camp life.[45]

Thus Signorini unmistakably credits the radical, the socialist
side of the Risorgimento as the catalyst for the genesis of the
movement, an admission that he reaffirms in the opening para-
graphs of the follow-up article. There he notes that immediately
after the wars of unification, those who remained faithful to the
reunions at the Caffè Michelangiolo began to exhibit their first
tentative experiments, "which passed from aspiration to effort,
from effort to research, and finally to accomplished fact." Free-
dom of conscience and reason were their primary guides, as they
researched, "with an anguished desire for progress, *la macchia*,
that is, the clear expression [*evidenza*] of chiaroscuro, and marked
this first step of progress towards modern art." This brought
down on the group the wrath of the conservatives, and the grow-
ing controversy led staight to Signorini's historic exchange with
Rigutini in *La Nuova Europa*.[46]

The provocative debut of the Macchiaioli experimentalists is bracketed by the announcement of the Ricasoli contests in September 1859 and the inauguration of the first Italian National Exposition exactly two years later. These two events impelled the formation of the Macchiaioli and were politically and symbolically linked. It may be recalled that the competitions constituted part of Ricasoli's strenuous effort to forge the union of Tuscany with Piedmont, harping on the single obsessional idea of forming a great kingdom of Italy "under the constitutional scepter of Vittorio Emanuele." Although Ricasoli had behaved as if this fusion were a fait accompli by the time of the competitions, fusion only became official fact in March 1860 when the Florentine plebiscite overwhelmingly favored union and gave Ricasoli the greatest triumph of his career. One year later, a parliament representing all of the recently united provinces met at Turin and, by the grace of God and the will of the people, conferred on Vittorio Emanuele the new title of king of Italy. Following the sudden death of Cavour in June 1861, the king turned to none other than Ricasoli to assume the functions of prime minister. Ricasoli now set about organizing a symbolic expression of the winning of the geographical unity of Italy (minus Rome and Venice). This celebration took the form of the momentous Italian National Exposition that opened in Florence just three months after Ricasoli replaced Cavour.

FIVE

The First Italian National Exposition of 1861

Several of the paintings done for the Ricasoli contest, including Fattori's still unfinished *Magenta,* were exhibited at the landmark Esposizione Nazionale which opened to the public in Florence in September 1861 (figs. 5.1, 5.2).[1] The 1861 art exhibition was deliberately linked to the winning entries of the Ricasoli competitions, a gesture already anticipated in the government's proud display of Stefano Ussi's *Duke of Athens* with the competition entries the year before. This time Fattori's *Magenta,* Lapi's *Battle of Palestro,* Altamura's *Portrait of Carlo Troya,* Giuseppe Moricci's *La lettera del volontario dal campo, alla sua famiglia* (The Volunteer's Letter to His Family from the Field; fig. 5.3), and Giovanni Mochi's *Il ricevimento fatto da Vittorio Emanuele degli Inviati toscani che gli presentano il decreto dell'annessione* (King Vittorio Emanuele's Reception of the Tuscan Delegation Presenting Him with the Vote of Annexation; fig. 5.4), as well as a host of other examples, were included in the official exhibition for maximum propaganda impact. One of the most popular works was Cosimo Conti's monumental *L'eccidio della famiglia Cignoli per ordine del generale austriaco Urban* (The Execution of the Cignoli Family by Order of the Austrian General Urban), based on an incident from the recent campaign (fig. 5.5). On the morning of the battle of Montebello, an entire peasant family was shot in cold blood for the crime of possessing in their cottage some forbidden firearms. The theme narrativized, if only through allusion, the grand

duke's complicity in Austrian atrocities, and at the same time jus-
tified the necessity of revolution.[2] Although by now Ricasoli had
achieved his goal of annexation, he wanted to vaunt Tuscany's
historical role in unification—the thematic emphasis of the 1861
Exposition.

The comfortable coexistence between the fine arts and industrial
innovation had long been facilitated by the Florentine Academy,
where a special division of the mechanical arts, the Conservatorio
d'arti e mestieri, had been founded during the Napoleonic epoch
and remained in place until 1850. Schools of ornament, gem cut-
ting, floral design, and medal engraving provided first-rate crafts-
persons for local industrial interests. It is not surprising to find
that the same Tuscan elite organizing the National Exposition
had previously supported the Conservatorio, including Ginori,
Demidov (owner of a silk manufactory), Capponi, Ridolfi, and
Ricasoli.[3]

The national exhibition was an event of major importance for
the Macchiaioli, not only acting as a group catalyst but also
bringing them together with other regional painters. One highly
visible North Italian painter, the Torinese landscapist Antonio
Fontanesi, received widespread praise for his five displays, in-
cluding *Campagna con mandre un'ora dopo la pioggia* (Countryside
with Herds an Hour after the Rain), which won a medal and was
purchased by the king (fig. 5.6).[4] Fontanesi had taken part in the
military actions of 1848 (serving in the same Lombard volunteer
regiment with Garibaldi) and 1859, and during the interval lived
in exile as a political refugee in Switzerland and France, where
he was influenced by the technical procedures of the Barbizon
painters and Thomas Couture. His acclaim in 1861 affirmed
his international status and acknowledged his contributions to
unification.

Although Fontanesi typically preferred penumbral and other
atmospheric effects in his works, his hardy execution and pan-
oramic vistas ranged him alongside of his younger Tuscan col-
leagues. The National exhibition furnished the occasion for them
to meet at the Caffè Michelangiolo and exchange ideas, and
Fontanesi developed close friendships with several Macchiaioli,
especially Cristiano Banti.[5] As an influential member of Turin's
artistic circles, Fontanesi's contact facilitated their participation
in the 1861 Promotrice exhibition in that city, where Signorini
presented his controversial picture, *Il quartiere degli israeliti a Ve-
nezia* (*Il Ghetto di Venizia* [The Venice Ghetto]). The affection of
the Macchiaioli for Fontanesi is seen in Martelli's support for his
possible appointment at the Florentine Academy, but soon after,
a chair in landscape painting was created for him at the Accademia

Albertina of Turin.[6] His appointment to the prestigious North Italian institution helped legitimate the field of landscape painting as appropriate academic practice. It may be claimed that the National Exhibition proved decisive in the fortunes of nineteenth-century landscapists by revealing their abundant manifestations throughout the peninsula and attesting to an authentic national school complementary to the ideological projections of the 1861 exposition.[7]

This is one of several ways in which the organization, progress,

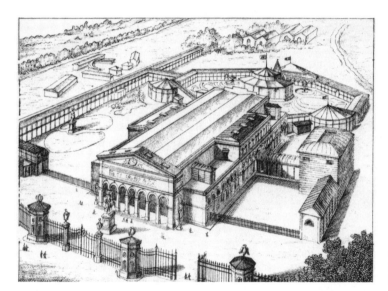

5.1 *View of the Site of the First Italian National Exposition*, 1861

5.2 *Façade of the Main Building of the National Exposition*, 1861

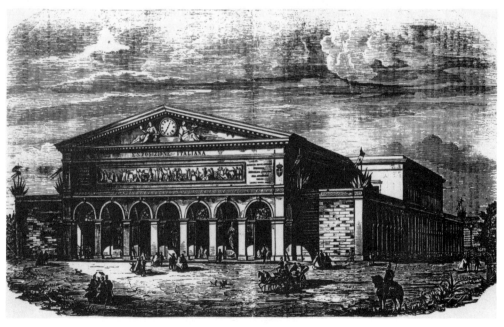

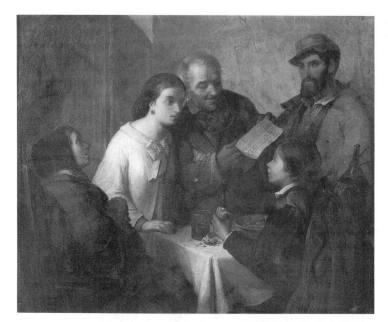

5.3 Moricci, *The Volunteer's Letter to His Family,* 1861

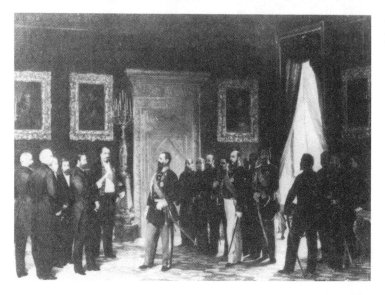

5.4 Mochi, *King Vittorio Emanuele's Reception of the Tuscan Delegation,* 1862

and aftermath of this occasion contributed to the nascent Italian, and particularly, Florentine culture. A milestone in the history of the Risorgimento, it had been planned in the summer of 1860 even before the Kingdom of Italy was proclaimed, and before Sicily had been incorporated legally into the Piedmontese state. Its organizers saw the exposition as a compact and concrete sign of consolidation that newly enfranchised citizens could readily grasp. They also saw it as an opportunity for a cultural attack on Austria and those countries that persisted in keeping Italy di-

5.5 Conti, *Execution of the Cignoli Family,* 1861

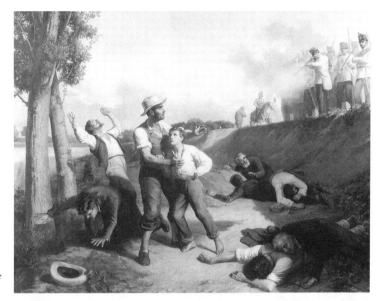

5.6 Fontanesi, *Countryside with Herds an Hour after the Rain,* 1861

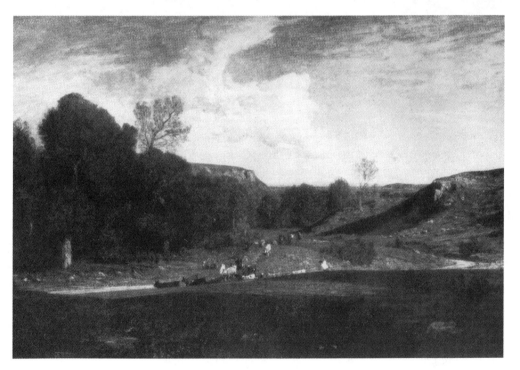

vided. (Lombardy, for example, needed Venice to export its products most economically via the Adriatic.) Primarily, however, they viewed it as a means of helping to overcome the isolation of the individual provinces and to pull the disparate regions together economically and culturally. Indeed, the need to combat separate-

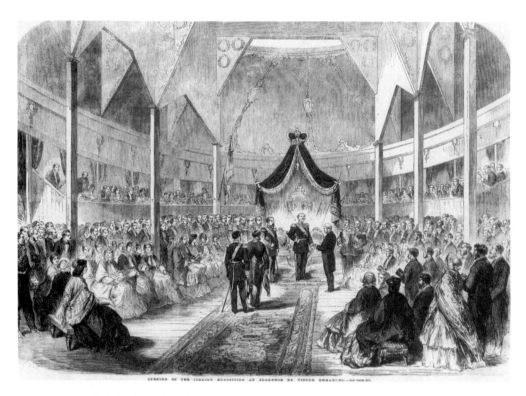

5.7 Opening of the Italian Exposition by Victor
Emmanuel, the *Illustrated London News,* 1861

ness was the exposition's unifying theme and explains why it
played such a crucial role in the history of the Risorgimento. The
prominent exposure of the nascent Macchiaioli in the exposition
proved vital to their careers, demonstrating not only their strong
support of Risorgimento ideals but also their social proximity
to the emerging ruling elite. Macchiaioli patronage essentially
derived from the new political and social alliance so brilliantly
represented in the 1861 industrial and artistic show.

The organizers made no attempt to conceal the politics of the
exhibition: it was opened in Florence by the king himself on
September 15, 1861 (fig. 5.7). Vittorio Emanuele and Cavour
wanted to persuade their domestic and foreign critics that they
had in mind not just the expansion of the Piedmontese state but
also the interests of the new nation of Italy. They felt that a major
exposition on the order of those in London in 1851 and Paris in
1855, but confined primarily to the peninsula, would have the
effect of binding the dominant groups into a psychological whole.
By 1861, as Denis Mack Smith has noted,[8] a professional and
business segment, allied to a new middle class of landed gentry,
broke up the traditional power of the landowning aristocracy

allied with the Catholic church. This group enthusiastically supported the moderate Risorgimento because they recognized that nationalism and liberalism would promote their prosperity. Ricasoli is an excellent case study: the winner of a medal for his Chianti wine display, his energetic support of unification was inseparable from his understanding that a divided Italy made industry inefficient and noncompetitive abroad, in particular the wine industry. The elimination of protectionism and restrictions imposed by the occupying powers, as well as the chance to appropriate confiscated Church domains in a cheap market, had obvious appeal. This new dominant group was well represented in the National Exposition, and it was really for them that the show was organized.[9]

Francesco Protonotari, an economist and law professor who edited the exposition catalogue and drew up the general report, was quite specific about the intentions of the exposition:

> A more powerful need, a more inward reason, a more noble inspiration than mere abundance of production, which at bottom is nothing but self-interest, lay behind the Italian Exposition. This was a political motive, which desired to see the recent triumph of unity immediately embodied in some great event, by representing and containing in itself the might of all its citizens, as the plebiscite had contained their wills, to repeat to a Europe which is bewildered and still uncertain whether Italy is or is not, the assertion of the ancient philosopher to the deniers of motion: *Behold, I move!*[10]

The grand display of agriculture, industry, and fine arts was meant to show off all aspects of national productivity at its best, and thereby demonstrate the potential of the new nation to establish solid diplomatic and commercial ties with other European countries. The façade of the main building symbolized this ambition in synthesizing elements of the Crystal Palace, the Paris Palais de l'industrie, and a Florentine *palazzo*.

A lavishly wrought iron gateway projected beyond the main façade, interrupted at intervals by octagonal towers that housed public security, monetary exchange, and other administrative services. Between this threshold and the main entrance stood the equestrian statue of King Vittorio Emanuele. The façade itself consisted of a portico divided into seven arcades on the front elevation and two lateral ones bearing the main structure, the whole surmounted by an imposing pediment. A frieze running the length of the façade, above the arcades, was decorated with

a bas-relief representing Liberty and the Genius of Italy, sur-
rounded by other allegorical sculptures personifying industry, art,
knowledge, and future prosperity. Here the new government
showed itself adept at exploiting the full propaganda potential of
the colossal world's fair that had only just surfaced at London and
Paris in the previous decade.

Yet Italy could boast its own homegrown precedent, if only
on a more modest scale. The immediate inspiration for the show
was the Tuscan triennial exhibition founded in 1839 by Leo-
poldo II.[11] Organized in the Palazzo Vecchio during the festivities
of San Giovanni, the patron saint of Florence, it had been devoted
to the arts and manufactures of Tuscany. The Provisional Govern-
ment announced a new exhibition on March 10, 1860, but the
national decree of July 8 nullified the earlier edict and expanded
the show into a pan-Italian exposition. The Georgofili members
were given pride of place, with the organization's president,
Marchese Cosimo Ridolfi, appointed as secretary and second in
nominal authority only to the honorary president, Prince Eu-
genio Carignano of Savoy. Although members of the commission
included some of the peninsula's most prominent industrialists,
agriculturalists, and academicians, Tuscans filled the dominant
positions.

The inaugural address, delivered by Prince Eugenio on Au-
gust 20, 1861, emphasized the exposition's relationship to the
major military and political events of the Risorgimento. After
demonstrating its military valor in actual combat and its political
capacity in the parliamentary domain, the Kingdom of Italy was
ready to present a pacific expression of strength and capacity by
exhibiting the products of its national labor and its artistic ge-
nius. Taking his cue from the previous English and French inter-
national exhibitions, the prince emphasized that this show would
increase the credit of the new state, project a sense of unity and
new-found prosperity, and stimulate industry and the arts. Vit-
torio Emanuele seconded these remarks when he opened "la
prima Esposizione Nazionale Italiana" on September 15, 1861,
and promised to preserve the traditional Italian genius for art and
science during his reign.

HIRAM POWERS'S *AMERICA* AS METONYM FOR THE MODERATE RISORGIMENTO

The exhibition's emphasis on bourgeois advances and consti-
tutional government was well understood by foreigners who
reviewed it. John Stewart, the critic for the English *Art-Journal*,

however, responded with some surprise to the visible manifesta-
tion of political and economic ideology in the themes chosen by
the artists. He asserted that the Italian school distinguished itself
from other Western nations by this marked tendency:

> The recent political life of the country has exercised a
> deplorable influence on the subjects chosen by the art-
> ists. Nothing, perhaps, can more vividly portray the
> actual feelings of the people than the appeal to their
> sympathies and consciences which their artists make
> through pictorial representations. It is so in England,
> where the mass of pictures exhibited speak of peace
> and home joys. In France they tell of military exploits
> and martial glory; and in Germany, of abstract thought
> amidst high themes. But this exhibition at Florence
> in its broad aspects has but two subjects—the cruelties
> of kingcraft or priestcraft, separate or in combina-
> tion, and the struggles of the people to throw off
> the double-headed oppressor. . . . All foreigners seem
> nearly equally astonished at this peculiarity of the pic-
> torial section of the exhibition; and without the least
> desire to cross the forbidden boundary line of poli-
> tics, a fact so conspicuously potent over the pictures
> exhibited cannot be entirely ignored.[12]

The reviewer singled out two sculptures in the exhibition to
support his contention. Surprisingly, one was by the Yankee
sculptor Hiram Powers and entitled *America*, a marble to which
the sculptor attached considerable importance (fig. 5.8). Despite
his New England pedigree, Powers settled in Florence in 1837,
raised his large family there, was appointed professor at the Ac-
cademia in 1844, and remained in the Tuscan capital until his
death in 1873. He closely identified his interests with the Flor-
entine people and the Italian Risorgimento, and had joined Flor-
entine citizens in a large demonstration in September 1847 to
press the grand duke to maintain independence from Austria and
follow the pope's liberal lead. His correspondence of the period
attests to his personal identification with the Florentines: "We
Italians have been doing something in the way of revolution." He
continued to support Italian insurrectionary movements in 1848,
and it is clear by his participation in the 1861 National Exposition
that he sympathized with the recent unification of Italy under the
Piedmontese government.

His allegorical sculpture, executed in marble in 1858, embod-
ied his dual loyalties and benefited from a propitious moment
when America served as a role model for Risorgimento ideals.

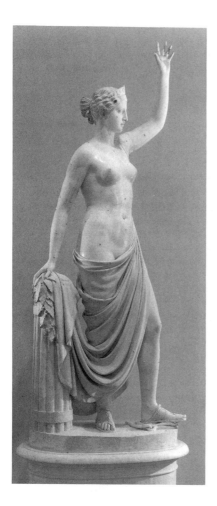

5.8 Powers, *America,*
ca. 1848–50

That nation had provided asylum for many Italian refugees and
exiles during the period 1848–60, and the United States press
compared Garibaldi to Washington, and the Risorgimento to
America's struggle for independence.[13] The Italian critic Yorick
(pseudonym of Pietro Francesco Leopoldo Coccoluto-Ferrigni)
perceived the statue "rising again [*risorta,* from *risorgere,* the root
of *Risorgimento*] to new life, and trampling on her chains," thus
identifying it with the Italian cause.[14] Powers's personification
treads on a broken chain, "and resting on what may be supposed
a pillar of Eternal Truth, pointing to her destiny when the chain
of slavery shall be snapped."[15] Stewart shrewdly observed that
"this was probably not Mr. Powers's reading of the statue when it
was begun, but it fully sustains this interpretation, as well as the
artist's high reputation as a sculptor."

Thanks to the research of Vivien Fryd Green we can catch a
fairly accurate glimpse of the different readings that the sculptor

himself gave the work.[16] He conceived of his statue in 1848 as a celebration of the revolutionary forces of that year, and hoped at that time that Congress would purchase it as well for the United States Capitol. Partially nude, the statue is crowned by a diadem decorated with thirteen stars (for the thirteen original colonies), and the first plaster showed the figure stepping forward with her left foot on a manacle, emblem of despotism, which was later changed to the broken chains in the marble. What Stewart saw as a pillar of Eternal Truth was actually the fasces of unity, whose sticks resemble the fluted indentations of a pillar.

Powers's biggest problem with the statue turned on the choice of an attribute for despotism, experimenting at various times with the idea of crown, scepter, chains, and manacle. The failures of 1848 and the growing sectional crisis in the United States over slavery invested the allegory with new signification. By 1849, Powers envisioned *America* as emblematic of both Italy and the United States. For Italy's defeated revolutionaries it would serve to illustrate that national unity could usher in the type of republican government established in the United States. *America* would also remind citizens of the United States that they faced potential disunity and the sectional disharmony rife in Europe, and he placed a laurel wreath on the fasces to emphasize the importance of national cohesion. As he outlined his new plan to a friend in November 1849:

> Suppose the union dissolved upon the slave question. Quarrels would soon arise between various governments. . . . The strongest would subjugate the weakest who would then become slaves, and so it would be until we should all be slaves, and have kings. . . . I am doing something in my small way to illustrate the advantages we enjoy, the dangers which we must guard against and the means by which we must preserve our liberties. I am endeavoring to embody our political creed.[17]

Powers also wavered over the introduction of chains beneath America's foot, concerned that it might "not be noticed as having some relation to slavery in America." Then he began to regret that the presence of chains would be viewed negatively by Southerners, especially given the heated climate in Congress over slave extension. Powers finally resolved to put chains in the work but now insisted that they referred to freedom generally rather than to black emancipation. He added the chains in 1855 when Congress ordered a work from him, and at a time when he responded in anger over the Kansas-Nebraska Act of 1854 which repealed the

Missouri Compromise. In response to the bill's passage, he scornfully proposed a new version of the statue which would show the figure holding a banner in one hand with the inscription "all are born free and equal," and in the other a cat-o'-nine-tails held over a "nigger" kneeling at her feet begging for mercy.

By 1857, Powers could see the sectional disharmony erupting into Civil War and he expressed resignation to the fact that his allegory would seem to be rendered irrelevant by events. "Her bundle of sticks may be unloosed and scattered to the four winds of Heaven. Her crown stars torn from her head, and the chains now under the foot may now be welded upon her arms . . ." Although as late as 1860 he continued to insist that the work bore no allusion to black slavery, after the Civil War he applied his connotation to the work: "It represents our country with her foot on slavery, broken and destroyed forever."[18]

Thus it is possible that Powers could have invested the statue with this meaning when he exhibited it at the Italian National Exposition in 1861. The Civil War had broken out several months earlier, and his agonized response may have found an outlet in this celebration of Italian unity. The work was favorably received by Italian critics, one of whom described it as "America rising to a new life and trampling on its chains"—a clear reference to the Civil War.[19] Elsewhere, in reviewing Tito Conti's representation of Columbus receiving the support of Ferdinand and Isabella to sail for the New World, he rhapsodized about America: "If you had not had slavery and syphilis [*mal francese*] truly you would have been the promised land."

PIETRO MAGNI'S *LEGGITRICE*

Both the Italian and the English critic noted the tremendous popular enthusiasm for Pietro Magni's *Leggitrice* (Girl Reading; fig. 5.9).[20] If Powers's *America* represented the maturing nation "rising to a new life," Magni's young girl symbolized the regeneration of the older culture through the democratizing principle. Magni carved in marble an adolescent female totally absorbed in reading a book which she rests on the back of an ordinary wooden chair with a straw seat. She is not elegantly positioned nor does she read for leisure: she is intensely concentrated on the book and sits at right angle to the back of the chair, twisting her upper body to allow the light to fall on the page she reads. Her clothing is plain and even coarse, and her political position is demonstrated by the medallion of Garibaldi she wears around her neck.

5.9 Magni, *Girl Reading*,
ca. 1861

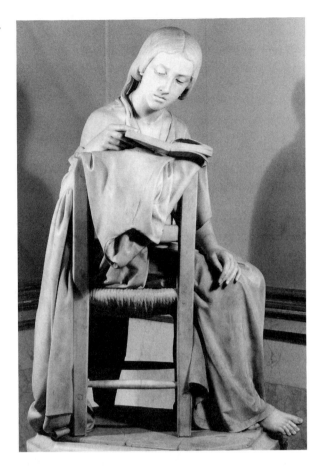

Stewart compared this work with another statue by Magni in
the exhibition representing Socrates, "one of the grandest historic
statues in the collection." He described the *Girl Reading* as essen-
tially different,

> and although lower in conception and style of Art,
> this statue is yet so successful in treatment as to be-
> come the most popular in the exhibition—as popular,
> for example, as the "Greek Slave," by Powers, was in
> the exhibition of 1851. The merits of this figure are
> extraordinary; the intensity of reading power in her
> face,—you could never fancy her doing anything else
> but read, although the head were severed both from
> the body and the book,—and the worn consumptive
> feeling thrown over the features, give double interest
> to the effort; but to those very high qualities have
> been added others, which help to popularity with the
> multitude, and which are far below the dignity of

high-class sculpture. A girl of the people, she sits upon
a common rush-bottomed chair—the rushes imitated
to admiration—dressed in a garment destitute of ele-
gance or reality in its folds, reading one of the popular
stanzas from a book, with a medal of Garibaldi around
her neck—all objects that attract the multitude.[21]

Stewart again demonstrates his discomfort before the examples of
the Italian exhibition, the magisterial qualities of the classical
sculptor applied to a popular subject has thrown him as much as
the overt politicizing of much of the painting. For him Magni,
quite capable of producing the kind of excellence Stewart identi-
fied with "high art," has in this instance produced a work of a
"lower class" in representing a member of a socially "lower" status
than is usually represented in sculpture.

Under the influence of the Risorgimento, however, Magni pro-
duced one of the most revolutionary sculptures of the period. Few
examples of the period can match the social and political realism
of contemporary painting, but Magni's even goes one step further
in treating both the gender and class issues with an unprecedented
openness and seriousness. Not only does he depict a working-
class female in other than an occupational role, but he shows her
capable of intense intellectual effort. As we shall see in a later
chapter, the Risorgimento released feminist as well as masculine
energies and its leaders often stressed the need for the thorough
education and training of women.[22] While this remained at the
level of theory until much later in the century, the genuine be-
lief in its potential to be actualized is exemplified in Magni's
sculpture.

Magni brought home his point with the medallion of Gari-
baldi, thus declaring the connection between national liberation
and the regeneration of working classes and women. As opposed
to the elite, abstruse allegorical statement of Powers, Magni draws
his inspiration from the popular classes. Powers's difficulties de-
rived from his impossible project to embrace all the political and
social contradictions of the United States, to somehow elide the
flaws by folding them into a higher order of vision. For Magni,
national coherence was a possibility for the improvement of social
life, while for Powers national coherence had meaning only at the
expense of its most underprivileged members.

Stewart expressed even more frustration with the landscape sec-
tions, a category in which "the Italians are, to English eyes, no-
where." This fact surprised him, given the spectacular beauties of
the Italian countryside: "True they want the rolling mist and
clouds, which play so important a part in the education of British

landscape painters but they have other excellences of atmospheric effect, that ought to produce tenderness of colour in landscape, of which England's climate teaches her artists little or nothing." His own taste ran to an old-fashioned nostalgia for the past, and he blamed the Italian lack of feeling for "every quality of tone and colour" achieved by all great landscape painters from Titian and Claude to Turner and Linnell, on the fact that modern Italian painters—mesmerized by the reputations of the figure painters of their country—respond indifferently "to the glories of high landscape art."[23]

But when Stewart got down to describing individual artists he could not help admiring their audacious treatment: Telemaco Signorini (whom he calls "Telemanco" in one place, "Temistocle"[24] in another) "produced a powerful effect in landscape, exhibited in a masterly background to one of those innumerable battles that line these exhibition walls." Then, as if embarrassed by his effusive remarks, he gets back on the track by condemning it for being "broad and clever to a fault,—the grand defect of all the landscape painters of Italy, who seem to mistake breadth of touch for breadth of style, and never has there been a more pernicious confusion of ideas." He characterized Signorini's picture of some cows in a stubble-field as "perhaps the very cleverest landscape in the exhibition," except that

> it is not a picture, it is an excellent sketch, from which a picture might be painted, bearing the same relation to a fine landscape that the rough clay sketch does to the finished marble statue. This is a grave error, arising from that negligence of details of nature, that will prove the grave of Art to these Italian landscape painters, unless their present suicidal course be altered.

In a similar vein, he begins by praising Borrani for getting "away from pigments and paint into genuine atmosphere and light," but then goes on to state that

> there never was such an empty, slovenly style of work seen, or one which had so little reference to the everyday realities of nature. Wheatsheaves, cows, women's dresses, trees, foreground, and distant hills, are all of one texture, and nothing but extraordinary power of colour could separate them perspectively; but with this faculty of colour, when Borrani begins to distinguish between the qualities of objects so essentially different, very high-class landscapes may be expected from his pencil.

Stewart was unable to make the connection between the powerful effects of light he observed in these studies and the uniform technical execution which treated the entire surface with a consistent all-over texture. For example, he praised Serafino De Tivoli's landscape which was "bathed in a flood of sunlight," but displayed "the faults of blotchiness, and a style of touch which reveals ignorance rather than hides knowledge of detail." Nevertheless, in this case he felt it to be "one of the most perfect landscapes in the galleries," and "one among that dozen of small landscape pictures here exhibited which one may be excused for feeling a strong desire to possess."[25]

It is very instructive to proceed to Stewart's second article on the National Exposition reporting on the industrial and commercial displays. A clear connection seems to have existed in his mind between the landscapes and the agricultural displays of farm machinery, novel foodstuffs, and livestock. The Italians devoted a major section to cows, horses, and other domestic animals, an innovation in shows of industry and art exemplifying "that hopeful breadth of vision of which the future of Italy stands so much in want, and of which the Tuscans especially have exhibited such ample stores in the difficulties and dangers that have so recently beset the common fatherland." Thus while he could not grasp the connections between Macchiaioli innovation and the commercial "breadth of vision" he so much admired, he nevertheless recognized the experimentation on both sides. In the end, he followed the "press releases" of the exhibition and got the point:

> In taking leave of the exhibition, it is impossible not to express admiration at the success with which a nation, struggling for political existence, has shown the world that in the higher arts of peace it still occupies a foremost place in Europe, and gives ample pledge of present and prospective ability to contribute its fair share to European progress and civilization.[26]

The exposition's publicists compared it favorably and doggedly with those of London and Paris. The combination of science and industry and fine and applied arts were meant to demonstrate that economic progress and artistic progress develop in tandem. Prominent exposure was given to the effigies of Physiocrat Sallustio Bandini and the economist Richard Cobden (1804–1865), the hero of Italian free traders. The organizers loudly proclaimed the virtues of capitalism, the division of labor, the construction of machinery, the application of steam as motive power, and improved means of communication.

Protonotari hinted that the parallel in culture to scientific progress was seen in the art categories of genre and especially landscape painting, where *il realismo* (originating in France) predominated. He suggested that, provided its representatives preserved traditional refinement, realism had the potential of rejuvenating the national art. He further observed that an intimate connection existed between the economic vitality of a nation and its high-art achievement, offering medieval Italy and Holland as examples. He frankly assessed Italy's backward industrial situation, and insisted that it could become great once again through a concord of modern economic and aesthetic principles.[27] This theme was also taken up by Francesco Carega, secretary-general of the Royal Commission whose "Circular to the Academies and Institutes of Fine Arts" of June 6, 1861, stated that the "flourishing or decadence of the fine arts in Italy has always reflected the life of the country."[28] The issue of realism occurred in the "Report on the Fine Arts," which connected Risorgimento culture with the then widespread preoccupation with positivism and defined the new trend as "a study of reality in all its forms, in all its effects of tones and light which is presented to the glance." The report claimed that the new realists were adopting every means to capture "the immediate sensation of the visual fact, rather than its image" and further suggested that the tendency to emphasize the light effect and vivacious light and dark contrasts constituted "the innovative part of the arts" during the critical time of transition.[29]

It is noteworthy that some of the competition pictures in this show were unfinished. No self-respecting French painter or Salon jury member would let pass under official guidelines a "quadro non terminato," but this was not a problem for Italians in 1861. Although the official line held that a *bozzetto* was an embryonic picture that had "yet to take life," the entries of the 1859 contest were judged on the basis of such compositional sketches.[30] The judges of the Exposition entries, both academicians and administrative officials, evidently felt comfortable with incomplete pictures that still displayed the promise of outstanding work. Like Italian academies generally, the program of the Florentine Accademia delle Belle Arti provided sketch exercises for students under the category of "bozzetto a olio d'invenzione."[31] Although traditionally the qualities of spontaneity and effect were admired in sketches, the full gifts of a painter came through only in noble, that is highly polished work. Nevertheless, it is clear that during the Risorgimento more liberty was permitted in this regard and the rules relaxed to accommodate the new trends. It may not be coincidental that in September 1859 a government-appointed commission of the leading artists of Florence, chaired by the ven-

erable Marchese Gino Capponi, met in session to draw up plans
for reform of the Academy. The committee members concluded
that it was necessary to counteract the stultifying effect of me-
chanical exercises, and to encourage the greatest possible degree
of liberty and spontaneity of each pupil's special talent.[32]

Despite the controversial reactions provoked by the Macchia-
ioli, we now see that there was a conscious attempt by critics to
understand their innovations in the context of political and social
reform. Their independence, sincerity and fidelity to nature were
lauded, even while the critics gently chided them for going to
excess to demonstrate their point. The attitude for the time being
was "buy Italian," in the same sense that the new unified state had
its own market of 22 million consumers and could profitably
manufacture its own products in every field without having to
depend on manufacturers in England and France.[33] This in turn
generated a more favorable climate for their experiments than ex-
isted elsewhere, where the "fini" was fetishized like a holy ritual.[34]
Here again we see how it was possible for the Macchiaioli to
identify with a word that implied technique and process—an
identification not possible in France or anywhere else at that
moment.

STIMULUS TO COLLECTIVITY

That the exposition proved to be a watershed event in the history
of the Macchiaioli group is indicated in part by the successes that
many of its members, and other artists close to the group, enjoyed
there. Vito D'Ancona and Giuseppe Abbati, both Macchiaioli,
and their close friend the caricaturist Angiolo Tricca (for lithog-
raphy), Antonio Puccinelli, Saverio Altamura, Antonio Rivalta
(for sculpture) all won medals for their entries; while others in
the group, such as Borrani, Cabianca, and Signorini, although
not prizewinners, certainly reaped popular esteem. It is not sur-
prising to learn that almost every winning entry was cited in
official exposition documents for its treatment of light effects.
D'Ancona's work, *Incontro di Dante con Beatrice* (The Meeting of
Dante and Beatrice, ca. 1859–60), was praised for its "very beau-
tiful effect of light in the sky and in the background generally."
Perhaps surprisingly, Carlo Ferrari's *Piazza Navona* (ca. 1860; a
non-Macchiaioli example) was cited specifically for its "great live-
liness in the macchiette" (little touches).[35]

The Macchiaioli presented a mixture of historical and modern
subjects, all of which shared an emphasis on the glorification of
Florentine history, past and present. Works directly inspired by
the Risorgimento, such as Fattori's unfinished *After the Battle of*

Magenta, and the non-Macchiaioli *Episodio della guerra del '59* (Episode of the War of '59, ca. 1860) by Rivalta, were hung with paintings of more conventional and traditional themes by academic painters, such as Alfonso Chierici's *Madonna col Bambino e due Santi* (Madonna with Child and Two Saints) and Luis Alvarez's *Sogno di Calpurnia, moglie di Cesare* (The Dream of Calpurnia, Caesar's Wife), which demonstrated to the public the innovations of the new tendencies.

The Macchiaioli painters exhibited twenty-two paintings in the 1861 exposition, all painted between 1859 and 1861, five of which represented Risorgimento themes. These included Borrani's *Il 26 aprile 1859* (The 26th April 1859), Signorini's *La cacciata degli Austriaci da Solferino* (The Expulsion of the Austrians from Solferino), Lega's *Una imboscata di bersaglieri Italiani: Episodio della guerra del 1859* (An Ambush by Italian Bersaglieri: Episode of the War of 1859), and Fattori's *Una ricognizione militare* (A Military Reconnaissance) and *Magenta*. The remaining works were history paintings such as D'Ancona's *Dante and Beatrice* and Cabianca's *I novellieri Fiorentini del secolo XIV* (Florentine Novella Writers of the Fourteenth Century), and a variety of genre and landscape canvases such as Borrani's *Mietitura del grano nelle montagne di S. Marcello* (Grain Harvest in the Mountain of San Marcello) and Cabianca's *Una ferriera nella Versiglia* (An Ironworks in Versiglia). Five out of twenty-two is a significant number of Risorgimento-oriented works, yet not included in that tally are the additional Risorgimento themes the exposition organizers encouraged painters such as Borrani, Signorini, and Lega to do but which for one reason or another did not get into the show. Moreover, with only two exceptions, all the landscape and history subjects had Tuscan, or specifically Florentine settings. Thus even when the entries lacked explicit Risorgimento references, they expressed a patriotic-national sensibility. Indeed, themes such as Borrani's *Grain Harvest* and Cabianca's *Ironworks* were made to order for the agricultural and industrial content of the exposition. Borrani included in the entry listings of his landscapes explanatory comments that alluded to the paintings' basis in observed reality. The *Grain Harvest* he described as a "motivo dal vero," (motif from nature) and another taken from a nearby site he called a "paesaggio dal vero" (landscape from nature).[36] This suggests that his large picture was completed in the studio after a macchia sketch, and that the second painting was done on the spot directly from nature. While the inclusion of this descriptive phrase could be found earlier in the Promotrice exhibitions and was used regularly by Serafino De Tivoli, it points to the legitimation of the Macchiaioli experiments at the 1861 Exposition.

The complexities of the 1861 art displays are exemplified in the

5.10 Ussi, *Expulsion of the Duke of Athens*, 1861

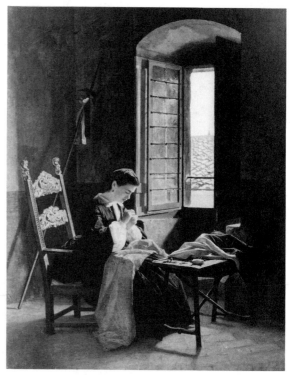

5.11 Borrani, *The 26th of April 1859*, 1861

two most popular works: Stefano Ussi's *La cacciata del duca d'Atene* (Expulsion of the Duke of Athens; fig. 5.10) and Borrani's *The 26th of April 1859* (fig. 5.11). The first was the official favorite, the second a popular success. Both in their own ways express the welling up of nationalism between 1859 and 1861. While done in diametrically opposing categories—Ussi's embodying the tradition of romantic historicism but encoded in the most advanced academic style and Borrani's the most experimental and independent—both reflect the thought of progressive minds dedicated to the Risorgimento ideal.

As a member of the Fratellanza Artigiana, Dolfi's mutual aid society for artisans, which contained some of the most radical elements of Florentine society in those years, Ussi was perhaps the more revolutionary of the two. Ussi, as Signorini noted, had participated in the 1848 campaign; he joined the Florentine Second Battalion that was defeated at Mantua, and he was imprisoned by the Austrians for several months. Signorini also published a caricature of Ussi and his friend Lanfredini in their "democratici mantelli"—their conspirators' cloaks drawn up over the shoulders (fig. 5.12). But Borrani was no less committed to the national cause. In 1859, together with Signorini, Cecioni, and Martelli, he had enlisted in the Tuscan artillery unit whose high morale he celebrated with a macchia study of his unit entering a town that same year (fig. 5.13).[37] Borrani was on close terms with Dolfi whose portrait he drew, and it is certain that his ironic title of *The 26th of April 1859*—the day before the revolution—points to his foreknowledge of the plot spun by Dolfi and his colleagues.

Both Borrani's and Ussi's paintings were purchased by the state. Ussi's, executed between 1859 and 1861, was subsidized by popular subscription and entered into the collections of the Tuscan government, while Borrani's was purchased by Prince Eugenio Carignano. The two paintings therefore upheld the moderate liberal ideology that motivated the exposition. Although Ussi's theme did not figure in the Ricasoli contests, the government decided to exhibit it still unfinished, with the sketch entries of the contestants, in April 1860.[38] This shows that the government wanted to capitalize on the work's propaganda appeal and thus reinforce the ideology of the competitions. The monumental work (12 by 8 feet) was the hit of the Ricasoli exhibition as well as of the exposition of 1861.

Ussi's picture drew upon the Florentine Renaissance chronicles of Giovanni Villani, published in 1348, to depict one of the most spectacular episodes in Florentine history, the rise and fall of the foreign tyrant Walter de Brienne. In March 1342, after defeat by the Pisans, the Florentines cashiered their captain-general and re-

5.12 Veraci, *Stefano Ussi and Alessandro Lanfredini*

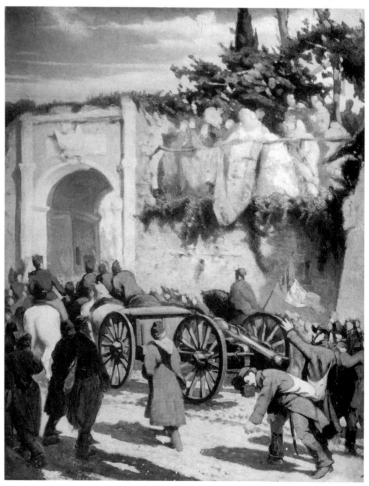

5.13 Borrani, *Tuscan Artillery at a City Gate*, 1859

placed him with the Frenchman Brienne, who called himself the "Duke of Athens." He lost no time in asserting his authority by eliminating potential rivals and political opponents. During his tenure of ten months and eighteen days, he plundered Florence of moneys, and inaugurated a reign of terror. While Brienne cleverly played off one class against another, hatred for the tyrant in the end induced the citizens to unite against him.

The insurrection began the morning of July 26, 1343, when the population barricaded the principal streets and all the entrances to the Piazza della Signoria, then as now, the heart and center of the city. The duke attempted to make some concessions, but it was clear that the populace wanted him to step down. Finally, the majority of citizens agreed to allow him to go free if he would renounce all title and pretension to Florentine rule and would deliver to them the three most repugnant members of his government. He at first refused but was ultimately persuaded to concede by his soldiers, who threatened to take matters into their own hands.

Ussi chose this moment of final hesitation for his painting and carefully reconstructed the episode using Villani's description. His scene is set in the hall of the Palazzo Vecchio, and through its lofty windows the towers of old Florence rise up into the pale-blue summer sky. They form the backdrop for the unseen crowd below, which was kept informed on the progress of the negotiations and which maintained pressure on their antagonist. In the center sits the immobile duke, his left hand pressed tensely on the paper he is about to sign yet still calculating the possibilities of retaining his power. The Bishop of Florence, dignified and resolute, stands in sharp profile at the right like a character from a Ghirlandaio fresco. Beyond him is Simone de Battifolle, captain of the people, who leans calmly on his sword. He knows that he has behind him the tumultuous crowd which now receives the signal by the flag waved from the window that victory is imminent.

Brienne etched himself deep into the collective Florentine memory. It is no coincidence that Ricasoli, as part of his own propaganda campaign, continually referred to the Duke of Athens in his addresses. In his address to the National Guard in November 1859, he alluded to the tyrant's overthrow in the context of his appeal to contemporary vigilance:

> Throng around this holy banner, this banner of your country, this symbol of your redemption, which recalls to you the blood shed by the brave Piedmontese in a hundred battles, and reminds you of the glory of

our king. . . . Now turn your eyes to yonder city, and
to the hills that surround it. Every monument, every
spot recalls some glorious deed of its citizens. . . .
From that city the Duke of Athens was driven igno-
miniously forth. . . . Think over these feats of old, and
prepare to imitate them by deed of prudence and of
peace . . . or, if need be, by deeds of daring and war.[39]

This back-and-forth confounding of glorious past and glorious
present gave a contemporary meaning to Ussi's work, despite its
ancient costumes and subject. Analogously, Ricasoli's govern-
ment transformed the old Renaissance buildings into modern in-
stitutions and updated their political functions. The Bargello, in
Brienne's time the site for the beheading of political dissenters,
became a museum, while the Palazzo Medici-Riccardi on the Via
Larga became the headquarters of the National Guard. An in-
scription on the building stated that "where once the Medici
opened the way for the enslavement of their country, is now the
headquarters of that Civic Guard which defends its liberty and
independence."

There could be no doubt in anyone's mind about the parallels
between July 26, 1343 and April 27, 1859. The relative restraint
of the populace, their single-mindedness and unity, their sustained
show of strength in the Piazza della Signoria, and Brienne's peace-
ful expulsion made the theme of the Duke of Athens an excellent
stand-in for the ejection of the Grand Duke Leopoldo II of
the House of Lorraine. For conventional critics, its theme and
methodical execution put it on a par with the "antique grandeur,"
but at the same time its fidelity to documentary fact and persua-
sive realism placed it in the front ranks of the modern school.

Borrani's *The 26th of April 1859* was a much more modest
picture, and it won no honors at the Exposition. But judging
from the critical response and the fact that Prince Carignano pur-
chased it, we know that it enjoyed the public's esteem. It is per-
haps one of the most important examples of a "finished" macchia
that retains the effect and mood of the original study. Borrani
searches for strong light-and-dark contrasts—the narrow window
opening onto the gloomy room and the sunlight falling on the
bloused white sleeves of the seamstress.

Italian critics generally admired it: Yorick declared that he
could in no way pass over silently "the delicate idea of Signor
Borrani, who in a young woman seated in an attic-chamber, to-
tally absorbed in her work on the tricolor flag, wished to express
the eve of the peaceful Tuscan revolution (April 26, 1859)." For
those, like Yorick, who recall that happy day when the Grand
Duke was sent packing "digesting the breakfast he chewed poorly

in the Palazzo Pitti, the picture is a gracious souvenir and a faithful reproduction of the truth *(del vero)*." Here, perhaps without realizing it, Yorick summarizes the basic aspirations of the Macchiaioli—shared by the most advanced thinkers of the Risorgimento—to be modern, national, and truthful.[40]

A critic for *La Nuova Europa* observed that Borrani's painting symbolized "all the easy-going and venerable Giusti-like qualities of our revolution," and gave the following vivid description:

> In a small attic-room you admire a darling young woman, who is seated on an arm-chair intent on threading a needle in order to sew a tricolor flag: Her gracious figure, the simplicity and the exquisite taste of her clothing, the work table, another completed flag [*sic*], a window through which is perceived a neighboring roof below, are so masterfully illuminated that the surface of the canvas disappears and in its place we see a lovely stereoscopic view.[41]

There are several revealing features of this passage which help us put the painting into its proper historical context. It confirms the visual evidence that the woman is working in a hidden nook of the building and concealed from prying eyes. She is part of the conspiracy that will disclose itself on the morrow, in the full light of day. Secondly, the remarks on her person and costume indicate that she belongs to the upper classes, further confirmed by the Renaissance chair on which she sits. Hence she belongs to the inside circle of the conspirators—Giuseppe Dolfi, Ermolao Rubieri, and Piero Cironi.

Despite his Mazzinian working-class sympathies, Dolfi's plea for annexation and his major role in organizing the 1861 exposition demonstrate his affiliation with the upwardly mobile class that was in the process of wresting power from the old ruling alliance. The Risorgimento was never a mass movement. The politicized groups included liberal aristocrats and segments of the upper, middle, and artisan classes. Thus it was in Dolfi's villa on April 26 that plans for the overthrow of Leopoldo II were laid and the green light given for the massive demonstration that took place on the following day.[42] As we have seen, Dolfi was an intimate of several of the Macchiaioli and their friends. Fattori dedicated his painting of a scene from Guerrazzi's novel *The Siege of Florence* to him, and Borrani sketched his portrait. Dolfi was a combination baker-entrepreneur, a wealthy merchant who supplied the best restaurants with bread and pasta and catered to the military.[43] His support of the Macchiaioli faciliated their entry into the exposition of 1861. He helped organize it and was ap-

pointed to serve on the jury of the section on food and hygiene, as well as oversee some of the key displays.[44] His central importance in the economic and political life of Florence is indicative of Macchiaioli patronage generally.

The shift in political and economic conditions expressed itself in the revolt Dolfi orchestrated. Early on the morning of April 27 the whole of the city's population poured into the streets. Significantly, the signal and rallying point everywhere was the tricolor flag. It was first hoisted on the walls of the Medici fortress in the northern part of the city known as the Fortezza da Basso and next in the nearby Piazza Barbano (later Piazza dell'Indipendenza). Throngs comprised of all classes waited everywhere to see the tricolor raised, signaling the overthrow of the foreign tyrant. Enrico Fanfani's *Il 27 aprile 1859* (The 27th of April, 1859) depicts one such celebration in the Piazza della Signoria and the raising of the flag on the Palazzo Vecchio, focusing on the statue of Benvenuto Cellini's *Perseus Holding the Head of the Medusa* to make the point about despots overturned and the resurgence of Renaissance glory (figs. 5.14, 5.15).

The banners and flags that proliferated in the ensuing days were sewn and embroidered by women, an act which in a sense announced a rejuvenation of their traditional role by putting their domestic skill to work for the revolution. Nevertheless, Borrani's female protagonist moves beyond the stereotyped role; she is privy to the revolutionary scheme and participates as one of the plotters. Her environment is not the typical domestic foyer but a concealed corner of an old Florentine building inhabited by the wealthier classes, and is identified with the Renaissance past through such accessories as the chair and the halberd draped with tricolor ribbons that leans against the wall. A combination axe and pike, the halberd was used mainly in the fifteenth and sixteenth centuries, thus connecting present and past militancy. In this way, although coming from a modern perspective, Borrani's picture partakes of the same historical mind-set expressed in the Ussi. Finally, Borrani's Italian Betsy Ross is a strong, unsentimentalized presence that adds a feminist note to both the Risorgimento and Macchiaioli painting, an issue to be elaborated on presently.

THE MACCHIAIOLI AND PHOTOGRAPHY

The critic of *La Nuova Europa* mentioned that Borrani's handling of light makes the canvas disappear and leave in its place a stereoscopic view, implying, in this instance, photographic illusionism. Borrani was, like most of his colleagues, fascinated with photog-

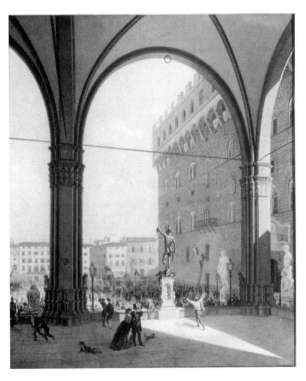

5.14 Fanfani, *The 27th of April 1859*, 1860

5.15 Fanfani, *The 27th of April 1859*, detail

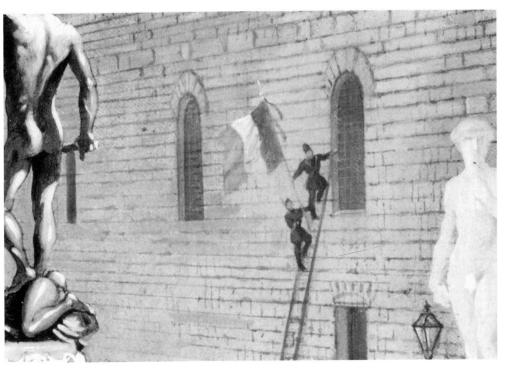

raphy, and he used old photographs and their tonal values as the basis for some of his paintings.[45] He even doctored one photograph to serve as the foundation of a study for a painting. The Macchiaioli did not embrace photography uncritically—Signorini rejected the "cold minutia of the photographic apparatus"[46]—but admired it for its capacity to capture the instantaneity of the light effect. Nancy Troyer's dissertation discusses the impact of photography on the Macchiaioli, emphasizing the role of Signorini who himself admitted a close relationship between the macchia and the new medium.[47] That it should be in everyone's mind at the time of the 1861 exposition is no coincidence; photography was given a place of honor in the show but buried under the class of "Chemistry" rather than that of "Drawing, Painting, Engraving, and Lithography." As a result, its importance at this time has tended to be generally overlooked.

A Florentine critic stressed in his review of the photographic display that while photography did not originate in Italy, it owed its origin to certain Italian discoveries such as scientific properties of silver salts and their sensitivity to light, and the invention of the camera obscura, which he erroneously attributed to Giovanni Battista Della Porta.[48] He was correct in implying that Italy had long been prepared for the advent of photography by the habitual use among its artists of the camera obscura. Fox Talbot's experiments with the calotype were encouraged through his contacts with the scientific community in Italy, and among his papers there was a description of a report on "photogenic images" presented before the Accademia dei Georgofili in 1840. Daguerre's process had been followed with special interest in Italy from the moment of its public announcement early in 1839, and several pamphlets on the discovery were published in the years 1839–40. Homegrown professionals, including former painters, soon spread throughout the peninsula, with a large concentration in the production of topographical views of Italy.[49]

The English critic for the *Art-Journal* noted the prominence of the photographic booth at the National Exposition and its demonstration of technical mastery:

> The display of photographs at Florence occupies a considerable space—more, perhaps, than the Photographic Society can secure for any of their exhibitions in the metropolis; and much of the Florentine space is covered with what is interesting, if not important, in this modern Art-science. One of the first, and by far the most conspicuous objects in the collection, is a photograph of his Majesty Victor Emmanuel, a full-length figure, almost, if not quite, life-size—the larg-

est and certainly the most striking photograph we ever
saw, the work of Duroni of Milan.

While Stewart regarded the photograph more as a novelty than as
a work of art, it is clear that the process involved in its production
constituted "an expansion of photographic capability such as
could hardly have been hoped for."[50]

The section on photography emphasized the popularity and
pervasiveness of the art. In addition to the work of the Alinari
brothers, Leopoldo and Vittorio, the catalogue noted the impor-
tance of the Società Fotografica Toscana, directed by Pietro Sem-
plicini of Florence, which was distinguished for its stereoscopic
views, as well as for its fine photographic reproductions of old
master paintings.[51] The critic Pietro Selvatico, who served on one
of the committees of the Exposition, had written in 1852 on pho-
tography's importance as a scientific base for the visual arts. He
claimed that artistic mediocrity resulted from want of science, and
claimed that the work of Daguerre and Talbot would excite the
artist's creative capacity and prove indispensable to the artist's
education. Photography would help reaffirm the diligent obser-
vation of nature and convey the effect of immediacy. It would not
replace invention, but would serve as an invigorating stimulus to
visual inspiration.[52]

Almost all the Macchiaioli shared this interest, and while docu-
mentation for it remains slight it is hinted at in such unexpected
finds as Abbati's charge to Martelli (then in Paris) to pick up ex-
amples of the work of the French photographer Nadar.[53] When
we recall that the painters thought of their experiments as "scien-
tific," we may conclude that the macchia was not just a concept
that they plagiarized from the past or from the Barbizon school
but represented an attempt to establish a basic principle compat-
ible with the industrial and economic ideals incarnated in the
1861 exposition.

The relationship between the macchia and photography cen-
tered on their association with the "effect." At that time, "effect"
implied the arrangement of the chiaroscuro, or pattern of lights
and darks, with coloration taking a subordinate role. The mod-
erns of the French and Italian schools analyzed the pattern into
discrete areas, eliminating as much as possible the transitional
halftones. Martelli's laudatory description of the French Edouard
Manet's painting as the "macchia larga" is related to this flat visual
arrangement that resulted from concentration on a limited series
of tonal values.[54] It is clear that artists seeking the most succinct
analysis of light and shade would find in photography a wonder-
ful tool and model. For the Macchiaioli, however, it was not a
question of exact appearance of form but capturing the effect

which governed its mood. These moods and their expression, subjective perceptions of the objective light conditions, challenged the painters' sincerity, and hence their national identity—a disposition Borrani exploits to great advantage in *The 26th of April 1859*.

The critic of *La Nuova Europa* referred specifically to the stereoscope, a special branch of photography exploiting binocular vision that developed in the 1850s and 1860s. At the Italian National Exposition, the Società Fotografica Toscana delighted the public with a show of stereoscopic views that stood out for their "accuracy and clarity."[55] Sir David Brewster's Paris-made lenticular stereoscope—through which two pictures of the same scene from slightly different points of view, are seen separately by each eye to produce the effect of a single scene in three dimensions—was first exhibited at the Great Exhibition of 1851 in London. The earliest stereo images, usually of interior views, were small, and because the focal length of the stereoscope was short, gave an instantaneous view, like a snapshot. By 1860, French photographers were doing series of Paris street scenes with an exposure time of a few seconds, fixing panoramic views on the glass plates with relative clarity. One album from the early 1860s by Hippolyte Jouvin was entitled *Vues instantanées de Paris,* attesting to the association of the stereoscopic views with the snapshot effect.[56]

Forever promoting the stereoscope for every purpose, Brewster especially recommended its use for painters. He insisted in his popular manual of 1856 that color and light effects "produced by the stereoscopic union of two plane photographs . . . are invisible in the single picture." He went on to stress the value of stereoscopy for the landscapist wanting to grasp a scene in relief and the relative distances of its various parts:

> Effects in outline, as well as in light and shadow, which may perplex him, will find an explanation in the relative distances and differences of apparent magnitude of individual parts; and, after becoming familiar with his landscape in relief, as it exists in Nature, he cannot fail to acquire new principles and methods of manipulation. Nature flattened upon paper or metal, and Nature round and plump, as if fresh from the chisel of the Divine sculptor, must teach very different lessons to the aspiring artist.[57]

Thus Brewster recommended the process for achieving the very aims so anxiously sought after by the Macchiaioli.

What popularized stereoscopic viewing in this period (as well as the practice of photography generally) was its unexpected illu-

sion of depth or relief somewhat analogous to 3-D movies in more recent times, often dramatized by some innocuous foreground object like a clump of grass or wall surface standing out solidly in space to function as a *repoussoir*. Crucial to its success, was the habitual ocular perception of the relative distances of near objects and previous knowledge of the shapes and sizes of distant objects. Thus overlapping forms almost always persuaded the conditioned viewer to accept the fact that the partially concealed object was the one set deepest in space. Stereoscope photographers accomplished this in panoramic views by angling the composition to include rooftops in the foreground and domes and towers on the distant horizon (fig. 5.16). The cunning Macchiaioli consistently frame their scenes with porticoes, architectural parts like walls, beams, columns, and windows, exemplified by Abbati's *Il torre del Palazzo del Podestà* (The Tower of the Palazzo del Podestà; fig. 5.17) whose series of overlapping parts resemble images designed for the stereoscope (figs. 5.18–5.19). Abbati manipulates the perspective of the scaffolding of the bell tower to act as an enclosed viewing device through which we glimpse another, brightly lit tower, somewhat reminiscent of the old portable camera obscura with its inverted shapes, sunlit projections on the floor, and lone observer within (fig. 5.20). Indeed, Abbati's picture metonymically conveys Macchiaioli awareness of modern optical phenomena and its role in their conceptualizing of nature.

It is no coincidence that one year after he painted this picture he exhibited a work (whereabouts unknown) entitled *Lo stereoscopio* (The Stereoscope), although it's not what you might expect. According to Signorini who reviewed the 1866 Promotrice, it depicted the interior of an artist's studio during the routine break of the model who seizes the opportunity to indulge in stereoscopic viewing.[58] Signorini made it a point to stress that as she does so she turns her back on the spectator. The model's gesture is another critical hint of Abbati's self-conscious incorporation of the stereoscopic metaphor into the very matrix of macchia aesthetics: in a sense, the model, normally the object of the male gaze, reverses roles by becoming simultaneously the controlling subject and a surrogate spectator able to stand within the visual space of the painting and view the scene through a binocular apparatus. This type of wry allusion to stereoscopic viewing is also found in Signorini's study of *Bimbi al sole* (Children in the Sunlight), where the upper corners of the picture are rounded off in conformation with standard framing of stereoscopic prints (figs. 5.21, 5.22).

In the case of Abbati, however, these allusions acquire an especial significance when we recall that the painter lost an eye at

5.16 *Panorama of Milan.*
Stereoscope view ca. 1880s

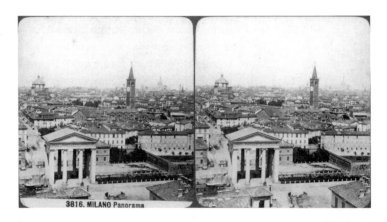

5.17 Giuseppe Abbati,
*The Tower of the Palazzo del
Podestà,* 1865

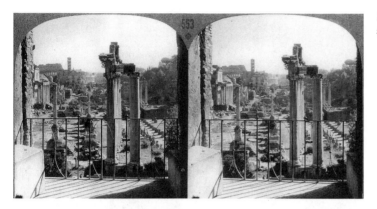

5.18 *Roman Forum.* Stereo-scope view ca. 1900

5.19 *Ancient Cloister of St. Paul's, Rome,* ca. 1870s

5.20 *Large Camera Obscura,* seventeenth century

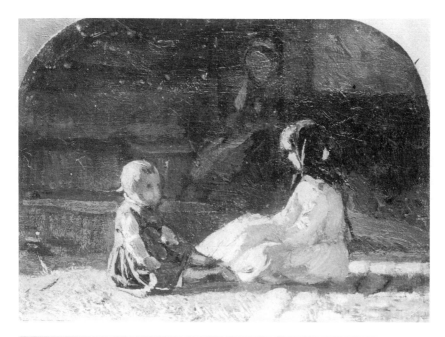

5.21 Telemaco Signorini, *Children in the Sunlight,* ca. 1860–62

5.22 *Palazzo della Signorina, Florence.* Stereoscope view ca. 1860s

the battle of Capua in 1860 while fighting with Garibaldi's Thousand. Thus he could not actually experience the illusionistic effects of stereoscopy. Yet it was undoubtedly the very lack of this capability that engendered his heightened interest in the binocular vision that others took for granted.[59] There is then a playful and self-deprecating wit at work in these pictures, consistent with the Macchiaioli's general identification with *process*. In this way, they defeat the mechanical, reproductive character of photography and exploit its sense of immediacy and effect.

Returning to Borrani's *The 26th of April 1859,* I want to consider one final feature that may have prompted the reviewer's comparison of the work to the stereoscopic phenomenon: this is

5.23 Borrani, *The 26th of April 1859,* detail

the striking still life of sewing materials arranged in impeccable
order on the table (fig. 5.23). Each article is delicately highlighted
and rendered with its own shadow, akin to the *trompe-l'œil* illu-
sionism of objects on a planar surface. Further—especially vivid
in the thimble—there is a feeling of an alternate play of concave
and convex planes that seem to reverse themselves like certain pro-
jections of geometric solids that appear to shift from inside to
outside. The seeming inversion of illuminated object and shadow,
push-and-pull of concave and convex shapes, form an eery spatial
dimension to the picture.

The National Exposition was an institutionalized expression of
the idea of progress, here embedded in the rhetoric of Risorgi-
mento unification. Macchiaioli theme and process were devoted
to the recording of the light of post-unity Italy as experienced by
the liberated citizen in the capacity as artist. It shared with pho-
tography an intimate connection with the scientific development
of positivism and its corollary, anticlericalism. Both the macchia
and photography—and here we might include Verga's verism in
literature—answered to the post-unity concern with inventoriz-
ing, cataloging, surveying, and classifying the physical and mental

space of the new Italy. This preoccupation with documenting the regenerated national domain extended to the everyday life and conditions of the people in the countryside and in the towns. The Macchiaioli's liberty to pursue these aims as full-time professionals depended on the same system of patronage that transformed the idea of the National Exposition into a reality.

SIX

Patronage and Reception of the Macchiaioli

By the time of the 1861 exposition the Macchiaioli enjoyed a substantial body of patrons drawn from the enterprising liberal noble and middle classes.[1] The king and crown prince owned work by Signorini, Cabianca, and Borrani, and Ridolfi (now minister of the interior under the new Tuscan regime) possessed a landscape by De Tivoli. Other notable collectors of their work included Isabella Falconer, the Baroness Favard De L'Anglade, and Doctor Corinaldi of Pisa. The close connection between the ideals of the organizers of the exposition and those of the Macchiaioli is evident from the fact that the participants in the fair were also their patrons and even their relatives. Dolfi, Ridolfi (who displayed his wine), Carducci (who wrote a cantata for the inauguration), Ricasoli, Demidov (who exhibited his exotic garden plants and horticultural methods) played major roles in the administration and organization of the exposition. One London-based relative of Felice and Serafino De Tivoli exhibited his novel prototype for an omnibus in which passengers sat facing each other across a central aisle instead of behind one another in rows (fig. 6.1).[2]

Perhaps the most direct link between the Macchiaioli and the sponsors of the fair is seen in the case of Vito D'Ancona, whose brothers Sansone and Cesare, and his uncle Laudadio Della Ripa, all figured prominently in the exposition.[3] The D'Anconas in particular played major roles in the organization of the Exposition

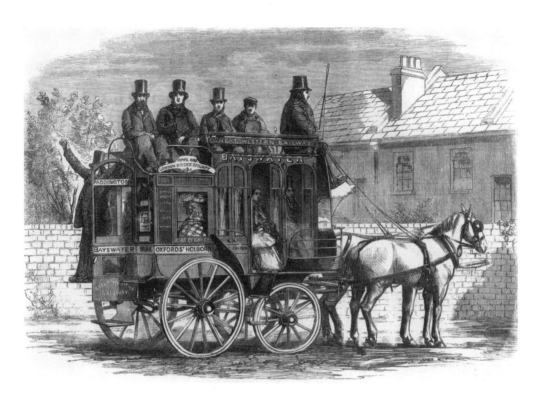

6.1 *De Tivoli's Patent Omnibus,* the *Illustrated London News,* June 9, 1860

and in its public relations. Sansone, Vito's older brother, was named to its chamber of agriculture, industry and commerce and served on several juries, while Cesare, a botanist and geologist, served as a judge for the class of floriculture and horticulture. Cesare also directed the major publicity organ of the Exposition, the biweekly newspaper *La Esposizione Italiana del 1861,* which reported on the various sections within current scientific, industrial, commercial and political contexts. Finally, Laudadio won a special recognition for the exhibit of the remarkable olive oil—"olio giallo-chiaro"—produced on his farms.

The D'Anconas represented in microcosm the new breed for whom the Risorgimento was a vital, living development. An educated, prosperous middle-class family connected with trade, gentleman farming, science and art, they were also moderate liberals who supported unification with Piedmont. They were descendants of Sephardic Jews invited to Italy by Italian princes after 1492, when the Inquisition shattered the equanimity of the thriving Jewish community in Spain and dispersed the survivors to various European refuges. The Italian rulers especially welcomed the Jewish merchant class to ports such as Pesaro, Ancona, and Livorno with the hope of promoting those stagnant port towns into dynamic trading centers that could rival Genoa.

The D'Anconas descended from the Pesaro-Ancona families on the maternal side, and from the Livornese on their father's. The favorable climate for the Jews, however, changed in the seventeenth century, when Pesaro passed out of the hands of the duke of Urbino into the pontifical dominions, and Jews were confined to the ghetto—an Italian word derived from the term for the foundry that marked the site of the first involuntary Jewish quarter in Venice. The history of persecution and reform in the Pontifical States and Tuscany now dictated the actions of the Jewish community in these areas. The majority were pro-French during the Revolution when Napoleon's troops occupied the Romagna and the Marches in 1791–98. Once the French withdrew, however, they were subject to reprisals on the part of the Pontifical government, which burned the two synagogues, confined them again to the ghetto, and exacted an enormous fine. Many Jewish families moved to Ancona, where French troops still remained. During the Napoleonic occupation, the ghettoes were abolished, and many of these families returned.

The parents of the D'Anconas, Giuseppe and Ester, were married and settled in Pesaro in 1813, and a year later Sansone was born.[4] Giuseppe was a well-to-do merchant in sugar and grains who lost his fortune after Napoleon was defeated and the Pope Leo XII returned to power. The new regime treated Jews repressively, and so eventually the D'Anconas made their way to Pisa, where the ruler was liberal and the university open to Jews. Giuseppe never fully recovered from his displacement, and suffered thereafter from a nervous debilitation; Ester's brother Laudadio began helping her to raise her sons.

Laudadio, who had left Pesaro for Florence in 1827, fared much better than his brother-in-law. He opened a successful bank, extended credit for investment, and traded in grain, hay, and straw hats—one of Florence's most important industrial manufactures in the nineteenth century. He participated in the liberal Florentine movement and established close contact with the circle of Vieusseux and the Georgofili, and became actively engaged in agrarian developments. Eventually, he purchased an estate at Volognano overlooking the village of Pontassieve at the confluence of the Sieve and Arno rivers, where he ran a major farm complex and gained a wide reputation for his pure olive oil. Vito D'Ancona's painting of the estate endows it with the clear light and brilliant color of the macchia—putting these qualities to the service of his powerful guardian-patron (fig. 6.2).

Laudadio's support was fundamental to the careers of his nephews. He introduced Cesare to plants on his estate, Vito to his Renaissance art collection, and Sansone to banking procedures. His business and social connections with progressive scions of the

6.2 D'Ancona, *View of Volognano*, 1878

old nobility facilitated their early successes. Politically, the entire family supported Piedmont beginning in 1848, and they were closely aligned with the Ricasoli government in 1859. Alessandro D'Ancona, the youngest of the brothers, devoted his literary talents to the cause of unification. He worked in Turin between 1854 and 1859, serving as mediator between Cavour and the moderate parties of Piedmont and Tuscany, and subsequently edited Ricasoli's newspaper *La Nazione*. Sansone, an expert in finance, was one of Ricasoli's closest advisers, and was appointed director of finance and public works in the Provisional Government. He was one of three Jews who sat in the parliament of the

new united Italy, voting consistently with Cavour's party. Cesare co-founded the Italian Botanical Society and belonged to the Accademia dei Georgofili and the national geological and geographical societies. Each of the brothers embodied an aspect of the new cultural, scientific, and economic forces that sought development and progress in a new Italy and which expressed themselves so forcefully in the exposition of 1861.

FATTORI AND HIS PATRONS

Yet another striking example of the connection between the major industrial and commercial participants in the 1861 exposition and the Macchiaioli was the subsequent subsidizing of two of Fattori's paintings through subscriptions organized by a group of prominent Livorno businessmen and industrialists.[5] The national government, now based in Florence, decreed a competition in July 1866 for original works in any category to be exhibited in the Accademia di Belle Arti in May 1868.

According to Fattori, an association of Livorno's leading citizens stepped forward with the offer to open a subscription to subsidize Fattori's entry, *L'Assalto alla Madonna della Scoperta* (The Assault at Madonna della Scoperta, ca. 1866; fig. 6.3) and later persuaded the Livorno city council to purchase it.[6] These prominent citizens were undoubtedly the same patrons who funded his earlier *Carica di Cavalleria a Montebello* (Cavalry Charge at Montebello, 1862), in hopes of stimulating a native of their town to move to the forefront of the new national culture. The group included Giovanni Santoponte who manufactured objects

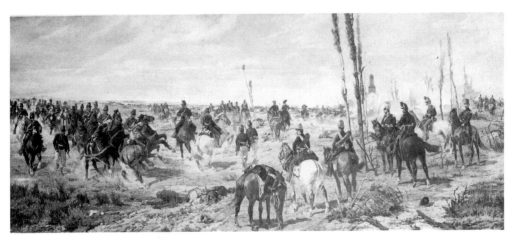

6.3 Fattori, *The Assault at the Madonna della Scoperta*, ca. 1866

of coral; Gustavo Corridi, an industrial and pharmaceutical chemist, who owned steam and hydraulic machinery; and the latter's brother Pasquale who produced fine marquetry and inlaid furniture. All three won medals for their displays at the 1861 exposition.[7]

Another member of Fattori's original support group was the democrat and mason Adriano Lemmi, a railroad magnate who managed to receive from Garibaldi during his dictatorship of Sicily the concession for a railway line in the Kingdom of the Two Sicilies. Garibaldi himself was initially attracted to the Risorgimento ideal because of trade restrictions imposed by peninsular divisions in his own entrepreneurial ventures, and favored commercial and industrial expansion. In the partnership of Garibaldi and Lemmi we see the close connections between the new middle-class power, the Risorgimento, and the taste for Macchiaioli verism.

Fattori's subject could not have been better timed. Its original title, *Un episodio della Battaglia di San Martino, movimento diretto da S.E. il generale Lamarmora presso la Madonna della Scoperta* (An Episode of the battle of San Martino. Movement directed by His Excellency General La Marmora near the Madonna della Scoperta), referred to the one engagement that Piedmontese troops won against Austrian troops in 1859.[8] San Martino and Madonna della Scoperta were small villages a few miles north of Solferino just east of the Mincio River, which divides Lombardy from the Veneto. Early on June 24 (the same day as the battle of Solferino), the Piedmontese stumbled into a surprise encounter with their enemy. The two sides fought indecisively for several hours while a confused Vittorio Emanuele, directing his forces from some miles away, found himself unable to concentrate them and bring the battle under control. Only in the afternoon, after the French had won at Solferino, did he conclude that it was vital that the Piedmontese share the victory. He ordered General La Marmora to take command of the various divisions and brigades for a final attack on San Martino. La Marmora rushed to the combat zone to reorganize the troops, but left the actual direction for the assault to General Giovanni Durando. Late in the afternoon, after an initial setback, San Martino was captured, and the King and the Piedmontese, with the help of the propagandists, won their place in military history.

Fattori depicts the moment when La Marmora, shown on horseback in the middle distance facing left, assembles the various divisions at a point halfway between Madonna della Scoperta and San Martino; the latter is identified only by the small Romanesque church on the horizon at the right. Typically, Fattori avoids

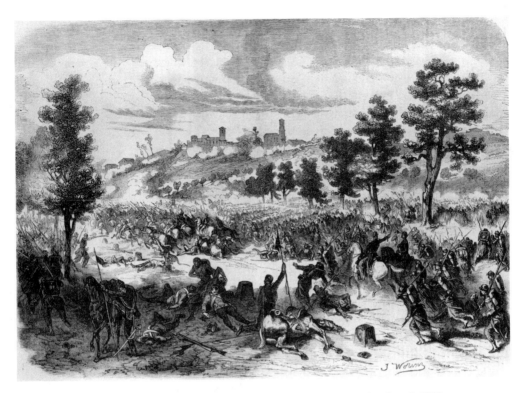

6.4 *Attack on the Village of Montebello, L'Illustration*, June 4, 1859

a heroic clash or death-defying assault. He shows a transitional moment when there is still some disorder in the ranks and the outcome is not assured. Fattori's landscape, persuasive even today, was carefully reconstructed from direct observation of the topography. His knowledge of the battle was derived from eyewitness reports, battlefield sketches, and photographs (fig. 6.4). The immediacy of the action is sustained by the movement of the troops and horses. Fattori's macchia aesthetic enables us almost to hear the horses whinnying, the officers shouting commands, the hoofbeats, and the scuffling of the foot soldiers.

At the same time, the scene actually shows the preparations for the second phase of the assault on San Martino, the one that resulted in victory for the Piedmontese. The first phase was condemned to failure by the disorganization and the impulsiveness of some officers who wanted to achieve individual distinction. The second phase, engineered by General Durando, the real hero of the day, gained widespread publicity in Italy because it succeeded in unifying all the Italian divisions. Thus Fattori chose a moment when that military unity was forming, a moment which could serve as a metaphor for the new nation-state.

Fattori's painting was done at a propitious time; in June 1866

La Marmora and the Piedmontese troops were fought to a stand by vastly inferior Austrian forces at the Battle of Custoza. It was a humiliating episode in the war of that year which saw Italy allied with Prussia against the Austrians. This catastrophe, in which Italy's military weakness and incompetent leadership were shockingly revealed, was a tremendous psychological defeat for the entire country. It would seem that the government-sponsored competition, including Fattori's final canvas, *The Assault at Madonna della Scoperta,* was meant to distract the public from the social and political consequences of the national disaster. By recalling an earlier, successful engagement against the Austrians, Fattori's painting both blunted the pain of the moment and served as grist for the national propaganda machine.

Evidence that the competition sponsored by the government in July–August 1866 aimed at soothing wounded feelings could be gleaned from the desperate attempts of politicians to rewrite history by putting out falsely triumphant reports. Since Custoza was technically neither a victory nor a defeat, they claimed that Custoza, in paving the way for recovery of Venice, even added to the prestige of the monarchy. Hence Fattori's painting could be seen as an extension of the propaganda machine, commissioned and subsidized by the supporters of La Marmora and the national government. Fattori himself may not have been conscious of all the forces shaping ideas and events in those years, but it is clear that he contributed his talents to Risorgimento politics.

AGRARIAN REFORMERS AND THE LAND

If Fattori's military pictures incarnated the aspirations and ideals of the *artigiani* and urban rich, his rustic landscapes reflected the ideals of the landed proprietors and country gentlemen who joined forces with them in appropriating the Risorgimento. The countryside was the most neglected aspect of this political movement. In particular, the peasant class was kept little informed about its political progress, yet in the end was forced to shoulder the bulk of its expenses. The Macchiaioli painters' frequent depiction of the olive groves, the vines, the farmhouses, and villa of the Tuscan countryside reflected a broad range of rural social relations. When Fattori, for example, depicted the *Contadina nel bosco* (Peasant Woman in the Woods, 1861; fig. 6.5), he presented a glimpse of agrarian labor governed by a type of land tenure peculiar to Tuscany. This fundamental institution of Tuscan rural society—the sharecropping system known as *mezzadria*

6.5 Fattori, *Peasant Woman in the Woods*, ca. 1861

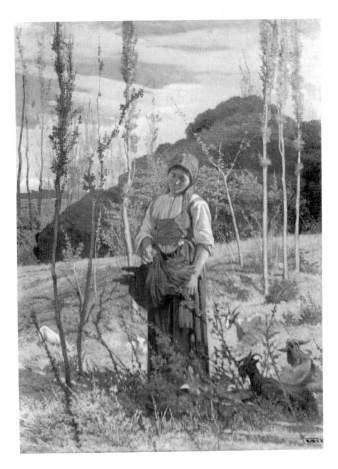

was brought into national focus both by the emphasis placed on the agrarian economy by the exposition of 1861 and by the paintings of the Macchiaioli.

MEZZADRIA

The primary patron and theorist sustaining the Macchiaioli was Diego Martelli, who himself was a major landlord and supporter of this farming system. Many of the Macchiaioli painters became intimately familiar with rural organization during their frequent and extended visits to Castiglioncello, the Martelli family's vast estate in the Maremma countryside, inherited by Diego in 1861. It was his main source of income, furnishing grain, wine, and charcoal cut from the dense *macchia* of the Maremma, as well as rich pasturage for the grazing of cattle and other animals.

Martelli used his estate as a meeting-ground for his artist

friends, and invited them to paint and live there during part of the year. The number of works generated as a result of this hospitality was sufficient to give them a collective title, the "Castiglioncello school." These paintings most often depict the villa, the grounds, the *case coloniche* (peasant dwellings) of the *mezzadri,* and the *mezzadri* themselves at work in the fields. In this sense, the paintings from the Castiglioncello period can be said to have derived their basic inspiration from the mezzadria system. The painters documented the environment and holdings of a major landed proprietor. Although Martelli was not a good business manager and exhausted most of his capital on radical political causes, he nonetheless exemplified the Tuscan country gentleman who upheld the mezzadria system.

Under the traditional mezzadria pattern, the property of the landlord was divided into one or more estates.[9] An estate was known as a *fattoria,* a single administrative unit subdivided into a series of peasant farms called *poderi.* The *fattoria* was the center of administrative control, usually run by the agent of the proprietor, or *fattore,* while the *poderi* were the units of actual cultivation. The working of the land was governed by a contract between the landlord and the *mezzadro* (peasant tenant) under a form of a partnership. In principle, the landlord furnished the land, and the *mezzadro* the labor, while all the produce and expenses of cultivation were divided equally. The proprietor's share of the crop was either consumed in whole or in part, or sold for profit; the peasant's share represented his or her only source of subsistence.

On the face of it nothing seems to have been fairer, and in fact the official view of the traditional Tuscan contract—a view that dominated the discussions of the Accademia dei Georgofili, the agrarian and economic society that represented the landlords' interests—held that the mezzadria system constituted a sort of social utopia. They pointed out that in industry and in the northern countryside where wage labor prevailed, there was continual class conflict and constant threat to the social order. Not so in Tuscany, however, where peasant and landlord were equal partners united by a common interest in the greatest productivity of the soil. The increase of either party meant the benefit of both. As early as 1847, Vincenzo Salvagnoli, a spokesman for the Tuscan landed aristocracy declared:

> The owner prefers the well-being and dignity of the tenant to the highest income; he cares not for a machine, but for the man; he desired not a servant but a comrade. . . . In such a relation, there is no desire on the one side to oppress, and no occasion for ven-

geance on the other. This benign economic relation
has joined landlord and tenant together in a moral
bond of civil harmony. . . . These partners in agricul-
ture would never stand as brother against brother in
civil war.

Such arguments continued right through the century, sometimes
sounding like the defense of the slavery system in the southern
American states: "The contract of mezzadria . . . makes the peas-
ant happy, honest and at ease."[10]

In fact, the mezzadria partnership was unequal and favored the
landlord. The landlord could prescribe what crops were grown
and how they should be cultivated. The landlord held the power
in the form of the ownership of the means of production—the
land, the peasant dwelling, the seed, the fodder, the tools and
machinery of cultivation, and the work animals, and could evict
without notice; the *mezzadri* possessed only their labor power
and perhaps a few simple tools and one or two animals. In addi-
tion, old feudal regulations remained: The *mezzadri* were bound
to render special services to the lord of the estate beyond the di-
vision of the produce. The landlord could exercise the right to
regulate their private lives, even giving or denying permission to
marry.

The relationship was also unequal in terms of economic power.
For the tenant, it was a question of survival; for the owner, a
question of profit. The landlord could exploit his end to fuller
advantage by increasing the intensity of cultivation in smaller and
smaller units to the minimum for the tenant's subsistence. Re-
gardless of size of tract, the peasant's subsistence needs went un-
changed, and since the *mezzadro* and his family gave their labor
in a context unregulated by stipulated hours and wages, child
labor laws, and legal holidays, there was no end to the share-
cropper's exploitation. If the tenant fell behind in his annual ac-
counting, the landlord could extract even greater advantage by
hiring the *mezzadro* at wage rates well below those earned by day
laborers, thus securing cheap year-round labor for the estate.

It was the ability to intensify labor that kept the mezzadria
system going in the face of competition from more rationalized
systems of agriculture. It was the tenants' cheap and unrelenting
toil that maintained the system. Recent studies of the mezzadria
system show that the sharecroppers' remuneration was lower than
that of any category on industrial worker. In addition, the *mez-
zadri* received no benefits and little charity except in occasional
cases when the owner provided for a doctor, provided periodic
gifts, and underwrote the expenses of festivals.

The mezzadria system was best adapted to an environment
such as that of much of Tuscany, where the geological facts—a
predominance of hills and mountains and thin rocky topsoil—
made investment relatively risky and created problems for agri-
cultural machinery. It was especially suited to the cultivation of
crops which, like the Tuscan olives and vines, required close
attention throughout the year. Fattori's *Contadina al campo* (Peas-
ant Woman in the Field, ca. 1867; fig. 6.6) unites the farm-
worker formally with the foreground plane, which emphasizes her
rapt concentration and back-breaking labor. Signorini was fasci-
nated by the dense olive groves at Settignano, and one of his
studies integrates a young peasant woman with the trees as if to
demonstrate an intimate relation with her surroundings. *Mez-
zadria* was bound up with the mode of agriculture known as
mixed cultivation *(coltura promiscua)*, in which fields of wheat
or maize were interspersed with rows of vines, olives, or fruit
trees. While denounced as economically irrational because of low
yields, it did allow the peasant some measure of self-sufficiency

6.6 Fattori, *Peasant Woman
in the Field*, ca. 1867

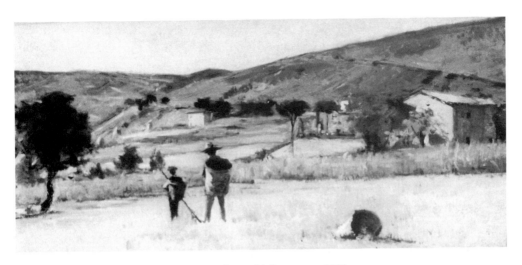

6.7 Lega, *Landscape with Peasants*, ca. 1871

and helped spread the risks of a bad year. One perspective on *coltura promiscua* is given in Lega's *Paese con contadini* (Landscape with Peasants, ca. 1871; fig. 6.7), in which peasants walk in fields of sheaved grain with the inevitable conical haystack *(pagliaio)*, while carrying on their backs large wicker baskets for the gathering of fruits and vegetables.

The Georgofili always stressed the social harmony of the system, and while the class differences of the partners, and a history of guerrilla warfare in the form of theft, fraud, poaching, barn-burning, and machine-breaking seems to contradict the claim, it is true that the Tuscan peasantry remained more or less docile throughout the century. The landlord's paternalism and actual presence on the property mitigated the impulse to rebellion, and the fact that several generations of the same family often occupied the same *podere* tied the *mezzadri* to the land as if it were their own. The *mezzadro*'s sense of independence was reinforced by the somewhat removed character of the landlord's control. The tenant lived in a separate dwelling, isolated even from other tenants of the same estate. Rarely did the peasant meet with intervention from the landlord, giving the system an impersonality that made disaster seem like a providential act rather than one attributable to the landowner's economics. Although eviction was always a possibility, it was seldom invoked; the Tuscan sharecropper did enjoy a relative security. Whatever their living standards, the *mezzadri* occupied a niche, albeit a precarious one, in the social order.

Generally, the *mezzadro* also experienced a sense of independence. While the landlord clearly established the physical and psy-

chological context of the system, the reality of this control was
hidden from sight. The crops grown—chiefly wheat, corn, olives,
and grapes—were those that had been cultivated for centuries and
carried on by the seemingly abstract force of necessity. Since the
tenant produced for subsistence with no other source of income,
and rarely encountered the supervision and intervention of the
landlord, the underlying economic causes of bad times were not
easily traceable to the system. This was further guaranteed by the
isolation of the *mezzadri* in the day-to-day routine. Tuscan share-
croppers did not live in villages, but in a separate dwelling on the
podere isolated even from the tenants of the same estate. The tar-
get was diffused, and discontent could not be channeled effec-
tively into collective action.

The sense of self-reliance was underscored by the organization
of the extended mezzadro family. The patriarchal peasant family
undertook a crude division of labor under the authority of the
capoccia, usually chosen or sanctioned by the landlord. The *ca-
poccia* (not always the father) was the legal representative of the
family in its dealings with the owners, and was its effective and
authoritarian head. He determined the tasks for the field work,
while his wife, the *massaia,* apportioned domestic industry—a
major element in the sharecropping family economy—among
the women of the household. Hence, the attachment of the *mez-
zadro* to the existing order was secured by bonds of filial piety and
family affection.

Beginning with unification, a whole series of changes took
place that radically altered social conditions in the Tuscan prov-
inces and contradicted the system's allegedly utopian character. At
the most general level, these changes were related to the way Tus-
cany belatedly joined the national and international markets. Ital-
ian unity, which eliminated internal barriers to trade, created the
possibility of a regional division of labor in Italy. For the proper-
tied classes, this integration of Tuscany into the world economic
system created the opportunity for increased profits from more
intensive cultivation while increasing the risk of lower returns
from the traditional methods. At the same time, unification re-
quired the state to accumulate capital steadily, and the years after
the Risorgimento witnessed a heavy increase in taxes to support
the construction of roads, railways, and the military forces. The
state accomplished this through a variety of indirect and direct
levies on agriculture such as the family tax, the land tax, the grist
tax, the salt duties, and the cattle tax, which fell most heavily on
the agricultural areas and, within them, on the peasantry. So while
the development of Italian capitalism meant greater market out-
lets for the landlords, it also meant further impoverishment for
the *mezzadri.*

The Tuscan landlords, however, wanted to retain the system for political and social reasons, a desire rationalized by the economic and geographic conditions in the Tuscan countryside. At the same time, insofar as people like Ricasoli and Ridolfi were interested in commercial agriculture, they also had an interest in the removal of obstacles to trade. Hence the nobility and rural landlords were key supporters of the Risorgimento and its economic changes—often even more supportive than the commercial or industrial bourgeoisie—while yet holding on to the social structure based on the mezzadria system.

RICASOLI AND THE MAREMMA SYSTEM

Baron Bettino Ricasoli represented the paradigm of the Tuscan landlord, a complex patriarchal figure who knew what was best for "his" peasants.[11] He was an ambitious proprietor whose urge for achievement and search for profit led him to apply intense effort to the rationalization of agriculture. Tuscany produced few fine wines at this time. Ricasoli was one of a handful of landowners who succeeded in emulating French wine growers in the consistency of his vintage. To achieve this he had to introduce a rigid discipline and regimentation which went beyond the normal demands of the mezzadria system.

Ricasoli actually codified all the laws of his domain, printing his rules in a pamphlet entitled *Agricultural Regulations of the Estate of Brolio,* published in 1843. This pamphlet abounds in practical issues such as the proper methods of working the soil, of tending vines and olive trees, of using manures, nurturing animals, and caring for tools—almost every detail concerning economy and efficiency of cultivation. Then follows a declaration of the penalties to be meted out to the *mezzadri* who do not conform to good morals, orderly cultivation, and industriousness, or who fail to dress with "that simplicity which befits a peasant."

In addition, Ricasoli pioneered a new conception of agriculture and, up to a point, tried to promote new methods of agricultural technology then being fostered in the United States, England, and France. He dreamed of a "grand culture" in the Maremma, a vast expanse of fertile, flatland lying between Cecina and Civitavecchia and snuggled just inside the western coastal zone.[12] Its rolling woods and green swamps stretched endlessly toward the south, an environment where, according to an old Tuscan proverb, "you get rich in a year and die in six months." It was one of the few major areas of fertile flatland in Italy but, unfortunately, the coastal marshes were conducive to the spread of malaria. A dual problem of irrigation and drainage existed there, specifically

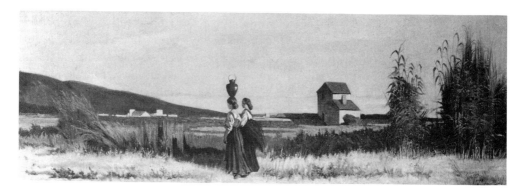

6.8 Fattori, *The Water-Carriers of Livorno,* 1865

related to the difficulty of controlling the flow of water in the low-
lying plains at the foot of steep slopes where the streams fanned
out. As a result, the Maremma was fever-ridden from July to No-
vember and, despite its natural fertility, was unfit to be used as
wet pasturage or for wheat fields. Nevertheless, Ricasoli wanted
to transplant the mezzadria system to the area, replacing the pre-
vailing wage labor arrangement dictated by the dangers of living
there.

Malaria had not yet been traced to the anopheles mosquito but
was associated with stagnant waters and marshes. Hence most
scientists and agronomists of the period correctly surmised that
draining the Maremma would not only help prepare it for culti-
vation but would also rid it of malaria. Indeed, the Maremma had
such an excess of moisture that sea water constantly combined
with drinking water, which further contributed to the ill-health
of the indigenous population. One of Fattori's striking images of
the near-deserted Maremma shows two female water carriers
trudging through the desolate countryside, one of whom balances
on her head the typical copper *mezzina* for transporting clean
drinking water to contaminated areas on the coastal plain near
Livorno (fig. 6.8).

Prior to unification, the Georgofili were fascinated with the
possibilities of the Maremma, and, in the process of considering
large-scale reclamation projects, commissioned studies of its pe-
culiar geographical and social conditions. Among these numer-
ous studies was the *Statistical-Economical Reports on the Tuscan
Maremma,* compiled in 1846 by Antonio Salvagnoli-Marchetti,
a Georgofili member. Salvagnoli, who dedicated the work to
Cosimo Ridolfi, called for a "physical and economical risorgi-
mento of the Italian coasts."[13] His model was the Netherlands,
which drained its marshes and stagnant areas and built a complex

system of canals for irrigation, drainage, and transportation. He recommended a similar large-scale, state-controlled project less concerned for immediate profit than would be the case if it were undertaken by private enterprise. Salvagnoli called attention to the rich potential of the Maremma, noting its merino sheep, horses, and cattle, its potential for large-scale cultivation of cereals, and even its mining and light manufactures. He observed that the conditions for the breeding of domestic animals, especially horses, in the Maremma could be excellent. Animals could be trained to haul machinery for the reaping and threshing of grain, and their manure would replenish the soil. He argued the need for reforestation of the depleted woods, which had been destroyed by charcoal burners, and for the introduction of advanced crop rotation techniques making use of artificial grasses for pasturage and manure for replenishing the soil. Salvagnoli noted that one of the most promising areas was the fertile plain of Cecina, bordered on the northwest by the hills of Livorno and Rosignano Marittimo. Well situated for year-round living, it was favored with the best topographical and geological conditions in the area. In addition, the proximity of Livorno and Pisa would offer major markets for the Maremma's products.

It is no coincidence that Diego Martelli's father, Carlo, a water-and-road engineer who understood the technical problems of drainage and irrigation, purchased a huge tract of land at Castiglioncello in the province of Rosignano Marittimo, just north of the Maremma. Carlo evidently purchased this land for speculation based on his knowledge gained from reading Salvagnoli's work and the *Giornale agrario Toscano,* the organ of the Georgofili, about plans for reclaiming the Maremma. Opposed to the private railroad-building schemes that would isolate Castiglioncello from central markets, Martelli wanted a line running perpendicular to the Adriatic coast, thus insuring the best possible distribution for his own products.[14] He condemned the idea of a longitudinal railway running through the Maremma on the grounds that the sparse population and lack of agricultural and manufacturing output would make it unprofitable. And he cited the statistical evidence of Salvagnoli to support his arguments.

Martelli was deeply fascinated by the Maremma, but protested the government's proposed improvements when it failed to consult the local landowners. The government probably surmised correctly that the only way to effect large-scale reclaimation of the area was to bypass the landlords, whom the arrogance of government officials further alienated. They resisted the grand duke's attempts at improvements until in exasperation, he published a *Regolamento* requiring a fine of owners of wild animals damaging

river embankments. The senior Martelli was highly critical of the government's heavy-handed techniques in trying to reclaim the Maremma, even calling for drastic political changes. But the tension between the proprietors of land in the Maremma and contiguous areas and the grand-ducal government sprang largely from self-interest.

Diego inherited the vast Castiglioncello estate after his father's death in 1861, and it became the family's chief economic resource.[15] Besides its grain and vines, and rich pasturage for the animals, the large territory contained areas of brushwood, holm oaks, turkey oaks, and myrtle trees, which were cut mainly for the burning of charcoal, a major product of the Maremma. The oak bark served the tanners of Tuscany who used it to tan hides, while the acorns were used for feed.

Castiglioncello was a *fattoria* divided into seven *poderi* run according to the system of *mezzadria*. Each *podere* supported an extended family of up to twenty-six members. Martelli now became a major proprietor, and labored over the years to make the farm pay. Although he employed the latest scientific information for cultivation, there are no visible signs in the Macchiaioli paintings that he used machinery or made large-scale changes. I suspect that here he and his protégés were responding to the ideas of their favorite philosopher, Proudhon, who insisted on small, self-contained units of rural and industrial labor and a proportionate relationship between production and consumption.[16] Proudhon made sledgehammer pronouncements against the introduction of machinery that enslaved the worker and reduced him to the state of an appendage to a mechanical beast. Machinery disrupted the lives of small producers and left them exposed to the encroachments of monopoly capitalism.[17] Tuscan democrats generally had in mind the possibility of a landowning peasantry, the *mezzadri* of central Italy, when they dreamed of the ideal constituency to become the cornerstone of the new Italy and its economy. They preferred forestalling the introduction of machinery to violently disrupting the traditional social and power relationships in the countryside.

Proudhon, however, wished that the small farmers would, by the payment of rent, gradually gain a right to a part of the land. Through the development of this process the large landowners would tend to disappear and the small farmers would become directly the proprietors of the land they cultivated. It would seem that Martelli was not yet able to take this measure, for he maintained the labor-intensive mezzadria system and the seven divisions of the estate until he sold the complex much later in the century. One of the most progressive among the Macchiaioli cir-

cle, a radical who donated huge amounts of money to Garibaldi's ventures and who himself volunteered for the 1866 campaign, Martelli may have been able to rationalize his position as landowner by the relative independence he granted his *mezzadri*. Nevertheless, the ultimate effect was social conservativism in terms of the countryside, and, in this sense, typical of the Risorgimento elite.

PATRON OF THE MACCHIAIOLI

The artists who visited Martelli at Castiglioncello worked directly from their observations of the patron's environment. Signorini painted the commanding coastal view from the front window of Martelli's house, Borrani the endless stretches of the patron's *poderi*, while Cabianca depicted the gloomy and inhospitable landscape of the nearby Maremma in paintings such as his *Canale della Maremma* (Canal in the Tuscan Maremma, 1862; fig. 6.9). This was the type of canal typically used for drainage purposes, most often to keep sea water from contaminating drinking water.

One of Fattori's most important early works is *Pastura in Maremma* (Pasture in the Maremma, 1863–64; fig. 6.10). Like Cabianca, Fattori projects the sweep of the Maremma and its melancholic desolation. Showing wild animals grazing on carefully divided and rotated fields, he testifies to an awareness of the improvements and cultivation of the area. These fields are in various stages of development, freshly plowed, planted with artificial grass or clover, and cereal. To the left a few *contadini* carry a load of cane *(cannetti),* which still grows everywhere in Tuscany and is used for fences, roofs, and stakes for vines, among other things. A feeling of isolation pervades the painting, conveying the constricted lives of the peasants.

Fattori's fascination for the Maremma, analogous to the American frontier fantasy of the Old West, absorbed him throughout his life. His later works exemplify the heroic actions of the *butteri,* the so-called "Tuscan cowboys" who herded the wild animals in the region. In such works as *I Butteri* (The Cowboys) and *La marcatura dei puledri in Maremma* (The Branding of the Colts in the Maremma, 1887; figs. 6.11, 6.12) the relationships of the human figure to the landscape is reversed, as Fattori presents an alternative perspective on life in Tuscany. His disillusionment with the progress of the Risorgimento took the form of melancholy resignation, expressed in gloomy views of the Maremma plains and the day-to-day grind of the *butteri,* whose individuality he nevertheless invested with mythical status.

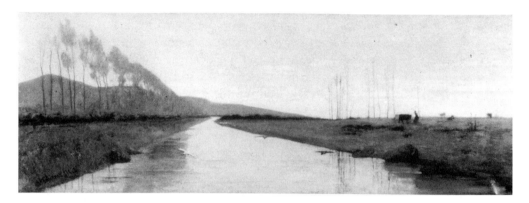

6.9 Cabianca, *Canal in the Tuscan Maremma*, 1862

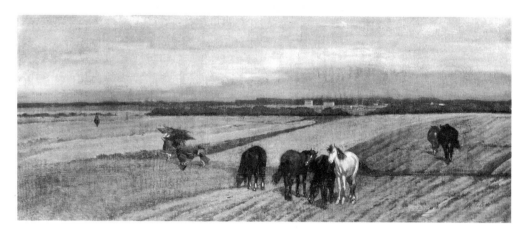

6.10 Fattori, *Pasture in the Maremma*, 1863–64

The depiction of peasants in early Macchiaioli rural scenes may be described as falling somewhere between the approach of Constable, who reduces the peasants of the English countryside to insignificance (fig. 6.13), and that of Millet, who makes his French peasants either imposing or palpably heroic (fig. 6.14). The *mezzadri* and *contadini* are present as an integral part of the landscape, even if they often seem to pose, as in a number of Borrani's landscapes done at Castiglioncello. Borrani's remarkable panoramic views are inevitably occupied by the peasant who tends the grounds, most often standing squarely in the middle ground (fig. 6.15). There is nothing sentimental about his peasant woman in *Casa e marina a Castiglioncello* (House and Seacoast at Castiglioncello, ca. 1864; fig. 6.16) who feeds her chickens; she is a strong presence, taking a frontal stance, as so many of the Macchiaioli peasants do, while looking down at the flock.

The Macchiaioli painters reveal in their rural images the some-

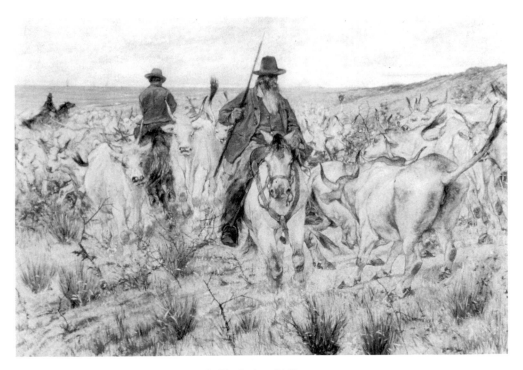

6.11 Fattori, *The Cowboys*, 1893

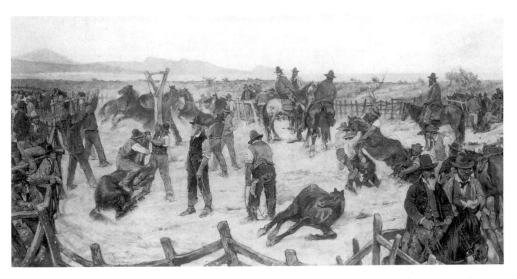

6.12 Fattori, *The Branding of Colts in the Maremma*, 1887

what contradictory social views embodied in the outlook of Ricasoli. When he spoke of liberty and social justice, he had in mind the great landowners. For while he believed in charitable support for the depressed *contadini*, he did not advocate the kind

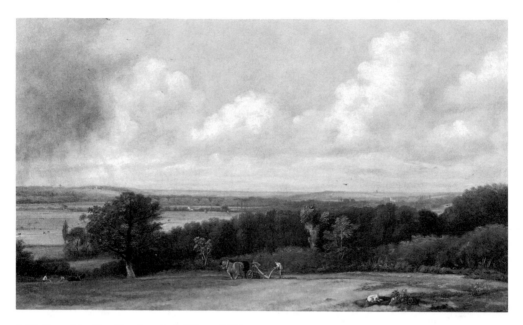

6.13 Constable, *Ploughing Scene in Suffolk*, ca. 1824

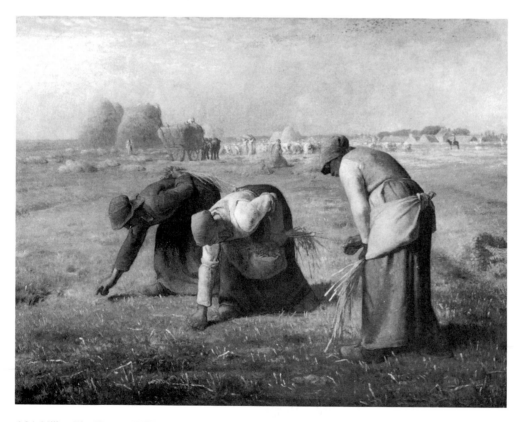

6.14 Millet, *The Gleaners*, 1857

6.15 Borrani, *Vegetable Garden at Castiglioncello,* ca. 1864

6.16 Borrani, *House and Seacoast at Castiglioncello,* ca. 1864

of social change that would give them control over the land they worked, as recommended by Proudhon and the socialist reformers. This contradiction was embodied in his vision of the Maremma. Unlike Martelli, on the other hand, he hoped to combine his love of profit with his idea of national progress by modernizing farming methods in the Maremma. He wanted to regenerate the moral life of the country and expand the national market to the outside world, and here he tied his hopes to the use of machinery in the Maremma, where he purchased a major tract of land known as Barbanella.[18] He experimented with a mechanical reaper and thresher of a type manufactured by McCormick that saved time and human labor, and would be impervious to malaria. Perhaps not surprisingly, it was Laudadio Della Ripa and Sansone D'Ancona who underwrote his investments in the region.[19]

When Ricasoli became head of the Provisional Government in 1859 he quickly focused attention on the Maremma. Steam machinery was introduced there, and the government lost no time in organizing a committee to study the possibilities for transforming the region into the grain belt of Tuscany. Ricasoli made it a high priority to ameliorate the situation of the peasantry there. The

6.17 Borrani, *Red Cart at Castiglioncello,* ca. 1867

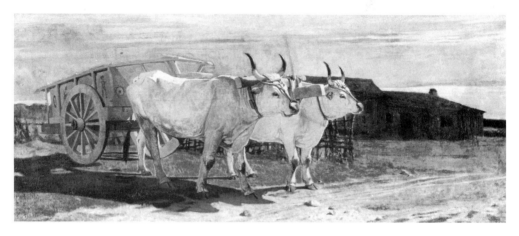

6.18 Giuseppe Abbati, *Cart and Oxen in the Tuscan Maremma,* ca. 1867

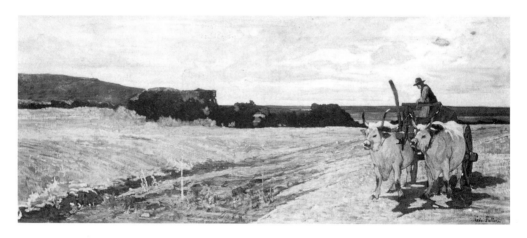

6.19 Fattori, *Cart and Oxen,* ca. 1867–70

land was hungry for capital and demanded the tireless, round-the-clock attentiveness to well-defined areas that marked the cooperative system of the mezzadria.

Yet a basic rural conservatism and class ambivalence informed Ricasoli's Maremma policies. As stated earlier, he wanted to supplant the existing wage labor arrangement with the mezzadria sys-

tem, thus maintaining the hierarchy of Tuscan landownership. At the same time, with Ridolfi, he recognized that mezzadria could only flourish in the Maremma at a late stage in the improvement of the region, when malaria was eliminated, the land was productive, houses were built, and settlement patterns were stabilized. But Ricasoli also resisted exclusive and even extensive use of machinery under normal conditions that would undermine the sharecropping system. While he wanted to alleviate the drudgery and make the system more efficient and profitable, his main intention was to maintain the rural social system that had operated in Tuscany since the Renaissance. Similarly, the Macchiaioli, while highly sensitive to the plight of the *mezzadri,* display no references to farm machinery and other symbols of reform, which they viewed as potential encroachments upon the sacred agricultural precincts. The most radical position in the countryside advocated peasant entitlement to the soil he or she worked, but on this issue the Macchiaioli take a more moderate stance. They may have decried the peasant's lack of security and opted for some redistribution, but their sympathies lay primarily with traditional Tuscan proprietorship. The artist's pictorial projection of the peasantry grants the farm-workers an inherent niche in the rural spaces but it does not allow them total mastery of it. Hence their love of the indigenous white oxen early trained into drawing carts in desolate places, suggesting a hierarchy in the macchie on the most elementary level that only serves to emphasize the limited control of man and beast (figs. 6.17–6.19). Here the Macchiaioli adamantly remain within the implications of the old Tuscan proverb: "Chi ha carro e buoi, fa bene i fatti suoi"—"whoever has a cart and oxen does a good business."

CARDUCCI AND THE MAREMMA

We find a literary complement to the aesthetic endeavors of the Macchiaioli and the agricultural activity of the Accademia dei Georgofili in Maremma in the work of the Risorgimento poet, Giosuè Carducci.[20] Author of among other things patriotic *stornelli* and the celebrated *Discorso* for Garibaldi's death, Carducci belonged to the democratic faction of the Risorgimento. He espoused the principle of adapting the whole of Italian culture to a popular culture capable of inspiring the people to a high level of intellectual self-sufficiency and independence of judgment. He was a close friend and supporter of several of the Macchiaioli, whose political and cultural ideals he shared.

Carducci was a political poet who disdained the school of ro-

mantic poetry, just as the Macchiaioli rejected historical romanti-
cism. He employed mundane and historical fact in opposition to
the mystical and vague, which he associated with the neo-Guelphs
and neo-Catholicism. This abhorence of romanticism moved him
in the direction of realism, leading him to depict contemporary
people and to regard everyday subjects of modern life, such as
railway stations, with a poetic eye. He believed that schools
should stress civics, geography, and political economy, providing
a practical and scientific base for stimulating the imaginations of
the students. Carducci envisioned a new generation of creative
scientists and scholars regenerating the young nation.

Carducci identified nature with the Italian landscape, often fo-
cusing on the scenery of the Maremma and another Tuscan re-
gion, the Versilia. His loving renditions of the countryside were
as much an expression of his patriotism as his writings dedicated
to Garibaldi. Characteristic rural scenes and incidents of the Ital-
ian countryside are drawn with vivid touches and a sober sim-
plicity that recall the Macchiaioli. His patriotism, which gave rise
to poems with historical themes as well as to those dealing with
nature, predisposed him to see in mountains, fields, trees, and
rivers not merely beautiful natural objects but Mother Italy. His
landscapes, like those of the Macchiaioli, are the landscapes of the
Risorgimento.

His poems on the Maremma combine his love of his native
region with his larger love of country. In the "Maremman Idyll,"
from the *Rime nuove* (New Rhymes, 1861–87) he gives a sketch
of a young *contadina* crossing the wheat fields on a summer after-
noon, and shapes from this material a metaphor for a free Italy.
He regrets not having lived the rugged life of the *buttero* instead
of indulging in "paltry rhymes":

> Better through pathless scrubwood to go and track some
> Driven buffalo, which in the bush will wait
> And gaze, then leap from the underbush when pursuers
> come.

Here the Italian term for underbrush is the familiar *macchia* which
rings out of the poem like a vivid brushstroke in the landscape of
the Macchiaioli.[21]

Similarly, Cecioni's sculptured representation of a *mezzadro*-
peasant mother, *La Madre* (1880), inspired Carducci's ode of the
same title to the ideal state:

> And when from the toil she lifted her swelling breast,
> Face Sun-browned and dark locks, O Tuscany,

> Thy vesper lights have touched with flaming
> Gold all the lines of her stalwart beauty.

Her labor is positive:

> Domestic work smiles all around her
> The swaying crops on the green hillside,
> The lowing cattle, and the crested
> Cock crowing proudly on the threshing-floor.

This leads Carducci to ruminate on the meaning of work in a free society, expressing the hope that all people can find joy in labor in such a society:

> When shall a common folk of free citizens
> Say as they gaze at the sun: —illuminate
> Not sloth nor wars waged by tyranny,
> But the charitable justice of labor—?

Here the mezzadria system becomes a model for the whole of humanity and a source of love and joy akin to the ideals of the patriotic poet Giuseppe Giusti (1809–1850).

Cecioni himself felt that Carducci's ode captured the spirit of his sculpture, and in a letter expressing gratitude to the poet he went on to praise the general character of his poetry—its imagery as well as its words, its simple truth, and even its chiaroscuro and color, which he thought to be "extraordinary." Not surprisingly, Cecioni—the future transcriber of the group's aesthetics—used the visual vocabulary of the Macchiaioli to define Carducci's work.[22]

GEOLOGY, GEOGRAPHY, AND
TOPOGRAPHICAL RENDERING

The key sciences in all the projects to improve agriculture and reclaim and drain the Maremma were geology and geography. The annual scientific congresses, the Georgofili, and the universities all emphasized and promoted these disciplines. Typically Tuscan were the regional "statistical" studies that were a synthesis of geographical, ecological, agricultural, and folkloric observations. Yet Geological and geographical exploration assumed a special interest during the period of the Risorgimento as a means of concretizing the abstract ideal of *La Patria* and mapping its physical and topographical context. For the professional geographer, mea-

suring, classifying, and inventorizing the surface of Italian territory was the closest one could get to *italianità*.

The Georgofili members, ever involved in exploiting this land, stimulated numerous geological studies of its various sections. In 1830, Cosimo Ridolfi addressed this body on the chemical analysis of the marshland around Castiglione, while in the 1840s numerous studies were published including those of Salvagnoli-Marchetti. In 1843, the Reunion of Italian Scientists took up the question in their section on mineralogy and geology, inquiring on the origins of the area in the context of a discussion of the marshlands on both shores of the peninsula. Such sustained involvement and interest inspired the experiments of Ricasoli, himself a serious student of geology in relation to viniculture.

It is no coincidence that the circle of the Macchiaioli included prominent students in the fields of geology and geography. We have seen that Vito D'Ancona's brother, Cesare, was a professional geologist. Martelli's father, as a road engineer, was well versed in geology, and Diego himself studied it at the University of Pisa. Of all of them, however, the most important was Diego's fellow student at Pisa and dear friend Gustavo Uzielli (1839–1911).[23] Indeed, Uzielli was the intimate friend and patron of several of the Macchiaioli, and it was he who edited the writings of Cecioni on the Macchiaioli in 1905. He commissioned his lifelong comrade Signorini to provide illustrations for his publications on Leonardo da Vinci, Uzielli's alter-ego, whom he credited as the founder of modern science. His geological interests complemented the landscape studies of the Macchiaioli, and he also shared their hopes for a scientific socialism—the achievement of a balance between individual liberty and the collective well-being of society.[24] What he required were systematic empirical investigations of economic and material conditions of different regions, to seek solutions peculiar to them.

Significantly, Cesare D'Ancona and Gustavo Uzielli were both founding members of the Società Geografica, the Italian geographical society organized in 1867. The aim of the society, as stated in article 2 of the foundation instrument, was to promote "every study particularly directed to the exact knowledge of Italian soil *(suolo)*."[25] As an offspring of the Risorgimento, one of its initial projects was to map a united Italy. The society comprised a large number of geologists, a fact reflected in the prominent role given to them in the bulletin published annually, and then biannually, starting in 1868. Uzielli wrote regularly on geological issues, especially on problems dealing with orography, topography, hydrography, and the control of water. He contributed an essay on the oscillation of the Italian soil and one on topographical and

6.20 Telemaco Signorini, *Anchiano,* ca. 1872

hydraulic geology, giving Leonardo credit again as the founder of the science of hydraulics. In 1872 he published a book on Leonardo's scientific thought, illustrated with Signorini's etchings (fig. 6.20).

Uzielli's admiration for Garibaldi was unbounded. He joined the Sharpshooters of the Alps in the campaign of 1859, while in 1860 he served under him as a second lieutenant and joined him again in 1866. In 1860, he was one of the illustrious heroes who fought valiantly in the south, winning a silver medal for bravery in the Battle of Volturno. Undoubtedly, it was Uzielli who saw to it that a picture of Garibaldi's home on Caprera was given pride

6.21 Fattori, *Battle at Volturno*, ca. 1891

of place in one issue of the geographical society bulletin.[26] Analogous to the landscapists who expressed their patriotism through images of Tuscan countryside and its inhabitants, Uzielli's professional work involved the intense exploration of geological structure and the surface of Italian terrain. Their interaction resulted from common objectives and a shared scientific outlook. The landscapes and topological drawings reproduced in the *Bolletino della Società Geografica Italiana* were executed—analogously with the Macchiaioli studies—"dal vero."[27]

Fattori's *Battle at Volturno*, painted in 1891, commemorates a decisive episode in the Sicilian campaign in which Uzielli played a critical role (fig. 6.21).[28] Capua proved to be the bloodiest battle of the campaign, for it is here that the king of Naples and his 40,000 regulars decided to make a final determined stand against the upstart *garibaldini* (Figs. 6.22, 6.23). Before Capua and along the Volturno River the worst fighting took place, and the early stages of the battle augured poorly for the Red Shirts. Many of them fled in panic in the face of the fearful odds, and Uzielli was called in from another post to rally them. Seeing that they were hopelessly outnumbered but commanding a key site, General Milbitz set up two cannon beneath the ancient Roman triumphal arch of Capua and ordered Uzielli to pound the enemy continuously with artillery fire. Uzielli remained at this post for almost five hours, loading the cannon. The conflict ended with a decisive triumph for the *garibaldini,* assisted by a battalion of Piedmontese *bersaglieri* that had just landed at Naples. Milbitz and other eyewitnesses documented Uzielli's heroic action in the battle, including a French correspondent for *L'Illustration* who later wrote an extensive account of the Sicilian campaign.[29]

One of the most thorough accounts of the encounter came

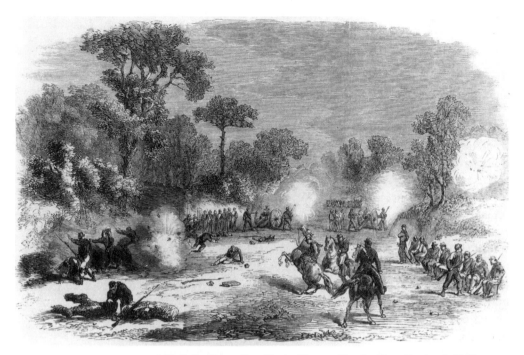

6.22 *Before Capua, Sept. 19,* the *Illustrated London News,* October 6, 1860

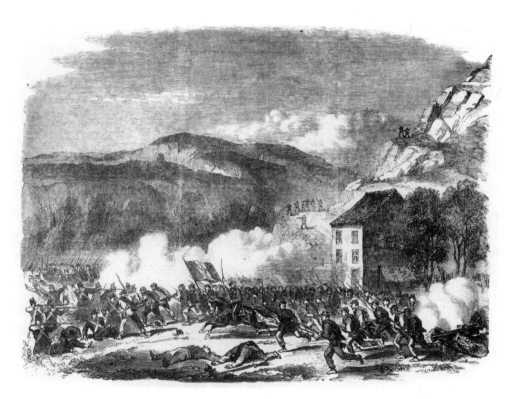

6.23 *The Final Repulse of the Neapolitans,* the *Illustrated London News,*
October 20, 1860

from Uzielli himself, published just before he died in 1909 in the journal *Il Risorgimento Italiano*.[30] His article included a number of supporting documents confirming his performance in the battle and a reproduction of Fattori's painting, which formed part of his collection of Macchiaioli pictures. The historical accuracy of the painting demonstrates that Uzielli supplied Fattori with his documentation and eyewitness testimony. It displays Fattori's typical deadpan vision of battle, with the scene organized panoramically and the troops strung out along the horizon line, thus precluding the heroic convergence and upward surging movement typical of romantic military representations. Uzielli is given a somewhat heroic pose as he stands isolated under the arch at the right, feet spread apart and grasping the ramrod, but we quickly move from him to the troops behind the artillery pieces and culminate at the extreme right of the picture where Milbitz energetically thrusts up his arm to signal a command to an unseen body of troops. Uzielli and Milbitz, at two extreme stages of a physical action, frame the scene but do not concentrate it: they carry the beholder's gaze across and out of the picture. The result is consistent with the decentralization and flattening-out process that we have associated with Macchiaioli realism.

In addition to Uzielli's testimony, Fattori may have visited the site and/or had at his disposal detailed photographs of the setting. He meticulously depicted the double triumphal arch known as Porta Capua in its ruinous state, carefully rendering the recessed niches in the pillars, as well as the remnant of the second arch that stood east of the gate. Accounts of the battle describe the fog and smoke pervading the landscape; Fattori heightened the realism of his scene by shrouding the figures in a smoggy ambience. He also accurately oriented the cannon to face the northwest, in the direction of the Bourbon front lines.

The architectural setting of the picture clearly identifies the site as the second-century ruins of the Porta Capua near the ancient amphitheater at Santa Maria Capua Vetere. On the east pillar of the arch a plaque commemorating the battle was affixed on October 1, 1861. It reads:

> Here—the First Day of October 1860—GIUSEPPE GARIBALDI—defeated the last King of the Two Sicilies—the People of Santa Maria—Those who witnessed it will remember it always—Having wished to preserve the name—THE GARIBALDI BATTERY AT PORTA CAPUA—Have installed at this site in the days of the battle near the ancient arch—where they thundered against the enemies of Italy—this dedication to that memory—The First Day of October 1861.

The area around the Volturno River possesses some of Italy's most fertile agricultural land, and the topography that Uzielli observed in southern Italy inspired some of his most eloquent passages. His account attests to the merging of his patriotic sensibility with his scientific interests. He observed the magnificent spectacle of Mount Vesuvius, which although then not in a state of eruption, nevertheless displayed an incandescence which "cast a sinister light on the enchanting region." He marvels at the scenic beauty of the Straits of Messina, dividing the picturesque shores of Sicily from those of Calabria, the contrasts of mountainous topography with stretches of tropical vegetation.[31] The impressions of the landscape and its incorporation into a united Italy left an indelible imprint on his subsequent development. He and his colleagues from Pisa left Naples with two powerful feelings: first, the sense that they had fulfilled their obligations as citizens of Italy, and second, their heady ambition to pick up as quickly as possible their professional objectives. In the case of Uzielli we can see how these two feelings merged in his thinking and set the subsequent pattern of his career.

This explains the curious appearance of his account of the battle so late in his life, an act that would seem self-serving given his own role in that event. But Uzielli's article carried a subtext, that emerges most vividly in the concluding paragraph of his account:

> Sometimes in moments of profound distress over the fate of Italy, I reflect on the wars of independence, on the valor and distinction that I witnessed there, and then it seems as if I were standing on that fatal road where Milazzo and Tito Zucconi were gushing blood and crying: "THE BULLETS DON'T MATTER!" And then I wish that many similar heroes would emerge for the future trials of the country.[32]

Uzielli's purpose in publishing this article was to provide an example for the younger generation, to recover the idealism and enthusiasm that motivated his generation and its positive contribution to the Risorgimento.

Fattori and his colleagues similarly shared the sense of disillusionment and pessimism expressed by Uzielli. The painting of the *Battle of Volturno* was painted over thirty years after the event, and while harking back to Fattori's earlier scenes of Risorgimento battles like Magenta, Montebello, and San Martino, its immediate reference is the state of mind of Fattori and his friends in the 1890s rather than the heroic age of the 1859–60 drive for independence. The imperialistic and colonialistic designs of President Francesco Crispi (1887–91, 1893–96)—himself a former

garibaldino and revolutionary activist—especially in the context of economic crisis and depression in the early 1890s, outraged the former progressives of the Risorgimento. In place of Garibaldi's self-sacrificing nature and authentic patriotism, they saw only overweening ambition, corruption, and chauvinistic pride.

Confronted with this post-Risorgimento syndrome, Uzielli turned increasingly to his research on Leonardo da Vinci for solace and scientific utopianism. Yet it was precisely his obsession with Leonardo that made him a loyal patron of the Macchiaioli. While he could identify with the scientific and literary side of his hero, he needed the connection with the painters to contribute the artistic side and satisfy his self-image as a Renaissance-Risorgimento Man. He implicated Signorini in his project on Leonardo by commissioning him to make studies of the terrain and local population of Leonardo's hometown, Vinci, two etchings of which he published. As a geologist, Renaissance scholar, and Risorgimento combatant, Uzielli's patronage of the Macchiaioli has a certain symmetry about it and demonstrates the interaction of the text- and image-makers in the construction of the new Italy.

SEVEN

Religious and Social Themes

Gustavo Uzielli came out of the Jewish community in Livorno, the son of Sansone and Marianna Foà (the name Uzielli is derived from a Hebrew word and means "God is my strength"). He was one of a number of Jews who participated in and helped stimulate the Macchiaioli movement.[1] We have already seen the role played by the D'Anconas, but even more important to the theoretical foundation of the movement was the painter Serafino De Tivoli, also born in Livorno. De Tivoli's father was a merchant, a descendant of an old Tuscan Jewish family whose ancestors could be traced to the Renaissance and included prominent rabbis and bankers. It was De Tivoli and his less well-known brother Felice who pioneered in painting the Tuscan countryside "dal vero," and it was they who mediated the contact between Costa and Fattori. Finally, it was Serafino who brought back his observations of the 1855 exposition in Paris, and formulated the theory for the painting experiments that led to his designation as the "papà della macchia."

Vito D'Ancona and Serafino De Tivoli, like their other colleagues of the Macchiaioli, were democratic activists who participated energetically in the Risorgimento battles. In 1848 they joined the Tuscan volunteers and fought at Curtatone and Montanara.[2] In 1849 De Tivoli fought under Garibaldi in the defense of Rome, where he first met Costa. The fact that D'Ancona and De Tivoli were Jews adds a historical dimension to their associ-

ation with the progressive political and aesthetic movement in mid-nineteenth-century Italy. This was acknowledged indirectly by their younger colleague Adriano Cecioni, who noted the stimulus of the exchanges of the two Jewish painters at the Caffè Michelangiolo:

> To see these two facing each other at the same little table, both of the same race, similar in stature, voice, in their way of talking and laughing, and above all in their intelligence; to see these two men telling each other off without swearing or ever losing their tempers, rather, smiling all the while, even as they exchanged witty and cutting remarks, was among the best entertainment at the Caffè Michelangiolo.[3]

Indeed, the condition of Italian Jews was central to the policies of the architects of the Risorgimento, since their anticlerical arguments were aimed at religious discrimination. Democrats and even moderate liberals expected to benefit from the abolition of all educational and social barriers against non-Catholics. Until every group in Italy was free, they claimed, "freedom" would remain an empty abstraction. The presence of ghettoes in Italian cities was seen as a symbolic contradiction of the Catholic Church's preachments on love and humanity, and provided a prime target for Risorgimento polemics. It is therefore not surprising that many Italian Jews threw themselves heart and soul into the movement.[4] A significant number of Livornese Jews had been members of the Carbonari; a police memorandum of 1817 lists forty-four Jewish suspects, many of whom were subsequently arrested, imprisoned, and exiled. The Jewish communities of Venice, Rome, Milan, and Livorno pledged their money and their bodies to the revolutionary regimes in 1848.

It is no coincidence that Giovanni Costa's first appearance on the scene of politics after joining Giovine Italia was on the night of April 17–18, 1847, when, together with his colleagues from the Trastevere, he broke open the gates of the Roman ghetto, which traditionally (except during the Napoleonic era) had been shut at the hour of Ave Maria. This revolutionary act was symptomatic and symbolic. The barriers that religious intolerance had until now opposed to all forms of independent thought were to be broken down and the start was made with these gates of the ghetto, a step that led to the social emancipation of Roman Jews. Mazzini's Provisional Government ordered the destruction of the ghetto gates and the restoration of full civil rights for Jews.

In Venice, the Republic proclaimed on March 23 was led by

Daniele Manin, whose paternal grandfather was Jewish. In the first days of January 1848, the Jewish community in Venice requested Manin, as the acknowledged leader of the legal agitation, to incorporate the demand for the complete emancipation of the Jews in his reform program. In return they promised him the unequivocal support of the Jewish community for what he was trying to do. In this sense, the Risorgimento was symbolically inscribed in the struggles for Jewish emancipation.

For Jews, the Risorgimento had a double implication: by fighting for a free, united Italy they imagined themselves to be fighting for self-emancipation. Oppressed both as Italians and Jews, they fought as if they had nothing to lose. Hence, the rejoicing of the Jewish community in Venice on March 11, 1848, when the republican government there declared that henceforth "the citizens of the United Provinces of the Republic, whatever their religious faith, shall enjoy perfect equality of civil and political rights."[5]

Unfortunately, the defeat of the revolutionary regimes and the subsequent reaction swept away all the gains. Jewish disappointment, like the general disillusionment, was one of the bitter fruits of the general disaster. Although the gates of the Venice ghetto had been broken down in 1797, and under Austrian rule Jews were free to own property, some restrictions still applied, and many poor Jews continued to live in the ghetto. After the Treaty of Villafranca, the Veneto still belonged to Austria, and amid the celebrations in Milan and Florence, Venice was mourned as if dead by Lombards and Tuscans who had achieved union after the wars of 1859.[6]

Thus it is not wholly fortuitous that the generative production of the macchia movement is Signorini's *Il Ghetto di Venezia* (The Venice Ghetto, ca. 1860; fig. 7.1). Everywhere in Italy, the ghetto signified not only the subjection of the Jewish people, but also the fundamental oppression of the Italians. Founded on April 10, 1516, the Venetian ghetto was in fact the original ghetto, the first enforced zone of residence for Jews in Italy, and the place which set the example for urban slums down to our own day. Signorini's original title for the work was "Il quartiere degli Israeliti a Venezia," (The Jewish Quarter in Venice). It was first shown at the Promotrice exhibition in Turin in 1861, where it created great controversy and was attacked for its exaggerated "chiaroscuro." Signorini later referred to it as one of his most "subversive" pictures; the use of the term in this instance must have implied more than its antiacademic sprightly technique.[7] His choice of Turin as the city in which to introduce the painting was significant, for it was not only the capital of Piedmont and of the new Italian state but was also one of the most liberal on the question of Jewish civil

7.1 Telemaco Signorini, *The Venice Ghetto,* ca. 1860

rights. This was due largely to the efforts of the charismatic Rabbi Lelio Cantoni, an eloquent spokesman for Turin's Jewish community who had the ear of the city's liberals.

One dramatic testimony to this liberal tendency under Cavour was the response of Turin's press to the notorious case of the papally sanctioned kidnapping of Edgar Mortara, the six-year-old child of Momola Mortara, a Bolognese Jew who had violated a municipal law in keeping a Christian nurse for his children. Edgar was kidnapped on June 23, 1858, on the allegation that two years previously he had been subjected to the rite of lay baptism by the nurse. He was placed in an institution and withheld from his parents under the express sanction of the pope. It was clear to almost everyone that the papal authorities concocted this pretext to punish Mortara for violating the municipal law. But although the incident aroused worldwide controversy, the Piedmontese papers were the only Italian journals that dared to criticize the pope.[8]

The democrats and liberals of the north had consistently advocated a very broad interpretation of civil equality for religious minorities, expecting to benefit politically from the elimination of

social barriers against Jews and Protestants. Members of these groups were certainly attracted to the anticlerical theme of democratic propaganda, and it seemed likely that if they could leave their ghettos and be allowed to participate in the mainstream, they would become a bulwark of support for the Piedmontese left.

One of the most influential works on Italian Jews came from the pen of the Piedmontese aristocrat Massimo D'Azeglio, whose *On the Civil Enfranchisement of the Jews,* published in 1847, had a major impact throughout the peninsula. He contended that Jewish emancipation was not only required by Christian duty but that it was ultimately linked with that of the Italian people as a whole. D'Azeglio's brother, Roberto, and other prominent figures in Piedmont, such as Vincenzo Gioberti, Cesare Balbo, and Camillo Cavour—all instrumental in guiding the course of the Risorgimento—actively championed the emancipation of Jews as being in the Risorgimento's best interest. Cavour had taken up the question in his newspaper *Il Risorgimento,* and when Carlo Alberto was finally persuaded to follow a liberal policy it was impossible to avoid taking this religious agitation into account. On March 29, 1848, he signed a decree extending civil rights to Jews and other non-Catholics in his domain and abrogating all previous laws to the contrary. As annexation to Piedmont took place, the provisions of the Piedmontese constitution, including emancipation of the Jews, were extended throughout the country. Thus the regeneration of Italian Jewry was henceforth bound up with Turin, Piedmont, and Cavour. Cavour received financial, political, and moral support from the most active segment of the Jewish population, who were essentially middle-class moderate liberals like the D'Anconas.

Signorini must have counted on this favorable climate for the reception of his theme of the Venice ghetto. He painted it at a time when his patriotic impulses were strong, when there was a growing market for Risorgimento themes, and when artists were pressed to depict patriotic themes in preparation for the 1861 exposition. Signorini was discharged from the Tuscan artillery in October 1859 and spent the following winter in Florence. At the 1860 Promotrice he exhibited two military themes (perhaps done for the Ricasoli contest), including *L'Artigliera toscana a Montechiaro* (The Tuscan Artillerymen at Montechiaro; fig. 7.2) which was purchased by Prince Eugenio Carignano of Savoy. He then made a special trip to Solferino in 1860 in preparation for his military picture displayed at the exposition—*Expulsion of the Austrians from Solferino* (1860). His study of *Il cimitero di Solferino* (The Cemetery of Solferino) also dates from this period, and its combination of documentary realism and symbolic signifi-

7.2 *(top)* Telemaco Signorini, *Tuscan Artillerymen at Montechiaro* 1859–60

7.3 *(middle)* Telemaco Signorini, *Cemetery of Solferino*, ca. 1860

7.4 *Recovery of Weapons Abandoned by the Austrians in the Cemetery of Solferino, L'Illustration*, 1859

cance closely resembles that of contemporary graphic journalism (figs. 7.3, 7.4). He continued on to Milan and Turin before going to La Spezia to make his boldest macchia studies to date. He applied the structure of one of these macchia studies to sketches he had made of the Venice ghetto in 1856 when he visited there with D'Ancona. Thus, as in the case of Fattori, Signorini's most daring experiments of the period cannot be separated from his involvement with the national movement.

While at Turin to see the Promotrice of 1861, he went to hear Cavour in parliament, the minister's last speech there before his death on June 6, 1861. Signorini was in Paris when he heard the news, and attended a memorial service for the statesman at the Church of La Madeleine. Signorini hoped for a positive response to his heightened sense of patriotism when the *Venice Ghetto* was exhibited in Turin. There, as in Milan and Florence, patriotism and the art market were inseparable, and Signorini reminds us in a note that his military paintings sold well.[9] He clearly imagined that the painting would reach the same market and take advantage of the same climate. But what was acceptable in a battle picture was evidently seen in a different light when it was exposed at such close range and with such shocking visual effects of the lingering degradation and poverty of Venetian Jewish life.

Signorini's picture, which horrified portions of the public, depicts a mass of seedy tenements with living quarters piled story upon story in narrow, cavernously dark streets. Wretched, hopeless ghetto dwellers are slumped dejectedly in corners or walk listlessly. Yet this is no ordinary genre picture à la Decamps, but rather a pitiless, unsentimentalized examination of conditions akin to those described by D'Azeglio in his analysis of the Roman ghetto:

> It is a formless mass of houses and hovels that are badly kept up, in constant need of repairs and falling half apart. In it vegetates a population of 3,900 souls, in a space where even half that many would live badly. The narrow streets, which are choked with people, the lack of air, the constant dirt which is the inevitable result of forced overcrowding, all of these factors constitute to make this area sad, ill-smelling and unhealthy.[10]

Using his macchia technique to emphasize the gloomy archways and cavernous alleys, Signorini was clearly trying to adumbrate an analogous vision. His harsh sunlight reveals through explosive contrast with shadowed corners an environment that rarely saw the light of day, and whose denizens lived so close to the edge

that survival required shunning the light. Signorini's macchia technique exposed the frayed textures, the sickening smells, and the grimy aspects of ghetto life.

At the same time, no one could have missed the fact that the *Venice Ghetto* was a metaphorical image of a Venice still bound to Austria. Several paintings of 1861–62 made allegorical allusions to the isolated Veneto, including Domenico Induno's *Povera Venezia* (Poor Venice) exhibited together with his *Bolletino del giorno 14 Iuglio 1859 che annunziava la pace di Villafranca* (Bulletin of July 14, 1859, Announcing the Peace of Villafranca) which portrays the disillusionment in Milan with the terms of the treaty (fig. 1.8). The shock of the Treaty of Villafranca, which left the Veneto under Austrian rule, fell heavily on the Venetian population, and contemporary descriptions characterize the people as martyred, mangled, and bleeding from every vein, enduring an ancient yoke, and writhing "under stripes yet fiercer than those of old." Reports in November described the people as oppressed and desolate, with "gloomy, sullen silence" brooding over the once cheerful population that now moves about "noiselessly and abruptly . . . without apparent reason."[11] In this sense, Signorini's robot-like figures are taken to symbolize the depressed state of Venice's population at that time.

Like Fattori, Signorini avoids dramatic and emotional devices. He depicts an ordinary moment in the lives of the ghetto inhabitants rather than a festive holiday or ceremonial event. The macchia is used specifically to objectify the conditions of a particular corner of Italian society. While the image may now seem tame to us, it struck the conservative segment of the Turin public in 1861 as unremittingly ugly, a vision of a world they would rather avoid, or, at best, glimpse in a more agreeable guise. Signorini had the general public—not the connoisseurs—in mind when he used the word "subversive" to characterize the picture.

That the ghetto was an abidingly serious subject for Signorini, as well as for Italian society generally, is seen in the fact that he repeated the theme in 1882, this time showing *Il Ghetto di Firenze* (The Florence Ghetto; fig. 7.5) at a time when this traditional site of a teeming populace had been condemned to demolition.[12] Cecioni considered this painting one of Signorini's best. He especially admired the figure of the elderly man wearing tattered clothing and a hat who walks toward the spectator, the direct counterpart of the stout woman carrying the basket in the Venice Ghetto. For him, this sympathetic but pitiful figure symbolized the tragic fate of the Florentine ghetto.

Signorini painted the picture in the fall of 1882 when the Mercato Vecchio and the Ghetto had both been doomed to destruction. The Ghetto in fact lay between the Mercato Vecchio and Via

7.5 Telemaco Signorini,
The Florence Ghetto, 1882

Tornabuoni, and the rehabilitation plans called for the elimina-
tion of the old marketplace to make way for modern buildings and
shops, although all this was rationalized in the name of hygiene
and civic improvement.[13] The municipal government trotted out
all the standard justifications for slum removal, stressing the crime
and degradation of the quarter, its unsanitary conditions, and
especially its squalorous appearance in the midst of Renaissance
glory which shocked foreign tourists. The real impulse behind
demolition was a Haussmannization mentality that would hand
over the valuable real estate to developers and speculators. Cer-
tainly, the old market remained a vital center of activity, crowded
from morning to night with an unending stream of buyers and
sellers. It was a favorite motif of Signorini in the 1880s, and he

did an album of etchings based on this subject. Meanwhile, the Ghetto was no longer the exclusive prison of the Jews, who had first been confined within its gates in 1571. By the 1880s, the Ghetto had become a hotbed of criminals of every ethnic status, and of vulnerable senior citizens who could not afford to leave. Again, Signorini depicts a squalid population who rarely saw the sunlight, and the sense of hopelessness that marked the poor in the Ghetto, both Jew and non-Jew alike. Signorini faithfully records the conditions analyzed by municipal inspectors and health inspectors who had declared the area as unsafe. This is the real political position of the Macchiaioli—the equivalent of the middle class transforming the slums but regarding their passage with wistful nostalgia. Signorini in fact profited from the event by energetically producing a series of etchings and canvases of the Mercato Vecchio which sold well in the period that saw the actual demolition of the quarter.[14]

The debates over the proposed demolition began in the summer of 1882, and at the end of the year the historian and critic, Guido Carocci, launched a series of articles in the *Arte e Storia* recounting the history of the Ghetto. His series began:

> If there is one ardent prayer, more than amply justified, if there is a single desire shared by every Florentine citizen, it is to witness the disappearance of the Ghetto, that vile heap of errors, of impossible tenements, of lurid hovels, that den of thieves and vagabonds, that refuge of vice, mystery and filth.[15]

Fair enough. But for the rest of the piece, and in the subsequent three installments, Carocci recalls with nostalgia the distinguished personalities and nobility who inhabited the quarter in the early Renaissance, as well as the medieval edifices which bore on the history of the city. Carocci stresses its significance for the historical development of Florence, then goes into a tailspin when he reaches the stage of the sordid persecution of its Jewish inhabitants, winding up practically in tears. He quickly recovers at the end of the final article, reminding his readers that, despite all the hardships, Florentine Jews made notable contributions to the culture of the state. On balance, for Carocci the memory of the oppression of Jewish citizens is too painful to recollect, and it would be to everyone's advantage to efface the Ghetto's physical and historical traces:

> Given the deplorable state to which this ancient center of power and of the town nobility has fallen, we can have but one wish: to see it disappear as quickly as possible to the honor of our city.[16]

Thus history was once again about to be rewritten to allow the emergent middle-class to exercise a free hand unencumbered by the past. One part of the debate centered on the project's unrestrained grab of contiguous areas including some medieval monuments and buildings that could be preserved without affecting the general plan. In the end, however, it became clear that concern for hygienic conditions and the elimination of vice and filth was secondary to what is still blushingly called "progress." And, as always, hundreds of families were forced to relocate, some in "model houses" for the poor but the majority in disused convents with conditions almost as poor as those they vacated.[17]

ANTICLERICALISM

The call for Jewish emancipation reflected the larger issue of religious liberty, and the prevailing anticlericalism suggested in the striking absence of religious themes in the work of the Macchiaioli, painters in a culture where the Church was, and remains, a dominant force. One seeming exception is Vincenzo Cabianca's *Il Mattino* (The Morning, 1862), now called *Il Mattino. Le Monachine* (Morning. The Nuns; fig. 7.6). One version was exhibited in the same Turin Promotrice as the *Venice Ghetto,* and another in the Italian national exposition later that year. Both were based on studies Cabianca did with Signorini at La Spezia in 1860, and caused almost as much controversy as Signorini's painting. In Cabianca's case, the staunch anticlericalists in the Turin audience were thrown off balance by this image of a religious subject in a humdrum context; the work neither obviously condemned nor celebrated the religious life of a convent.

Cabianca projects his view above a sweep of pale-blue sea and

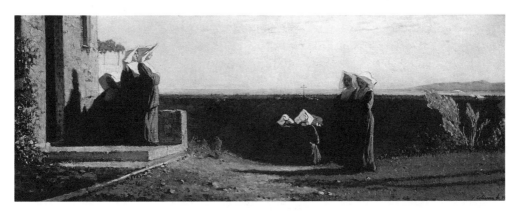

7.6 Cabianca, *Morning (The Nuns),* 1862 replica

undulating coast line, elevating the eye to a grassy height whose stone rampart cuts across the picture plane just below the horizon. In the left foreground, listless pairs of white-coifed nuns issue from the grim portal of the convent. They move robot-like to take their recreation on the breezy terrace; one pair stands watching the cooing flirtations of several white pigeons. The other nuns, as one local English critic wrote, descend a stairway "into the cold blue shadow of a burial crypt." While complaining of the lack of "manual industry" in the execution, Theodosia Trollope was clearly impressed with the originality of Cabianca's presentation of the religious subject.[18] There is an unmistakable affinity between the white flaps of the nun's coifs and the pigeons's outstretched wings.[19] Cabianca draws a contrast between the freedom of the birds and the mechanized routine of the nuns, who are fenced in by the heavy stone rampart. The nuns move in measured cadence, with neither gesture nor facial animation. Despite the fact that it is set in an oceanside environment, dominated by a limpid sky reflected in the sparkling blue sea, the picture has a mournful air.

A milestone in the formation of the Macchiaioli compositional structure, the *Nuns* is one of the first major examples of the oblong or panoramic format that almost all of the painters in the group employed at one time or another. Their large body of work in this format seems to be unique in nineteenth-century painting and probably derives from their studies of Renaissance altars and murals and composite panoramic photography. They use it most often to catch the sweep of a landscape while keeping the human action within view. This type of composition "pans" across the picture frame, with the horizon parallel to the frontal plane. Generally included are groups of *contadini* or of fashionable middle-class people moving across the picture almost at eye level. As in a frieze or mural, the group movement more or less sustains the lateral compositional rhythm, with the figures confined to the coordinate views, profile or full-face.

I am convinced that their peculiar rectangular format is based primarily on the predellas seen at the foot of large altarpiece panels. I have in mind such examples as Gentile da Fabriano's predella of the *Flight into Egypt* for his *Adoration of the Magi* and Sandro Botticelli's predella of the *Annunciation* to the *Coronation of the Virgin* in the Uffizi (figs. 7.7, 7.8). These predellas provided narratives ancillary to the exalted religious event staged in the central panel. The artist took greater liberties in these small oblong panels than in the solemn and restrained large paintings, giving the predellas an energetic movement in counterpoint to the neutral zone above them. Working in smaller range, the painters could concentrate dramatic power into single scenes, or wax playful as

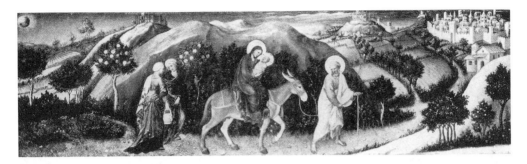

7.7 Da Fabriano, *Flight into Egypt*, 1423

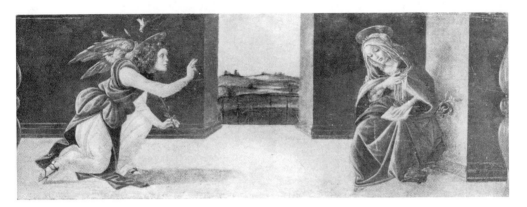

7.8 Botticelli, *Annunciation*

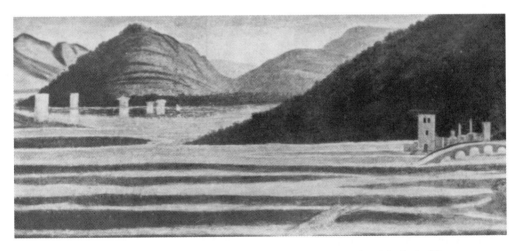

7.9 Lotto, *Predella of the Dead Christ*, Parish Church in Asolo, Vicenza

in the marginalia of medieval manuscript illumination. There are even examples of deserted landscapes reminiscent of the elongated studies painted by the Macchiaioli at Martelli's estate at Castiglioncello (fig. 7.9). Significantly, the predella is a peculiarly Italian invention, and examples in other countries are rare.[20]

7.10 Giuseppe Abbati, *Cloister,* ca. 1861–62

Signorini and others noted the inspiration of the Quattrocento masters on the Macchiaioli, and it would have been perfectly consistent with Macchiaioli wit and irony to have appropriated not the central painting of a *capo-lavoro* but the subsidiary vignettes in which the older painters could have more freely expressed their conceptions. In the language of the nineteenth century, the predellas provided artists with the opportunity to manifest their sincerity. The simplicity and directness of the predella inventions presented a reference point for the Macchiaioli's search for role models rooted in their indigenous past and uniquely Italian. They borrowed the schema of the Renaissance predella as a window on to their glorious history and used it to frame the life of the present. By so doing, they united tradition and modernity to signify Italian continuity, and appropriated a vehicle for religious themes for their snapshots of the contemporary world.

Another example of Macchiaioli "secularization" is Giuseppe Abbati's *Chiostro* (Cloister, ca. 1861–62; fig. 7.10), one of a series of macchia studies he did during the restoration and renovation of the Gothic Church of Santa Croce. While at 19 by 25

centimeters it does not conform strictly to the panoramic format, its central motif—the piled-up marble blocks and the low cloister wall on which a lone youth sits—hangs in the central zone like Fattori's French soldiers, and emphasizes a horizontal disposition. Santa Croce was one of several buildings in Florence restored between 1857 and 1863, the first stage of Florentine "Haussmannization." In addition to Santa Croce, the Bargello, Santa Maria della Novella, and the Palazzo Medici-Riccardi all underwent renovation in these years. These improvements were geared to appeal to the civic pride that developed apace with the Risorgimento and reached a peak in the wake of independence.

Although some of these restorations began prior to the termination of the grand duchy, they were continued and paid for out of a special tax on the city's householders. It was resented at the time that foreigners attributed the improvements to the initiative of the grand duke, since it was the decision of the municipality in the first place and had nothing to do with the state government. The façade of Santa Croce was paid for in part by the convent and private donations. These improvements at the time were thus considered an expression of civic patriotism in the wake of independence.

Abbati's interest in Santa Croce is connected to his interest in interiors. Although a cloister is simultaneously an interior and exterior, Abbati forces us to look toward the interior as a darkened backdrop for the brilliant highlights of the marble blocks. Abbati's father, the son of a Neopolitan officer in the army of Murat, was himself a famous painter of interiors. He was earlier attached to scenic design, and worked for the Theater of San Carlo in Naples, physically and institutionally connected with the Royal Palace. His steady patron was the reactionary Duchess de Berry, for whom he did most of his later commissions. His main activity was painting sacred interiors, often focusing on well-dressed women praying before altars (fig. 3.2). He gained a reputation for his pious scenes, the choir, the sacristy, and the chapter house. He transmitted this specialty to his son, Giuseppe, whose early work imitated the religious interior. Giuseppe exhibited three works at the National Exhibition of 1861, all interiors painted in Santa Maria Novella and San Miniato al Monte.

It was in the period of this show that Abbati's patriotism and attachment to Florence began to express itself in macchia experiments. These experiments coincided with exposure to the nationalistic works at the Exposition and perception of the macchia in its relationship to the Risorgimento. In 1860 he was one of Garibaldi's Thousand, and in the battle of Capua in early October, he lost an eye. Two years later he joined Garibaldi again for

the aborted March on Rome and agonized through the tragic
episode of Aspromonte. During the interval, he met Serafino De
Tivoli who introduced him to the Caffè Michelangiolo circle. Ab-
bati's politicization in this period is shown by his rejection of the
medal offered him by the jury of the National Exposition; he had
joined a group of dissident participants who refused to recognize
the jury because of its conservative predisposition.

As in the case of Fattori, Signorini, and Cabianca, Beppe Ab-
bati's early experiments in the macchia are inseparable from his
political engagement. His approach to Santa Croce is in fact a
remarkable case of artistic and philosophic self-restraint, consis-
tent with the understatement and objectivity of the macchia in
general. He steadfastly refused to allow himself to be seduced by
the tradition of his father, and the conventional approaches to
church imagery. Rather, he looked to the sections of the church
under repair or restoration. Even in the larger, more finished
work, *Il chiostro di Santa Croce* (The Cloister of Santa Croce),
where monks read or stroll in the shadow of the cloisters, the half
of the picture in the sunlight exposes the work site with day la-
borers loading stones and marble blocks onto a cart; here chiar-
oscuro presents not only a formal opposition but a narrative and
political confrontation as well (fig. 7.11). As against the stereo-
typical view of the monastic *vita contemplativa*, Abbati asserted its
dialectical and ideological counterpart, *vita activa*, as a force for
change (fig. 7.12).

Abbati's self-restraint appears even more remarkable when we
recall the importance of this medieval edifice in Florentine his-
tory. The church may be called the Pantheon of modern Italy, for
here are buried some of its greatest heroes including Machiavelli,
Michelangelo, Galileo, and Alfieri. The great poet of the early
Risorgimento, Ugo Foscolo (1778–1827), wrote his master-
piece, *Dei Sepolcri* (On Tombs, 1807), with the Santa Croce in
mind. Foscolo apostrophized the great heroes of antiquity and set
them to fight again the battles of their time. The tone of the poem
became the dominant tone of the early, romanticized Risorgi-
mento, but it had a profound appeal for the later leaders like Maz-
zini and Garibaldi. Foscolo was Garibaldi's favorite poet; for him,
the last four lines of Foscolo's poem evoked a great love of Italy
and willingness to die for it:

> And you, Hector, will be honored in tears
> wherever they deem holy and lament blood
> shed for one's country, and so long as
> the Sun shines upon human sorrows.

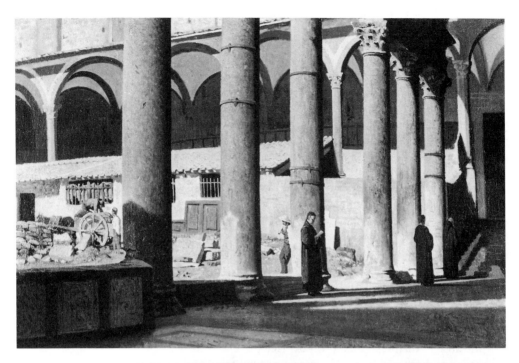

7.11 Giuseppe Abbati, *The Cloister of Santa Croce*, ca. 1862

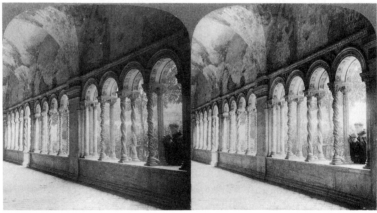

7.12 *Ancient Cloister of St. Paul's, Rome*. Stereoscope view, 1897

It is the section in which Foscolo imagines himself in Santa Croce that most interests us here. Foscolo evokes a kind of symbolic role call of the heroes of Italian culture. After eulogizing the contributions of Machiavelli, Michelangelo and Galileo, he apostrophizes the city of Florence,

> for your happy breezes stirring with life, and for the streams that Apennine pours down to you from her crests! The moon, glad with your air, clothes your

hills, that are rejoicing for the wine harvest, with clearest light, and the clustering valleys peopled with houses and olive groves send up a thousand flowering incenses: and you first, Florence, heard the song that lightened the anger of the fugitive Ghibelline [Dante], and you gave parents and speech to that soft lip of Calliope [Petrarch] who, adorning Love, naked in Greece and naked in Rome, with a veil of the whitest, restored her to the lap of Heavenly Venus; but more blessed because you keep, gathered in one temple, Italian glories, that are unique perhaps, since the ill-contested Alps and the changing omnipotence of human fate have spoiled you of arms and possessions and altars and native land and everything, except memory. So when hope of glory comes to shine upon daring minds and upon Italy, from these we shall draw auguries. And to these marble tombs Vittorio [Alfieri] came often for inspiration. Angry with his country's gods, he would wander silently where the Arno is most barren, and look lovingly at the fields and the sky; and when no living sight softened his cares, here the austere man rested; and on his face there was the pallor of death and hope. He lives eternally with these great; and his bones tremble with love for his country.

At the time the poem was published, it was widely noted that the poet chose as his somber recollections Santa Croce rather than St. Peter's, and that he celebrated authors, scientists, and statesmen rather than popes or princes. It appeared as a republican lineup with the implications of an end to monarchy and to the Church's temporal power and a scientific approach to government and society. While the poem was originally inspired by Napoleon's ban on further burials in church vaults due to the danger of disease, it came to signify for Italian liberals the overthrow of all foreign tyrants by an appeal to its heroic past as an example for the present.

Furthermore, Foscolo takes Santa Croce not only as the symbol of Florentine greatness but of Italy as a nation. The heroes of Italian culture were gathered in Florence, making it the symbolic focus of the Risorgimento. He pinpoints specific geographical sites such as the Arno and the Apennines, the wine harvests, and the hills of Tuscany, but these successive landscape images are meant to be focused on the "Italian glories" gathered in one temple. In the same way, the Macchiaioli took as their point of departure the specific topographical sites associated with the Tuscan countryside, as rays of light are gathered into the focus of a

magnifying lens, to give the one area the political and spiritual dimensions of the entire map of Italy.

Santa Croce was thus a vital symbol of the Risorgimento, a church that had deep secular significance for the Italian national ideal. Its restoration during the period 1857–63 was closely interwoven with Tuscan patriotism. This patriotism had even more contemporary implications, since Santa Croce had been the site of popular demonstrations and violent action throughout the decade of the 1850s.[21] On May 28, 1859, a solemn memorial commemorating the Tuscans who fell in 1848 at Curtatone was held at Santa Croce, with two bronze tablets bearing the names of the fallen set on either side of the high altar. These tablets had themselves a major role in bringing about the fall of the House of Lorraine. They had originally been installed a few months after the event by the municipality, and services were conducted there in subsequent years. In 1851, the occupying Austrian troops were ordered not to allow the commemorative service to take place. The citizens, however, forbidden to sing mass or light candles for the departed, brought garlands to hang upon the votive tablets, and they were immediately repulsed by disguised police. On resisting, they were met by more plainclothesmen who issued from hiding in the sacristy and even fired on the crowd in the body of the church. Thus, Tuscans were still mourning the death of the victims of the day's demonstration when the government ordered the tablets to be removed and concealed at the Fortezza da Basso. The bitterness aroused by this event burned itself deeply into Tuscan memory, and not surprisingly, one of the first acts of the Provisional Government in 1859 was to restore the tablets to their original place in Santa Croce.

One month after liberation the dense crowds filled the Piazza Santa Croce hours before the church opened at 9:00 A.M. Over each of the three portals an inscription was placed: The central one proclaimed the anniversary of the struggle for Italian independence; the one on the right read, "Enter safely, on this day at least, from impious and murderous orders, to do honor to the slain vanguard of the liberation of the country"; while the one at the left admonished the crowds to "bring not hither tears and lamentations, but crowns of laurel to those who laid down life against the Austrian tyrant." From the roof of the nave hung a huge black velvet banner over a colossal military catafalque with the words: "Today we celebrate the morrow of 1848."

Thus Santa Croce became a powerful national symbol during the phase of Tuscan independence in 1859, and it is not surprising that during the series of bombing incidents in January 1860, the

Convent of Santa Croce was targeted along with the homes of Ricasoli and his minister Salvagnoli.[22] It was the Convent that supplied a major portion of the funding for the restoration of the church façade, and this new damage (although slight) had also to be accounted for. It was the work of right-wing extremists who wanted to put blame on the "partito rosso" in Tuscany, thinking that the attack on the religious institution would be automatically blamed on them.

Under the grand duke, Santa Croce had been the scene of spectacular ceremonies during Easter Week. Attended by his guard of nobles, the duke in great pomp visited the church on a route that took him to seven of the principal churches of the town. The interiors of these churches were spectacularly adorned, with Santa Croce in particular singled out by its resplendent high altar and magnificence of decoration. Its hangings of gold and silver brocade, massive candelabras of precious metals, brilliant flower arrangements, innumerable wax candles, made up a scene of gorgeous splendor that dazzled the tourists. This was the tradition of the grand-ducal regime, now converted into a kind of "secular" ritual by the Ricasoli government and one particularly galling for the grand duke's dispossessed partisans.

And now we come back to the studies of Abbati, so simple and yet so extraordinary both in terms of their artistic heritage and Risorgimento idealism. His *Cloister* is the exact opposite of his father's interiors, which would have glorified the splendor and the spectacle of church and chapel. Like Signorini, who transformed his father's Vedutisti tradition, Abbati converts the conventional and aristocratic code to an image that permits the spectator to enter a secularized world of cloisters and church under repair. Abbati divests Santa Croce not only of its religious sanctity but also of the glorified, heroic associations celebrated by Foscolo.

Yet Abbati has not abandoned Santa Croce as a patriotic emblem. He shows it in a fresh and modern context. His accomplishment, and that of the Macchiaioli generally, was to encode Italian culture as a channel of communication for the contemporary ideals of the Risorgimento. *The Cloister,* with all its apparent innocence, embodies a democratic and scientific approach compatible with the new, secular attitude. The crumbling of the old order in Tuscany was heralded in the fresh experiments of the Macchiaioli. Abbati's other scene of Santa Croce, showing the monks and the workmen, does not exalt or dramatize its content, but flattens everything out like the concept of nationalism itself— a process that in principle brings everyone to the same social level. The absence of social caste, like the absence of churchly and hierarchical trappings, makes Abbati's flat macchie—expressed most

vividly in the marble blocks and their contrast with the darkened area of the cloistered walks—a leveling experience, akin to the principle of nationalism itself.

ITALIAN FEMINISM

It is this consciousness of the leveling aspect of their art that makes much Macchiaioli imagery important in still another respect, their fresh examination of the role of women in the context of Italian feminism. Until now this factor has not been given the attention it deserves, but it would seem from both textual and visual evidence that the Macchiaioli viewed women in a much more favorable light than most of their male contemporaries both at home and abroad. This is remarkable when we recall that in nineteenth-century Italy women could acquire status almost exclusively in the roles of wife and mother.

One example of their respect for women is De Tivoli's profound admiration of the work of Rosa Bonheur. De Tivoli was an *animalier* himself and could evaluate Bonheur's scrupulous constructions of animal forms. But he especially admired her powerful chiaroscuro, which he likened to the work of such renowned male painters as Decamps and Troyon.[23] The same year that De Tivoli brought back his report on the techniques of the French painters that he observed at the Universal Exposition of 1855, William Michael Rossetti, the son of an ex-Carbonaro from Naples and fervent supporter of the Risorgimento, unreservedly praised Rosa Bonheur for the "vigor" and "truthfulness" of her productions.[24] It is the openness of the Italians and others who supported the Italian cause to the possibilities of learning their craft from a woman that makes them unique in the nineteenth century.

One of Lega's most loving pictures is *La Pittrice* (The Female Painter), indicating the presence of gifted women artists in his circle (fig. 7.13). Although dressed a bit too primly for messing about at the easel (but no differently in this respect from many elegantly dressed male artists who posed before their easels), the woman is totally absorbed in the act of painting. She is depicted alone, in full command of her private working space, and the narrowly confined focus on her full-length figure and telescoped interior reinforces the sense of concentration and leaves no room for anyone else. Indeed, she is so close to the frontal plane that it is difficult to imagine the position of the artist. Thus she disrupts the conventional designation of the feminine social space and denies the voyeuristic potential of the male gaze.

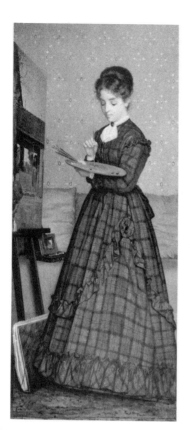

7.13 Lega, *The Female Painter*, 1869

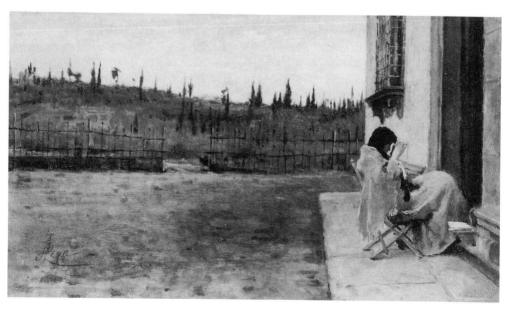

7.14 Lega, *Dedication to Work*, 1885

Still another example of female absorption in the act of working is Lega's *Un'occupazione al lavoro* (Dedication to Work), depicting a seated female so intent upon her sewing that she brings it up to within inches of her eyes for utmost precision (fig. 7.14). Lega ingeniously exploits the Macchiaioli penchant for oblong compositions by pushing the woman all the way over to the doorway at the extreme right of the picture, and showing her with her back turned to the expanse of landscape behind her. As in *The Female Painter*, the woman creates her own space within the environment that allows for her total concentration and at the same time protects her from encountering the male gaze.

This is not to say we should look for radical feminist suggestions in the work of the Macchiaioli. They came from a predominantly bourgeois and patriarchal background, where women bore not only the weight of male oppression, but the omnipresent pressure of the Church in everyday family life. Elaborate rituals for young women on holy and festival days and daily religious duties occupied a major portion of female activity. The role of the priest in the life of the women of upper-class families went beyond normal religious functions; he was also the personal advisor, intermediary, and administrative assistant. The priest's role in influencing women is the theme of a popular novel of the period, *Vincenzo, or Sunken Rocks,* by Giovanni Ruffini (1807–1881), the son of a revolutionary family closely allied with Mazzini and Giovine Italia. Published in 1863, the novel takes place against the background of the Risorgimento, and recounts a husband's attempt (not undertaken without condescension) to break through his wife's socialization pattern and heighten her political consciousness. Rose, however, turns the tables on him and tries to win him to Catholicism through the wily coaching of the family priest, Don Pio. The tension created leads to profound domestic strife, a conflict typical of Italian families in this period.

Except for Mazzinian aims, the Risorgimento had not in any sense been feminist in intent; after unification, state policies attempted to reassert social and political stability, not a new social order. Nevertheless, for democrats the fight for female suffrage was always waged within the context of the larger struggle for the democratization of all Italian political and social institutions. Long before the approval of the Civil Code of 1865 democratic deputies had sponsored bills to enfranchise women and to reform the patriarchal character of Italian family law. Thus it was inevitable that women as well as men would be politicized during this movement and actively engaged in political agitation. Italian feminists were anticlerical, focusing their attack on the Church and

the patriarchal state. Italian Jewish women also found an outlet for resistance in Risorgimento politics: Noerina Noè, the daughter of a wealthy and cultured merchant who married the *garibaldino* Giacinto Bruzzesi, wrote articles for the democratic press, particularly on women's issues. She and other young women of her ethnic and social background had as their role model the Mazzinian loyalist Sara Levi Nathan, whose entire family had participated in one way or another in Risorgimento politics from the beginning of the movement.[25] This heady involvement of women in democratic politics disrupted the boundaries between political and private life, and even traditional domestic roles assumed political significance. Once unification was achieved, women participants in the Risorgimento could turn the political networks they helped develop into organizations for the improvement of female status in all spheres of Italian national life.[26]

The heightened female presence in the Risorgimento also drew foreign women, feeling blocked by their own repressive societies, into the orbit of the Italian national movement. The American Margaret Fuller realized her radical aspirations in serving Italian unification, inspired by the passionate idealism of Mazzini, whom she met in London on the eve of the revolutions of 1848.[27] She allied herself with the democratic faction of the Risorgimento, including the Princess di Belgioioso who in 1849 organized the women in support of the short-lived Roman republic. Fuller wrote articles for the *New York Tribune* pointing out the betrayal of then President Louis-Napoleon of France, who wished to restore the papal power, and assumed the responsibility of *regolatrice* of the hospital of the Fate Bene Fratelli for the care of the wounded when French troops beleaguered the republic. Following the defeat of Rome, Fuller and her husband, Giovanni Angelo Ossoli, who had fought in defense of the republic, left for Florence. But after being submitted to harassment by the Austrian government for their involvement in the revolution, they decided to leave for America. Tragically, the ship ran into a gale just off the coastline of Fire Island, and Fuller, her husband and infant child, and everyone else aboard were drowned.

English writer Jessie Meriton White's encounter with Mazzini and Garibaldi in the 1850s proved decisive for her entire career, since she not only became a devoted supporter of Italian liberation but as an outspoken journalist and lecturer for republicanism and unification earned her livelihood interpreting that movement and its later developments for Anglo-American audiences.[28] Between the years 1866 and 1906, she herself wrote 143 articles for the *Nation* covering the post-unification developments. In 1857 she married the *garibaldino* journalist Alberto Mario and together

they propagandized in numerous local and foreign periodicals in behalf of the Italian cause. It may be recalled that Mario—himself a profeminist writer[29]—was one of the founders of *La Nuova Europa*, the journal sympathetic to the Macchiaioli, and it was through him that she established direct contact with Martelli and the Macchiaioli circle.[30]

Examining now the works of the Macchiaioli, we may note that with the exception of their military themes, women statistically predominate over men in their paintings. While showing women in their traditional spaces, the home and the garden, doing such traditional chores as sewing and embroidering, they portray them with a directness and sense of dignity that is rare in mid-nine-teenth-century painting. Fattori's women, for example, are often powerful presences who look at the spectator with astonishing candor. Their heads do not tilt coyly, nor do they appear passive or melancholy (figs. 7.15, 7.16). Generally speaking, the women in Macchiaioli paintings do not engage in flirtatious exchanges or share private feelings with a peering male voyeur, imagined or real. They do not show off fancy gowns or comport themselves for display in gardens or at the lakeside or oceanside as do women in French and American Impressionist works. While Fattori's *Rotonda di Palmieri* (The Palmiere Pavilion, 1866) does portray a group of upper-class women at the seaside dressed at the height of fashion, their grave, dignified silhouettes dominate the scene, yielding a sense of group activity and serious conversation rather than one of leisure-time frivolity (fig. 7.17). Their gravity is akin to that seen in Fattori's portrait of his first wife, Settimia Van-nucci, and in his 1861 historical image of Mary Stuart, Queen of Scots. Although the Macchiaioli painted the occasional women with a parasol and the daydreaming young girl, a major portion of their work depicts females engaged in useful work or in con-versation during a pause in their labors. Women are shown col-laborating and enjoying each other's company.

These depictions of women in their intimate spaces are invalu-able for understanding Tuscan social relations in both peasant and upper-class environments: the formality, hierarchy, politeness, eti-quette, and repression of emotions that seemed typical of bour-geois life in Tuscany in this period. Banti's *Riunione di contadine* (Gathering of Peasant Women, 1861; fig. 7.18) shows women attending their children, or winding yarn on a hand-held distaff, even during pauses in their field labor. It may be argued that males are absent because the painters chose to depict the interior, more intimate domestic spaces (i.e., female spaces) while men oc-cupied the public and outdoor spaces, the cafés, squares, streets, and markets. It is also true that many men were still fighting in

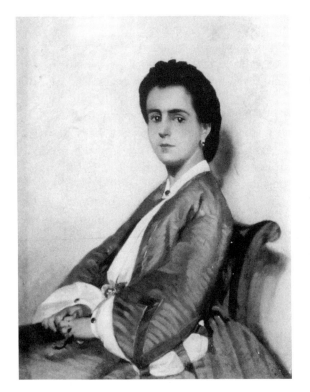

7.15 Fattori, *Cousin Argia*, 1861

7.16 Fattori, *Portrait of the Artist's First Wife*, 1865

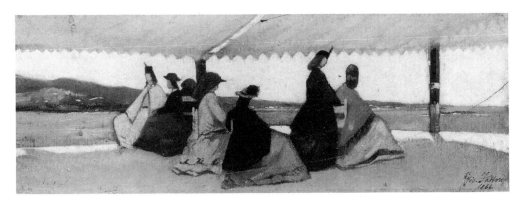

7.17 Fattori, *The Palmiere Pavilion*, 1866

the armies of Garibaldi and Piedmont, or were working out of the country. Whatever the reason, the visual evidence demonstrates that the Macchiaioli painters consistently presented women empathetically rather than voyeuristically.

I have previously touched on the implications of Borrani's *The 26th April 1859* for its feminist content (fig. 5.11). Confirmation of this reading comes from an unexpected source: a poem inspired

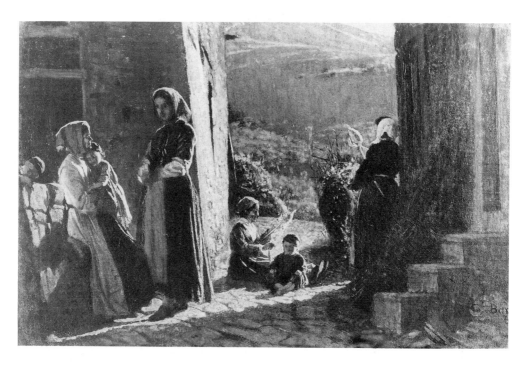

7.18 Banti, *Gathering of Peasant Women*, 1861

by the same experience by the Armenian nationalist poet, Mikael
Nalbandian (1829–1866). A friend of Herzen and Bakunin,
deeply influenced by the writings of Owen, Fourier, and Prou-
dhon, Nalbandian advocated a form of socialist democracy not
only for Armenia but for all peoples. He kept a close eye on the
French and Russian revolutionary movements and the Italian Ri-
sorgimento. He rejoiced on hearing of Italy's independence, and
believed that the Armenians should follow in the footsteps of the
Italian liberation movement. Under the influence of Mazzini, he
helped found a fraternal organization in Constantinople modeled
after Giovine Italia and freemasonry.[31]

In June 1859, two months after the revolution in Florence,
Nalbandian composed his poem entitled "The Song of an Italian
Girl" (later changed to "Our Fatherland").[32] He wrote it during
his second trip abroad in Zoden, near Frankfurt-am-Main, after
having visited France, Italy, and England. At Park House, Lon-
don, Nalbandian met Italian exiles and made friends with Maz-
zini, who persuaded him that only revolution combined with
national liberation could emancipate an oppressed populace: de-
pendence on foreign arms, as in the case of Italy's dependence on
France, only meant switching from one yoke to another. Through
his meetings with Mazzini and the knowledge of Garibaldi's

symbolic presence, Nalbandian increasingly recognized the commitment of Italian women to the Risorgimento cause and their willing sacrifice of their sons for the liberation of their home country. The central position of women in the Italian national movement stimulated him to rethink his priorities and inspired "Mer Hayrenik" (Our Homeland, literally Our Fatherland).

Nalbandian's trip to Italy included a stopover in Florence, where he would have experienced the euphoria of its citizenry in the aftermath of the revolution. The close parallel between his poem and Borrani's painting attests to the key historical role performed by Florentine women in the insurrection, and mutually reinforce the other's authenticity. Nalbandian's poem unfolds from the perspective of the woman assembling the flag with whom he identifies:

> Our fatherland, miserable, unprotected.
> Crushed by our enemies.
> Its sons cry now
> For vengeance, rancor and retaliation.
>
> Our fatherland enchained
> For so many years bound
> With the holy blood of its valiant sons
> Will at last be liberated.
>
> Here brother is a flag for you
> That I have made with my own hand
> During sleepless nights
> I washed it with my tears.
>
> Look at it, with three colors.
> Venerable our symbol
> Let it flutter before our enemy
> Let Austria be destroyed.
>
> How many women, men and defenseless people
> Have engaged in war duties and action
> To help their brother
> With no hesitation out of love for you.
>
> Death is the same everywhere
> All men will die at one time
> Great will be that nation
> Whose sons sacrifice themselves for liberty.
>
> Here is my work, here is my flag
> Mount a horse like a cavalier
> Go liberate our fatherland
> At the war's stormy front.
>
> Go brother, let God be your hope
> Spread the love of nation everywhere.

Go, though I am unable to join
My soul will be your guide.

Go, die like a cavalier
Let not the enemy see your back
Let not the enemy say,
"Decadence is synonymous with Italian."

As she said this she gave
Her brother the flag
It was silk, elegantly executed,
With three zones of color glowing radiantly.

Her brother took it and said goodbye
To his beloved sweet sister
Took the gun, sword and rifle
Mounted his black horse and said

Sister—goodbye, goodbye
My beloved sister
On this flag will gaze
The entire Italian army with admiration.

It is sacred to me since it is baptized
And drenched with your tears
You provided me a memory of
Our sacred fatherland.

Listen, if I should die
Rest assured that I will have taken with me
To the Kingdom of Death
A score of enemies.

So stated the valiant brother as he rode to the front
To meet the Austrian foe
To purchase with immortal blood
The liberty of Italy.

Nalbandian ends the poem by shifting the narration to the first person singular and addressing the Armenian people directly:

Oh—my heart is cut to pieces
Seeing such love and devotion
Toward a suffering fatherland
That was tyrannized, brutalized.

If only half, half of a half [of this category of women]
Appeared in my nation.
But our women . . .
Where are our gentle women.

Oh—tears are welling up within me
I can no longer speak.
No—Italy is not suffering
As long as it has women like this one.[33]

Thus Borrani's painting documents a rising male recognition of the active role of women in national liberation movements and the need to mobilize them for full participation of the aggrieved people. Closer to our own time, it is not surprising to learn that the parliament of the newly independent Armenian republic selected Nalbandian's song as its official national anthem, with one spokesperson claiming that it stood for the Armenian people's identity and revolutionary spirit. Could he also have known its history when he declared that the song, "like the tricolor flag, holds historical significance for Armenians"?[34]

Another visual example of this empathy is Borrani's *Le cucitrici di camicie rosse* (The Seamstresses of the Red Shirts, 1863; fig. 7.19), an extension of the theme of *The 26th of April 1859* and a sign that the Tuscan Risorgimento was no longer clandestine. Borrani's lone female figure in the earlier painting can now work as part of a team, a kind of feminist collective. The portrait of Garibaldi on the wall at the right, as well as the collage of Garibaldiana at the left, demonstrates the political engagement of these industrious women. Exemplified by the female at the right whose head is bent in rapt concentration, they are absorbed in their tasks. Few works of the nineteenth century compare to this portrayal of women dedicated to a task of such political significance. While all the typical accessories of the intimate bourgeois domestic interior are present, the women who occupy the space are not pictured idly staring or waiting for a male to divert them, as they are in many "bourgeois" domestic scenes of the period.

Of course these shirts are being sewn for men, and the gloomy mood and somber physiognomies suggest that the work is done with a heavy heart. The group is sewing red shirts for Garibaldi's volunteers; their men could be declared outlaws or even be maimed or killed. (The date of the work makes it probable that the shirts are being prepared for the ill-fated attempt on Rome in 1862, which culminated with the tragic episode at Aspromonte.) But the precise realism of this interior, with its murano glass, matching furniture, and chintz curtains (strongly hinting at a photographic source), makes it clear that the painter wished to show that bourgeois women were now inspired to lend their unqualified support to the national cause. This is borne out by accounts of foreigners who expressed astonishment at the fierce patriotism of Italian women. No one impressed the English economist Cobden more, on his tour of Italy, than the Neapolitan woman who told him that she would give the blood of her four sons to see Austria expelled from their land.[35]

Borrani's intimate domestic scenes are free of the sense of Victorian morality evoked by Pre-Raphaelite interiors. In Tuscan

7.19 Borrani, *The Seam-stresses of the Red Shirts,* 1863

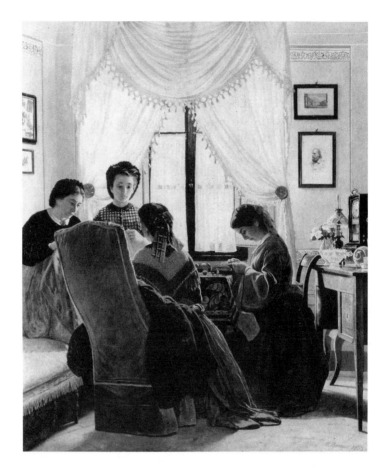

realism there is no overt moralizing, no histrionic breakthrough, simply the grinding day-to-day routine transcribed with incisive accuracy. While Macchiaioli practitioners often painted domestic interiors without explicit political comment, they have to be viewed within the context of the profound pressures exerted on daily life by Risorgimento politics and war. The work of the farm and of the home continue, but amid the strains of unification. Borrani's glimpses of feminine participation in the Risorgimento yield an unexpected insight into the way political life intruded into the ordinarily solemn sanctuary of the Italian family.

Nowhere is this more evident than in the remarkable series of paintings of women done by Silvestro Lega in the 1860s. These works are stimulated by his contact with the Batelli family, with whom he lived at Piagentina (a suburb of Florence) beginning in the mid-1860s. They are sharply insightful images of a prosperous middle-class family, seen through the lens of a radical social consciousness. Signorini astutely remarked that Lega's perceptions of life in the Batelli villa were painted "in the clearest and

most luminous range of the chiaroscuro values, where the different feelings of women of all ages were delicately analyzed, in all their passions and social conditions."[36]

Signorini also claimed that Lega was the most consistent of the Macchiaioli in his political ideals, refusing to compromise them like many of his friends. He does seem to have been the most radical of the group, not only participating in the wars of the Risorgimento (he enrolled as a Tuscan volunteer in 1848) but also taking part in Mazzini-inspired conspiracies in the early 1850s. He had close contact with the radical circle around Dolfi, and Martelli relates how Lega, neatly attired in a fashionable stovepipe hat, kept concealed under it a stack of revolutionary handbills and a pot of paste. Just before midnight Lega would quickly dispatch the handbills on the public walls of Florence.[37]

Lega's radicalism and his insightful glimpses into female life in mid-nineteenth-century Italy may be understood only within the context of contemporary agitation for female emancipation. Upper- and middle-class women participated in the work force at a low level, and had little liberty outside the home. As daughters, wives, mothers, and even widows, they were subjected to a routine oppression that seemed to question their status as rational beings. They were watched, guarded, mistrusted, and deprived of free choice. Their education, which was woefully weak in comparison with that of males, emphasized learning to dance, sing and play the piano, and to read and write French. Learning to dress well and according to the latest fashion was also a major part of their education.

Not surprisingly, Italian reformers of the Risorgimento placed as much emphasis on the emancipation of women as on that of the Jews. Silvio Pellico (1789–1854), the author of *Le mie prigioni* (My Imprisonment, 1832), elsewhere attacked the Italian marriage system and advocated urgent reform of the social code. "Domestic virtues," he wrote, linking such reform to national liberation, "form the basis of national virtues." He further claimed that Italy could become great only when "the homes from which her people issue are purified from the unholy influences pervading them at present."[38] This meant above all, the elevation of the social position of woman in every phase of her existence, her full liberation and education.

Pellico was no exception; Mazzini, Garibaldi, Cavour, and even Ricasoli demonstrated enlightened attitudes toward women. Ricasoli devoted much time and effort to the education of his only daughter, Elisabetta, thinking that he would set an example for the new Italy by giving to it a woman of high intelligence and noble character. Cavour's exchange of correspondence with Ana-

stasie Klustine, the Comtesse de Circourt, whose salon in Paris was a meeting ground for eminent literary, artistic, and political leaders, suggests a friendship of intellectual and cultural equality. (For political reasons, however, he was not above persuading the king to marry off his daughter Clothilde to Prince Napoleon.) Garibaldi, influenced by Saint-Simonist feminism, supported women's suffrage movements, and women (sometimes in disguise) fought with his red shirts. He based his novel *I Mille* (The Thousand, 1874) on the story of one *garibaldina* who eventually dies fighting for her leader near Naples. He also worked closely with the English writer Jessie White, whose marriage to Alberto Mario and devotion to the Italian cause resulted in lifelong promotion of the Risorgimento outside of Italy. Guerrazzi's novels almost always spotlight strong female characters; the protagonist of his *Beatrice Cenci* (1853) is literally a superwoman. D'Azeglio's females are more pliant and fit the stereotype more closely, but even he feels constrained to apologize from time to time for fear of offending his women readers. He wrote in his memoirs that "intellectually there is little difference between persons of the two sexes."[39]

But of all the patriarchs of the Risorgimento, it was Mazzini who came closest to articulating a consistent program for the liberation of women. This was perhaps not surprising since throughout his career, starting with the powerful moral and intellectual support given by his mother, he was dependent on strong and courageous women who aided him in his personal and political life. In 1858 he spelled out his program in *The Duties of Man*, dedicated to the Italian working classes. Here, he declared unequivocally that the emancipation of Italy required the full emancipation of women:

> Cancel from your minds every idea of superiority over Woman. You have none whatsoever. Long prejudice, an inferior education, and a perennial legal inequality and injustice have created that apparent intellectual inferiority which has been converted into an argument of continued oppression. But does not the history of every oppression teach us how the oppressor ever seeks his justification and support by appealing to a fact of his own creation? The feudal castes that withheld education from the sons of the people excluded them on the grounds of that very want of education from the rights of the citizen. . . . The slaveholders of America declare the black race radically inferior and incapable of education, and yet persecute those who seek to instruct them. For half-a-century, the support-

ers of the reigning families of Italy have declared the Italians unfit for freedom, and meanwhile . . . close every path through which we might overcome the obstacles to our improvement. . . . Now, we men have ever been, and still are, guilty of a similar crime towards Woman. Avoid even the shadow or semblance of this crime; there is none heavier in the sight of God, for it divides the human family into two classes, and imposes or accepts the subjugation of one class to another.

Mazzini admonishes his readers to consider women as partners in all attempts at social amelioration, as the equal of the male in civil and political life. Male and female then become like "two human wings" which carry society to the ideal of the new nation.[40]

Mazzini considered gender equality so essential to the new state that he repeated his position in the final statement of his book:

At the present day, one-half of the human family . . . is, by a singular contradiction, declared civilly, politically, and socially unequal, and excluded from the great unity. To you who are seeking your own enfranchisement and emancipation in the name of a religious truth, to you it belongs to protest on every occasion and by every means against this negation of unity. The emancipation of woman, then, must be regarded by you as necessarily linked with the emancipation of the workingman.[41]

There is no question that the many leaders of the Risorgimento were stirred to their awareness of the need for female emancipation by women themselves. If Italian women had few avenues for taking political initiatives, they were nevertheless a tremendous force in public life. Priscilla Robertson, who while duly acknowledging the standard tokens of esteem expressed by writers for wives, mothers, and daughters, nevertheless noted the numerous autobiographies of the Italian leaders of the period which are full of unprecedented gratitude and respect for the women in their lives. Mazzini's mother supported him during his years of exile with understanding and with all the material means she could muster. Anita Garibaldi was a genuine heroine of 1848, a Brazilian woman who learned to ride through the jungles and swamps, to shoot, and to sail Giuseppe's ships.[42]

While the literature on it remains scanty, there was a feminist movement in Italy inspired by the drive for national unity.[43] One of its leaders was Cristina Belgioioso (née Trivulzio, 1808–1871),

the daughter of Milanese nobility who spent much of her life in exile in Paris.[44] Belgioioso followed the political route of most Italian reformers, beginning as a member of the female equivalent of the Carbonari known as the Giardiniere (female gardeners). She then worked with Mazzini, served Giovine Italia by securing arms and ships from France and acting as an intermediary with the French government, and finally shifted her allegiance to Piedmont and the House of Savoy. She devoted most of her adult life to the Italian nationalist movement, in the process becoming an ardent feminist.

After unification in 1861, she wrote articles defending the new state and attacking its enemies, both foreign and domestic. In 1866 she made her major contribution to the Italian feminist movement with the essay "On the Present Condition of Women and Their Future." While not involved in the issue of militant feminism, she nevertheless used the essay to analyze dispassionately the conventional subjugation of women and the means to achieve its abolition.

Two years later, she published her important "Observations on the Current State of Italy and Its Future," an essay which shows that the status of women and the status of Italy were linked in her mind. As in the earlier work, she begins by recapitulating the tyranny which for many years the Italian people accepted as a natural condition. She compares Italy's psychological fragmentation to women's lifelong self-deception, relating the latter to inherited myths of racial and regional inferiority. She concludes that the solution for Italy's problems lies in total reeducation, to correct their ingrained habit of thinking like a conquered people.

In Italy, as in France, 1848 released new feminist energies which took off in various directions during the second half of the nineteenth century. One woman enlightened by the events of 1848 was Anna Maria Mozzoni (1837–1920), a key figure in Italian feminism.[45] Like Belgioioso, she came from Lombard nobility, but her contact with workers' movements after 1848 made her more militant. She fought wage discrimination on behalf of both sexes and in the process discovered the sexism inherent in the workers' movement. Her important book, *Woman and Her Social Relations* (1864), provided a major contribution to feminist thought in the aftermath of unification.

Another source of empowerment was the first major Italian feminist journal, *La Donna,* founded in Genoa in 1855 by a group of women exiles.[46] *La Donna* seems astonishingly up to date in its concerns, addressing social injustices, tracing the origins of female discrimination, supplying advice on dealing with everyday oppression, and exposing contradictions in the marriage

laws. Its first issue took up the question of young female suicides, attributing them to societal pressures and hypocrisies. Besides attacking masculine oppression, *La Donna* provided instruction in the sciences and took positions on other important issues of the day. Above all, it advised its readers to help the poor and involve themselves in charitable causes to ameliorate the condition of the underclasses, thus benefiting all of society and accelerating the process of national regeneration.

La Donna's involvement in the Risorgimento also expressed itself in an appreciation of Italian folklore, especially the folk songs known as *rispetti* and *stornelli*.[47] The *rispetto* was almost always a love song, while the *stornello*—from the verb *storno* (to re-echo)—could be lyrical, satirical, or political. These were printed in *La Donna* to help promote an understanding of how the condition of women in Italian history had been fixed in popular culture. The *stornelli* were seen as key to unlocking the patriarchal hold on the female imagination.

This dual interest in folklore and feminist ideology was embodied in the work of the Piedmontese anthropologist and professor of Sanskrit, Angelo de Gubernatis (1840–1913).[48] De Gubernatis was well known to the Macchiaioli, especially to Diego Martelli and Signorini, who wrote for the *Rivista Europea*. De Gubernatis' thought gives us some insight into the feminist ferment of the 1860s and its influence on the Macchiaioli. Martelli was most likely a prime link between the feminists and the Macchiaioli. His mother, Ernesta, was a strong personality quite open to feminist ideas and social reform. Raised by her distinguished maternal aunt, Quirina Mocenni Magiotti, an unusually cultured and forthright woman who supported the early Risorgimento heroes, Ernesta was a warm friend of Foscolo, Capponi, Pellico, and Mazzini; this last an ardent champion, as we have seen, of female emancipation. Thus Martelli and his friends were probably in close touch with feminist activity stimulated by the Risorgimento, especially as filtered through the work of Belgioioso and Mazzini.

The Risorgimento proved to be a stimulus to women's awareness of the need for a change; its idea of cohesion of all social groups led to a critique of the traditional female role of "spose e madri" as the exclusive destiny of women. It encouraged the idea of an active collaboration of the sexes to create the new nation. For most of its male leaders, Risorgimento in part stood for the "rehabilitation" of women, and this meant primarily full educational and professional opportunities. Both Mazzinian and Catholic liberals could agree on this. But Italian women also made their political potential felt by participating in large numbers in

the Milan uprising of 1848, and their large turnout in the squares of Florence on April 27, 1859 helped insure the success of the "pacific revolution."

LEGA AND SOCIAL ISSUES

Returning now to Lega, we find that his radicalism was nurtured by Mazzinian ideals. A Tuscan volunteer in 1848, he painted a solemn portrait of Garibaldi shortly after the fall of the Roman Republic the following year (fig. 7.20). One of Lega's closest friends in Modigliana was the Mazzinian priest Don Giovanni Verità, whose likeness he painted at least twice (fig. 7.21). Verità had joined Giovine Italia early on and was one of Garibaldi's most ardent supporters among the clergy. It was he who helped engineer Garibaldi's escape from the French and Austrians during the retreat from Rome in 1849; this parish priest was a critical link in the chain as Garibaldi was passed from one farm to the next.

After the fall of Rome, Lega became fiercely anti-French, even resisting the lure of the Barbizon School and Courbet because of his patriotism. But in 1859 his political position changed, and like most of the other Macchiaioli (and the middle classes in general) he joined the ranks of those who favored union with Piedmont. Here he may also have taken his cue from the moderate shift of his friend Verità.[49] Nevertheless, he remained a faithful partisan of Mazzini to the end; one of his most moving paintings is the deathbed portrait of the great patriot, *Mazzini morente* (Giuseppe Mazzini on His Deathbed, 1873; fig. 7.22).

After a long illness, Mazzini died on March 10, 1872 in Pisa in the house of Giannetta Nathan Rosselli, where he had been nursed by Rosselli and her mother, Sara Levi Nathan. Immediately upon receiving the news, Lega rushed to Pisa to make sketches for a picture of the dying patriot. Consistent with Macchiaioli Realism, Lega does not glorify Mazzini with melodramatic effects or religious transfiguration, but shows him in an evenly lit room with his head propped up and enveloped by a plain pillow and lying on his side facing front, as if seen by a bedside visitor (fig. 7.23).[50] The attention to the texture and pattern of the blanket wrapped in heavy folds around Mazzini and the ordinary setting minimize dramatization yet retain something of the man's spartan simplicity. What we are left with is the profound impression of death as the ultimate leveler, the common denominator of that humanity for which Mazzini labored so intensely. Despite the unsentimentalized presentation of the great enemy of the Church and its rejection of secular hagiography, the

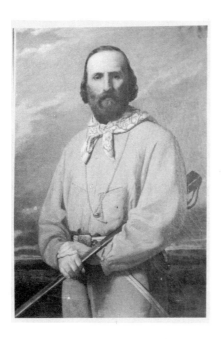

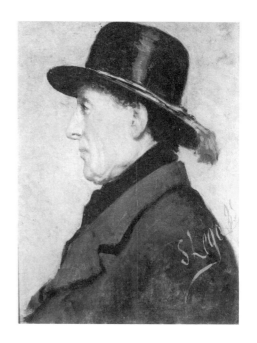

7.20 Lega, *Portrait of Garibaldi*, ca. 1850

7.21 Lega, *Don Giovanni Verità*, 1885

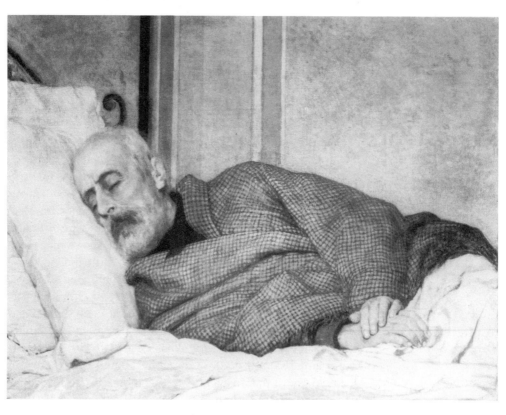

7.22 Lega, *Giuseppe Mazzini on His Deathbed*, 1873

7.23 Lega, *Giuseppe Mazzini on His Deathbed*, detail

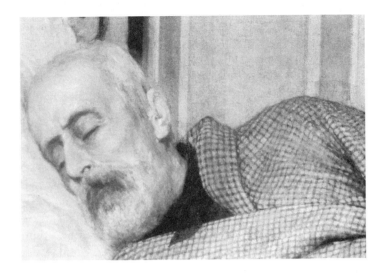

portrait's hushed veneration manages to inspire the kind of ironic comment intoned by Alberto Mario at the conclusion of his eulogy for the patriot: "Mazzini was a saint."[51]

Following the completion and exhibition of the portrait in 1873, Lega suffered severe depression. His repudiation of hagiolatry (Martelli claimed that the public wanted to see an apotheosis) failed to generate interest in Italy, and the death of Mazzini signified the disappearance of Lega's youthful ideals. The painter now turned his attention to the international scene, attesting to his desire to exploit Mazzini's marketability outside his native land as well as to his sense of solidarity with the wider community of Risorgimento sympathizers. Knowing of the abundance of fellow-feeling for Mazzini in England, Lega wrote in February 1874 to the British poet Algernon Charles Swinburne inquiring about the possibility of an exhibition and sale of the portrait in London. Swinburne, who had dedicated his Risorgimento poems "A Song of Italy" (1867) and "Songs Before Sunrise" (1871) to Mazzini, had written soon after hearing the news of his death, "I have lost the man whom I most loved and honoured of all men on earth." Apologizing to Lega, however, for his lack of business experience, Swinburne replied that he would pass on the request to William Michael Rossetti and Emilia Venturi, two loyal Mazzinians more capable of handling the affair. But judging from Swinburne's subsequent letter of March 1, 1874 to Rossetti, it appears that both Rossetti and Venturi suspected Lega's motives for what Swinburne referred to as the painter's "speculation." And there the matter rested. The exchange reveals prior contacts between the Macchiaioli and the Pre-Raphaelite circle, pointing to previously shared political as well as aesthetic aims. This rejection from the

English at this particular time (the work eventually wound up in England before the turn of the century) must have further wounded Lega and reinforced his sense of loss.[52]

In the earlier period between the second war of independence and the opening of the Italian National Exposition of 1861, Lega emulated his Macchiaioli colleagues in the production of military images. He even entered the Ricasoli competitions with his *Il general Garibaldi a Varese nella gloriosa giornata del 26 maggio* (General Garibaldi at Varese on the Glorious Day of May 26; 1859–60), depicting the victory of Garibaldi's Sharpshooters over the Austrians near Lake Maggiore in 1859. That day nearly the entire population of Varese came out to cheer Garibaldi when he addressed the crowd from the balcony of the town hall. Lega won a first prize for his picture, marking his transition to more moderate politics. Between 1859 and 1861 he executed several patriotic military paintings based on episodes of the 1859 wars, one of which—the *Bersaglieri's Ambush*—was shown at the exposition that year (figs. 7.24, 7.25). According to his own testimony, this series, forged out of Risorgimento travail, signaled his breakthrough period.

One clue to Lega's transition is his special commission to paint the four lunettes in the Oratory of the Madonna del Cantone in his hometown of Modigliana between the years 1858 and 1863 (figs. 7.26–7.29).[53] The four subjects of the lunettes bracket the critical years of the Risorgimento, and the content of the last example is more radically painted than the first. They ostensibly refer to calamitous episodes in the history of Modigliana and its surroundings which were miraculously preserved by the divine intervention of the Virgin. Yet it could not have escaped anyone's attention that the catastrophic themes of *Pestilence* (1858), *Famine* (1858), *Earthquake* (1863), and *War* (1863), figuratively and literally alluded to the turbulent years of violent upheaval in the period of their execution. All four works are naturalistically painted, especially evident in the physiognomies of the victims (the prostrate woman in *Famine* looks like a clinical case study of madness), but the last two demonstrate a more profound preoccupation with the physical environment. *Pestilence* and *Famine* are built around figures that are foregrounded and projected bigger than life, with women portrayed as the principal victims. The upward gaze of the woman imploring heaven with her outstretched arms, however, is a far cry from the rolling eyeballs of baroque sentimentality, and even suggests a kind of cynical frustration that Lega managed to smuggle into his scenario.

War is set in the time of the Renaissance, but the photographic naturalism of the landscape, the urban perspectives, and street ac-

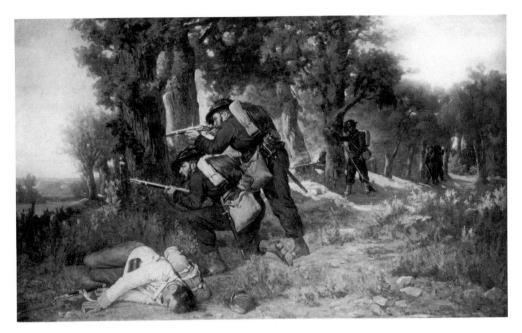

7.24 Lega, *The Bersaglieri's Ambush*, 1861

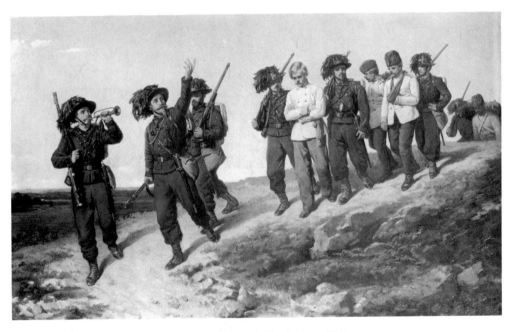

7.25 Lega, *Bersaglieri Leading Prisoners*, 1861

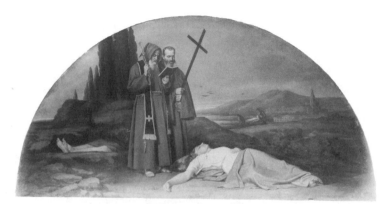

7.26 Lega, *Pestilence*,
1858

7.27 Lega, *Famine*, 1858

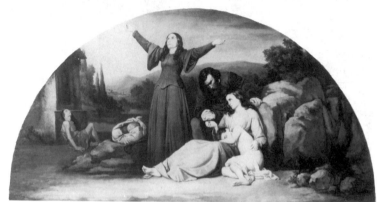

7.28 Lega, *Earthquake*,
1858

7.29 Lega, *War*, 1858

tion convey the atmosphere of a Garibaldi campaign. The scrupulously drawn rooftop figures hurtling down destruction on their enemies below might have been taken from the street fighting in Sicily. Lega echoed Fattori's ingenious conceit of the *Garibaldi at Palermo* in stopping fallen debris in midair, creating a sense of progressive motion that marks Macchiaioli time. In addition, the participation of the townspeople in their own defense hints that collective action itself helps overcome catastrophic occurrences. *Earthquake* depicts a mountainous terrain also reminiscent of Sicily where seismic activity is ongoing and violent, and the striking resemblance of the bearded male protagonist to Garibaldi may yet bear further allusions to the Sicilian campaign. By any gauge, Lega's concatenation of horrors all point to contemporary events, signaling that Providence, Nature and human beings conspire to bring about destruction on earth. Perhaps it is this inherent pessimism of Lega's program—easily interpreted to imply that earthly agencies alone do not remedy catastrophe—that explains why the local Church authorities permitted him to carry out the commission.

Lega's subsequent testimony reveals the close links between his aesthetic development and the events of the Risorgimento. He recalled his "conversion" following the completion of the first two lunettes:

> Since I had never painted landscape, when the lunettes were completed, I visited the countryside with some friends to make studies. I felt within me an impression, as though transported into a new world of art. It was 1859. With the outbreak of war, I occupied myself with making battle pictures. . . . These pictures, I believe, signaled a complete departure from the academic styles. There I was, beginning to do what I felt, what I wanted to do, and what I understood.[54]

In this striking passage Lega informs us that his natural feeling and response to nature were fueled by a patriotism that expressed itself both in the subject and in the rejection of foreign-imposed styles.

It was in 1861 that Lega first met Spirito Batelli, who had inherited from his father a major publishing and printing establishment.[55] Batelli was a liberal supporter of the Ricasoli government, and he and Lega immediately hit it off. Concerned about the health of his daughters, Batelli had moved just outside the city to Piagentina, near the Via Aretina in the southeast, along the banks of the river Affrico, a tributary of the Arno. Lega developed a close relationship with the family and by 1865 had moved in with

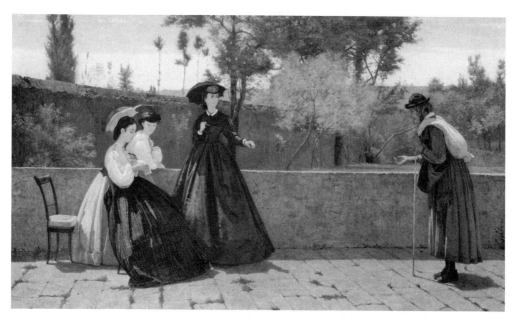

7.30 Lega, *Charity,* 1864

them. Later, Batelli's house would become a sanctuary and meet-ing place for several of the Macchiaioli, including Signorini, Ser-nesi, Abbati, and Borrani.

In the mid-1860s the family was beset with personal torments. Batelli's wife had died in 1863, his mother in 1865. The eldest daughter, Virginia, was separated from her husband, and the youngest, Maria Delfina, always in delicate health, was to die pre-maturely in 1867. Lega brought both his compassion and ad-vanced social perspective to his experience with the Batelli family during these difficult years; the result was a series of penetrating glimpses of intimate family life during the Risorgimento period.

L'elemosina (Charity, 1864; fig. 7.30) takes us into the enclosed garden of the Batelli villa, where an elderly female beggar con-fronts the two sisters and their female friend, who is shown stand-ing against the low wall of the terrace. The old woman holds out her hand to receive alms from the friend, while the two sisters preoccupy themselves with a newspaper. Lega has visually empha-sized the class differences between the beggar and the three young women, not only by their dress but also—using the typical Mac-chiaioli panoramic effect—by stationing the old woman at the far right and the three younger women at a considerable distance from her on the left. The beggar "keeps her place" while accosting her young hostesses, and they in turn maintain social distance either by ignoring her or making little effort to reach out to her.

At the same time, the three seem to accept her intrusion calmly and she maintains her dignity. The mendicant clearly expects to receive something, and her demeanor is neither threatening nor aggressive.

There was a group of beggars in Tuscany who supplemented their regular means of survival by collecting charity.[56] Throughout the plains through which the Arno winds there issued the cry of both sexes and of every age: "Datemi qualche cosa! ho fame, ho tanto fame! Datemi una piccola moneta, per l'amore della sanctissima Vergine!" ("Give me something! I am hungry, so very hungry! Give me a little money for the love of the Blessed Virgin!") Most of these beggars were rural cast-offs, victims of the failings of the mezzadria system, the unexpected vine disease, the burdensome land-tax, or the sale of the land to the new breed of gentleman farmer more concerned with efficiency than with sustaining at a loss the mezzadri who may have lived on the land for several generations.

Peasant women, whose husbands cultivated a small plot of land in the mezzadria system, regularly went around seeking monetary and other kinds of donations. Indeed, since the mezzadria system meant that families almost always lived on the threshold of pauperism, it was considered good politics to engage in these acts of paternalism on a regular basis. Thus almsgiving in the Tuscan countryside had something of a regularity and fixed schedule, in some cases certain days of the week were set aside for alms-giving. Most villas had one or two days in the week when alms were distributed to all who came and asked, usually Monday and Thursday at 10:00 A.M. This not only had the sanction of the Church, but it clearly contributed to sustaining the social system and postponing real social reform. Charity was the one form of redistribution of wealth that the Tuscan-Christian tradition promoted.

The elderly beggar in Lega's painting is clearly of this category; she most likely worked on one of the *poderi* owned by Batelli. While he did not own a large tract of land, Batelli employed a number of *contadini* who lived in their own houses with attached plots of land. Lega is finely attuned to this confrontation of two generations of women and two different social classes. The rich guest extends her hand toward the beggar in a parsimonious gesture; almsgiving is still not an occasion for open generosity. It is done out of duty rather than love, which is why the elderly woman expects it. Lega's work documents a moment in Tuscan life when rhetoric about liberty and justice applied to only a small portion of society who could use it to its advantage. And he envisions this social confrontation in a feminine context; the men-

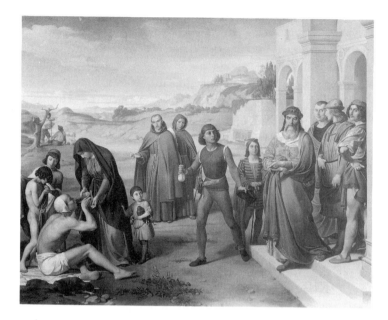

7.31 Mussini, *Almsgiving according to Evangelical Charity,* 1844

dicant searching for castoff clothing for herself or money for her family is allowed to intrude in the intimate space of upper-class women.

Lega's interpretation of the subject of charity becomes clearer if we contrast it with a work on a similar subject by his teacher, Luigi Mussini, *L'elemosina secondo la carità evangelica e secondo la mondana ostentazione* (Almsgiving According to Evangelical Charity and According to Worldly Ostentation; fig. 7.31).[57] Steeped in the religious sentiment of trecento and quattrocento art, Mussini rejected neoclassicism in favor of a Christian imagery capable of inspiring the same kind of piety he observed in the indigenous Italian painting. His allegorical treatment of almsgiving dispenses charity from on high as a religious duty imposed on the rich. Although he also suggests that charity has a meretricious component related to worldly prestige and power, the actual act itself takes place under the divine demand of those who have to help those of lesser means.

Mussini was a curious combination of religious conservative and political progressive, who enlisted with his pupil in the Tuscan volunteers and participated in the campaigns of 1848 and 1849. His love of the trecento and quattrocento was predicated on his celebration of the national school and his rejection of neoclassicism as the product of foreign-dominated academies. But the anticlericalism of the younger generation discomfited him, and his representations remained rooted in the conservative ideology of

the German Nazarenes who also took the Italian trecento and quattrocento artists as their point of departure. The Macchiaioli secularized the early Italian "primitives," assimilating them for their national heritage and stressing their simplicity and sincerity, but divesting them of their religious significations.

Lega shared the admiration of his teacher for the older Italian painters, evident in his rigid profile views and mural-like formats. But at the same time he deliberately secularized their stylistic traits, bringing them up to date in the light of contemporary social and political life and scientific innovation. Lega's theme of almsgiving is unrelated to churchly charity although it retains "Christian" overtones, but occurs within the framework of social relations in the countryside. He gets right to the heart of the economic system itself and challenges its assumptions by showing us how it works. He needs no allegorical justification for he wishes to understand the material basis of charity and its function in preserving the status quo.

Lega's *Il canto dello stornello* (Singing the Stornello, 1867; fig. 7.32) moves back into the interior, into a space and mood reminiscent of the sanctuary in Borrani's *The Seamstresses of the Red Shirts*. There is no air of sadness here; the three women are bound together through a folk song whose words ring out in declaration of their togetherness. The woman standing in the center fingers her chin awkwardly as she simultaneously sings and contemplates the lyrics. The woman seated at the piano also intones the words but concentrates on hitting the right keys. The whole work has the gravity of a religious rite, and when combined with the monumental figures and silhouetted profiles brings to mind the works of Piero della Francesca (fig. 7.33). Martelli observed that Lega's ingenious contours could be compared with those of the "quattrocento fathers of art."[58] In the insightful memoirs Martelli and Signorini wrote on their friend, Signorini described how Lega's nationalist aspirations inspired the work:

> To exemplify his commitment to his program to produce an art whose sincere interpretation of authentic reality would, without plagiarizing Pre-Raphaelite ideas, hark back to our own quattrocento painters and extend their wholesome tradition, no longer with the spiritual sentiment of their time, but with the secular humanist sentiment of our epoch, he painted in his largest canvas, *Il Canto dello stornello,* three young women, two standing and one seated at the pianoforte, who plays and sings together with her dear friends.[59]

7.32 Lega, *Singing the Stornello*, 1867

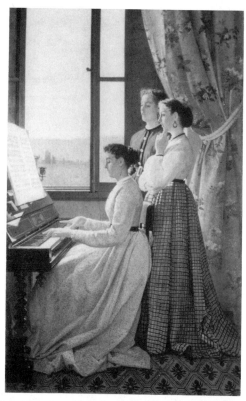

7.33 Della Francesca, *The Discovery and the Verification of the True Cross*, ca. 1452–57

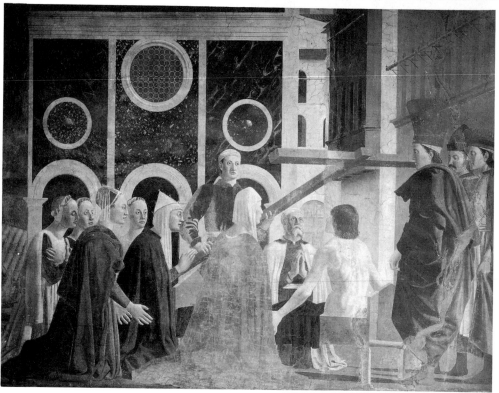

In the male-less space, the women neither pose nor behave self-consciously but use their precious leisure time to be together in a meaningful way. Their bodies press close together and they sing in harmony, their lips parted almost identically. The ritualistic harmony is a metaphor for national unity and the new female promised by the Risorgimento.

As indicated previously, the *stornello* was a folk song that often recounted the status of women in the past. Folk songs helped shape the social attitudes of children and adolescents, showing them the time-honored path to adulthood, courtship, and marriage. They allowed the singers to express their feelings through a conventional form that did not cause embarrassment. *Stornelli* often consisted in an improvised defiance suited to the company, ending with some kind of refrain or chorus which the group sang in response. It is this exchange, and its uniform metrical system, that make the *stornello* unique. Lega shows us this exchange in his painting, the moment of the refrain when the group answers the first singer. Alessandro Falassi, who has written brilliantly on Tuscan folk traditions in his *Folklore by the Fireside,* shows the wide variety of *stornello* themes and the ways in which they encoded the rebellious ideas of the younger generation.[60] For example, referring to someone not favored by a mother, a young woman might sing:

> I want a husband of my own choice
> Because it's me who has to be with him, not her.

Other unorthodox songs threatened escape or a marriage "in the woods without a priest." Sometimes the woman would chide the king for taking the country's youth:

> Vittorio Emanuele, what are you doing?
> You want all the best of the youth,
> And what will we do with the old ones?

During the Risorgimento *stornelli* took on patriotic sentiments, altering the character of the Tuscan folk song. One of the best known was the one that followed the Tuscan volunteers as they marched to the field of battle when the cause of Italian unity hung in the balance:

> Farewell, farewell, my fair one!
> The army goes on its way,
> If I did not march with it,
> I would be a coward.[61]

While it is tempting to conjecture that the women in Lega's painting sing a patriotic *stornello,* the precise nature of their song is less important than the way they are portrayed singing it.

This is no Pre-Raphaelite morality play or Impressionist moment of carefree abandon; it is a vision of Italian femininity on the threshold of independence. The three women stand by an open window which looks out to the distant fields and hills—a contrast between nature and the civilized refinement of the impeccably groomed women and the fashionable interior. The precise detail of the costumes, the carpeting, the piano, and the sheet music suggest a distinct photographic source, and reinforce the contrast between the room and the fields. The bright, clear light that streams in dissolves the membranous wall separating inner and outer realms, and suggests future possibilities. The private but exclusive space they command at present expands into the wild and potentially hostile realm beyond.

Lega's *Il Pergolato* (The Trellis, 1868; fig. 7.34) is set in a typical villa garden with a trellis walk. The long pergola formed the shady arbor that offered respite from the afternoon heat and was the place where hosts and their guests took refreshments. The pergola was the symbolic focus of villa life, the symbol of leisure; the real labor in the sun was left to the peasants. The dynamic between work and leisure is the dominant motif in Lega's painting. The central figure under the arbor turns her head at the approach of the young female servant who strides in from the right carrying a pot of coffee. More precisely she carries *una caffettiera napoletana,* a favorite utensil of the period and part of the daily ritual of the leisure class. The mistress's abrupt reaction to the servant is emphasized by the profile silhouette of her body and frontally turned head. This establishes an unusual tension, reinforced by the arrangement of the trellises and the low wall on which the central woman sits. The composition follows a step-like pattern, echoed by the disposition of the women. The tension between the hostess and her domestic is as much social as it is formal; a gap is established between the classes. The upper-class woman's facial expression, with its mingled expectation and self-consciousness, is countered by the confident and self-contained look and posture of the servant. Indeed, the servant's bearing is as regal as that of her mistress, and Lega carefully aligns their heads at the same level.

Again, the general compositional movement carries the social theme; the women are organized around the angular pergola structure leading to the approaching servant and then back again along the diagonal leading past the mother and daughter into the field beyond. Lega would seem to be preoccupied with the intergenerational transmission of political values in the social relations

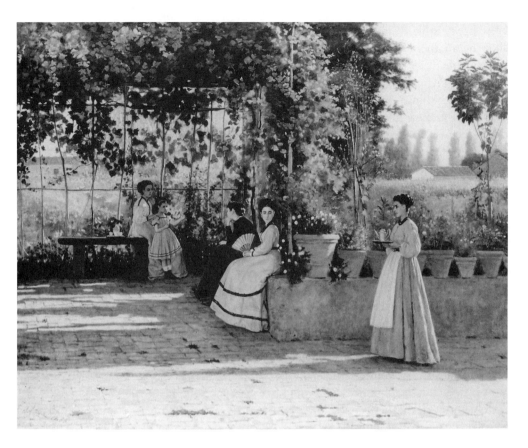

7.34 Lega, *The Trellis,* 1868

he establishes. The child motif, which became increasingly impor-
tant to Lega in the next decade, is crucial here as a sign of political
socialization and metaphor for Italy's future. Research has shown
that Risorgimento democrats were generally reared in families
with a progressive political tradition. The Risorgimento's fore-
most spokesperson for women's rights, for example, Salvatore
Morelli, emphasized the influence of his mother on his ideas.[62]
Thus I see the path from the trellis, the barest of thresholds be-
tween villa and field, metaphorically following along the social
trajectory of emancipation and equality promised by the Risorgi-
mento. Lega, however, consistent with Macchiaioli verism, ad-
vances this idea without flourish or fanfare, subtly incorporating
it into a scene of an everyday Tuscan upper-class life.

Lega's *La visita* (The Visit, 1868; fig. 7.35) struck Cecioni
as an intimate expression of Tuscan life. He emphasized Lega's
characterization of the culture and physical environment in and
around Florence, another affirmation of the close connection be-

tween Macchiaioli landscapes and national life. In this case, however, Lega ruthlessly dissects the formality of bourgeois life by showing a rather chilly greeting of visiting friends. Certainly the scene would differ little from similar ones in Victorian London or pre-Freud Vienna, but Lega puts this chill into his treatment of the figures and into the landscape itself. The hostess greets twin sisters on vacation from school who line up mechanically to receive their kiss on the cheek, while their mother trails behind and looms almost threateningly in the background. The gray, overcast light and barren trees suggest a time in late autumn, and the melancholy evoked by the landscape resonates with the cool reception. The rigidity of the sisters under the ever-watchful eyes of their mother underscores the type of control exerted over women in nineteenth-century Italian society.

This control is the theme of Lega's satirical *I promessi sposi* (The Betrothed, 1869; fig. 7.36), exhibited at the 1869 Promotrice in Florence. Executed in the Macchiaioli predella-panorama format, it shows a betrothed couple strolling arm-in-arm across a field while a female relative trails closely behind. Chaperons were a fact of everyday life, and no unmarried woman left home without one. Any young woman who walked out with her betrothed unaccompanied by a duenna would have been the subject of much comment by watchful neighbors. A girl could not walk with the boy alone without risk to her reputation; a powerful escort of sisters or friends stayed by their side whenever they promenaded or talked together inside. Not even casual flirting was permitted, for mothers, aunts, and duennas made certain that the young woman never evaded strict surveillance.

Lega, however, sees the chaperon custom with a somewhat wry sense of humor. The pair are clearly in love, and their chaperon reacts anxiously to her child who stops to pick flowers, preventing her from keeping up with the betrothed couple. The title was taken from Alessandro Manzoni's popular novel of the same name (1827), and is clearly meant to be satirical. The obstacles presented by Lega's duenna are rather mild to endure compared to the agonizing trials and tribulations of Manzoni's ill-fated pair—even though the story has a happy ending. Lega, too, wished to give his visual narrative a happy ending, and painted the couple in a separate picture minus their assiduous chaperon (fig. 7.37).

During the following decades, Lega's views took a conservative turn, probably corresponding to his disillusionment with the slow progress of the Risorgimento and its failures. It may be recalled that Lega suffered a severe bout of depression attendant upon the death of his hero Mazzini, who himself had expressed grave misgivings about the direction of the new Italy. Lega's later work

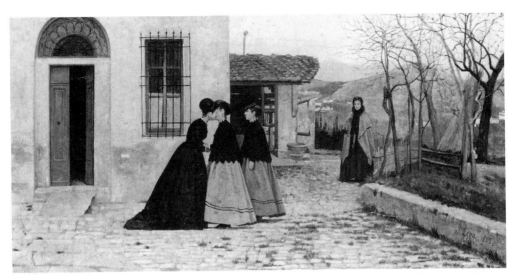

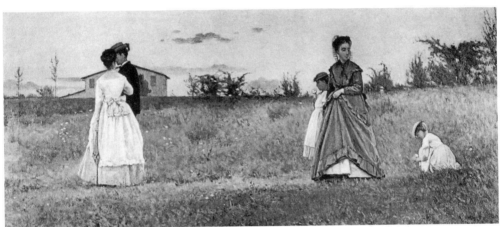

7.35 (*top*) Lega, *The Visit*, 1868

7.36 Lega, *The Betrothed*, 1869

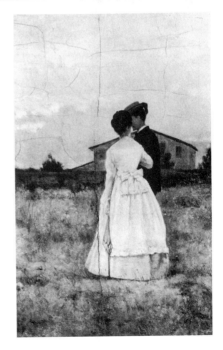

7.37 Lega, *The Betrothed*, 1869

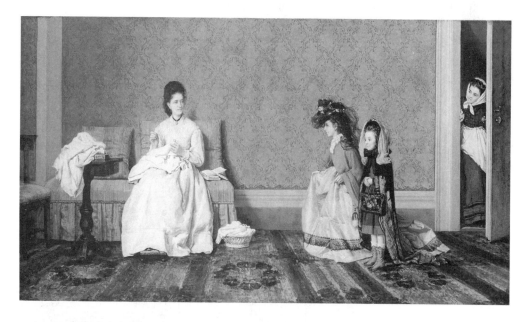

7.38 Lega, *Little Girls Playing as Adults,* 1872

7.39 Lega, *The Grand-mother's Lesson,* ca. 1881

depicts family life as it revolved around childhood, depicting chil-
dren dressing up as adults in play, and mothers and grandmothers
teaching children to read and write (figs. 7.38–7.40). Thus his
social center of gravity shifted to an emphasis on the domestic

7.40 Lega, *The Mother,* ca. 1864

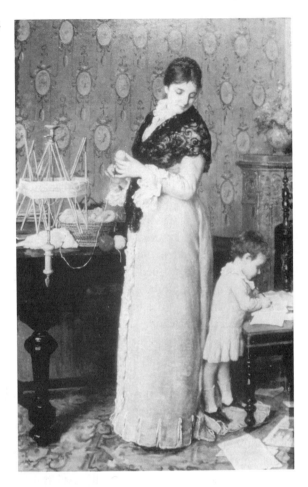

and maternal realms, as if to reinscribe the Risorgimento metaphorically into the development of the younger generations.

A parallel to Lega's emphasis on childhood may be found in the writings of Carlo Lorenzini (1826–1890), better known by his pen name, Collodi. Collodi was one of the regular clients of the Caffè Michelangiolo and a friend to the Macchiaioli (he even entitled one of his writings *Macchiette*—"Little Patches"), especially Lega whom he deeply admired. An enthusiastic supporter of the Risorgimento, he was one of the Tuscan volunteers in 1848 and 1859. He worked for a time on Ricasoli's newspaper and reviewed the competition results with great enthusiasm.[63] However, in the 1860s he, like Lega, Mazzini, and many others, became profoundly disillusioned with the failure of the Piedmontese government to create the society promised by the Risorgimento. Weary of adult promises and compromises, he took it upon himself to appeal to children, to future Italian generations. He began writing children's stories to indoctrinate a younger generation

with the solid virtues and character traits required to build the ideal society.

Collodi's most popular work was *Pinocchio,* first published in serial form in 1880, and then as a book three years later. As everyone knows, Pinocchio tells the story of a mischievous marionette who longs to be a real child but whose bad habits keep him confined to a subhuman state. At last, after demonstrating his "humanity" and virtuous side, he is rewarded by being transformed into a real, live boy. Pinocchio was in fact an allegory of recent Italian history. His successive metamorphoses follow the evolution of the oppressed Italian adult, from a marionette forced to dance to the tune of others, to a donkey (for nineteenth-century Italian caricaturists a favorite symbol of those who followed Church doctrine blindly) forced to submit to malevolent institutions, to an independent and socially responsible personality. Collodi's puppet was formed from a piece of scrub pine (hence the origin of the name) and realized as a human—the symbolic passage from an embryonic macchia to a "finished" production. Whether Walt Disney knew it or not when he produced his popular animated cartoon, Pinocchio was a macchiaiolo metaphor for the incomplete Risorgimento and a prayer for its fulfillment through a new morality.

Lega and Collodi were not the only ones in the Macchiaioli circle to show acute psychological insight into the issues of childhood and the status of women. Borrani's *L'analfabeta* (The Illiterate, 1869; fig. 7.41), like Lega's *The Trellis,* depicts a tense relationship between a woman and her female domestic. The mistress of the household is evidently writing a letter for her servant, who is unable to read or write. The maid appears shy and slightly embarrassed, however, in being dependent on her mistress for what must be an intimate note. She has to expose herself and her thoughts to the mistress, and most likely the person for whom the letter is destined will need someone to read it. Thus the most private feelings and thoughts of a servant often were monitored by the same person who controlled the domestic domain. In a sense, illiterates had their patrons write their letters in exchange for devotion and loyalty. But the effect of this, as Borrani suggests, was a form of humiliation akin to religious confession.

Borrani's theme distances itself from Magni's *Leggitrice* (Girl Reading) which was exhibited in the 1861 National Exhibition and held up as a model the spread of education to all classes and genders. The promise and optimism had vanished when ideals had to be translated into public policy. The high level of illiteracy throughout the peninsula was a major embarrassment to the leaders of the new Italian union.[64] Over 70 percent of men and

7.41 Borrani, *The Illiterate,* 1869

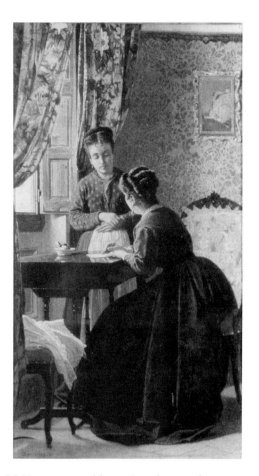

women marrying in 1860 were not able to sign the marriage reg-
istry, while in the period 1861–1870, there were only 63 stu-
dents per 1,000 inhabitants in elementary schools. (As late as
1881, the number of *analfabeti* between the ages of six and twelve
stood at 64.1 percent.)[65] Mazzini had made education one of the
principal planks of his social platform. For him, education had
the potential of making all the people of one nation feel like
brothers and sisters, of taking them out of the isolation and de-
pendence in which they found themselves, of making possible the
full development of their faculties, and of overcoming the condi-
tion of social inferiority in which so many of them were con-
demned to live. This education was to be supplied by the state; it
was to be public, free, and of a uniform high quality. But the
Risorgimento could not live up to Mazzini's dreams. Although
the Casati Law of 1859 required two years' compulsory educa-
tion, parents in rural areas often did not cooperate and teachers
were unavailable. Since funding for primary education fell upon
the village taxpayers they tended to resist it. Therefore, in one

sense Borrani's *Illiterate* points up to the failings of the Risorgi-
mento and the ever-decreasing role of the people in public policy
decisions.

Borrani's painting also introduces an ironic element by way of
the framed picture by Signorini hanging on the wall at the right.
The Macchiaioli often added ironic touches to their paintings, and
Signorini himself wrote in an ironic vein and was an inveterate
punster. Here, however, Borrani uses the Signorini to show group
solidarity and to keep attention focused on the Tuscan milieu that
supported their efforts. Signorini, no less than Lega and Borrani,
approached his themes of women and men in a broad sociological
context. His *La sala delle agitate a S. Bonifacio di Firenze* (The
Mental Ward at San Bonifazio, Florence, 1865; fig. 7.42) is one
of the few shocking pictures of the Macchiaioli, but more shocking
for its subject than for his treatment of it. How far removed it is
on the one hand from the virginal, motherly, reassuring women
in most early nineteenth-century painting and, on the other, from
the fin-de-siècle attacks on the female gender! Signorini shuns the

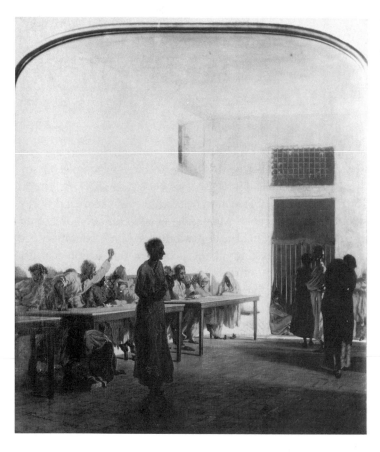

7.42 Telemaco Signorini,
*The Mental Ward at San
Bonifazio*, ca. 1865–70

stereotype of women's social roles and appearances in order to expose some of the results of female oppression in Italian society.

Formerly located at 82 via San Gallo, just north of the Duomo, the modern mental asylum of San Bonifazio was established in 1788 in a late-fourteenth-century building built by Bonifazio Lupi.[66] Under the supervision of Vincenzo Chiarugi, whose groundbreaking text on insanity and its classification gave him international stature,[67] it soon established itself as one of Europe's leading institutions for the mentally ill. In 1818 the pioneer French alienist, Jean-Etienne-Dominique Esquirol, singled it out for special praise in his article on insane asylums in the *Dictionnaire des science médicales*. He admired its hygienic conditions and patient care, but at the same time criticized the practice of chaining some lunatics. Esquirol and others described the interiors of the cells with the lofty ceilings and barred windows high up on the walls, exactly as we see them in Signorini's painting.[68]

Women in the asylum of San Bonifazio occupied the upper story, and the institution had retained its reputation for its advanced facilities and hygienic conditions. Nevertheless, the treatment of the women was still backward as seen in Signorini's picture.[69] Analogous to the central female in *The Venice Ghetto* is the immobile, seemingly transfixed woman in the foreground who established the alienating atmosphere of the asylum. Her estrangement is thrown all the more in relief by the lofty interior space and light walls that isolate the inmates and give a frozen, barren look to the room. Some women stare straight ahead, others are collapsed on the floor or squat in the doorway, while still others sit on wooden benches. Only one woman breaks the spell of torpidity, raising her arm and shouting in defiance of her mental prison. These women are the victims of a patriarchal society which reduced them to nonentities and deprived them of liberty of choice and action, both de facto and de jure.

Statistics indicate an enormous increase in the growth of Italian mental institutions from the mid-1860s through the first decade of the next century.[70] Hence insanity became a major problem for Italian society as elsewhere in the period, and by 1872 the government called upon the most eminent alienists in the kingdom for advice. The history of Italian asylums, however, is filled with scandal due to the unusually cruel treatment of mental patients as a matter of course.[71] The "no restraint" and "open door" treatments, already pioneered in some institutions in England, were debated in this period but not deemed appropriate for Italian institutions. Restraints were still used in Florentine clinics in Signorini's time. Signorini captured the tense atmosphere in the

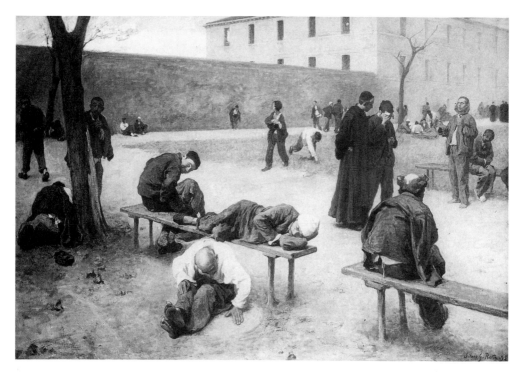

7.43 Rotta, *Clinic*, 1895

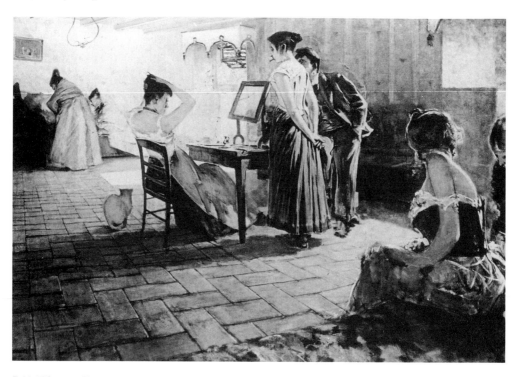

7.44 Telemaco Signorini, *The Morning Toilet*, 1898

asylum without the histrionics of earlier and even later depictions of the insane (fig. 7.43); his work recalls the detachment of Géricault's portraits of monomaniacs which try to portray inner turmoil rather than exterior behavior. Except for one agitated patient in Signorini's scene, who is contained by the pictorial structure and the sedate behavior of the others, Signorini's laid-back composition is consistent with Macchiaioli realism.

It was a period of clamor for penal reform and hygienic and sanitary codes for civil institutions. Hospitals and asylums came under more direct state supervision, but social legislation in this respect was paltry. It is paintings such as Signorini's *Mental Ward;* his *Bagno penale di Portoferraio* (The Portoferraio Penitentiary, 1894), depicting well-dressed inspectors accompanied by prison guards examining inmates in a lineup; and his *La toilette del mattino* (The Morning Toilette, 1898; fig. 7.44), showing the interior of a brothel early in the morning, that attest to the artist's identification with reforms such as those advocated by A. J. B. Parent-Duchâtelet, the French sociologist who devoted himself to a study of Parisian prostitution, and Cesare Lombroso, the famous pioneer of criminal anthropology who served as physician and psychiatrist in Turin's prisons and mental hospitals. Lombroso's empirical methods, exemplified in such writings as *Genius and Madness* (1864) and *The Delinquent Woman, the Prostitute, and the Normal Woman* (1893), contributed to the institutional reforms that were carried out later in the century. (Lombroso's rampant sexism, however, reduced women to a less-than-human status and reinforced the gender bias in Italian society.) Signorini's sociological paintings refer to actual locations, the first to a specific asylum, the second to the main prison on the island of Elba (always a favorite Italian location for captives, including Napoleon and Guerrazzi), and the third to a notorious brothel on the Via Lontan Morti in the Mercato Vecchio section of Florence. Again, the absence of drama and the unpretentious compositions are consistent with the Macchiaioli aesthetic and convey the air of contemporary photography. The women in the brothel fix their hats, chat, and prepare to go shopping or perhaps even return to their homes to live out their "normal" lives.[72] Signorini depicts the prostitutes in such a pure morning light and at such a casual moment that it is hard to believe the work was painted in a period dominated by male fears and fantasies about women, many of which became embodied in popular literature and art as satanic femmes fatales. And it was a far cry from the hysterical anti-woman crusade of the next generation of Italian avant-garde painters, the Futurists, whose founding manifesto of 1909 promised to fight feminism and promote "scorn for women."

EIGHT

A Requiem for the Caffè Michelangiolo

Telemaco Signorini's *Caricaturists and the Caricatured at the Café Michelangiolo,* published in 1893, but based on his earlier series of articles written in 1866–67 is considered the bible of the Macchiaioli movement; in many ways its contents justify the claim.[1] On the surface, it appears to be a gossipy compendium that re-creates the rowdy atmosphere of the popular café located at 41-43 Via Larga (now 21 Via Cavour and housing the "Caffè New York") and documents the behavior of its lively clientele. Interspersed with its anecdotal accounts are biting caricatures of the clients, many of whom were Macchiaioli. Among Signorini's most cherished possessions was Adriano Cecioni's wicked caricature of the group huddled into the Victorian ambience of their favorite hangout (fig. 8.1). Probably done in the late 1860s, the watercolor suggests that the group has lost some of its earlier steam and settled into bourgeois respectability.

As Signorini attempts to conjure up the old animated, debate-filled scenes from the dust of the past, he makes a precious contribution to social history. For underlying its seemingly disjointed narrative—the humorous sallies, songs, and random remarks—is a coherent theme that gives the whole a remarkable structure. From its opening page to its last the booklet incorporates the group's response to the Risorgimento—its promises, its disappointments, and its failures.

When Signorini wrote down his recollections in the 1890s, the

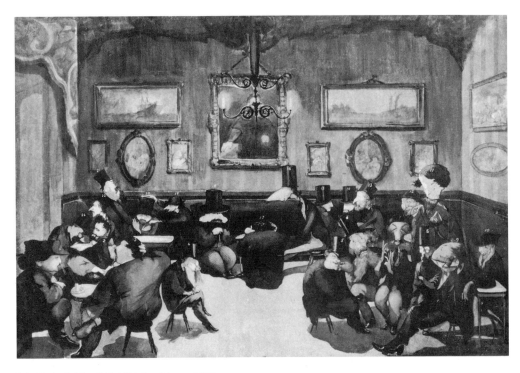

8.1 Cecioni, *The Caffè Michelangiolo*, ca. 1860s

last Risorgimento democrats were retiring from politics or dying. Ironically, some of them were being accused of being "café republicans" *(repubblicani da caffè),* which must have especially rankled the Macchiaioli.[2] They had had the historic task of keeping the embers of the political revolution aglow within the framework of monarchical institutions. Now this task fell to a younger generation whose strategy was affected by the corruption of the system known as *trasformismo*. Under Umberto I, both the left and the right were split into several small factions, all of them ready to barter their support for office. The inherent instability resulted in the absence of a settled parliamentary majority and a succession of short-term, revolving-door cabinets. In principle, *trasformismo* (from *trasformare,* to transform in the sense of party realignment) meant the dissolution of party politics into the workings of national government, in which the most qualified persons for office were to be chosen, regardless of party affiliation. In practice, however, the system gained its working majority by offering inducements to individuals and groups to vote for the government. Those who dissented were bribed into participation by profitable posts, decorations, or profitable inside information. Parliamentary politics became a hotbed of intrigue that rendered it unable to provide solutions to pressing national problems, resulting in the loss of public respect for representative institutions.

The compromise Risorgimento left the new state with many unresolved problems. Post-unified Italy was the creation of a coalition that imposed a relatively advanced political structure on an economically retarded society. This minority deployed a restricted suffrage (a law of 1882 widened the franchise from 600,000 to about 2 million electors out of a population of 30 million) and coercive domestic policy to preserve the new state from the perceived threat from radicals whom they feared might organize the peasant masses to overthrow the constitutional monarchy. While excluding the masses from political participation, the new rulers of Italian government simultaneously embarked on domestic and international policies designed to move the nation into the European mainstream of economic and military power. At home, the government's objective was to aid its entrepreneurial sector to rapidly accumulate capital for investment. This was done at the expense of consumers, who bore the burden of regressive taxes on foodstuffs and other basic items of consumption.

As modern industry and agriculture developed gradually in the 1870s and 1880s, the Italian state began to make a claim for great-nation status. But it needed massive public backing for its policies, and to do so in the face of conspicuous social inequities and a growing working-class militancy, it embarked on a colonial enterprise. It hoped to appeal to the peasantry and to the Roman Catholic church with a program that would involve cheap sources of raw materials and a launching pad for new missionary activities. Italy's efforts to play the game then popular among the other leading European nations proved to be extremely risky to its internal social and political stability.

Signorini's book appeared in 1893, its conception and execution spanning the governments of prime ministers Francesco Crispi (1887–91, 1893–96), Antonio Di Rudinì (1891–92), and Giovanni Giolitti (1892–93).[3] The veteran Crispi, one of the few active surviving Risorgimento democrats and former *garibaldini,* had long since accepted the monarchical principle and claimed to belong to neither Left nor Right. The economic crisis of the late 1880s and early 1890s and the sense of national inferiority in the face of foreign competition stimulated Crispi to embark on a series of colonialist and imperialist ventures counter to the liberal aspirations of the old Risorgimento activists. The political mechanism fell into a shambles: Cavour's carefully engineered parliamentary majority had long since broken down into rival factions, and the radical republicans had lost their steam with Mazzini's death in 1872 and the withdrawal of Garibaldi from active politics. Garibaldi did lend his name to the cause of socialism, which began to take off in the 1880s, but its pressure pushed the moderate Right into chauvinistic policies to shore up its

popular base. There were few heroes to look to for leadership, and the 1880s and early 1890s were marked by a series of unstable ministries, each of which seemed more illiberal and unenlightened than its predecessors.

The corruption of party politics and instability of the government, the sellout of old Risorgimento veterans like Crispi, and the nascent colonialism tainted even the remarkable emergence of the Italian Socialist party (PSI) against all odds in the years 1892–93. It even survived Crispi's ruthless onslaught begun the following year on the pretext that it formed part of a foreign plot against Italian unity. In their late years, the Macchiaioli revealed a deep ambivalence towards socialism: although they agreed with its analysis of the inequities of capitalism, they found its remedies as hopelessly inadequate and as repressive of those of its antagonists.[4] They still hated the social injustice they witnessed, but their nostalgia for the heroes of the independence movement kept them mired in a time warp.

It has already been shown to what extent the Macchiaioli express their growing disillusionment and pessimism in the face of the collapse of their ideals fostered by the Risorgimento enthusiasm. Fattori's personal bitterness manifested itself in a late acrimonious condemnation of all the political parties for their lack of social and humanitarian concerns.[5] He and Uzielli collaborated on the painting of the *Battle of Volturno* around the time Signorini planned his book as an example to inspire the energies of a younger generation. Uzielli certainly spoke for the group when he expressed the hope for a Baron Stein to emerge, as in the case of Prussia after its crushing defeat at Jena, to rescue the nation, someone who could "motivate spirits with unconstrained energy and silent dignity, and with well-thought-out and consistent ideas to heal the nation and establish a fiscally sound and honest administration." Finally, Uzielli affirmed, "we wish only to realize through the energy of future generations the exalted condition for a true and radical regeneration of the new Italy."

Uzielli's paradoxical call for a regeneration of the new Italy signified his gloomy prognosis of the world his peers had fought for. Nevertheless, in the conclusion to his article on his participation in Garibaldi's *Thousand,* he manifested the dream of seeing that spirit come alive again:

> Sometimes in moments of profound distress over the destiny of Italy, I reflect on the wars of independence, of the valor and distinction I witnessed there, and then everything becomes vivid to me, as if I were still standing on the fatal street where Milazzo and Tio Zucconi were gushing blood and crying: "Bullets don't mat-

ter!" And I wish that a multitude of similar heroes would emerge to meet the future trials of the country.[6]

It is this same sense of pessimism and melancholy that underlies Signorini's later reminiscences and which, analogous to Uzielli's narrative, he hopes to overcome through an appeal to a younger generation. Signorini's work in fact winds up confessing to the failure of the moderate liberalism the group espoused in the interests of a united Italy. He begins with an epigraph drawn from Massimo D'Azeglio's autobiography, *I miei ricordi* (Things I Remember, 1867): "Quite often I see at once the ridiculous side of serious matters, and the serious side of ridiculous matters." Signorini uses this citation to justify the caricatural material of his work, as well as to hint at its historical and nostalgic significance. But at the same time this borrowing from D'Azeglio declares a spiritual bond between two generations of intellectuals, united in their dreams for Italian nationhood.

Signorini and his friends admired D'Azeglio for having celebrated the indigenous landscape and having lent support to their aims in *I miei ricordi:*

> We love independence and nationalism, we love Italy; further, the landscape painters all chant together "Rome or death," but when they take up their brushes, the only thing they don't paint is Italy. The magnificent Italian landscape, the glorious light, the rich hues of the sky over our heads and the earth we tread; no one considers these things worthy of being painted. Go to exhibitions and what do we see? A scene from the north of France, imitation of so and so; a seascape at Etretat or Honfleur, imitation of someone else; a heath in Flanders, a wood at Fontainebleau, copied from God knows whom! . . . They prefer a nature without a soul, without character, weak and tempered like a muted violin. For this they renounce Italy, her sky and the beauty which once brought so many enemies into our land, but which today, thank God, brings only friends who never tire of acclaiming it.[7]

Written in the early 1860s, this passage demonstrates the existence of a patriotic landscape ideal, and substantiates the links between the Risorgimento and cultural production. That it was written by a social conservative who wielded immense political power underscores the contradictions inherent in the context in which the ideas of the Macchiaioli unfolded.

An unspoken manifesto is carefully mapped out by Signorini,

beginning with the first page. Like the history of the Macchiaioli movement itself, Signorini's book is grounded in the struggles of the group to forge an aesthetic identity out of their participation in Risorgimento politics. The entire text, spiced with the wisdom of retrospection, is interspersed with memories of the critical episodes and the key actors. As he introduces us to the favorite haunt of the Macchiaioli, Signorini notes that after the restoration of the grand duke in the spring of 1849 the Caffè Michelangiolo "gathered almost all of the painters who had participated in the campaign of Lombardy in 1848 and in the defense of Venice, Bologna, and Rome in 1849." Its fortunes thrived for nearly twenty years, until around 1867, when Signorini wrote his first account of the café for *Il Gazzettino delle Arti del Disegno,* and included the second generation which took part in the Garibaldi and Piedmontese campaigns of 1859–61. These campaigns recur like a leitmotif throughout the booklet, often with a note of pathos when associated with colleagues who have fallen in battle.

Signorini's list of the café's clients reads like a Risorgimento litany: Francesco Domenico Guerrazzi, the romantic novelist and head of the Tuscan government prior to the grand duke's restoration in 1849; Giuseppe Dolfi, the chief organizer of the insurrection of April 27, 1859; and his more reluctant allies Bartolommei and Ricasoli, who were ultimately swept along by his success. Early on, Signorini informs us of the breathtaking episode of April 27 and the flight of the grand duke, and finally of the collaboration of Dolfi and Ricasoli in bringing about union with Piedmont. Signorini informs us later of his own support for annexation; at a performance of Giovanni Niccolini's *Arnaldo da Brescia* in 1860 he distributed pamphlets by Dolfi urging the people to vote for union.

The last section of Signorini's booklet is a sad recounting of the changes in Florence after the National Exposition of 1861, and of the transformation of the city into the capital of Italy four years later. The old gang began to break up, and the café underwent changes, probably in response to the new clientele brought into the city by the change in its national status. Signorini notes that many of the painters, including the De Tivoli, D'Ancona, De Nittis, and Zandomeneghi, were among other things disgusted with politics, and went abroad to Paris and London. Nostalgically, he recalls his dear friends Abbati and Sernesi and others who died in the wars or from tragic circumstances, and by the final pages the echoes of the laughter of other times had faded into moroseness and his mood shifts abruptly from satire and irony to lamentation and regret.

Signorini confesses that these recollections of his friends and their ideals come back to him only at certain moments, especially

during a beautiful autumn morning, or on a balmy spring day, or in a winter mist, or amid the sultry passions and strident song of the harvest-time crickets, when it happens that I climb alone the smiling hills of memories which crown our city; or stroll along the fields and gardens populated with farmhouses and villas, along the banks of the Mugnone or the Arno, the Mensola or the Affrico, and come upon a small grassy area, off to the side and in the shade; then, having put down my old paint box, the faithful custodian of my personal impressions, inseparable companion of my distant voyages and nearby excursions, I lie down on my back next to it, and gazing intently at the profound blue of the heavens, I return with my thoughts to the past, now having become more significant to me than the future! . . . And my entire past unfolds, not only its mad joys and its daring undertakings, but also its profound sadnesses and its infinite vexations.[8]

Suddenly, in this moving passage, the long string of seemingly random recollections and anecdotal accounts come into sharp focus, making meaningful the historical details interspersed throughout the text. What Signorini reveals in this next-to-the-last paragraph is the profound relationship between landscape and the unfolding of the Risorgimento. The landscape impressions are inseparable in his mind from his native Tuscany, and the high points of his life come back to him when he remembers the sites depicted by the Macchiaioli. The passage culminates with the mood of pessimism common to many of the participants in the Risorgimento, but it is compensated for by the positive reminiscences of a time when art and life were inseparable from one's ideals and aspirations.

Signorini's final paragraph evokes the memory of all his friends of the glorious past and concludes with verses from Giacomo Leopardi's autobiographical poem *Le Ricordanze* (Memories, 1829):

> It is left to others
> To pass over the earth today
> And dwell awhile among these hills.[9]

Nevertheless, Signorini holds on to the souvenirs of his youth, the fight for social justice and artistic freedom, the loves and hates, the doubts and hopes, the laughter inspired by caricature, and the tears born of the remembrances of those loved and lost. By closing *Caricaturists* with this romantic evocation of Leopardi, Signorini affirmed an intellectual link to that side of the Risorgimento that

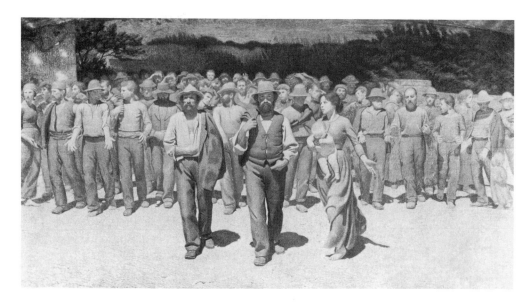

8.2 Da Volpedo, *The Fourth Estate*, 1898–1901

Mazzini relegated to an outworn tradition, but simultaneously willed his memories of collective action to succeeding generations with the hope of keeping the struggle alive.

At the very moment when Signorini was bemoaning his fate, a younger generation of disciples of the Macchiaioli were preparing to make their contributions to socially engaged art. One of them, Giuseppe Pellizza Da Volpedo, had studied in Fattori's studio in Florence during the winter of 1887–88 where he may have met Plinio Nomellini for the first time.[10] Together they helped found Divisionismo, a modernist movement based on a systematic investigation of optical representation—specifically, that unmixed macchie juxtaposed (or "divided") would fuse optically at a distance, resulting in maximum luminosity and fidelity to actual light conditions—as part of a radical social program embracing politics, science and art.

The evolution of Pellizza's signature piece, *Il Quarto Stato*, spans the ten-year period from the publication of *Caricaturisti e Caricaturati* until Signorini's death in 1901, and thus may well have been a response to Signorini's closing statements. Stimulated to action by the deepening economic crisis that affected Italy during the Crispi ministries and the ruthless suppression of strikes, Pellizza joined the nascent socialist movement (the Società Agricolo-Operaia di Mutuo Soccorso in Volpedo, one of the self-help societies that spawned Italian socialism), and projected his monumental painting in which a phalanx of male and female

workers—"intelligent, strong, robust, united"—marches frontally toward the viewer (fig. 8.2). Using the panoramic proportions of the Macchiaioli but replacing the view of the Arno with a human torrent (one of his early titles for the work was *Fiumana* = Stream of People), this symbolic river of humanity flows towards social justice, "overthrowing every obstacle in its path."[11] As in the case of the Macchiaioli, Pellizza's painting reached its apogee at the point of his greatest adherence to radical politics and the maturation of the Italian socialist movement. Now, exactly one hundred years later, as the industrialized world proclaims the death of the Left and yet remains unable to halt its own slide towards millennial chaos, Signorini's closing thoughts and Pellizza's visual rejoinder are still worth pondering.

11. Durbé is not always happy with what he has spawned: see his cautiously respectful critique of my essay for the Wight exhibition: D. Durbé, "Attualità di Fattori," *Giovanni Fattori, Dipinti 1854–1906* (Florence: Centro Mostre di Firenze, 1987), 13–16.

12. D. Durbé, "Significato del 48–49 nello svolgimento dell'arte Fattoriana," *La difesa di Livorno,* numerico unico a cura del Comitato Communale per le celebrazioni del Centenario della Difesa di Livorno, Livorno, 11 May 1949.

13. *Garibaldi. Arte e Storia,* 2 vols. (Florence: Centro Di, 1982).

14. This should not be construed to imply that no exchange took place between Italian and French avant-garde artists. For this interaction see P. Dini, *Dal Caffè Michelangiolo al Caffè Nouvelle Athènes* (Turin, 1986), 15–91.

15. C. M. Lovett, *The Democratic Movement in Italy 1830–1876* (Cambridge, Mass., 1982), 4–5.

16. B. Croce, "Una teoria della macchia," in *Problemi di estetica e contributi all'estetica italiana* (Bari, 1940), 241ff.

17. Ibid., 245.

18. R. Shiff, *Cézanne and the End of Impressionism* (Chicago, 1984), 73.

19. A. W. Salomone, "The *Risorgimento* between Ideology and History: The Political Myth of *Rivoluzione Mancata*," *American History Review* 68 (October 1962): 38–56.

20. A. Gramsci, *Il Risorgimento, Opere* (22 vols.; Turin, 1947 et seq.), 4:81–82, 100–104; idem., *Selections from the Prison Notebooks,* ed. Q. Hoare and G. N. Smith (New York, 1971), 74–76, 98–102.

21. B. Croce, *History of Europe in the Nineteenth Century* (New York, 1933), 225, 253.

22. Gramsci, *Opere,* 4:94–95.

23. N. Broude, *The Macchiaioli: Italian Painters of the Nineteenth Century* (New Haven, 1987), 5–12, 276–83; idem., *World Impressionism: The International Movement, 1860–1920* (New York, 1990), 6–7, 9–34, 170–209.

24. On this question see my exchange with Broude: N. Broude, "The Macchiaioli: Art or History?," *Art Journal* 46 (Summer 1987): 139–41, 143; A. Boime, "The Macchiaioli: Art *and* History," *Arts Magazine* 62 (January 1988): 35–37.

CHAPTER ONE

1. L. Salvatorelli, *The Risorgimento: Thought and Action* (New York, 1970). An important recent work analyzes Italian films to explore the imagined national self growing out of the influence of the Risorgimento on Italian culture including the Macchiaioli. See A. D. Vacche, *The Body in the Mirror* (Princeton, 1992), 105–14, 129.

2. S. B. Clough, *The Economic History of Modern Italy* (New York and London, 1964).

3. *Memorie sulle società segrete dell'Italia meridionale,* trans. A. M. Cavallotti (Rome and Milan, 1904).

4. G. O. Griffith, *Mazzini, Prophet of Modern Europe* (London, 1932); G. Salvemini, *Mazzini* (Stanford, California, 1956).

5. H. R. Marraro, *American Opinion on the Unification of Italy* (New

York, 1969), 78–78; A. Slater, *In Search of Margaret Fuller* (New York, 1978); W. C. Bryant, *Prose Writings,* 2 vols. (New York, 1884), 2: 343–46.

6. G. M. Trevelyn, *Garibaldi's Defence of the Roman Republic (1848–9)* (London, 1949); idem., *Garibaldi and the Thousand (May 1860)* (London, 1948); idem., *Garibaldi and the Making of Italy (June–November 1860)* (London, 1948); D. Mack Smith, *Garibaldi* (London, 1957).

7. *Times* (London), March 24, 1864. See also "A Sketch of Garibaldi," *Times,* July 26, 1859.

8. A. B. Paine, *Th. Nast, His Period and His Pictures* (New York, 1971), 51.

9. H. Tyrell, "Garibaldi in New York," *Century Magazine* 74 (May–October 1907): 174–84.

10. E. Amfitheatrof, *The Children of Columbus* (Boston and Toronto, 1973), 94–100.

11. Marraro, *American Opinion,* 285.

12. H. Nelson Gay. "Lincoln's Offer of a Command To Garibaldi: Light on a Disputed Point of History," *Century Magazine* 75 (November–April 1907–08): 63–74.

13. Trevelyan, *Garibaldi's Defence,* 119. Among the Macchiaioli who painted Garibaldi's portrait or otherwise alluded to him in their work are Borrani, Lega, De Tivoli, Fattori, and Cabianca. For a history of the fascination of Italian artists with Garibaldi, see *Pittura Garibaldina da Fattori a Guttuso,* Galleria Nazionale d'arte moderna (Rome, 1982); for De Tivoli's less well known portrait, see C. Benedicti, "Serafino De Tivoli," *Liburni Civitas* 2 (1929), 146, 149.

14. *The Complete Letters of Vincent van Gogh,* 3 vols. (New York, 1958), 2:617, L. 513.

15. Paine, *Th. Nast,* 45–63.

16. D. Mack Smith, *Victor Emanuel, Cavour, and the Risorgimento* (London, 1971).

17. For Orsini see M. St. John Packe, *Orsini, the Story of a Conspirator* (Boston, 1957).

18. A. Gramsci, *Opere,* 4:73.

CHAPTER TWO

1. An invaluable source for this subject is S. Pinto, *Romanticismo storico* (Florence, 1973).

2. R. Crampini, *Il '59 in Toscana* (Florence, 1958), 172; Giuseppe Cesare Abba, *The Diary of One of Garibaldi's Thousand,* trans. E. R. Vincent (London, 1962), 26, 35–36, 38, 42, 48, 70.

3. G. Lukács, *The Historical Novel,* trans. H. Mitchell and S. Mitchell (Lincoln, Nebr., 1983), 19–30.

4. W. R. Thayer, *The Dawn of Italian Independence* (Boston, 1894), 314, 316.

5. A. Manzoni, "Lettre a M. C. . . . sur l'unité de temps et de lieu dans la tragédie," in *Tutte le opere* (Florence, 1928), 239–79.

6. When Manzoni went to Florence to revise the text of *I promessi sposi,* he compared this action with "rinsing" his rags in the Arno River. This is an apt metaphor for all those who made the pilgrimage to forge a

new Italy with the language of Tuscan rhetoric—verbal and visual. See F. Capelvenere, *Manzoni a Firenze e la "risciacquatura" in Arno* (Florence, 1985).

7. A. Manzoni, *I promessi sposi* (Harmondsworth, 1983), 481.

8. T. Dandolo, *Panorama di Firenze* (Milan, 1863), 153.

9. *Descrizione dell'apparato fatto in Firenze sulla piazza di S. Marco dalla regia Accademia delle belle arti nell'occasione del fausto ritorno in toscana di S. A. I. ER. Il granduca Ferdinando III* (Florence, 1814), 6.

10. "Ingresso di Carlo VIII in Firenze," *La Esposizione italiana del 1861* (Florence), September 15, 1862, 369–70. This was a biweekly paper published by Andrea Bettini and edited by Cesare D'Ancona, a brother of Vito.

11. Of course, Manzoni also wrote drama, and it was a French critic's attack on Manzoni's tragedy *Il conte di Carmagnola* that led to his long discussion of the Aristotelian unities of time and place. See his preface to the play in *Tutte le opere,* 47–52.

12. D. Martelli, *Scritti d'arte,* ed. A. Boschetto (Florence, 1952), 237ff.; T. Signorini, *Caricaturisti e caricaturati al Caffè Michelangiolo,* ed. B. M. Bacci (Florence, 1952), 174–75. Signorini's memory failed him here, however, putting the performance before April 27, 1859, the day of the revolutionary outbreak in Florence.

13. F. D. Guerrazzi, *L'Assedio di Firenze* (Florence, 1932), 743.

14. F. D. Guerrazzi, *Beatrice Cenci: A Historical Novel of the Sixteenth Century,* 2 vols. (New York, 1900), 1:19.

15. Here again, Guerrazzi reveals his conscious "presentism" in the preoccupation with the status of Italian Jewry that becomes central to the anticlerical thrust of the Risorgimento movement. He was caught up in the condition of Jews in his native Livorno, where there was a major Jewish community, and anti-Semitism reared its ugly head. See T. Scappaticci, *Un intellettuale dell'Ottocento romantico: Francesco Domenico Guerrazzi* (Ravenna, 1978), 55–56.

16. Massimo d'Azeglio, *Ettore Fieramosca, or, The Challenge of Barletta. The Struggles of an Italian Against Foreign Invaders and Foreign Protectors* (Boston, 1859), v–vi.

17. Massimo d'Azeglio, *Things I Remember,* trans. E. R. Vincent (London, 1966), 311.

18. Abba, *Diary,* 26. At another point in the fighting, Abba sees Garibaldi's officer Bixio attempt to shield the exposed leader with his horse, which instantly brought to his mind the episode in Guerrazzi's *L'Assedio di Firenze* when Goro da Montebenichi tries to protect the heroic Francesco Ferruccio (ibid., 35–36). At Palermo, a crowd at the door of a bakery recalls bread riots in *I promessi sposi* (ibid., 70).

19. Massimo D'Azeglio, *Florence Betrayed, or, The Last Days of the Republic (Niccolò de' Lapi)* (Boston, 1886), 182, 233.

20. F. Hayez, *Le mie memorie* (Milan, 1890).

21. M. C. Gozzoli and F. Mazzocca, *Hayez* (Milan, 1983), nos. 43, 102, pp. 100–101, 215–218.

22. Hayez influenced the liberal Torinese painter Andrea Gastaldi, whose *Il primo moto del Vespro Siciliano* (The Initial Impulse of the Sicilian Vespers, 1857) similarly fused patriotic sentiments with history painting. See R. Maggio Serra, *Andrea Gastaldi 1826–1889: Un pittore a Torino tra Romanticismo e Realismo* (Turin, 1988), 200, no. 6.

23. Abba, *Diary,* 45.

24. Gozzoli and Mazzocca, *Hayez*, 215. For the earlier version Hayez was asked to incorporate portraits of the patron's entourage in the work including the liberal Pompeo Belgioioso. See Hayez, *Le mie memorie*, 57.

25. See M. Amari, *History of the War of the Sicilian Vespers*, 3 vols. (London, 1850), 1:180ff.

26. See Maggio Serra, *Andrea Gastaldi*, 202, no. 17. A. Zobi, *Cronaca degli avvenimenti d'Italia nel 1859 corredata di documenti per servire alla storia*, 2 vols. (Florence, 1859), 1:739 and note 1. A statue of Pietro Micca was unveiled in 1864 and associated with the Piedmontese action against the Austrians leading to unification. See L. Rocca, ed., *La società promotrice delle belle arti, in Torino. Album dedicato a S. S. R. M. Re Vittorio Emanuele II ed offerto a tutti i benemeriti che contribuirono all'erezione dell'edicifio per le esposizioni di belle arti* (Turin, 1864), 12, 30.

27. This has its parallel in the contemporary novels of the exiled patriot Giovanni Ruffini, whose novel *Doctor Antonio* (first published in English in 1855, with many subsequent editions) makes the eponymous hero—torn between his love for an aristocratic English woman and his commitment to the Italian nationalist movement—say at last: "Lucy, I love you ... But my country has claims on me prior to yours." G. Ruffini, *Doctor Antonio* (Leipzig, 1861), 329.

28. Quoted in *Garibaldi. Arte e Storia*, 1:145.

29. A similar scene was painted by another Neapolitan painter in the same period, the *Episodio risorgimentale sullo sfondo di S. Miniato* by Bernardo Celentano. See *Il Secondo '800 Italiano: Le poetiche del vero*, ed. R. Barilli (Milan, 1988), 123.

30. V. Durbé and D. Durbé, *La giovinezza di Fattori* (Rome, 1980), 305.

31. Dandolo, *Panorama di Firenze*, 179ff., 276ff., 345ff.

32. A. de Demidoff, *Voyage dans la Russie meridionale et la Crimée par la Hongrie, la Valachie et la Moldavie* (Paris, 1841), i–ii, v, 5, 16, 22, 62. This book is illustrated by Auguste Raffet, Demidov's favorite artist who accompanied him on the voyage in Crimea. Raffet's military drawings, in abundance at the villa of San Donato, would have an influence on the work of the Macchiaiolo Giovanni Fattori. See V. Durbé and D. Durbé, *La giovinezza di Fattori*, 244–57.

33. Signorini's father had been commissioned by Demidov to decorate the villa with frescoes, a relationship that may later have facilitated his entry into the Demidov circle. See Signorini, *Caricaturisti e Caricaturati*, 139–40.

34. See G. Matteucci, *Cristiano Banti* (Genoa, 1982), 50–51. The work influenced the *Ascanio Sforza* of Federico Faruffini, a Hayez disciple who was soon to undergo a Risorgimento phase with his series on the legendary Cairoli brothers who fought with Garibaldi. See A. Finocchi, *Federico Faruffini, un pittore tra Romanticismo e Realismo* (Sesto San Giovanni, 1989), 13, 51–52, no. 75; 77–85, nos. 124–34.

35. Yorick, *Guide Bettini. Viaggio attraverso l'esposizione italiana del 1861* (Florence, 1861), 181, where the author states that Cabianca's *I novellieri italiani* would have been a beautiful picture, "if the artist had taken the trouble to finish it." Another prominent critic claimed that Cabianca's painting is "nothing more than a simple lay-in (*abozzo*)." See P. Selvatico, *Arte ed artisti: Studi e racconti* (Padua, 1863), 51.

36. For the full story see H. Acton, *The Pazzi Conspiracy: The Plot Against the Medici* (London, 1979).

37. D. Mack Smith, *Italy and its Monarchy* (New Haven, 1989), 20.

38. V. Gioberti, *Del Bello* (Milan, 1845). I am using the translated edition of 1860: *Essay on the Beautiful, etc., or, Elements of Aesthetic Philosophy,* trans. E. Thomas (London, 1860), 127–28.

39. I Nievo, *The Castle of Fratta,* trans. L. F. Edwards (Boston, 1958).

40. I Nievo, *Gli amori Garibaldini* (Milan, n.d.).

41. For Fucini and Fattori see R. Fucini, *Acqua passata e foglie al vento* (Florence, 1935), 157–62; L. Pescetti, "Fucini, Fattori e Marradi," *Liburni civitas,* vol. 12 (1939), 185–89. For Fucini's relationship with the Macchiaioli generally and his important collection of their work, see E. Matucci and P. B. Lande, eds., *I Macchiaioli di Renato Fucini* (Florence, 1985).

42. A. Alexander, *Giovanni Verga, A Great Writer and His World* (London, 1972).

43. G. Cecchetti, *Giovanni Verga* (Boston, 1978), 12–13.

44. G. Verga, *I Carbonari della montagna,* ed. R. Verdirame, vol. 1 in *Edizione nazionale delle opere di Giovanni Verga* (22 vols.; Florence, 1988), 5.

CHAPTER THREE

1. Although the original establishment of the Accademia delle Belle Arti long predated Austrian rule, its modern reconstitution, pedagogical program, and centralization had been carried out under the auspices of Grand Duke Pietro Leopoldo I in 1784. See L. Biagi, *L'Accademia di belle arti di Firenze* (Florence, 1941), 19–26; C. I. Cavallucci, *Notizie storiche intorno alla R. Accademia delle arti del disegno in Firenze* (Florence, 1873), 53–61. In the end, it was the "Austrian Connection" that colored every act of Leopoldo II's reign and made even his most benign gestures suspect to the Tuscan populace. See A. Zobi, *Cronaca degli avvenimenti d'Italia nel 1859 corredata di documenti per servire alla storia,* 2 vols. (Florence, 1859), 1:7–9, 12–14, 113, 121–22, 157; M. Carletti, *Quattro mesi di storia toscana dal 27 aprile al 27 agosto 1859* (Florence, 1859), 11–12, 36.

2. This refers to Carlo Morelli's portrait of 1840; see *Libro terzo degli Atti della 1° classe dell'I. e R. Academia delle Belle Arti di Firenzi* (Florence, 1840), nonpaginated, under "Adunanza pubblica de' 20 septembre 1840," and marginal heading "Esposizione dei quadri nel 1840." Another embarrassment must have been the pomp and vulgar ostentation of the Academy's reception for Leopoldo II's father when he returned to assume the Tuscan throne after the fall of the Napoleonic machine. See *Descrizione dell'apparato fatto in Firenze sulla piazza di S. Marco dalla regia Accademia delle belle arti nell'occasione del fausto ritorno in Toscana di S. A. I. ER. Il granduca Ferdinando III* (Florence, 1814), 3–6.

3. See *Statuto della R. Accademia delle arti del disegno di Firenze* (Florence, 1860); *Statuti e regolamento disciplinare della R. Accademia di Belle Arti in Milano, approvati col R. decreto 3 novembre 1860* (Milan, 1860). The Macchiaioli were abetted by the reformist mood in the academies generally in this period: see A. Bruneri, who stated that an academy should be organized like a "republic" (*Sulle desiderabili riforme dell' Accademia Albertina di belle arti* [Turin, 1854], 5).

4. E. Vedder, *The Digressions of V.* (Boston and New York, 1910), 149–51, 154–56, 163, 165–66, 171. Vedder also discusses a caricatur-

ist who never quit his subject "until he had taken from his poor victim every trace of self-esteem." This must be Angiolo Tricca, the close associate of the Macchiaioli.

5. For the school of Posillipo see R. Causa, *La Scuola di Posillipo* (Milan, 1967).

6. *Cultura neoclassica e romantica nella toscana granducale. Sfortuna dell'Accademia* (Florence: Centro Di, 1972), nos. 6–7.

7. *Catalogo delle opere ammesse nelle sale della Società promotrice delle belle arti in Firenze per la solenne esposizione dell'anno 1853* (Florence, 1853), 3.

8. D. Durbé, *La Firenze dei Macchiaioli: un mondo scomparso* (Florence, 1985), 22–24.

9. It could have been otherwise: Mark Twain lived at the Villa Viviani at Settignano and claimed that the view from his terrace overlooking Florence seemed like "the most enchanting . . . picture on our planet." See I. Ross, *The Expatriates* (New York, 1970), 217.

10. N. Broude, *The Macchiaioli: Italian Painters of the Nineteenth Century* (New Haven, 1987), 49.

11. A. Cecioni, *Scritti e Ricordi*, ed. G. Uzielli (Florence, 1905), 334.

12. Vedder, *The Digressions of V.*, 374.

13. See the translations of these articles in Emilio Cecchi and Mario Borgiotti, *The "Macchiaioli"* (Florence, 1963), 25–31. In the English edition the date of Signorini's first article has erroneously been changed from October 19 to "10 October" 1862.

14. Cavaliere Bagetti, *Analisi della unità d'effetto nella pittura e della imitazione nelle belle arti* (Turin, 1827), 10, 17, 38, 67–69. Bagetti investigates visual perception and its relationship to the imagination, and carries out a microanalysis of the different constituents of a work that participate in the total "unity of effect." This work has thus far gone unnoticed in the literature, indicating once again that Italian aestheticians have been given short shrift in the modernist discourse.

15. *Statuti dell'insigne Accademia del Disegno di Roma detta di San Luca Evangelista* (Rome, 1796), 1–2, 24, 27, 33.

16. Mussini did volunteer for the Tuscan contingent to support Piedmontese King Carlo Alberto's campaign against the Austrians in 1848 at Curtatone, but the Tuscan volunteers were sanctioned by Leopoldo II (albeit under popular pressure) and at a time when it appeared that pope Pio Nono (Pius IX) favored liberal action. Mussini's *La musica sacra* was painted as proof of his progress while a pensioner at Rome. See Biagi, *L'Accademia di belle arti di Firenze*, 59–60.

17. T. Signorini, "Del paesaggio e della sua influenza nell'arte moderna," 9 September 1867; reprinted in A. M. Fortuna, ed., *Il Gazzettino delle arti del disegno di Diego Martelli 1867* (Florence, 1968), 266.

18. *Regolamenti della Reale Accademia delle Belle-Arti* (Turin, 1825), 20; *Reale Accademia delle Belle-Arti di Torino. Programma pel concorso de' posti di studio a Roma* (Turin, 1825), 2.

19. Florence, Accademia di Belle Arti, *Imperiale e reale Accademia delle Belle Arti di Firenze. Concorso triennalle dell'anno 1852*, 41; *Adunanza ordinaria del dì 13 settembre 1857*.

20. *Masaccio orazione di Melchior Missirini letta nel giorno della solenne distribuzione dei premi maggiori nell'I. e R. Accademia delle belle arti* (Florence, 1846), 31.

21. P. Selvatico, *Intorno alle condizioni presenti delle arti del disegno e all'influenza che vi esercitano le accademie artistiche: considerazioni* (Venice,

1857), 61–63, 68–69; N. Broude, *The Macchiaioli,* 37–38. Not without reason, Selvatico considered Ussi a model painter: see Selvatico, *Arte ed artisti: Studi e racconti* (Padua, 1863), 19, 29. For information on Selvatico, whose addresses at awards ceremonies could fill several volumes, see E. Bassi, *La regia Accademia di belle arti Venezia* (Florence, 1941), 52–54. The type of artist who graduated from the Venice Academy during Selvatico's tenure and went on to achieve popular success displays the middle-of-the-road compromise that Selvatico preached: included are Giacomo Favretto, Tranquillo Cremona, Luigi Nono, Ettore Tito, Alessandro Milesi, and Napoleone Nani. One exception is Guglielmo Ciardi.

22. *Lettere di Cammillo Pucci pittore sulle accademie di belle arti in Italia* (Florence, 1847), 10–11, 35–36. His solution to the problem was a return to the Renaissance tradition and widespread involvement of enlightened patronage and governments in the ordering and commissioning of major works of art. This offbeat pamphlet was dedicated to Roberto Tapparelli D'Azeglio, brother of Massimo and an irremediable classicist. The author complained of the "fatale Davidismo" (referring to the French neoclassicist, Jacques-Louis David) that had penetrated Italian academies and that needed to be purged in favor of indigenous heroes such as Giotto, Leonardo, Michelangelo, etc. Indeed, Selvatico's projected reforms were designed to meet the attack of critics such as those of his "friend Camillo Pucci." See Selvatico, *Intorno alle condizioni presenti,* 78. The idea of a "Risorgimento" in art coming out of Tuscany was a familiar theme and goal, but here were tactical differences about how to achieve that end. See M. Missirini, *Della potenza del genio nelle belle arti. Ragionamento* (Florence, 1831), 17–18, 23.

23. Rome had a triennial landscape competition (*un bozzetto ad olio*) during the Napoleonic epoch: *Statuti dell'insigne Accademia romana di S. Luca* (Rome, 1812), 9, 20. Venice and Milan opened its landscape courses as early as 1838: Bassi, *La regia accademia,* 50; Milan, Archives, Accademia Belle Arti di Milano, TEA G 111 23, "Scuola di paesaggio dal 1838 al 1876"; *Statuti e Regolamento interno dell'I. R. Accademia di belle arti di Milano-Venezia* (Milan, 1842). Turin founded its landscape school only in 1856, but had been debating the idea for years: *Statuti delle reale accademia Albertina* (Turin, 1856). For Parma and Bologna see *Statuto della Reale Parmense Accademia di belle arti,* June 14, 1856; A. Gatti, *Notizie storiche intorno alla R. Accademia di belle arti in Bologna* (Bologna, 1896), 30, 37.

24. D. Durbé, *Fattori e la scuola di Castiglioncello,* 2 vols. (Florence, 1982–83), 2:46. Martelli had been reading *La Nuova Europa* since its founding in 1861, and wrote that he enjoyed its radicalism since it did not rail against the government in a hostile manner.

25. D. Mack Smith, *Italy and Its Monarchy* (New Haven, 1989), 3.

26. E. Conti, *Le origini del socialismo a Firenze (1860–1880)* (Rome, 1950), 44–47; R. Hostetter, *The Italian Socialist Movement,* vol. 1: *Origins (1860–1882)* (Princeton, N.J., 1958), 1–2.

27. R. Composto, "Sulle origini de 'La Nuova Europa,'" *Rassegna storica toscana* 10, no. 2 (July–December 1964): 201–17.

28. Alberto Mario was the key inspiration of the paper's editorials, and a close friend of the poet Giosuè Carducci, and of Dolfi. For his role in the founding of the paper and his relationship with Dolfi in the radical movement see R. Balzani and F. Conti, eds., *Alberto Mario e la cultura democratica italiana dell'Ottocento* (Bologna, 1985), 68, 77, 79, 81–85,

91; G. Carducci, ed., *Scritti politici di Alberto Mario* (Bologna, 1901), 48–75; J. Mario White, "Della vita di Alberto Mario," in Carducci, ed., *Scritti letterari e artistici di Alberto Mario* (Bologna, 1901), cxlv–cli.

29. F. Fiorelli, "Lettere di Giuseppe Manzoni a Carlo e Diego Martelli," *Archivio storico pratese* 25 (1949): 3–20.

30. D. Durbé, *Fattori e la scuola di Castiglioncello* (Florence, 1983), 46.

31. A. Mario, "L'arte nella storia," *Scritti letterari e artistici*, 51, 67–68; T. Signorini, "Del paesaggio e della influenza nell'arte moderna," *Gazzettino delle arti . . . Diego Martelli*, August 31, 1867, 259.

32. "X" [T. Signorini], "Del fatto e del da farsi nella pittura," *La Nuova Europa*, August 2, 1863.

33. See the editorial "Non ho trovato un maestro e sono ministeriale," *Gazzetta del Popolo*, November 8, 1862.

34. The radical position of *La Nuova Europa* is seen in the attacks on it even by moderate papers. See the articles "I funerali per la grand'anima del Conte di Cavour," "L'Italia e i partiti," and "Ammonimenti al popolo," *L'Arlecchino*, 12 and 14 June 1861.

35. Cecchi and Borgiotti, *The "Macchiaioli,"* 31.

36. See *Gazzettino delle arti . . . Diego Martelli*, February 23, 1867, 45–46; July 15, 1867, 206, where he quotes Proudhon on the concept of liberty.

37. P.-J. Proudhon, *De la justice dans la révolution et dans l'église*, 3 vols. (Paris, 1858), 3 : 37–38. Cabianca's letter to Signorini of July 17, 1868 states that he is reading with great pleasure Proudhon's *De la justice* and that he regrets not having read it sooner. See L. Vitali, *Lettere dei macchiaioli* (Milan, 1978), 274–75. Elsewhere he refers to "friend" Proudhon: A. Marabottini and E. V. Quercioli, *Diego Martelli, corrispondenza inedita* (Rome, 1978), 136.

38. Proudhon, *De la justice*, 2 : 208–40. Signorini wrote as early as 1855: "I am reading Proudhon and becoming an apostate of the Mazzinian system." See E. Somarè, *Telemaco Signorini* (Milan, 1926), 268.

39. Uzielli discusses Proudhonian principles in his book *La scienza e il socialismo* (Florence, 1901; cited in E. C. Kaplan, "Gustavo Uzielli: A Renaissance Scholar and a Patriot as a Mentor and Patron to the Macchiaioli Painters" [Ph.D. diss., University of California at Los Angeles, 1991], 48–50). But he reveals an ambivalence to Proudhon's dogmatic assertions: P. Dini, *Diego Martelli* (Florence, 1978), 243.

40. For Martelli's interest in Proudhon and his take on socialism see Dini, *Diego Martelli*, 14, 127–28, 220, 229, 349; Marabottini and Quercioli, *Diego Martelli*, 62–64.

41. P.-J. Proudhon, *Du principe de l'art et de sa destination sociale* (Paris, 1865), 63; P. Dini, *Dal Caffè Michelangiolo al Caffè Nouvelle Athènes* (Turin, 1986), 35; Marabottini and Quercioli, *Diego Martelli*, 59–60, 71.

42. Proudhon, *Du principe de l'art*, 264–78.

43. G. Fattori, *Scritti autobiografici editi e inediti*, ed. F. Errico (Rome, 1980), 32–33, 106.

44. The classic definition of the Macchiaioli method is by A. Cecioni, "Vincenzo Cabianca," *Scritti e Ricordi* (Florence, 1905), 333–34.

45. See G. Matteucci, *Cristiano Banti* (Genoa, 1982), nos. 84–87, 116, 130, 132.

46. Fortuna, *Gazzettino delle arti . . . Diego Martelli*, 214.

47. Fortuna, *Gazzettino delle arti . . . Diego Martelli*, 321.

48. A. Falassi, *Folklore by the Fireside* (Austin, 1980), 20.

49. K. Hooker, *Byways in Southern Tuscany* (London, 1919), 51, 54.

50. G. Verga, *I Carbonari della montagna. Sulle Lagune,* ed. R. Verdirame, *Edizione nazionale delle opere di Giovanni Verga* (22 vols.; Florence, 1987–1988), 1:5–6.

51. Ibid., 359, 360, 364, 366, 370 and passim.

52. For a reprint of the review and an analysis of Verga's early work in the light of the ideology of *La Nuova Europa,* see C. Annoni's introduction to G. Verga, *I Carbonari della montagna. Sulle Lagune* (Milan, 1975), 3–5, 50–56. *La Nuova Europa* also serialized Verga's Venetian novel *Sulle Lagune* from January 13 to March 15, 1863. Set in Venice in 1861, the novel opens with the citizens confronting their Austrian occupiers with a patriotic celebration of Garibaldi's entrance into Naples.

53. A. Alexander, *Giovanni Verga, A Great Writer and His World* (London, 1972), 38.

54. G. Cecchetti, *Giovanni Verga* (Boston, 1978), 51–52.

55. G. Verga, "L'amante di Gramigna," in *Vita dei campi,* Edizione nationale delle opere, 14:95.

56. O. R. Agresti, *Giovanni Costa, His Life, Work and Times* (London, 1904), 67.

57. *Il secondo '800 italiano; Le poetiche del vero,* ed. R. Barilli and E. Farioli (Milan, 1988), 328–29.

58. In Guerrazzi's *Beatrice Cenci* he makes one of the protagonists say about a *carbonaro:* "This class is the people, which although it always endures, sometimes also devours." See F. D. Guerrazzi, *Beatrice Cenci: A Historical Novel of the Sixteenth Century,* 2 vols. (New York, 1900), 2:10–11.

59. T. Frost, *The Secret Societies of the European Revolution, 1776–1876,* 2 vols. (London, 1876), 1:213, 218.

60. Ibid., 1:217; *Memorie sulle società segrete dell'Italia meridionale e specialmente sui Carbonari,* trans. M. Cavallotti (Rome and Milan, 1904), 31, 37, 39–40, 66.

61. For Italian Freemasonry and the Risorgimento see A. Comba, "La Massoneria in Italia dal Risorgimento alla grande guerra (1859–1915) dall Unità all'Intervento," in A. Alessandro Mola, ed., *La massoneria nella storia d'Italia* (Rome, 1981), 79; A. Alessandro Mola, *Storia della Massoneria italiana dall'Unità alla Repubblica* (Milan, 1976); A. Luzio, *La massoneria e il risorgimento italiano,* 2 vols. (Bologna, 1925).

62. A. Marabottini and V. Quercioli, *Diego Martelli, corrispondenza inedita* (Rome, 1978), 20, 61.

63. Fattori, *Scritti autobiografici,* 25.

64. Fortuna, *Gazzettino delle arti . . . Diego Martelli,* 17–18.

65. A. J. Rusconi, "Il centenario di Giovanni Fattori," *Emporium* 42 (November 1925): 290. The full text of the Italian runs: "È a questo proposito non è fuor di luogo chiarire un equivoco che molti ancora perpetuano, considerando il Fattori non solo come uno dei rappresentanti più tipici dei macchiaioli fiorentini, ma anche come il fondatore e il battezzatore di quel gruppo artistico che avrebbe preso il nome da un quadro di lui intitolato *Macchiaiole* dipinto ad Antignano ed esposto a Firenze nel 1867 [*sic*]."

66. For Gioli see *Esposizione Internazionale d'Arte della Città di Venezia. Catalogo* (Venice, 1914), 113, no. 24.

67. At this writing there is no monograph on Gioli: the best source of information is a compilation of his friends written shortly after his death and edited by his friend Antonio Fradeletto. See A. Fradeletto, ed., *Francesco Gioli e la sua Opera* (Florence, 1923). A description of the work

may be found on page 22. See also A. R. Willard, *History of Modern Italian Painting*, 2d ed. (London and New York, 1900), 650–51; A. M. Commanducci, *Enciclopedia della pittura Italiana*, 2 vols. (Milan, 1950), 1:1484–85.

68. See Gioli's autobiographical statement in *Esposizione Internazionale*, 110–11.

69. For Gioli's portrait of Martelli see the frontispiece to B. Maria Bacci, *L'800 dei Macchiaioli e Diego Martelli* (Florence, 1969); for Lega's portrait of Gioli see Broude, *The Macchiaioli*, 174.

70. G. Mazzini, "Modern Italian Painters," *Westminster Review* 35 (1841): 185.

CHAPTER FOUR

1. Telemaco Signorini, *Caricaturisti e caricaturati al Caffè Michelangiolo*, ed. B. M. Bacci (Florence, 1952), 88. For De Tivoli see C. Benedicti, "Serafino De Tivoli," *Liburni Civitas* 2 (1929), 139–50.

2. *Exposition universelle de 1855* (Paris, 1855), nos. 2135–36. D'Ancona showed *L'Abandonnée*, a subject Cabianca would paint three years later.

3. M. Nobili and S. Camerani, eds., *Carteggi di Bettino Risacoli*, 29 vols. (Bologna, 1939–1988), 7:274, 283.

4. W. K. Hancock, *Ricasoli and the Risorgimento in Tuscany* (New York, 1969), 34.

5. T. Signorini, "Cose d'arte," in *Il Risorgimento*, June 1874, reprinted in E. Somarè, *Signorini* (Milan, 1926), 256.

6. D. F. Mosby, *Alexandre-Gabriel Decamps, 1803–1860*, 2 vols. (New York and London, 1977), 1:100–101, 111–20.

7. R. Causa, "I fratelli Palizzi," *Catalogo dell'arte italiana dell'Ottocento* 13 (1984): 42, 47.

8. E. Gebaüer, *Les beaux-arts à l'exposition universelle de 1855* (Paris, 1855), 143.

9. *Exposition universelle de 1855. Explication des ouvrages de peinture, sculpture, gravure, lithographie et architecture des artistes vivants étrangers et français* (Paris, 1855), no. 4095.

10. T. Gautier, *Les beaux-arts en Europe, 1855*, 2 vols. (Paris, 1856), 2:120–21. Gebaüer, however, did not like the work and considered it inferior to Bonheur's normal production. See *Les beaux-arts à l'exposition . . . 1855*, 158.

11. For the role of animals in Bonheur's life and work see A. Boime, "The Case of Rosa Bonheur: Why Should a Woman Want to be More Like a Man?" *Art History* 4 (December 1981): 384–409.

12. W. Rossetti, "Correspondence," *The Crayon* 1, no. 26 (June 27, 1855): 408.

13. *Catalogo illustrativo delle opere di pittura, disegni, incisioni ed altri oggetti di belle arti ammessi alla prima Esposizione Italiana de 1861 in Firenze* (Florence, 1861), no. 908.

14. According to General Zédé, author of a detailed diary of the campaign, this regiment was always referred to as the "fifth wheel," because "it never did anything." See P. Turnbull, *Solferino, the Birth of a Nation* (London, 1985), 97.

15. T. Trollope, *Social Aspects of the Italian Revolution* (London, 1861), 30–34. This is a valuable eyewitness source for Florentine social history

in this period by the correspondent for the English journal *The Athenaeum* who was a permanent resident of the Tuscan capital.

16. L. Vitali, *Lettere dei Macchiaioli* (Turin, 1953), 33.

17. Ibid., 212–13.

18. D. Durbé, *I Macchiaioli* (Florence, 1976), 81, no. 22.

19. For Ricasoli see G. Spadolini, ed., *Ricasoli e il suo tempo* (Florence, 1981); G. Spadolini, *Firenze capitale: gli anni di Ricasoli* (Florence, 1979). In English there is Hancock, cited above, note 4.

20. On this quote from Stanislao Bianciardi, *Leopoldo II e la Toscana. Parole di un sacerdote al popolo,* see Hancock, *Ricasoli,* 212; Trollope, *Social Aspects,* 64–68, analyzes the work in some detail.

21. Signorini, *Caricaturisti e caricaturati,* 174–75.

22. R. Crampini, *Il '59 in Toscana* (Florence, 1958), 213–15.

23. Bulletins announcing the contest and reporting its progress were first published in the official newspaper (*Il Monitore Toscano*) and then reprinted in Ricasoli's journal, *La Nazione.* The original decree signed by Ricasoli and Ridolfi on September 23, 1859 was published on the 24th in the former and on the 25th in the latter. See also "Programma per concorse nazionale alle opere d'arte che il Governo della Toscana statuiva allegarsi per conto dello Stato col Decreto del 23 settembre 1859," *Monitore Toscano,* October 18, 1859; *La Nazione,* October 19, 1859; "Belle Arti," *Monitore Toscane,* February 25, 1860 (announcing the gathering of the jury); the "Atti Governativi" posting the final results in *Monitore Toscano,* May 12, 1860; *La Nazione,* May 14, 1860.

24. "Atti Governativi," *La Nazione,* September 25, 1859.

25. "Atti Governativi," *La Nazione,* October 19, 1859.

26. A. Zobi, *Cronaca degli avvenimenti d'Italia nel 1859 corredata di documenti per servire alla storia,* 2 vols. (Florence, 1859), 1:487–88.

27. G. Fattori, *Scritti autobiografici editi e inediti,* ed. F. Errico (Rome, 1980), 104.

28. "Risciacquatura in acqua d'Arno": F. Capelvenere, *Manzoni a Firenze e la "risciacquatura" in Arno* (Florence, 1985).

29. C. L. Dentler, *Famous Foreigners in Florence 1400–1900* (Florence, 1964), 62, 201–2, 251–52, 259.

30. E. Bacciotti, *Guide-Manuel de Florence et ses environs* (Florence, 1888), addresses at the back, p. 10. Stefano Ussi, Carlo Ademollo, Nicolò Barabino, and Antonio Ciseri also advertised in this guidebook.

31. R. Williams, *Culture* (Glasgow, 1981), 83ff.

32. Costa, *Quel che vidi,* 253; P. Micheli, "Spigolature Livornesi," *Liburni civitas,* vol. 2 (1929), 93. The author notes that the two dominant strains in Costa's career and affections were *arte* and *patria.*

33. See the slightly differing versions in O. R. Agresti, *Giovanni Costa, His Life, Work and Times* (London, 1904), 95–96; Giovanni Costa, *Quel che vidi e quel che intesi* (Milan, 1927), 141; and Fattori, *Scritti autobiografici,* 92.

34. G. Saviotti, "L'arte di Giovanni Fattori," *Liburni civitas,* vol. 2 (1929), 117.

35. In the Bacciotti guidebook cited above, Fattori's painting (then in the modern gallery of the Accademia delle Belle-Arti) is given the French title *Filles de la charité à Magenta:* Bacciotti, *Guide-Manuel,* 71.

36. Zobi, *Cronaca,* 620–21, 640.

37. N. Troyer, "The Macchiaioli: Effects of Modern Color Theory, Photography, and Japanese Prints on a Group of Italian Painters, 1855–1900" (Ph.D. diss., Northwestern University, 1978), chap. 5.

38. See "Un dessinateur de L'Illustration sur le champ de Bataille de Magenta," *L'Illustration* 33 (June 18, 1859): 438.

39. H. Jouin, *Adolphe Yvon* (Paris, 1893), 44.

40. J.-H. Dunant, *Un souvenir de Solferino* (Geneva, 1862); "Il servizio sanitario internazionale in tempo di guerra," *Annuario scientifico ed industriale* (Milan, 1864), 1:232–33.

41. Zobi, *Cronaca*, 655–56.

42. Fattori's deadpan representations of battlefield encounters were evidently linked to rumors of cowardice concerning his abstention from military service in 1859. As a younger contemporary stated: "Some people cannot discern heroism unless it is in a military dress, and to them this abstention from war on the part of Fattori may seem regrettable." See G. Papini, *Laborers in the Vineyard*, trans. A. Curtayne (New York, 1930), 30.

43. *Garibaldi. Arte e storia*, 172, no. 5.6.1.

44. Fattori, *Scritti autobiografici*, 23.

45. A. Maria Fortuna, *Il Gazzettino delle arti del Disegno di Diego Martelli, 1867* (Florence, 1968), 197–99. The date of this article was July 6, 1867.

46. Ibid., 206, July 15, 1867.

CHAPTER FIVE

1. See *Esposizione italiana tenuta in Firenze nel 1861,* 3 vols., ed. Francesco Protonotari (Florence, 1864–1867); *La Esposizione italiana del 1861. Giornale con incisione,* ed. A. Bettini (Florence, 1861); *Catalogo illustrativo delle opere di pittura, disegni, incisioni et altri oggetti di belle arti ammessi alla prima Esposizione italiana de 1861 in Firenze* (Florence, 1861); B. Cinelli, "Firenze, 1861: anomalie di una esposizione," *Ricerche di storia dell'arte* 18 (1892): 21–36; G. Fabre, "The Ideology of Progress," in *Modern Italy: Images and History of a National Identity,* vol. 1: *From Unification to the New Century* (Milan, 1982), 71–73.

2. For Cavour's propaganda memorandum on the incident circulated to the regional centers see A. Zobi, *Cronaca degli avvenimenti d'Italia nel 1859 corredata di documenti per servire alla storia,* 2 vols. (Florence, 1859–60), 2:541–43.

3. A. G. Martucci, *Il conservatorio d'arti e mestieri, terza classe dell'Accademia delle belle arti di Firenze (1811–1850)* (Florence, 1988), 29–53, 71.

4. *Esposizione italiana,* 3:286, where it is recognized for its "buono effetto."

5. T. Signorini, *Caricaturisti e caricaturati al Caffè Michelangiolo,* ed. B. M. Bacci (Florence, 1952), 120; M. Calderini, *Antonio Fontanesi, pittore paesista* (Turin, 1925), 114.

6. L. C. Bollea, "Antonio Fontanesi all'Accademia Albertina," *Atti della Società piemontese di archeologia e belle arti* 13 (1932): 74, 89ff.

7. Ibid., 109. Fontanesi's school, comprising landscapists from throughout Italy, came to be known as the "paesisti fontanesiani." For the landscape development see C. F. Biscarra, *Del paesaggio e di alcuni pregevoli dipinti dell'esposizione di belle arti 1860* (Turin, 1860).

8. D. Mack Smith, *Italy: A Modern History* (Ann Arbor, 1959), 36.

9. "L'esposizione Italiana," *L'Arlecchino,* July 10, 1861. One moderate critic vaunted Italy's historical contributions to science as demonstrated

in the exposition, and claimed that the success of the show would isolate the Vatican on the one hand, and on the other cause scientific societies to replace secret societies. A. C., "La prima esposizione italiana a Firenze considerata politicamente," September 25, 1861, in *La Esposizione italiana del 1861* (Florence, 1862), 43, 46.

10. F. Protonotari, "Relazione generale," *Exposizione italiana tenuta in Firenze,* 1:5–6.

11. *Rapporto della pubblica esposizione dei prodotti di arti e manifatture Toscane eseguita nel settembre 1841* (Florence, 1841), v.

12. J. Stewart, "The Exhibition at Florence," *Art-Journal*, n.s., 13 (1861), 343.

13. H. R. Marraro, *American Opinion on the Unification of Italy* (New York, 1969), 184, 280.

14. Yorick, *Viaggio attraverso l'esposizione italiana del 1861* (Florence, 1861), 87. For an anecdotal biography of this influential critic and satirist see M. Ferrigni, *Uomo allegro . . . "Yorick"* (Rome, 1930). The introduction to *La esposizione italiana del 1861* (like Yorick's *Viaggio* it was published by Bettini) used almost identical language in discussing the recent unification: "A people enslaved for centuries rises again [*risorge*], new Lazarus, from the tomb to shatter its chains" (see *La esposizione,* July 15, 1861, p. 2).

15. Stewart, "The Exhibition," 343.

16. V. Green Fryd, "Hiram Powers's America: 'Triumphant as Liberty and in Unity,'" *American Art Journal* 18 (1986): 54–75.

17. Ibid., 65.

18. Ibid., 69.

19. Yorick, *Viaggio attraverso,* 87.

20. Ibid., 217. For the theme of the female reader in nineteenth-century art, see A. Finocchi, *Lettrici* (Nuoro, 1992).

21. Stewart, "The Exhibition," 341; see also Yorick, *Viaggio attraverso,* 140–41.

22. The stresses within Italian society over the feminist issue are already expressed in the National Exposition of 1861, as seen in the remarks of the director of a teacher's school for women (Scuola magistrale femminile di Firenze) regarding the school's display of its embroidered backing for the king's throne. She expressed concern that the genders were becoming confused, and that in the upside-down world women would be doing scientific, literary, and artistic work, and regulating the affairs of state, and men would weave and sew. Although she did not rule out a wider range of activities for women, she thought society would be stabler if women continued to specialize in the domestic arts. See "Spalliera pel trono del Re d'Italia ricamata nella scuola magistrale femminile di Firenze," *La Esposizione italiana del 1861,* September 2, 1861, pp. 27–28.

23. Stewart, "The Exhibition," 344.

24. Stewart, "The Exhibition," 344. Yorick also called Signorini "Temistocle," which suggests that there may have been a misprint on a label. But there is no doubt that he has our Signorini in mind, whom he classifies as "uno de' nuovi"—one of the new ones. See Yorick, *Viaggio attraverso,* 122.

25. Stewart, "The Exhibition," 344.

26. Stewart, "The Exhibition in Florence," second article, *Art-Journal,* n.s. 13 (1861), 353–58.

27. Protonotari, *Esposizione italiana,* 1:148, 152, 154.

28. Ibid., "Documenti," nos. 71, 22.

29. Ibid., III, 283.

30. Nobili and Camerini, *Carteggi di Bettino Ricasoli,* 12:63. Not everyone was happy with the signs of incompleteness. Selvatico felt there were too many "abozzi briosi" (vivacious sketches) in the show. See P. Selvatico, *Arte ed artisti: Studi e racconti* (Padua, 1863), 9.

31. Lega's and Borrani's prizewinning sketches in the category of "bozzetto a olio d'invenzione," were documented as part of the Academy's collection in 1861: see *Description des objets d'art de la royale Académie des Beaux-Arts de Florence* (Florence, 1861), 22ff.

32. T. Trollope, *Social Aspects of the Italian Revolution* (London, 1861), 123–26.

33. Yorick, *Viaggio attraverso,* 159.

34. Ibid., 124.

35. Protonotari, III, 286.

36. *Catalogo illustrativo,* nos. 664, 714.

37. I believe that it is possible to identify the town as Rubiera thanks to a study by Signorini strikingly close to the Borrani entitled *Gli zuavi francesi e gli artiglieri toscani entrano in Rubiera* (French Zouaves and Tuscan artillery troops entering Rubiera). For a reproduction see E. Allodoli, "Telemaco Signorini, pittore e scrittore, *Rassegna della istruzione artistica,* vol. 9 (1938), 197. For Tuscany's mobilization including two artillery batteries see the report of Ricasoli, Ridolfi, Salvagnoli et al. in Zobi, *Cronaca,* 516–21.

38. Trollope, *Social Aspects,* 250ff. Ussi was fortunate in benefiting from the time of reception, for although the work is dated 1860 it was actually begun in the mid-1850s when Ussi was a pensioner at Rome, but like the history novels and their themes of despotism overthrown his picture was bound to be prophetic one day.

39. Ibid., 168; M. Nobili and S. Camerani, eds., *Carteggi di Bettino Ricasoli,* 29 vols. (Bologna, 1939–1988), 10:376.

40. Yorick, *Viaggio attraverso,* 180; A. Zobi, *Cronaca,* 2:3–6.

41. "La Esposizione," *La Nuova Europa,* February 2, 1862.

42. D. Mack Smith, *Victor Emmanuel, Cavour, and the Risorgimento* (London, 1971), 121.

43. E. Conti, *Le origini del socialismo a Firenze (1860–1880)* (Rome, 1950), 42, 44ff.

44. Protonotari, *Esposizione italiana,* 2:123, 167, 192.

45. P. Dini and D. Durbé, *Contributo a Borrani* (Rome, 1981), 63–64.

46. "Del paesaggio e della sua influenza nell'arte moderna," August 31, 1867. In A. Maria Fortuna, ed., *Il Gazzettino delle arti del disegno di Diego Martelli 1867* (Florence, 1968), 259.

47. N. Troyer, "The Macchiaioli: Effects of Modern Color Theory, Photography, and Japanese Prints on a Group of Italian Painters, 1855–1900" (Ph.D. diss., Northwestern University, 1978), 139.

48. E. C., "Le fotografie," *La esposizione italiana del 1861,* October 4, 1861, pp. 55–56. The Neapolitan scientist, Giovanni Battista Della Porta, was the first to suggest the camera obscura for drawing and described the invention more fully than anyone else before him, but other Italians, including Leonardo da Vinci, knew of the device. See H. Gernsheim, *The Origins of Photography* (London, 1982), 7–11.

49. Gernsheim, *The Origins of Photography*, 167–78.

50. Stewart, "The Exhibition," second article, 354.

51. Protonotari, *Esposizione italiana*, "Documenti," 1.60, 2:469–74; T. C., "Le Fotografie," *La Esposizione italiana del 1861*, October 4, 1861; T. C., "Fotografie. Ritratti per ingrandimento," November 7, 1861; T. C., "De'Ritratti in fotografia," March 10, 1862; T. C., "Fotografie rappresentanti monumenti," July 15, 1862; T. C., "Fotografia," August 5, 1862.

52. Pietro Selvatico, "L'Arte insegnate nelle Accademie secondo le norme scientifiche," *Atti dell'Imp. Reg.: Accademia di Belle Arti in Venezia per la distribuzione dei premii nel giorno 8 agosto 1852* (Venice, 1852), 24ff.

53. D. Durbé, *Fattori e la scuola di Castiglioncello*, 2:57–58.

54. D. Martelli, *Scritti d'arte*, ed. A. Boschetto (Florence, 1952), 121. Martelli also noted that the French painter adored Garibaldi.

55. *Esposizione italiana*, 2:471.

56. J.-L. Daval, *Photography: History of an Art* (Geneva, 1982), 64–65.

57. D. Brewster, *The Stereoscope, Its History, Theory, and Construction* (London, 1856), 180–81.

58. Signorini, "L'esposizione di belle arti della società d'incoraggiamento in Firenze," February 9, 1867, in *Gazzettino delle arti . . . Diego Martelli*, 27–28; N. Broude, *The Macchiaioli: Italian Painters of the Nineteenth Century* (New Haven, 1987), pp. 133–34.

59. As background to this discussion, I used the article on "Stereoscope" in the 11th edition of the *Encyclopaedia Britannica* and was surprised to come across a footnote that stated that the author of the article, who had extensively developed the subject of stereoscopy, had lost one eye and "could no longer enjoy the beauties of stereoscopic sight." See C. P., "Stereoscope," *Encyclopaedia Britannica*, 11th ed. (29 vols.; London, 1910–11), 25:895–900.

CHAPTER SIX

1. This is evident from the owners of the works listed in the *Catalogo illustrativo*. One mysterious patron, overlooked as such until now, is the French etcher and painter Marcellin Desboutin. A legacy enabled him to purchase the Villa Ombrellino, just southeast of Florence, in 1857. His estate was divided into *poderi*, or farms, and he thus lived as a Tuscan aristocrat, yet his social circle of friends comprised members of the democratic left including Signorini and Uzielli. I suspect that he was involved in the uprising of April 27, 1859; one clue is a neighbor of his, a master baker, who baked his copies of the old masters to give them an antique look. The only baker who could have afforded a villa in the vicinity would have been Beppe Dolfi. In one instance, Desboutin commissioned Signorini to do the landscape of a composition of the Florence ghetto for which he supplied the figures. See Clément-Janin, *La curieuse vie de Marcellin Desboutin* (Paris, 1922), 15, 18, 27, 64, 260.

2. The critic Yorick had a field day with this invention, describing it as a "model for prison cells." See Yorick, *Viaggio attraverso l'esposizione italiana del 1861* (Florence, 1861), 266. The work was also reproduced in *La esposizione italiana del 1861*, March 20, 1862 (Florence, 1862), 165.

3. F. Protonotari, ed., *Esposizione italiana tenuta in Firenze nel 1861* (3 vols.; Florence, 1864–67), "Documenti," 1 : viii, 2 : 1, 196, 3 : 1.

4. For the D'Anconas see Flora Aghib Levi D'Ancona, *La giovinezza dei fratelli D'Ancona* (Rome, 1982).

5. G. Fattori, *Scritti autobiografici editi e inediti,* ed. E. Errico (Rome, 1980), 75, 77; Dario Durbé and Cristina Bonagura, *Fattori da Magenta a Montebello* (Rome, 1983), 297ff.

6. See Livorno, Municipal Archives, Minutes of the City Council dated February 27, 1871.

7. Protonotari, *Esposizione italiana,* 2 : 134, 142, 204, 361, 486, 206, 217.

8. D. Durbé, *Fattori e la scuola di Castiglioncello,* 1 : 182ff.; D. Mack Smith, *Victor Emmanuel, Cavour, and the Risorgimento,* 103ff.

9. I have found very useful for my understanding of the mezzadria system the essays in J. A. Davis, ed., *Gramsci and Italy's Passive Revolution* (London, 1979).

10. Cited by F. M. Snowden, "From Sharecropper to Proletarian: The Background to Fascism in Rural Tuscany, 1880–1920," in Davis, ed., *Gramsci and Italy's Passive Revolution,* 137.

11. C. Pazzagli, "Prime note per una biografia del Barone Ricasoli," *Ricasoli e il suo tempo,* ed. Giovanni Spadolini (Florence, 1981), 270ff.

12. See Giovanni Spadolini's preface to *Agricoltura e società nella Maremma Grossetana dell'800* (Florence, 1980), ix. This book is invaluable for information on the history and development of the Maremma.

13. A. Salvagnoli-Marchetti, *Memorie economico-statistiche sulle Maremme Toscane* (Florence, 1846), 2.

14. See Carlo Martelli, "Esame delle condizioni economiche della strada ferrata Maremmana del Chiarone," in Francesco Guerrazzi, T. Magnani and Carlo Martelli, *Causa relativa alla costruzione delle ferrovie maremmane* (Livorno, 1846), 33ff. Guerrazzi and Magnani also owned property in the Maremma.

15. P. Dini, *Diego Martelli* (Florence, 1978), 31ff.; Durbé, *Fattori e la scuola di Castiglioncello,* 2 : 9ff., 19ff.

16. P.-J. Proudhon, *Qu'est-ce que la propriété? ou recherches sur le principe du droit et du gouvernement* (Paris, 1841), 308–9.

17. P.-J. Proudhon, *Du principe de l'art et de sa destination sociale* (Paris, 1865), 236–39.

18. Spadolini, *Agricoltura e società nella Maremma,* ix–x. In the same volume, D. Barsanti, "Caratteri e problemi della bonifica maremmana da Pietro Leopoldo al governo provvisorio toscano," 61; and I. Imperciaderi, "Ricasoli pioniere dell'agricoltura moderna in Maremma," 7–8.

19. G. Biagioli, "Vicende e fortuna di Ricasoli impreditore," *Agricoltura e società nella Maremma,* 96. See also *XII Lettere di Bettino Ricasoli a Sansone D'Ancona* (Massa, 1913), where Ricasoli writes of his plans to cultivate tobacco in the Maremma.

20. L. Barboni, *Giosuè Carducci e la Maremma* (Livorno, 1885), 53. The book was dedicated to Ferdinando Martini, a statesman who befriended and encouraged the Macchiaioli painters.

21. The original Italian reads: "Meglio ir tracciando per la sconsolata / Boscaglia al piano il bufolo disperso, / Che salta fra la macchia e sosta e guata."

22. L. Vitali, *Lettere dei Macchiaioli* (Turin, 1953), 170–71.

23. For Uzielli see now E. C. Kaplan, "Gustavo Uzielli: A Renais-

sance Scholar and a Patriot as a Mentor and Patron to the Macchiaioli Painters" (Ph.D. diss., University of California, Los Angeles, 1991).

24. G. Uzielli, *La scienza e il socialismo* (Florence, 1901).

25. *Bollettino della Società Geografica Italiana* (1868): 1:3ff.

26. *Bollettino*, 2d series (1878), 3:274.

27. *Bollettino*, 2d series (1880), 5:596ff.

28. For the history of this event see Partiti Popolari Democratici, *Albo Storico. Nel Cinquantenario della Battaglia del Volturno* (Naples, 1911).

29. U. de Fonvielle, *Souvenirs d'une chémise rouge* (Paris, 1861), 135–37.

30. G. Uzielli, "Dai ricordi di uno studente Garibaldino (1859–1860)," *Il Risorgimento Italiano* (1909), 2:915–51.

31. Ibid., 921, 933, 938.

32. Ibid., 944.

CHAPTER SEVEN

1. For Jewish participation in the Macchiaioli movement see A. Boime, "The Macchiaioli and the Risorgimento," in Frederick S. Wight Art Gallery, University of California, *The Macchiaioli: Painters of Italian Life 1850–1900* (Los Angeles, 1986), 53, 59–60; E. Braun, "From the Risorgimento to the Resistance: One Hundred Years of Jewish Artists in Italy," in *Gardens and Ghettos: The Art of Jewish Life in Italy,* ed. V. B. Mann (Berkeley and Los Angeles, 1989), 139–45.

2. F. A. L. Ancona, *La Giovinezza de fratelli D'Ancona* (Rome, 1982), 58.

3. A. Cecioni, *Opere e scritti* (Milan, 1932), 151–55.

4. For the participation of Jews in the Risorgimento movement see S. Foà, *Gli ebrei nel Risorgimento italiano* (Rome, 1978); G. Formiggini, *Stella d'Italia, Stella di David: gli ebrei dal Risorgimento alla Resistenza* (Milan, 1970); A. Milano, *Storia degli ebrei in Italia* (Turin, 1963), 365; C. Roth, *The History of the Jews in Italy* (Philadelphia, 1946), chaps. 9, 10.

5. Roth, *History of the Jews,* 463; P. Ginsberg, *Daniele Manin and the Venetian Revolution of 1848–49* (Cambridge, 1979), 73.

6. W. Arthur, *Italy in Transition. Public Scenes and Private Opinions in the Spring of 1860* (New York, 1860), 91, 226.

7. L. Vitali, *Lettere dei Macchiaioli* (Turin, 1953), 113.

8. M. T. D'Azeglio, *La politica e il diritto cristiano considerati riguardo alla questione italiana* (Bologna, 1860), 7–8.

9. Quoted in *Garibaldi. Arte e Storia,* 167, no. 5.4. In the same period the Circolo artistico di Milano bought his *Alto di granatieri toscani a Calcinatello* (Halt of the Tuscan Grenadiers at Calcinatello). See V. Pica, "Artisti contemporanei: Telemaco Signorini," *Emporium,* vol. 8 (November 1898), 325.

10. Cited in Milano, *Storia degli ebrei,* 532.

11. T. Trollope, *Social Aspects of the Italian Revolution* (London, 1861), 52–53, 57, 132–33.

12. L. Scott, *Tuscan Studies and Sketches* (London, 1888), 254–55. It may be recalled that Signorini had collaborated with Marcellin Desboutin as early as 1864 on a painting entitled *The Florentine Ghetto,* Signorini executing the streetscape and Desboutin the figures. See Clément-Janin,

La curieuse vie de Marcellin Desboutin (Paris, 1922), 260. Borrani also did a number of oil and watercolor sketches of the Florence ghetto in this period, including the identical backdrop of Signorini's 1882 scene. See P. Dini, *Odoardo Borrani* (Florence, 1981), nos. 174–76, 178–79, 182. Many of these, however, are misidentified and located simply in the "Mercato Vecchio."

13. D. Durbé, *La Firenze dei Macchiaioli: un mondo scomparso* (Florence, 1985), 250–56, 268–70, 292–95.

14. E. Somarè, *Telemaco Signorini* (Milan, 1926), 279.

15. G. Carocci, "Mercato Vecchio. Curiosità Storiche. Il Ghetto," *Arte e Storia* 1, no. 27, December 10, 1882. This was the first of a four-part series; see also nos. 28–29, December 17 and 24, 1882, and vol. 2, no. 1, January 7, 1883.

16. G. Carocci, "Mercato Vecchio. Curiosità Storiche. Il Ghetto," *Arte e Storia* 2, no. 1, January 7, 1883.

17. In his pamphlet "The Housing Question" (1872), Engels defined "the method called 'Haussmann' . . . I mean the practice, which has now become general, of making breaches in working-class quarters of our big cities, especially those that are centrally situated . . . The result is everywhere the same: the most scandalous alleys and lanes disappear to the accompaniment of lavish self-glorification by the bourgeoisie on account of this tremendous success—but they appear at once somewhere else, and often in the immediate neighborhood." *Marx-Engels Selected Works*, 2 vols. (Moscow, 1955), 1:559, 606–9.

18. T. Trollope, "Fine Arts: Florence Exhibition," *The Athenaeum*, October 19, 1861, pp. 514–515.

19. Cabianca repeated the identical conceit in his later *Nuns on the Seashore* (1869, Musei Civici, Milan). See P. Brugnoli, *La pittura a Verona dal primo Ottocento a metà Novecento*, 2 vols. (Verona, 1986), 1:221.

20. R. Salvini and L. Traverso, *The Predella from the XIIIth to the XVIth Centuries* (London, 1959), vii–viii.

21. Trollope, *Social Aspects*, 18–22.

22. R. Crampini, *Il '59 in Toscana* (Florence, 1958), 108–9.

23. T. Signorini, *Caricaturisti e caricaturati al Caffè Michelangiolo*, ed. B. M. Bacci (Florence, 1952), 88.

24. W. M. Rossetti, "Correspondence," *The Crayon* 1, no. 26 (June 27, 1855): 408.

25. C. M. Lovett, *The Democratic Movement in Italy 1830–1876* (Cambridge, Mass., 1982), 220.

26. For an overview of Italian feminism see F. P. Bortolotti, *Alle origini del movimento femminile in Italia, 1848–1892* (Turin, 1963). Also J. J. Howard, "Patriot Mothers in the Post-Risorgimento: Women after the Italian Revolution," *Women, War, and Revolution*, ed. C. Berkin and C. M. Lovett (New York, 1980), 237–58.

27. A. Slater, *In Search of Margaret Fuller* (New York, 1978).

28. See E. A. Daniels, *Jessie White Mario, Risorgimento Revolutionary* (Athens, Ohio, 1972). Curiously, she was highly ambivalent on the issue of Italian feminism: see J. W. Mario, "On the Position of Women in Italy," *The Nation* 9, no. 230, November 25, 1869, pp. 456–57; no. 231, December 2, 1869, pp. 480–82.

29. A. Mario, "Donne Scienziate" and "Donne Artiste," *Scritti letterari e artistici di Alberto Mario*, ed. G. Carducci (Bologna, 1901), 69–95, 97–145. It is worth noting, given Mario's support of the Macchiaioli,

that Jessie White Mario, who wrote a long biography of her husband for this edition, dedicated it to Adriano Lemmi, a radical democrat and patron of Fattori!

30. P. Dini, *Diego Martelli* (Florence, 1978), 221, 224, 356.

31. L. Nalbandian, *The Armenian Revolutionary Movement* (Berkeley and Los Angeles, 1963), 56–61, 72.

32. K. Simonian, "The History of a Poem: 'The Song of an Italian Girl,'" *Kronk* 8 (1986): 19–20.

33. M. Nalbandian, *Collected Works,* 2 vols. (1979), 1:107–9.

34. "Parliament Selects Anthem," *Asbarez,* vol. 83, July 6, 1991, p. 1.

35. P. Robertson, *Revolutions of 1848: A Social History* (Princeton, 1980), 313.

36. T. Signorini and D. Martelli, *Per Silvestro Lega* (Florence, 1896), 10.

37. Ibid., 18–19.

38. Cited in M. S. Crawford, *Life in Tuscany* (New York, 1859), 148–50.

39. M. T. D'Azeglio, *I mei ricordi,* 177.

40. *I doveri dell'uomo,* translated in Giuseppe Mazzini, *Life and Writings* (6 vols.; London, 1891), 4:284–85, 377–78.

41. Ibid., 377–78.

42. Robertson, *Revolutions of 1848,* 312–13.

43. See F. P. Bortolotti, *Alle origini del movimento femminile in Italia 1848–1892* (Turin, 1963); G. Pomata, *In scienze e coscienza: donne e potere nella società borghese* (Rome, 1979); V. Cian, "Femminismo patriottico del Risorgimento," *Nuova Antologia,* June 1, 1930, pp. 3–32.

44. H. Remsen Whitehouse, *A Revolutionary Princess: Christina Belgioioso-Trivulzio* (London, 1906); B. A. Brombert, *Christina* (New York, 1977).

45. Pomata, *In scienza e conscienza,* 45ff.

46. *La Donna: Foglio settimanale di scienze morali e naturali—di letteratura e arti belle* (Genoa), August 4, 1855. A second, better-known journal with the same title was founded in Venice in 1868 by Gualberta Alaide Beccari, who later moved it to Bologna, where it enjoyed a huge success until it fell on economic hard times in the 1880s.

47. See the articles on "Rispetti e Stornelli" in *La Donna* 10, January 24, February 14, 1857.

48. Pieroni Bortolotti, *Alle origini del movimento femminile,* 29 and 29n.

49. Verità worked closely with Ricasoli after the 1859 revolution and kept him informed on the events in his region. Nobili and Camerani, *Carteggi di Bettino Ricasoli,* 8:292–93; 10:381–82, 403; 11:174–76, 220–21; 13:153–54.

50. See the article by Diego Martelli, "Gli ultimi momenti di G. Mazzini. Quadro del Sig. Silvestro Lega," *I Giornale Artistico,* October 25, 1873, pp. 124–25.

51. A. Mario, "Mazzini Morto," *Scritti politici di Alberto Mario,* ed., G. Carducci (Bologna, 1901), p. 90.

52. On this episode see G. Matteucci, *Lega: L'Opera completa* (2 vols; Florence, 1987), 1:226–27; C. Y. Lang, ed., *The Swinburne Letters,* 6 vols. (New Haven, 1959–62), 2:174, 283; D. Durbé and C. Bonagura, *Silvestro Lega* (Bologna, 1973), 48–50. Mario Tinti has written that the Macchiaioli are the "true Pre-Raphaelites" in their attempt to surmount academic convention and achieve a state of naïveté close in spirit to the early Renaissance and thus bridge the gap between Italian

greatness in the past and in the present. See M. Tinti, *Silvestro Lega* (Rome and Milan, 1926), 14–15.

53. Durbé and Bonagura, *Lega*, 5–8; N. Broude, *The Macchiaioli: Italian Painters of the Nineteenth Century* (New Haven, 1987), 153–54.

54. L. Vitali, *Lettere dei Macchiaioli* (Turin, 1953), 127.

55. P. Dini, *Silvestro Lega: gli anni di Piagentina* (Turin, 1984), 17ff.

56. Serafino De Tivoli's *La questua* (Begging for Alms) of 1856 shows a beggar knocking at the entrance of a country estate, with the silhouette of Florence distinctly in view to link the micro and macro of this institutionalization of almsgiving in Tuscany. See Mann, *Gardens and Ghettos*, 140–41.

57. Durbé and Bonagura, *Lega*, xxi.

58. A. M. Fortuna, ed., *Il Gazzettino delle arti del disegno di Diego Martelli 1867*, December 7, 1867 (Florence, 1968), 324.

59. See Signorini and Martelli, *Per Silvestro Lega*, 11.

60. A. Falassi, *Folklore by the Fireside* (Austin, 1980), 106–24, and passim.

61. Ibid.

62. Lovett, *The Democratic Movement*, 68, 77.

63. Signorini, *Caricaturisti e caricaturati*, 50, 74–76; Nobili and Camerani, *Carteggi*, 11:310; M. Giardelli, *Silvestro Lega* (Milan, 1965), 26; Matteucci, *Lega*, 1:186.

64. See O. Barrie, *L'Italia nel Ottocento* (Turin, 1964), 270ff., 671ff.

65. J. E. Miller, *From Elite to Mass Politics: Italian Socialism in the Giolittian Era, 1900–1914* (Kent, Ohio, 1990), 3.

66. For the history of San Bonifazio see W. and E. Paatz, *Die Kirchen von Florenz. Ein kunstgeschichtliches Handbuch* (Frankfurt am Main, 1955), 1:395–405; E. Coturri, "L'Ospedale cosi'detto 'Di Bonifazio' in Firenze," *Pagine di Storia della medecina* 3 (March–April 1959): 15–33.

67. *Della Pazzia in genere, e in specie. Trattato Medico-Analitico* (3 vols.; Florence, 1793–94). See the excellent introduction by G. Mora to his translation of Chiarugi's text: V. Chiarugi, *On Insanity and its Classification*, trans. G. Mora (Canton, Mass., 1987).

68. J.-E.-D. Esquirol, "Maisons d'aliénés," *Dictionnaire des sciences médicales* (60 vols.; Paris, 1802–1820), 30:59; P. Serieux, *L'Assistance des aliénés en France, en Allemagne, en Italie, et en Suisse* (Paris, 1903), 501–3, 346–48, 502.

69. F. Fantozzi, *Nuova Guida . . . della Città e contorni di Firenze* (Florence, 1842), 443–44. Later guidebooks persisted in giving the Ospedale di S. G. Battista di Bonifazio a clean bill of health: E. Bacciotti, *Florence et ses environs* (Florence, 1888), 57–58.

70. R. Canosa, *Storia del manicomio in Italia dall'Unità a oggi* (Milan, 1979), 87.

71. Ibid., 77–78, 135.

72. For material on this issue see L. Guidi, "Prostitute e carcerate a Napoli: Alcune indagini tra fine '800 e inizie '900," *Memoria: rivista di storia delle donne*, no. 4 (1982): 123.

CHAPTER EIGHT

1. See P. Bargellini, *Caffè Michelangiolo* (Florence, 1944); Baccio M. Bacci's preface to Signorini, *Caricaturisti e caricaturati al Caffè Michelangiolo* (Florence, 1952), 7–37.

2. G. Carducci, ed., *Scritti politici di Alberto Mario* (Bologna, 1901), 397–99.

3. D. Mack Smith, *Italy and Its Monarchy* (New Haven, 1989), 87–113.

4. A Marabottini and V. Quercioli, *Diego Martelli, corrispondenza inedita* (Rome, 1978), 61–64.

5. F. Errico, ed., *Giovanni Fattori, Scritti autobiografici editi e inediti* (Rome, 1980), 46–49.

6. G. Uzielli, "Dai Ricordi di uno studente Garibaldino (1859–1860)," *Il Risorgimento Italiano* (1909), 2:944.

7. M. D'Azeglio, *Things I Remember* (London, 1966), 164. Signorini evidently felt a special affection for D'Azeglio: see E. Allodoli, "Telemaco Signorini, pittore e scrittore," *Rassegna della istruzione artistica,* vol. 9 (1938), 210.

8. Signorini, *Caricaturisti e caricaturati,* 186–87.

9. Ibid., 188.

10. *Post-Impressionism, Cross-Currents in European Painting* (Royal Academy of Arts, London, 1979–1980), 243; S. B. Robinson, *Giacomo Balla: Divisionism and Futurism 1871–1912* (Ann Arbor, 1981), 10.

11. A. Scotti, *Giuseppe Pellizza Da Volpedo: Il Quarto Stato* (Milan, 1976), p. 24, 104; *Post-Impressionism,* 245–47; H. Bredekamp, "Der vierte Stand," *Tendenzen* 21 (1980), no. 130, pp. 57–59. See also A. Scotti, "Giuseppe Pellizza: luce, pittura, divisionismo. Olivero, Barabino," *Divisionismo italiano* (Milan, 1990), 112–23.

Index

Pages in italics refer to illustrations.

Abbati, Giuseppe (Beppe), 10, 102–3, 147, 182, 193, 195–98, 248–50, 254–55, 278, 302; *Cart and Oxen in the Tuscan Maremma, 224,* 225; *The Chapel of San Tommaso d'Aquino,* 80, *81; Cloister,* 80, *248,* 248–49; *The Cloister of Santa Croce,* 80, 250, *251,* 254–55; *The Stereoscope,* 195; *The Tower of the Palazzo del Podestà,* 195, *196; View from Diego Martelli's Wine Cellar,* 118, *120*

Abbati, Vincenzo, 249; *The Monument of Paolo Savelli,* 79, *81,* 249

Academic practice, 91–94; Macchiaioli and, 94–96

Academies, 75, 91–94; criticism of, 94, 314n.22; landscape painting and, 94–96, 314n.23; regionalism and, 90–91

Academy of Turin, 91–92, 166–67

Accademia dei Georgofili, 32, 117, 210, 213

Accademia delle Belle Arti. *See* Florentine Academy

Accampamento (Fattori), 131–33, *132*

Accampamento di bersaglieri (Fattori), 131, *132*

Acquaiole della Spezia, Le (Telemaco Signorini), 102

Action party, 39, 96

Adam, Victor: *Rue St. Antoine,* 159, *160*

Adrian IV, 142

Agrarian reform, 216–18; Baron Bettino Ricasoli and, 223–25. *See also* Mezzadria system

Agricultural Regulations of the Estate of Brolio (Ricasoli), 215

Alinari, Leopoldo, 193

Alinari, Vittorio, 193

Alla Croce di Savoia (Carducci), 137–38

Almsgiving, *278,* 278–81, *280,* 327n.56

Altamura, Francesco Saverio, 79, 116, 118, 126; *The First Italian Flag Carried into Florence, 62,* 62–63; *Marius Conqueror of the Cimbri, 145; Portrait of Carlo Troya,* 165, 182

Alvarez, Luis: *The Dream of Calpurnia, Caesar's Wife,* 183

Amari, Michele: *La guerra del Vespro Siciliano,* 57–58

Ambulance, leitmotif of, 155–57, *156*

America (Powers), 173–76, *174*

Amore e patria (Verga), 72

Analfabeta, L' (Borrani), 290, *291,* 292

Anchiano (Telemaco Signorini), *229*

Ancient Cloister of St. Paul's, Rome, 250, *251*

Ancient Cloister of St. Paul's, Rome (Underwood and Underwood), 195, *197*

Anderson, John, 27

Anglade, Baroness Favard De l', 201

Annunciation (Botticelli), 246, *247*

Antiacademicism, 75, 312n.3

Anticlassicism: drama and, 48; the historical novel and, 42–44, 48–55, *51;* history painting and, 44–46, 47–48, 50, *51*

Anticlericalism, 68, 100, 107, 199, 236, 238–39, 245–50; Church of Santa Croce and, 250–55

Aragona, Marchesa Vittoria Visconti d', 57

Arnaldo da Brescia (Niccolini), 48, 142

Arno at the Cascine, The (Fattori), 149

Arrival of Prince Napoleon at Florence, The, 127, *128*

Art criticism, 2–3, 7, 17–18
Artigliera toscana a Montechiaro, L' (Telemaco Signorini), 239, *240*
Artisans' Brotherhood, 97
Artistic practice, 91–94, 181–82
Art-Journal, 192–93
L'Assalto alla Madonna della Scoperta (Fattori), 205, 206–7, 208
Associazione Agraria Subalpina, 32, 33
Attack on the Church of Magenta, The, 155
Attack on the Pickets of the Garibaldi Guard, 28
Austria, war with, 34–37, *37*
Auxiliary Transport of the Wounded, 156, *156*
Azeglio, Massimo d', 21, 38, 57, 72, 77, 107, 144, 241; Challenge of Barletta and, 50–54, 51, 310n.18; *Challenge of Barletta, 51,* 53; *On the Civil Enfranchisement of the Jews,* 239; *Ettore Fieramosca,* 50–54, *51, 52; Niccolò de Lapi,* 50, 54–55; *Things I Remember,* 301; *View of the Town of Apeglio,* 50, *52; Waterfall,* 50, *52*
Azeglio, Roberto d', 239

Babbo, Il (Dall'Ongaro), 138
Bacio, Il (Hayez), 59–62, *60*
Bagnara, Vincenzo Ruffo di Motta e, 57
Bagno penale di Portoferraio (Telemaco Signorini), 295
Balbo, Cesare, 33, 144, 239; *On the Hopes of Italy,* 22
Bandini, Sallustio, 143–44, 180
Banti, Cristiano, 10, 147, 166; *Galileo Galilei before the Inquisition,* 66, 67–68, 311n.34; *Gathering of Peasant Women,* 259–60, *261; Women Plait Weavers,* 102; *The Women Wood Gatherers,* 102, 108
Barbarossa, theme of, 142–43
Barbizon school, 101, 117, 166
Bartolommei, 302
Bastiat, Frédéric, 32
Batelli, Maria Delfina, 278
Batelli, Spirito: Silvestro Lega and, 277–80
Batelli, Virginia, 278
Battaglia di Legnano, La (Verdi), 142–43
Battle at Volturno (Fattori), *230,* 232, 233, 300

Battle of Magenta, 146, 150–57, *152, 154, 155,* 319n.42
Battle of Magenta (Yvon), 153, *154*
Battle of Palestro (Lapi), 165
Battle of Solferino, 35, 150–57, *153, 154*
Battle of Solferino (Yvon), 153, *154*
Battle scenes. *See* Military pictures
Bazille, Jean-Frédéric, 9
Beatrice Cenci (Guerrazzi), 49–50, 267
Beauharnais, Eugène de, 21
Before Capua, Sept. 19, 230, *231*
Beggars, *278,* 278–80, 327n.56
Belgioioso, Princess Cristina (née Trivulzio), 258, 268–69
Berchet, Giovanni, 144
Berry, Duchesse du, 79
Bersagliere (Fattori), 151, *152*
Bersaglieri Leading Prisoners (Lega), 274, *275*
Bersaglieri's Ambush (Lega), 274, *275*
Bertani, Agostino, 97
Bertini, Giuseppe: *Vittorio Emanuele II and Napoleon III at Milan,* 35, *36*
Bettino Ricasoli (Sernesi), 134, *135*
Bezzuoli, Giuseppe, 116, 131; *Entrance of Charles VIII into Florence,* 44–46, *45,* 65; *The First City of Tuscany Paying Homage to the Grand Duke, 47,* 47–48
Bianciardi, Stanislao: *Leopoldo II and Tuscany,* 137
Bimbi al sole (Telemaco Signorini), 195, *198*
Bivouac of Piedmontese Troops . . . after the Battle of Solferino, 131–33, *132*
Bivouac of the Third Corps at Solferino, 131–33, *133*
Black mirror, 82
Bonheur, Rosa, 117, 122–26, 255; *Haymaking in Auvergne,* 122–24, *125*
Borrani, Odoardo, 10, 145, 147, 179, 182, 185, 189, 219, 278, 292; child motif and, 290, *291,* 292; feminism and, 260–65; photography and, 190–92
—Works: *The Corpse of Jacopo de' Pazzi,* 68–70, *69; The Day before the Pacific Tuscan Revolution,* 70; *Grain Harvest in the Mountain of San Marcello,* 183; *House and Seacoast at Castiglioncello,*

220, *223; The Illiterate,* 290, 291, 292; *Red Cart at Castiglioncello,* 224, 225; *The Seamstresses of the Red Shirts,* 264, 265; *The 26th of April 1859,* 183, *184,* 188–89, 198–99, 199, 260–64; *Tuscan Artillery at a City Gate,* 185, *186; Vegetable Garden at Castiglioncello,* 220, 223
Boscaiuole, Le (Banti), 108
Boscaiuole, Le (Gioli), 108–10, 109
Botta, Carlo: *Storia d'Italia continuata da quella del Guicciardini,* 58
Botticelli, Sandro: *Annunciation,* 246, *247*
Bresci, Arnaldo di, 142
Breton, Jules: *Pulse Gatherers,* 110, 112
Brewster, Sir David, 194
Brienne, Walter de, 185–88
Brigandage, 103, 104–5
Briganti, Giuliano, 8
Brolio (home of the Ricasoli family), 134, *135*
Broude, Norma, 3, 14, 17–18; *World Impressionism,* 17–18
Brush gatherers, theme of, 107–10
Bryant, William Cullen, 23
Bulletin Announcing the Peace of Villafranca (Domenico Induno), *37,* 37–38, 242
Butteri, I (Fattori), 219, *221*

Cabianca, Vincenzo, 10, 38, 147, 182; *An Ironworks in Versiglia,* 183; *Canal in the Tuscan Maremma,* 219, *220; Florentine Novella Writers of the Fourteenth Century,* 183; *Florentine Storytellers, 67,* 68; *Morning (The Nuns),* 245, 245–46; *Peasant Woman at Montemurlo,* 94, *95*
Cacciata degli Austriaci da Solferino, La (Telemaco Signorini), 183, 239
Cacciata del duca d'Atene, La (Ussi), *184,* 185–88
Cadavere di Jacopo de' Pazzi, Il (Borrani), 68–70, *69*
Caffè Michelangiolo, 11, 76, 162, 297, 302
Caffè Michelangiolo, The (Cecioni), 297, *298*
Camera lucida, 82

Camera obscura, 192, *197,* 321 n.48

Campagna con mandre un'ora dopo la pioggia (Fontanesi), 166, *169*

Campo italiano dopo la battaglia di Magenta, Il (Fattori), 150–57, 165, 182–83, *183*

Canale della Maremma (Cabianca), 219, *220*

Cannicci, Nicola: *The Sowing of Grain in Tuscany,* 110, *111*

Canto dello stornello, Il (Lega), 281–83, *282,* 284

Cantoni, Rabbi Lelio, 238

Capponi, Marchese Gino, 77, 139, 144, 166, 182

Carbonai, I (Giuseppe Palizzi), 105, *106*

Carbonari, 21, 25, 57, 72–73, 236; Macchiaioli and, 103–5

Carbonari della montagna, I (Verga), 72–73

Carducci, Giosuè, 107, 201; *La Madre,* 226–27; Maremma and, 225–26; "Maremman Idyll," 226; *The White Cross of Savoy,* 137–38

Carega, Francesco: "Circular to the Academies and Institutes of Fine Arts," 181

Carica di Cavalleria a Montebello (Fattori), 205

Caricaturists and the Caricatured at the Cafè Michelangiolo (Telemaco Signorini), 297, 301–4

Carignano, Eugenio (Prince of Savoy), 172, 185, 239

Carlo Alberto (King of Piedmont), 26, 116, 144, 239

Carlyle, Thomas, 23

Carocci, Guido, 244

Cart and Oxen (Fattori), *224, 225*

Cart and Oxen in the Tuscan Maremma (Giuseppe Abbati), *224,* 225

Casa e marina a Castiglioncello (Borrani), 220, *223*

Casati Law, 291

Castelfranco, Giorgio, 8

Catholic Church, 67–68, 100–101, 106, 171, 236

Cattaneo, Carlo, 32

Cavalleria rusticana (Verga), 72

Cavour, Camillo, 15, 32, 33–35, 37–39, 89, 136, 170, 239, 266–67

Cecioni, Adriano, 10, 92, 101, 145, 185, 236, 285–86; *The*

Caffè Michelangiolo, 297, *298*

Celentano, Bernardo, 79

Cellini, Benvenuto: *Perseus Holding the Head of the Medusa,* 190

Cézanne, Paul, 9

Challenge of Barletta (Massimo D'Azeglio), 50–54, *51,* 310 n.18

Chapel of San Tommaso d'Aquino, The (Giuseppe Abbati), 80, *81*

Charcoal-making, 103–4

Charity. *See* Almsgiving

Charles V, 48

Charles VIII, 44–46

Chiaroscuro, 117–18, *120,* 162, 250, 255, 266. *See also* Effect; Light effects

Chiarugi, Vincenzo, 293

Chierici, Alfonso: *Madonna with Child and Two Saints,* 183

Child motif: Collodi and, 289–90; Odoardo Borrani and, 290, *291,* 292; Silvestro Lega and, 286–89, *288, 289*

Chiostro (Giuseppe Abbati), 80, *248*

Chiostro di Santa Croce, Il (Giuseppe Abbati), 80, 250, *251,* 254–55

Church of San Miniato al Monte, 62, 63

Church of Santa Croce, 248–49, 250–55

Cimbrians, defeat of, 118, *121*

Cimitero di Solferino, Il (Telemaco Signorini), 239–41, *240*

"Circular to the Academies and Institutes of Fine Arts" (Carega), 181

Cironi, Piero, 189

Clement VII, 48

Clinic (Rotta), *294,* 295

Cobden, Richard, 32, 180, 264

Code Napoléon, 21

Collodi (Carlo Lorenzini), 289–90; *Pinocchio,* 290

Compositional sketches, 181–82

Concerted Attack on the Village of Montebello, 207

Conciliatore, Il, 22, 144

Confessions of an Octogenarian, The (Nievo), 71, 72

Congress of Vienna, 21

Constable, John, 101; *Ploughing Scene in Suffolk,* 220, *222*

Contadina al campo (Fattori), *212*

Contadina nel bosco (Fattori), 208–9, *209*

Conti, Cosimo: *The Execution of the Cignoli Family,* 165, *169*

Conti, Tito, 176

Corinaldi, Doctor, 201

Corridi, Gustavo, 206

Corridi, Pasquale, 206

Costa, Giovanni, 89, 146–48, 236; influence on Giovanni Fattori, 148–50; *The Mouth of the Arno,* 148, *149*

Costa, Nino: *The Dance of the Charcoal Burners,* 105

Courbet, Gustave: *Return from the Conference,* 100–101

Cousin Argia (Fattori), 259, *260*

Couture, Thomas, 166

Cows at the Watering Place (Troyon), 122, *125*

Cranberry Harvest, The (Johnson), 110, *112*

Crispi, Francesco, 25, 107, 233–34, 299, 300

Croce, Benedetto, 15–17, 32; "A Theory of the 'Macchia,'" 12–13; *History of Europe in the Nineteenth Century,* 15

Cromwell and Charles I (Delaroche), 63–65, *64*

Cucitrici di camicie rosse, Le (Borrani), 264, *265*

Culture, politics and, 140–45, 301. *See also* Italian National Exposition of 1861; Ricasoli competitions

Dall'Ongaro, Francesco: *Big Daddy,* 138

D'Ancona, Alessandro, 204

D'Ancona, Cesare, 201–3, 228

D'Ancona, Sansone, 201–3, 204–5, 223

D'Ancona, Vito, 10, 45, 116, 147, 182, 201–3, 235–36, 302; *The Meeting of Dante and Beatrice,* 182, 183; *Portico,* 118, *120; View of Volognano,* 203, *204*

Danza dei Carbonari, La (Nino Costa), 105

D'Azeglio, Massimo. *See* Azeglio, Massimo d'

Decamps, Alexandre-Gabriel, 117–18; *The Defeat of the Cimbrians,* 118, *121; Rustic Courtyard,* 117–18, *119; Study for the Defeat of the Cimbrians,* 118, *121; Towing Horses,* 117, *119*

Defeat of the Cimbrians, The (Decamps), 118, *121*

Degas, Edgar, 10
Dei Sepolcri (Foscolo), 250–52
Delaroche, Paul, 150; *Cromwell and Charles I*, 63–65, *64*
Del Bello (Gioberti), 70–71
della Francesca, Piero: *The Discovery and the Verification of the True Cross*, 281, *282*
Della Porta, Giovanni Battista, 192, 321 n.48
Della Ripa, Laudadio, 201, 203–4, 223
Del rinnovamento civile d'Italia (Gioberti), 23
Demidov, Anatoli Nikolaevich, 65, 145, 147, 166, 201, 311 nn. 32, 33
Desboutin, Marcellin, 147
De Tivoli, Felice, 80, 101, 235
De Tivoli, Serafino, 10, 116, 117, 126, 147, 180, 183, 235–36, 250, 255, 302; *A Pasture*, 122, *124; View of the Arno from the End of the Cascine*, 80
De Tivoli's Patent Omnibus, 201, *202*
Difensori della libertà fiorentina affrontano conversando il patibolo, I (Fattori), 63, *64*
Discovery and the Verification of the True Cross, The (Piero della Francesca), 281, *282*
Divisionismo, 304
Doctor Antonio (Ruffini), 311 n.27
Dolfi, Giuseppe (Beppe), 25, 107, 302; partonage by, 145, 189–90, 201; politics of, 11, 63, 76, 97, 142; Telemaco Signorini and, 48, 139
Don Giovanni Verità (Lega), 271, *272*
Donkey, A (Filippo Palizzi), 118, *123*
Donna, La, 269–70, 326 n.46
Dopo la battaglia di Magenta (Fattori), 145–46, *146*, 150–57, 165, 182–83, 183
Duke of Athens (Ussi), 165
Dunant, Jean Henri, 157
Durbé, Dario, 8–9, 107–8, 133
Duties of Man, The (Mazzini), 267–68

Earthquake (Lega), 274, *276*, 277
Eccidio della famiglia Cignoli per ordine del generale austriaco Urban, L' (Conti), 165, *169*
Economic conditions, 32–39, 144

Education, 291–92
Effect *(effetto)*, 89–90, 94, 95, 193–94, 313 n.14. *See also* Chiaroscuro
Elemosina, L' (Lega), 278, 278–80, 327 n.56
Elemosina secondo la carità evangelica e secondo la mondana ostentazione, L' (Mussini), *280*
Empiricism. *See* Immediate sensation
Entrance of Charles VIII into Florence (Bezzuoli), 44–46, *45*
Entrance of Emperor Napoleon and the King of Sardinia into the City of Milan, 35, *36*
Episodio della guerra del '59 (Rivalta), 183
Esposizione Italiana del 1861, La (newspaper), 202
Esposizione Nazionale. *See* Italian National Exposition of 1861
Esquirol, Jean-Etienne-Dominique, 293
Ettore Fieramosca (Massimo D'Azeglio), 50–54, *51*, *52*
Evacuation of the Wounded (Yvon), 155

Fabriano, Gentile Da: *Flight into Egypt*, 246, *247*
Façade of the Main Building of the National Exposition, The, 165, *167*
Falassi, Alessandro: *Folklore by the Fireside*, 283
Falconer, Isabella, 201
Famine (Lega), 274, *276*
Fanfani, Enrico: *The 27th of April 1859*, 190, *191*
Fattori, Giovanni, 10–11, 45, 87, 91, 101, 105, 108, 147, 189, 232, 233; Giuseppe Garibaldi and, 157–61, *158*, *159*, *161*; history painting and, 63–67, *64*, *66*; influence of French illustrators on, 159, *160*; influence of Giovanni Costa on, 148–50; military pictures and, 127–34, 145–46, *146*, 156–57, 319 n.42; patrons and, *205*, 205–9, *209*; photography and, 151–53
—Works: *After the Battle of Magenta*, 145–46, *146*, 150–57, 165, 182–83; *The Arno at the Cascine*, *149; The Assault at the Madonna della Scoperta*, 205,

206–7, 208; *Battle at Volturno*, 230, 232, 233, 300; *Bersagliere*, 151, *152; Bivouac of the Bersaglieri*, 131, *132; The Branding of Colts in the Maremma*, 219, *221; The Brush Gatherers*, 107, 107–8; *Cart and Oxen*, 224, 225; *Cavalry Charge at Montebello*, 205; *Cousin Argia*, 259, 260; *The Cowboys*, 219, *221; The Defenders of Florentine Liberty Confronting the Executioner's Block*, 63, *64; The Encampment*, 131–33, *132; French Soldiers of '59*, 128, *129; Garibaldi at Aspromonte*, 160, *161; Garibaldi at Palermo*, 157, *158*, *159; The Italian Camp after the Battle of Magenta*, 150–57, 165, 182–83, 183; *The Look-Out*, 129, *130; Mary Stuart on the Battlefield at Crookstone*, 65–67, *66*, 148; *A Military Reconnaissance*, 183; *The Palmiere Pavilion*, 259, *260; Pasture in the Maremma*, 219, *220; Peasant Woman in the Field*, 212; *Peasant Woman in the Woods*, 208–9, *209; Portrait of the Artist's First Wife*, 259, *260; Study for the Battle of Magenta*, 151, *152; The Water-Carriers of Livorno*, 216
Fauvism, 102
Feminism, 178, 190, 259–60, 266–67, 270, 283–85, 320 n.22; Giuseppe Mazzini and, 267–68, *268*; Odoardo Borrani and, 260–65; opposition to, 295; Risorgimento and, 257–59, 270–71; Silvestro Lega and, 255–57, *256*, 265–66; unification and, 268–70
Ferdinando II, King of Naples, 35, 116
Ferrari, Carlo: *Piazza Navona*, 182
Ferriera nella Versiglia, Una (Cabianca), 183
Ferroni, Egisto: *Return from the Woods*, 110, *111*
Ferrucci, Francesco, 48–49
Fibonacci, Leonardo, 144
Final Repulse of the Neapolitans, The, 230, *231*
First City of Tuscany Paying Homage to the Grand Duke, The (Bezzuoli), *47*, 47–48
First Italian Flag Carried into Florence, The (Altamura), *62*, 62–63

Flight into Egypt (Fabriano), 246, *247*
Florence, 75–76, 77, 147–50
Florentine Academy, 2, 75, 90–92, 166, 181, 312 n.1; landscape and, 94–96; politics and, 96–99
Florentine Storytellers (Cabianca), *67*, 68
Florentine View (Markò the elder), 80–82, *83*
Folk songs, 270; Silvestro Lega and, 281–84, *282*
Fontanesi, Antonio, 33; *Countryside with Herds an Hour after the Rain,* 166, *169*
Foscolo, Ugo: *On Tombs,* 250–52
Frapolli, Ludovico, 107
Fratellanza Artigiana, La, 103, 185
Frederick I (Frederick Barbarossa), 142
Freemasonry, 25, 100; Macchiaioli and, 105–7
French art, 2, 32–33
French illustrators, influence of, 159, *160*
Friends (Filippo Palizzi), 122, *123*
Fucini, Renato, 72
Fuller, Margaret (Mrs. Giovanni Ossoli), 5, 23, 258

Galileo Galilei davanti al tribunale dell'Inquisizione (Banti), *66,* 67–68, 311 n.34
Garibaldi, Anita, 268
Garibaldi, Giuseppe, 58, 87, 107, 250; American support for, 27–28, 174; depictions of, 28–29, 29–32, *30, 31,* 32, 309 n.13; in exile, 25, 26–27; feminism and, 266, 267; Giovanni Fattori and, 157–61, *158, 159, 161;* Gustavo Uzielli and, 229–30; revolution and, 14–15, 23, 25–26, 38–39; Risorgimento and, 16, 24, 206; *The Thousand,* 267; Vittorio Emanuele II and, 69, 96; withdrawal from politics, 299–300
Garibaldi (Nast), 29, *30*
Garibaldi and His Army Arriving at Marsala, 157–59, *158*
Garibaldi a Palermo (Fattori), 157, *158, 159*
Garibaldi at Aspromonte (Fattori), 160, *161*
Garibaldi Legionnaire (Gerolamo Induno), 59, *60*

Gastaldi, Andrea: *Pietro Micca,* 58, *59*
Gazzetta del Popolo, 96, 97
Gazzettino delle Arti del Disegno, Il, 162, 302
General Blanchard Distributing Medals, 130, 131
General Garibaldi a Varese nella gloriosa giornata del 26 maggio, Il (Lega), 274
Genius and Madness (Lombroso), 295
Geography, role of, 148, 227–29, 230
Geology, 212, 227–29, 230
German Nazarenes, 91, 281
Ghetto di Firenze, Il (Telemaco Signorini), 242–43, *243,* 244, 324 n.12
Ghetto di Venezia, Il (Telemaco Signorini), 39, 166, 237, *238,* 241–42, 293
Ghettoes, 236–39, 241–45, 325 n.17
Ghiberti, Lorenzo, 150
Giannelli, Andrea, 97
Gigante, Giancinto: *Sorrento Coastline,* 78, *79*
Ginori, Lorenzo, 116–17, 126, 166
Gioberti, Vincenzo, 144, 239; *On the Moral and Civil Primacy of the Italians,* 22; *On the Civic Renewal of Italy,* 23; *Essay on the Beautiful,* 70–71
Gioli, Francesco (Cecco): depiction of women by, 108–12; *The Women Wood Gatherers,* 108–10, *109*
Giolitti, Giovanni, 299
Giornale agrario Toscano, 217
Giovanni da Procida (Niccolini), 48, 57
Giovine Italia. *See* Young Italy
Giusti, Giuseppe, 144, 227
Gleaners, The (Millet), 220, *222*
Gogh, Vincent van, 29; *Portrait of Père Tanguy,* 29, *30*
"Gramigna's Lover" (Verga), 105
Gramsci, Antonio, 14–15, 16–17, 39; *Prison Notebooks,* 5–6, 307 n.5
Grandmother's Lesson, The (Lega), *288,* 288–89
Graphic journalism, *240,* 241
Green, Vivien Fryd, 174–75
Grossi, Tommaso, 54
Gubernatis, Angelo De, 270

Guerra del Vespro Siciliano, La (Amari), 57–58
Guerrazzi, Francesco Domenico, 21, 77, 97, 107, 302; *Beatrice Cenci,* 49–50, 267; *The Siege of Florence,* 48–49, 63, 189
Guicciardini, Francesco, 48
Gusto dei Primitivi (Venturi), 7

Harper's Weekly, 5, 29
Hayez, Francesco, 131; history painting and, 55–58; *The Kiss,* 59–62, *60; Mary Stuart at the Moment of Climbing the Executioner's Block,* 65; *Sicilian Vespers,* 55–58, *56,* 63
Haymaking in Auvergne (Bonheur), 122–24, *125*
Histoires des républiques italiennes (Sismondi), 57
Historical novels, 41–42, 57, 72; anticlassicism and, 42–44, 48–55, *51. See also* Literature
History of Impressionism (Rewald), 6
History painting, 41, 59–63, 183; anticlassicism and, 44–46, 47–48, 50, *51;* Francesco Hayez and, 55–58; Macchiaioli and, 63–70, *64, 66, 67, 69*
Holy League, 46

Illiteracy, 290–92
Imboscata di bersaglieri Italiani, Una (Lega), 183
Imbriani, Vittorio, 13
Immediate sensation, 3, 70, 88–89, 102, 181, 183
Impressionism, 3–4, 7, 9–10, 11–12, 17–18, 101–2
Incontro di Dante con Beatrice (Vito D'Ancona), 182, 183
Incontro di Vittorio Emanuele II e Napoleone III a Milan, L' (Bertini), 35, *36*
Induno, Domenico, 145; *Bulletin Announcing the Peace of Villafranca,* 37, 37–38, 242; *Poor Venice,* 242
Induno, Gerolamo, 38; *Garibaldi Legionnaire,* 59, *60; Sad Presentiment,* 61, 62
Inquisition Scene (Ussi), 92–93, *93*
Insanity, 292, 292–95, *294*
International Red Cross, 157
Italian art: neglect of, 2, 4–5
Italian National Exposition of 1861, 33, 48, 163, 165–68, *167, 168, 169, 170,* 182–84;

Italian National Exposition
(*continued*)
compositional sketches and,
181–82; industrial and com-
mercial displays at, 180–81,
183; landscape painting at,
178–80; photography at,
192–93; Pietro Magni and,
176–78, *177;* politics of,
168–72, 176, 178, 199–200,
319n.9, 320n.22; Vittorio
Emanuele II and, *170,* 172. *See
also* Ricasoli competitions
Italian Socialist Party (PSI), 300

Japanese prints, impact of, 4
Jews, 201–4, 235–36, 239; Ri-
sorgimento and, 236–37, 258;
treatment of, 50, 202–3, 237–
39, 242–43, 244, 310n.15
Johnson, Eastman: *The Cranberry
Harvest,* 110, *112*
Jouvin, Hippolyte: *Vues instanta-
nées de Paris,* 194
Juste milieu program, 98

*King Receiving the Tuscan Delega-
tion* (Puccinelli), 145
Klustine, Anastasie (Comtesse de
Circourt), 266–67

Landscape painting, 50, *52, 77,
78,* 148–49, 167, 183, 208–9;
Florentine Academy and, 94–
96; at the Italian National Expo-
sition of 1861, 178–80; pan-
oramic format and, 246. *See also*
Posillipo school; Scenography
Lanfredini, Alessandro, 185, *186*
Large Camera Obscura, The, 195,
197
League of Venice, 46
Lega, Silvestro, 10, 82, 91, 145,
147, 292; compared to Luigi
Mussini, 280–81; depiction
of children by, 286–89, *288,
289;* feminism and, 255–57,
256, 265–66; folk songs and,
281–284, *282;* leisure class and,
277–80, *278,* 284–86, *285,
287;* Risorgimento and, 274–77
—Works: *An Ambush by Italian
Bersaglieri,* 183; *Bersaglieri Lead-
ing Prisoners,* 274, *275; The Ber-
saglieri's Ambush,* 274, *275; The
Betrothed,* 286, *287; Charity,
278,* 278–80, 327n.56; *Dedica-
tion to Work,* 256, *257; Don
Giovanni Verità,* 271, *272;*

Earthquake, 274, *276,* 277;
Famine, 274, *276; The Female
Painter,* 255, *256; General Gari-
baldi at Varese on the Glorious
Day of May 26,* 274; *Giuseppe
Mazzini on His Deathbed,* 271–
73, *272, 273; The Grandmother's
Lesson,* 288, 288–89; *Landscape
with Peasants,* 213, *213; Little
Girls Playing as Adults,* 288,
288–89; Mazzinian ideals and,
271–74; *The Mother,* 288–89,
289; Pestilence, 274, *276; Por-
trait of Garibaldi,* 271, *272; Saul,
Tormented by an Evil Demon, is
Pacified by David Playing His
Harp,* 92; *Singing the Stornello,*
281–83, *282,* 284; *The Trellis,*
284–85, *285; The Visit,* 285–
86, *287; War,* 274–77, *276*
Leggitrice (Magni), 176–78, *177,*
290
Leisure class, 277–80, *278,*
284–86, *285, 287*
Leith (Telemaco Signorini),
84–87, *86,* 88
Lemmi, Adriano, 107, 206
Lenticular stereoscope, 194. *See
also* Stereoscopic views
Leopardi, Giacomo, 22; *Le Ricor-
danze,* 303
Leopoldo II, Grand Duke, 47,
49, 75, 80, 91, 96, 116, 172,
312n.1
Leopoldo II and Tuscany (Bian-
ciardi), 137
*Lettera del volontario dal campo, alla
sua famiglia, La* (Moricci), 165,
168
Libertà (Verga), 73
Light effects, 117–18, 118–26,
181, 182, 188, 241–42. *See
also* Chiaroscuro; Immediate
sensation
Lincoln, Abraham, 28
Literature, 71–74; Macchiaioli
and, 73–74. *See also* Historical
novels
Little Girls Playing as Adults
(Lega), *288,* 288–89
Lombard League, 142, *143*
Lombroso, Cesare, 295
London Great Exhibition of 1851,
33, 194
Longhi, Roberto, 6–8
Look-Out, The (Fattori), 129, *130*
Lotto, Lorenzo: *Predella of the
Dead Christ,* 247
Louis-Napoleon. *See* Napoleon III

Loves of the Garibaldini (Nievo),
71–72
Lovett, Clara, 11
Lucini, Conte Francesco Todoro
Arese, 57
Luigi Mussini, 280–81
Lupa, La (Verga), 73
Lupi, Bonifazio, 293

Macchia, 93, 242; in artwork,
12–13; concept of, 94, 98–99,
101–2, 103–4, 151, 193
Macchiaiole: Le (Fattori), *107,*
107–8
Macchiaioli, 1–2, 12, 33, 39,
75–77, 101, 189; academic
practice and, 94–96; carbonari
and, 103–5; debt to view paint-
ers, 80–82; difference from
view painters, 82–88; disillu-
sionment of, 300–301; freema-
sonry and, 105–7; history
painting and, 63–70, *64, 66,
67, 69;* Impressionism and, 3–4,
7, 9–10, 11–12, 17–18; influ-
ences on, 117–26; as Italian Im-
pressionists, 3–4, 9; literature
and, 73–74; meaning and cul-
tural role of, 88–90; mezzadria
and, 209–10; nationalism and,
184–90; photography and,
151–53, 190–92, 193–99;
Pierre-Joseph Proudhon and,
99–100; politics and, 96–99,
103–4, 107–13; Risorgimento
and, 10–11, 115–27, 161–63,
183; scholarship on, 3, 4–5,
6–9; themes of, 11–12
Macchia-scape, 77
Macchia-sketch, 12, 14
Madonna col Bambino e due Santi
(Chierici), 183
Madonna del Cantone, Oratory of,
274–77, *276*
Madre, La (Carducci), 226–27
Magiotti, Quirina Mocenni, 270
Magni, Pietro: *Girl Reading,*
176–78, *177,* 290
Manet, Edouard, 10, 101, 193
Manin, Daniele, 237
Manzoni, Alessandro, 42–44,
144, 286; *The Betrothed,* 21–22,
43–44, 309n.6 to chap. 2
Manzoni, Giuseppe, 97
Marcatura dei puledri in Maremma
(Fattori), 219, *221*
Maremma, 103–4, 215–16;
agrarian reform in, 223–25;
Giosuè Carducci and, 225–26

"Maremman Idyll" (Carducci), 226

Maremma system, 216–18

Maria Stuarda al campo di Crookstone (Fattori), 65–67, *66, 148*

Maria Stuarda nel momento che sale il patibolo (Hayez), 65

Mario, Alberto, 97, 107, 258–59, 273

Marius Conqueror of the Cimbri (Altamura), *145*

Markò (the elder), Karoly, 33, 98; *Florentine View,* 80–82, *83*

Martelli, Carlo, 97, 102–3, 217–18, 228

Martelli, Diego, 6, 97, 100, 101, 104, 107, 108, 109, 166, 185, 218–19, 228, 266, 270, 281; patronage by, 209–10

Martelli, Ernesta, 270

Masterpiece creation, 91–94

Mattino, Il. Le Monachine (Cabianca), *245,* 245–46

Maximilian I, 46

Mazzini, Giuseppe, 32, 89, 96, 113, 258; death of, 271–73, *272, 273,* 299; *The Duties of Man,* 267–68; feminism and, 266, 267–68, *268;* freemasonry and, 25, 107; influence on non-Italians, 258, 261; leadership of, 142, 236, 291; Risorgimento and, 15, 22–24, 38–39

Mazzini morente (Lega), 271–73, *272, 273*

Medici, Cosimo de', 90, 143

Medici, Giacomo, 29

Medici, Giuliano di, 68

Medici, Jacopo di, 68–69

Medici, Lorenzo di, 68

Medici, Piero de', 46

Meissonier, Ernest: *Napoleon III at Solferino,* 151, *153*

Mental institutions, *292,* 292–95, *294*

Mercato Vecchio a Firenze (Telemaco Signorini), 82, 84, *85*

Meucci, Antonio, 26

Mezzadria system, 102, 208–9, 210–14, 218–29, 224–25, 227, 279; Macchiaioli and, 209–10. *See also* Agrarian reform

Mezza-macchia, 93

Michelangelo, 49

Miei ricordi, I (Massimo D'Azeglio), 301

Mie prigioni, Le (Pellico), 22

Mietitura del grano nelle montagne di S. Marcello (Borrani), 183

Military pictures, 141–43, *205, 206–8, 230, 231,* 274; Giovanni Fattori and, 127–34, 145–46, *146,* 156–57, 319n.42; Telemaco Signorini and, 239–41, *240*

Mille, I (Garibaldi), 267

Millet, Jean-François: *The Gleaners,* 220, *222*

Mixed cultivation, 212. *See also* Mezzadria system

Mochi, Giovanni: *King Vittorio Emanuele's Reception of the Tuscan Delegation,* 165, *168*

Modernity. *See* Presentism

Monet, Claude, 9

Montanelli, Giuseppe, 97

Monument of Paolo Savelli, The (Vincenzo Abbati), 79, *81, 249*

Morelli, Domenico, 15–26, 79, 118, 126

Morelli, Salvatore, 285

Moricci, Giuseppe: *The Volunteer's Letter to His Family,* 165, *168*

Mortara, Edgar, 238

Mother, The (Lega), 288–89, *289*

Mouth of the Arno, The (Giovanni Costa), 148, *149*

Mozzoni, Anna Maria: *Woman and Her Social Relations,* 269

Music, propaganda and, 137–38

Musica sacra, La (Mussini), 91, *92,* 313n.16

Mussini, Luigi, 91; *Almsgiving according to Evangelical Charity,* 280; *Sacred Music,* 91, *92,* 313n.16

Nalbandian, Mikael: "The Song of an Italian Girl" (later "Our Fatherland"), 261–64

Napoleon, Prince, 35, 117, 126–27, *128*

Napoleon III, 21, 34–37, 38, 49, 127, 136, 139, 258; statue of, 140–41, *141–42;* Vittorio Emanuele II and, 37, 38, 136, 139

Napoleon III at Solferino (Meissonier), 151, *153*

Nast, Thomas, 29–32; *Garibaldi,* 29, *30;* Illustrations of Garibaldi's Sicilian campaign, 29, *31; The Uprising of Italy,* 29, *31*

Natali, Renato, 8

Nathan, Sara Levi, 258, 271

National history, study of, 77

Nationalism, 21–22, 41, 184–90. *See also* Risorgimento

Nazione, La, 204–5

New York Tribune, 258

Niccolini, Giovanni Battista, 48; *Arnaldo da Brescia,* 48, 138–39, 142, 302; *Giovanni da Procida,* 48, 57

Niccolò de' Lapi (Massimo D'Azeglio), 50, 54–55

Nievo, Ippolito: *The Confessions of an Octogenarian,* 71, 72; *Loves of the Garibaldini,* 71–72

Nittis, Giuseppe de, 302

Noè, Noerina, 258

Nomellini, Plinio, 304

Novellieri Fiorentini del secolo XIV, I (Cabianca), 183

Nuova Europa, La, 73, 96–98, 104, 107, 162, 189, 194, 259, 316n.52

"Observations on the Current State of Italy and Its Future" (Belgioioso), 269

Observed reality. *See* Immediate sensation

Occupazione al lavoro, Un' (Lega), *256,* 257

Ojetti, Ugo, 7

Omnibus, 201, *202*

On the Civil Enfranchisement of the Jews (Massimo D'Azeglio), 239

On the Hopes of Italy (Balbo), 22

On the Lagoon (Verga), 73

On the Moral and Civil Primacy of the Italians (Gioverti), 22

"On the Present Condition of Women and Their Future" (Belgioioso), 269

On the principle of art and its social destination (Proudhon), 100

Opening of the Italian Exposition at Florence by Victor Emmanuel, *170*

Optical devices, 82

Orsini, Felice, 34

Ossoli, Giovanni Angelo, 258

Ottocento Painting (Quinsac), 2

Oxen Going to Work (Troyon), 122, *123*

Paese con contadini (Lega), *213*

Palazzo della Signorina, Florence, 195, *198*

Palizzi, Filippo, 13, 118–21; *A Donkey,* 118, *123; Friends,* 122, *123*

Palizzi, Giuseppe, 105; *The Charcoal Burners,* 105, *106*
Panorama di Firenze dal Monte alle Croci (Giovanni Signorini), 82, *83*
Panorama of Milan, 195, *196*
Panoramic format, 246–47, 286, 305
Parent-Duchâtelet, A. J. B., 295
Paris Universal Exposition of 1855, 33, 115–16, *116–26*
Passage from Adda to Cassano, 156, *156*
Pastura, Una (Serafino De Tivoli), 122, *124*
Pastura in Maremma (Fattori), 219, *220*
Patriotic art, 118
Patronage, 145, 147, 170, 189–90, 200, 201–2, 203–4, 322 n.1; by Diego Martelli, 209–10; Giovanni Fattori and, *205,* 205–9, *209;* Gustavo Uzielli and, 232, 234
Pazzi conspiracy, 68–70
Peasants, depiction of, 220–23, 225, 226–27
Peasant Woman at Montemurlo (Cabianca), 94, *95*
Pellico, Silvio, 144, 266; *Le mie prigioni,* 22
Pergolato, Il (Lega), 284–85, *285*
Perseus Holding the Head of the Medusa (Cellini), 190
Pestilence (Lega), 274, *276*
Photograph of Piedmontese Soldier, 151, *152*
Photography, 4, 88, 199, 295; at the Italian National Exposition of 1861, 192–93; Macchiaioli and, 151–53, 190–92, 193–99; as source of artwork, 264, 284
Piazza a Settignano (Telemaco Signorini), 82–84, *85*
Piazza del Duomo, 149, *150*
Piazza Navona (Ferrari), 182
Piedmont, 33–34, 38, 39, 115–16, 126–27; war with Austria, 34–37, *37*
Pietro Micca (Gastaldi), 58, *59*
Pinocchio (Collodi), 290
Pissarro, Camille, 10
Pitloo, Antonio, 78
Pittrice, La (Lega), 255, *256*
Pius IX, 23
Ploughing Scene in Suffolk (Constable), 220, *222*

Poggi, Enrico, 137
Politics, culture and, 140–45, 301. *See also* Italian National Exposition of 1861, politics of; Macchiaioli, politics and
Popular prints and paintings, 157–59, *158*
Porta, Giovanni Battista Della, 192, 321 n.48
Portico (Vito D'Ancona), 118, *120*
Portrait of Carlo Troya (Altamura), 165
Portrait of Garibaldi (Lega), 271, *272*
Portrait of Père Tanguy (van Gogh), 29, *30*
Portrait of the Artist's First Wife (Fattori), 259, *260*
Posillipo school, 78–80, *79*
Positivism. *See* Immediate sensation
Povera Venezia (Domenico Induno), 242
Powers, Hiram, 147, 178; *America,* 173–76, *174*
Predella of the Dead Christ (Lotto), 247
Predellas, 246–47, 248
Pre-Raphaelites, 273–74, 326 n.52
Presentism, 42, 50, 70–71, 310 n.15
Progressive classes, unification and, 143–44
Promessi sposi, I (Lega), 286, *287*
Promessi sposi, I (Manzoni), 21–22, 43–44, 309 n.6 to chap. 2
Promotrici, 32–33
Protonotari, Francesco, 171, 181; "Report on the Fine Arts," 181
Proudhon, Pierre-Joseph, 99–100, 218; *On the Principle of Art and Its Social Destination,* 100
Puccinelli, Antonio, 45, 182; *King Receiving the Tuscan Delegation Presenting the Decree of Annexation,* 145
Pulse Gatherers (Breton), 110, *112*
Purists, 91
Puritans of the Castle of Tillietudlem, The (Telemaco Signorini), 87–88

Quarto Stato, Il (Volpedo), *304,* 304–5
Quinsac, Annie-Paule: *Ottocento Painting,* 2

Realism, 94, 97, 129, 160–61, 178, 181, 226, 232, 264. *See also* Topographical exactitude
Recovery of Weapons Abandoned by the Austrians in the Cemetery of Solferino, 240, 241
Red Cart at Castiglioncello (Borrani), *224,* 225
Red shirts, 25
Regionalism, 4–5, 32–33; academies and, 90–91
Religious images, 280–81
Religious intolerance, 238–39
Renoir, Pierre-Auguste, 9
"Report on the Fine Arts" (Protonotari), 181
Reportorial illustrations, 131–33, *132, 133*
Return from the Conference (Courbet), 100–101
Return from the Woods (Ferroni), 110, *111*
Reunion of Italian Scientists, 228
Rewald, John: *History of Impressionism,* 6
Ricasoli, Baron Bettino, 107, 116–17, 118, 126, 127, *135,* 163, 166, 171, 201, 215, 228, 254, 266, 302; agrarian reform and, 223–25; *Agricultural Regulations of the Estate of Brolio,* 215; as landlord, 215–16; unification and, 134–40
Ricasoli competitions, 140–45, *145,* 163, 187–88, 318 n.23; antecedents to, 134–40. *See also* Italian National Exposition of 1861
Ricevimento fatto da Vittorio Emanuele degli Inviati toscani che gli presentano il decreto dell'annessione, Il (Mochi), 165, *168*
Richerche intorno a Leonardo da Vinci (Telemaco Signorini), 82, *84*
Ricognizione militare, Una (Fattori), 183
Ricordanze, Le (Leopardi), 303
Riderless Horse Race, The (Giovanni Signorini), 80, *81*
Ridolfi, Marchese Cosimo, 116–17, 126, 139, 145, 166, 172, 201, 215, 228
Rigutini, Giuseppe, 89, 96–99, 162
Ripa, Laudadio Della, 201, 203–4, 223
Risorgimento, 11, 14–17, 19–20,

77; antecedents of, 20–22; economics and, 32–39; failure of, 298–301; feminism and, 257–59, 270–71; Giuseppe Garibaldi and, 16, 24, 206; Giuseppe Mazzini and, 15, 22–24, 38–39; Jews and, 236–37; Macchiaioli and, 10–11, 115–27, 161–63, 183; perception of in America, 174; renewed interest in, 5–6; Silvestro Lega and, 274–77

Risorgimento, Il (newspaper), 33–34, 239

Risorgimento Italiano, Il (journal), 232

Riunione di contadine (Banti), 259–60, *261*

Rivalta, Antonio, 182; *Episode of the War of '59,* 183

Robertson, Priscilla, 268

Rob Roy (Scott), 87

Roman Forum, 195, *197*

Romanticism, 43

Rome Academy, 90

Romiti, Gino, 8

Rosas, Juan Manuel de, 25

Rosselli, Giannetta Nathan, 271

Rossetti, William Michael, 126, 255, 273

Rotonda di Palmieri (Fattori), 259, *260*

Rotta, Silvio Giulio: *Clinic, 294, 295*

Royal Theater of San Carlo, 79

Rubieri, Ermolao, 189

Rudinì, Antonio Di, 299

Rue St. Antoine (Adam), 159, *160*

Ruffini, Giovanni: *Doctor Antonio,* 311 n.27; *Vincenzo, or Sunken Rocks,* 257

Rustic Courtyard (Decamps), 117–18, *119*

Sala delle agitate a S. Bonifacio di Firenze, La (Telemaco Signorini), *292,* 292–95

Salvagnoli, Vincenzo, 210–11, 254

Salvagnoli-Marchetti, Antonio, 228; *Statistical-Economical Reports on the Tuscan Maremma,* 216–17

San Bonifazio, mental asylum at, 292–93

Sant'Antimo, Prince of, 57

Santoponte, Giovanni, 205–6

Saul, Tormented by an Evil Demon, is Pacified by David Playing His Harp (Lega), 92

Savonarola, Girolamo, 46

Say, Jean Baptiste, 32

Scenography, 79, 80. *See also* Landscape painting; View painters

Scott, Sir Walter, 41; influence of, 87–88; *Rob Roy,* 87

Secularization. *See* Anticlericalism

Selvatico, Pietro, 93, 193, 313 n.21

Semplicini, Pietro, 193

Senior, Nassau William, 32

Sernesi, Raffaello, 10, 278, 302; *Bettino Ricasoli,* 134, *135; Roofs in the Sunlight,* 94, *95*

Seward, William Henry, 28

Shiff, Richard, 13

Sicily, 55–58

Siege of Florence, The (Guerrazzi), 48–49, 63, 189

Signorini, Giovanni, 81, 82; *Panorama of Florence from Monte alle Croci,* 82, *83; The Riderless Horse Race,* 80, *81*

Signorini, Telemaco, 10, 82–88, 89, 100, 101, 108, 147, 182, 185, 212, 219, 270, 278, 292, 295, 320 n.24; Giuseppe Dolfi and, 48, 139; Gustavo Uzielli and, 228, 234; on the Macchiaioli, 11, 73, 89, 101, 116, 118, 162, 185, 265–66, 281; military pictures and, 239–41, *240;* on photography, 192; politics and, 96–99

—Works: *Anchiano,* 229; *Caricaturists and the Caricatured at the Café Michelangiolo,* 297, 301–4; *The Cemetery of Solferino,* 239–41, *240; Children in the Sunlight,* 195, *198; The Expulsion of the Austrians from Solferino,* 183, 239; *The Florence Ghetto,* 242–43, *243,* 244, 324 n.12; *Leith,* 84–87, *86,* 88; *The Mental Ward at San Bonifazio,* 292, 292–95; *The Mercato Vecchio at Florence,* 82, 84, *85; The Morning Toilet, 294,* 295; *Piazza at Settignano,* 82–84, *85; The Portoferraio Penitentiary,* 295; *The Puritans of the Castle of Tillietudlem,* 87–88; *The Tuscan Artillerymen at Montechiaro,* 239, *240; Veduta di Vinci,* 82, *84; The*

Venice Ghetto, 166, 237, *238,* 239, 241–42, 293; *Women Water Carriers of La Spezia,* 102

Singing, propaganda and, 137–38

Sisley, Alfred, 9

Sismondi, Jean-Charles-Léonard: *Histoires des républiques italiennes,* 57

Sixtus IV, 68

Sketching, 4, 7, 9, 91, 94, *95*

Smargiassi, Gabriele, 78

Smith, Denis Mack, 170

Social class, 178, 189, 206, 245; depictions of, 259–60, 278–80, 284–85, 290; Macchiaioli and, 102–3, 108, 202, 244. *See also* Mezzadria system

Socialism, 299–300, 304–5

Società Agricolo-Operaia di Mutuo Soccorso, 304

Società Fotografica Toscana, 193, 194

Società Geografica, 228

Società Nazionale Italiana, 34, 38

Sogno di Calpurnia, moglie di Cesare (Alvarez), 183

Soldati Francesi del '59 (Fattori), *128,* 129

Somarè, Enrico: *Storia dei pittori italiani dell'Ottocento,* 7

"Song of an Italian Girl, The" (later "Our Fatherland") (Nalbandian), 261–64

"Song of Italy, A" (Swinburne), 273

"Songs Before Sunrise" (Swinburne), 273

Sorrento Coastline (Gigante), 78, *79*

Sowing of Grain in Tuscany, The (Cannicci), 110, *111*

Statistical-Economical Reports on the Tuscan Maremma (Salvagnoli-Marchetti), 216–17

Stefano Ussi and Alessandro Lanfredini (Veraci), 185, *186*

Stereoscope, The (Giuseppe Abbati), 195

Stereoscopic views, 194–98, *196, 197, 198*

Stewart, John, 172–73, 174, 177–78, 193; on industrial and commercial displays, 180–81; on landscape painting, 178–80

Stornello, 138

Stornello. *See* Folk songs

Stuart, Mary (Queen of Scots), 259

Study for the Battle of Magenta (Fattori), 151, *152*
Study for the Defeat of the Cimbrians (Decamps), 118, *121*
Study of Sheep (Troyon), 118, *122*
Sublime, 71
Swinburne, Algernon Charles, 23; "A Song of Italy," 273; "Songs Before Sunrise," 273

Talbot, William Henry Fox, 192
Tetti al sole (Sernesi), 94, *95*
Thayer, William Roscoe, 5
Theater, propaganda and, 138–39
"Theory of the 'Macchia', A" (Croce), 12–13
Tiburzi, Domenico, 103
Times (London), 24
Toilette del mattino, La (Telemaco Signorini), *294*, 295
Topographical exactitude, 72, 77, 78, 88, 126, 207. *See also* Realism
Torre del Palazzo del Podestà, Il (Giuseppe Abbati), 195, *196*
Towing Horses (Decamps), 117, *119*
Transforismo, 298–300
Treaty of Villafranca, 72
Trecciaole, Le (Banti), 102
Tricca, Angiolo, 182
Triste presentimento (Gerolamo Induno), *61*, 62
Trollope, Anthony, 147
Trollope, Theodosia, 246
Troya, Carlo, 22, 144
Troyer, Nancy, 4–5, 8, 151, 192
Troyon, Constant, 117, 118–21; *Cows at the Watering Place*, 122, *125*; *Oxen Going to Work*, 122, *123*; *Study of Sheep*, 118, *122*
Turner, Joseph, 101
Tuscan Artillery at a City Gate (Borrani), 185, *186*
Tuscan triennial exhibition, 172
Tuscany, 75–76
26 aprile 1859, Il (Borrani), 183, *184*, 188–89, 198–99, *199*, 260–64
27 aprile 1859, Il (Fanfani), 190, *191*

Unification, 20–21, 39, 104–5, 163; Baron Bettino Ricasoli and, 134–40; effects of, 74; feminism and, 268–70; mezzadria system and, 214–15; progressive classes and, 143–44.

See also Italian National Exposition of 1861, politics of; Ricasoli competitions
Uprising of Italy, The (Nast), 29, 31
Ussi, Stefano, *186*, 321 n.38; *Duke of Athens*, 165; *Expulsion of the Duke of Athens*, 184, 185–88; *Inquisition Scene*, 92–93, *93*
Uzielli, Gustavo, 100, 228–29, 234, 235–36, 300–301; Battle of Volturno and, 230–32, 233, 300; Giuseppe Garibaldi and, 229–30

Vannucci, Settimia, 259
Varchi, Benedetto, 48
Vedder, Elihu, 76–77, 89, 147
Veduta, 4, 78–80. *See also* View painters
Veduta dell'Arno dal fondo delle Cascine (Serafino De Tivoli), 80
Vedutisti. *See* View painters
Vegetable Garden at Castiglioncello (Borrani), 220, *223*
Venice Academy, 93, 313 n.21
26 aprile 1859, Il (Borrani), 183, *184*, 188–89, 198–99, *199*, 260–64
27 aprile 1859, Il (Fanfani), 190, *191*
Ventura, Lorenzo, 27
Venturi, Emilia, 273
Venturi, Lionello: *Taste of the Primitives*, 7
Veraci, Beppe: *Stefano Ussi and Alessandro Lanfredini*, 185, *186*
Verdi, Giuseppe, 138; *The Battle of Legnano*, 142–43; *I Vespri Siciliani*, 57
Verga, Giovanni, 72–74, 199; "Gramigna's Lover," 105; *On the Lagoon*, 73; *Libertà*, 73; *Love and Nation*, 72; *The Mountain Cabonari*, 72–73, 104, 316 n.52; *Rustic Chivalry*, 72; *The She-Wolf*, 73
Verism, 72, 74, 199, 285
Verità, Don Giovanni, 26, 107, 271, *272*
Vespri Siciliani, I (Hayez), 55–58, *56*, 63
Vespri Siciliani, I (Verdi), 57
Vianelli, Achille, 78
Vieusseux, Giovan Pietro, 77
View from Diego Martelli's Wine Cellar (Giuseppe Abbati), 118, *120*

View of Gavazzano, on the Road to Tortone, 131–33, *133*
View of the site of the First Italian National Exposition, 165, *167*
View of the Town of Apeglio (Massimo D'Azeglio), 50, *52*
View of Volognano (Vito D'Ancona), 203, *204*
View painters, 77–80, *79*, *81*; difference from Macchiaioli, 82–88; influence on Macchiaioli, 80–82
Vigila della pacifica rivoluzione toscana, La (Borrani), 70
Villani, Giovanni, 185, 187
Vincenzo, or Sunken Rocks (Ruffini), 257
Vinci, Leonardo da, 228
Visita, La (Lega), 285–86, *287*
Vitali, Lamberto, 8
Vittorio Emanuele II, 34, 75, 143, 163, 206; depictions of, 29–32, 127, 140–41, *141–42*, 171; Giuseppe Garibaldi and, 69, 96; Italian National Exposition of 1861 and, 170, *170*, 172; Napoleon III and, 37, 38, 136, 139
Volpedo, Giuseppe Pellizza Da: *The Fourth Estate*, 304, 304–5
"Volunteer and his Beloved, The" (song), 59–62, *61*, 311 n.27
Vues instantanées de Paris (Jouvin), 194

War (Lega), 274–77, *276*
Water-Carriers of Livorno, The (Fattori), *216*
Waterfall (Massimo D'Azeglio), 50, *52*
White, Jessie Meriton, 258–59, 267
Williams, Raymond, 147
Woman and Her Social Relations (Mozzoni), 269
Women: as depicted by Francesco Gioli, 108–12; in the leisure class, 277–80, *278*, 284–86, *285*, *287*; treatment of, 50, 286, 292–93. *See also* Feminism
World Impressionism (Broude), 17–18

Yorick, 174, 188–89
Young Italy, 22–23, 24, 25, 106, 146
Yvon, Adolphe, 153–55; *Battle of Magenta*, 153, *154*; *Battle of Solferino*, 153, *154*; *Evacuation of the Wounded*, 155